Renaissance Engineers
From Brunelleschi to Leonardo da Vinci

FINMECCANICA

Istituto e Museo di Storia della Scienza

COMUNE DI FIRENZE

 Assitalia ISSC-IBM CASSA DI RISPARMIO DI FIRENZE

Renaissance Engineers
From Brunelleschi to Leonardo da Vinci

PAOLO GALLUZZI

GIUNTI

Acknowledgements

Franca Arduini, Irene Ariano, Duccio Balestracci, Lando Bartoli, Elena Bartolini Salimbeni, Pier Luigi Bassignana, Curzio Bastianoni, Andrea Becherucci, Francesco Berardino, Giovanna Bernard, Luigi Berlinguer, Paolo Bianchini, Bruno Bigliardo, Carla Guiducci Bonanni, Paolo Brenni, Stefano Casati, Mauro Civai, Guido Clemente, Pietro Corsi, Rosaria D'Alfonso, Riccardo Dalla Negra, Paolo Dal Poggetto, Alfonso De Virgiliis, Salvatore Di Pasquale, Paolo Fabbri, Maurizio Festanti, Marcello Finocchi, Antigono Frangipane, Bona Frescobaldi, Sergio Gambassi, Gianna Gheri, Tullio Gregory, Pamela Griffin, Francesco Gurrieri, Martin Kemp, Alessandra Lenzi, Rosalia Manno Tolu, Paolo Mazzoni, Romano Messina, Mara Miniati, Lucia Monaci, Giovannella Morghen, Rita Nuccio, Patrizio Osticresi, Franco Paoli, Donatella Parrini, Andrea Pecchio, Carlo Pedretti, Anna Maria Petrioli Tofani, Paola Pirolo, Daniela Pozzi, Mario Primicerio, Massimo Ricci, Vittorio Rimbotti, Stefano Rolando, Bruno Santi, Teresa Saviori, Fiorenza Scalia, Sergio Silienti, Claudia Soderi, Urano Tafani, Pierre Théberge, Piero Tosi, Isabella Truci, Francesca Vannozzi, Agnese Vastano, Saverio Vella, Gherardo Verità, Alessandro Vezzosi.

This edition of the catalogue has been published on the occasion of the Florence venue of the *Renaissance engineers* exhibition.
The exhibition was first presented in Paris, at the Cité des Sciences et de l'Industrie (November 1995-May 1996). Then it was shown in New York City (World Financial Center, October 1997-March 1998) under the title *Mechanical Marvels: Invention in the Age of Leonardo*, in London (Science Museum, October 1999 -August 2000) under the title *The Art of Invention: Leonardo and Renaissance Engineers*, and in Tokyo (National Museum of Emerging Science and Innovation, August-September 2001).

ISBN 88-09-20959-1

Renaissance Engineers: From Brunelleschi to Leonardo da Vinci

Florence, Palazzo Strozzi
June 22, 1996-January 6, 1997

UNDER THE PATRONAGE
OF THE PRESIDENT OF THE ITALIAN REPUBLIC

Patrons

Presidenza del Consiglio dei Ministri, Ministero degli Affari Esteri, Ministero per i Beni Culturali
e Ambientali, Ministero dell'Università e della Ricerca Scientifica e Tecnologica, Comune di Firenze

Concept and general coordination
Paolo Galluzzi

Organization
IMSS: Laura Manetti,
with Elena Montali, Francesca Malagodi
Finmeccanica: Giovanni Di Sorte,
with Gianna Dagnino, Manuela Missori,
Anna Anzellotti
Comune di Firenze:
Silvana Castaldi and Ada Tardelli

Exhibition design
Stefano Gris, with Luisa Tonietto
and Marco Nicolè

Graphic design
Peter Paul Eberle

Photographic production coordinator
Franca Principe (IMSS)

Multimedia and computer applications
IMSS multimedia laboratory: Marco Berni
(coordination and graphic design), Luisa
Barattin, and Monica Tassi, with NEXUS,
Florence

*Animation of original drawings
and virtual working models*
Orchestra, Milan: David Kuller and
Andrew Scupelli

Exhibition set-up and assembly services
Opera Laboratori Fiorentini, Florence:
Franco Ruggeri (coordination),
with Piero Castri

*Silk-screen and photographic
enlargements*
Studio 72, Florence

Transportation of original works
Borghi, Florence

Audioguides
Radio Guide, Florence

Press office
Studio Esseci-Sergio Campagnolo, Padua,
with Antonella Agnoloni, Florence

Administration services
Massimo Saba (IMSS)
Simonetta Vincenzi (Finmeccanica)

Insurance
Gruppo INA-Assitalia

*Studies for the construction
of working models*
Paolo Galluzzi

*Working models, relief models,
and copies*
L. Becagli and C. Cecconi, Florence
Dipartimento di Costruzioni,
University of Florence
FA-MA, Florence
V. Ghione, Turin
A. Gorla, Cividale Mantovano (Mantua)
A. Ingham & Associates and J. Wink,
London
G. Manetti, Impruneta (Florence)
M. Mariani, Florence
Modelli di Architettura, F. Gizdulich,
Florence
Muséo Techni, Montreal
Nuova SARI, Florence
Studio AREA, Florence
Studio Bossi e Bucciarelli, Florence

Lenders
Archivio di Stato, Florence
Archivio Storico AMMA, Turin
Bartolini Salimbeni Collection, Florence
Biblioteca Comunale degli Intronati, Siena
Biblioteca Medicea Laurenziana, Florence
Biblioteca Municipale Panizzi,
Reggio Emilia
Biblioteca Nazionale Centrale, Florence
Biblioteca Reale, Turin
Dipartimento di Costruzioni, University
of Florence
Gabinetto Disegni e Stampe,
Galleria degli Uffizi, Florence
Giunti Gruppo Editoriale, Florence
Alberto Gorla, Cividale Mantovano
(Mantua)
IBM Semea, Milan
Istituto e Museo di Storia della Scienza,
Florence
Museo Civico, Siena
Museo dell'Opera del Duomo, Florence
Museo Ideale, Vinci (Florence)
University of Siena

Translations
English: Jonathan Mandelbaum,
with Michael Gorman, Lynne Otten,
and Kate Singleton
French: Jacques Demarcq, Liliane Izzi,
Adriana Pilia, and Corinne Paul
German: Andrea Scotti

Exhibition film
Scientific project: Paolo Galluzzi,
with Gian Luca Belli, Daniela Lamberini,
and Roberto Masiero
Production: Garage Cinematografica,
Milan
Executive producers: Valerio Castelli and
Renata Prevost
Direction: Giampaolo Tescari
Photography: Fernando Ciangola
Text adaptation: Daniela Morelli

Catalogue

Text
Paolo Galluzzi

Editing
Laura Manetti,
with Elena Montali, Lynne Otten,
and Elisabetta Palazzi

Translation
Jonathan Mandelbaum,
with Michael Gorman,
Lynne Otten, and Kate Singleton

Graphic design
Franco Bulletti
Giunti Gruppo Editoriale, Florence

Page layout
Franco Barbini
Giunti Gruppo Editoriale, Florence

We wish to thank
The Istituto Nazionale delle Assicurazioni
for permission to use the prestigious
Palazzo Strozzi as a venue for the show,
and for having facilitated its installation
in so many ways.

Cassa di Risparmio of Florence for
providing generous backing for this
initiative.

ISSC-IBM for the free loan of the
interactive multimedia terminals
installed along the exhibition itinerary.

The exhibition on Internet
Detailed information on the exhibition is
available on the Istituto e Museo di Storia
della Scienza web site:
www.imss.fi.it/news/mostra/index.html

Contents

The exhibition provides an excellent illustration of the role played by science and technology in Tuscany and in Florence during the Renaissance. The high quality of its installation allows a simple and clear reading of otherwise extremely complex phenomena. It explains the hydraulic system of Siena, the architectural miracle of Brunelleschi's dome, as well as Leonardo's approach to mechanics and to the machine of the human body.

A happy conjuncture is provided by the fact that the exhibition will be housed in Palazzo Strozzi, opened specially for the occasion. It is fitting that an extraordinarily beautiful and austere palace, itself one of the jewels of the Renaissance, should provide the setting for an exhibition of the history of Renaissance engineering in its most important, noble and fruitful forms.

Art and scientific culture merge together, and there is no better way to represent their essential relationship and the productivity of the times when there was no separation between them.

This is a lesson, sometimes forgotten, which we should bear in mind. Florence is the natural place, the unique frame for this exhibition, which has already been extremely successful in Paris. Florence is not so much hosting the exhibition as illustrating it and bringing it to life, because the exhibition is Florence and Tuscany.

For this reason the town government is honoured to have been able to offer this exceptional opportunity, and is grateful to Finmeccanica, to the Istituto e Museo di Storia della Scienza, to INA Assitalia, to the Cassa di Risparmio di Firenze and to all those who made the event possible.

Mario Primicerio
Mayor of Florence

Guido Clemente
Municipal Councillor
for Cultural Affairs

Renaissance Engineers: From Brunelleschi to Leonardo da Vinci: the very title of this exhibition accounts for why Finmeccanica is happy to have been involved in it. The project itself was initially devised by the Istituto e Museo di Storia della Scienza in Florence, and its scope embraces Renaissance technological innovation. Following its first appearance in Paris, the exhibition is now showing in Florence, to coincide with the European Summit that winds up the Italian term of presidency. For this very special occasion, Palazzo Strozzi has been reopened thanks to the generous support of INA, to whom we should like to express our heartfelt thanks. No building could be more suitable, and we are delighted that an exhibition of this magnitude and interest should be housed in so prestigious a venue.

The term "Renaissance" tends to conjure up images of the extraordinary developments that took place in the figurative arts and architecture during the Quattrocento. Yet the period was also informed by the remarkable ideas and achievements of Renaissance men who turned their inventive minds to technology. Such works have been largely and wrongly neglected, so that Leonardo himself has been viewed as an exceptional genius rather than the culmination of a widespread artistic and technical tradition.

Which brings us back to the exhibition: its aim is to show and explain how the Renaissance was shaped by technological innovation well before Leonardo's time thanks to the fertile minds of a number of "polytechnic" geniuses. Of these, Leonardo is undoubtedly the most emblematic and outstanding. Yet he was also the youngest, and thus able to benefit from what his predecessors had already established.

Backing this exhibition and the knowledge it provides comes naturally to Finmeccanica, since it fits in perfectly with the company's own international identity as a purveyor of advanced technology and innovation. Far from seeking short-lived publicity, the Group has always chosen to promote events whose fruits contribute to a real enrichment of our cultural heritage. Such goals are very much part of our daily ideals.

The concept of culture as an intrinsic part of our industrial enterprise has long been essential to the Finmeccanica philosophy. Forty years ago we were behind the birth of *Civiltà delle Macchine*, a magazine that has left its mark on Italian thought and awareness. There is thus deliberate continuity in our current link with the "polytechnic" men of the Renaissance whose works embody a true synthesis of technical inventiveness and artistic creativity.

Finmeccanica's involvement in external events has always sought to show how technology, art and knowledge must go hand in hand if they are to contribute to lasting and beneficial innovation. The company is deeply committed to keeping up with the times; indeed, to forging ahead in research while respecting the heritage of our traditions.

Fabiano Fabiani
Chairman of Finmeccanica

Preface

Above all else, the Renaissance has traditionally been seen as an extraordinary flowering of arts and letters. The persistence of this view has long obscured the revival of technical activity that began in the late fourteenth century – notably in Italy – and lasted, with undiminished vigor, through the fifteenth century. A close examination of the process shows that its prime movers were, in most cases, the same "artists" ("artificers" might be a more suitable term) who led the radical renewal of painting, sculpture, and architecture during those decades. Indeed, it is all too often forgotten that Renaissance artists were routinely involved in activities that we would now define as engineering. Moreover, their workplace – the celebrated "artist's workshop" of the Renaissance – had more in common with a bustling factory than with the modern cliché of an artist's studio. This helps to explain the long-held belief, still widespread today, that Leonardo was an utterly unique manifestation in his time – a brilliant scientist and engineer, as well as a peerless artist. In other words, his greatest inventions are regarded as the product of a towering genius who anticipated by centuries the technological achievements of the modern age, not as the attempts of a singularly gifted man to satisfy the expectations and aspirations prevailing in his cultural environment. In fact, for anyone who examines it attentively and without preconceptions, fifteenth-century culture displays a profusion of technical enterprises, often bold in scope and usually successful. Before the emergence of Leonardo, a host of highly talented artists were involved in such projects.

This historical context provided the inspiration for the present exhibition, *Renaissance Engineers: From Brunelleschi to Leonardo da Vinci*, which has two basic purposes. The first is to put on public display the most significant technological achievements of some of the artist-engineers who preceded Leonardo. These forerunners were instrumental in defining and subsequently winning recognition for a new breed of professional: the artist-engineer-architect-author, who soon attained a secure status throughout Europe.

The second aim of the show is to provide tangible evidence of the fact that Leonardo's "universal" intellectual experience – embracing art, technology, and science – was not an isolated phenomenon, but rather the supremely creative culmination of a long process: the renewal of technical knowledge that persisted throughout the Renaissance, nurturing and stimulating all sectors of artistic endeavor. The exhibition thus restores to its proper place a major cultural phenomenon that can

be described as the "renaissance of machines," a phenomenon still unfamiliar today because it has been dwarfed and obscured by the revival of arts and letters.

The show comprises three sections, devoted respectively to Filippo Brunelleschi, the Sienese engineers (Taccola and Francesco di Giorgio), and Leonardo da Vinci.

One of the prime attractions is an array of large, vivid silk-screen prints, forming a gallery of "machine portraits" by the major artist-engineers of the fifteenth century. Thanks to state-of-the-art multimedia applications, these still views have been put into motion, enabling even non-specialists to understand how the devices worked. The multimedia program also reproduces several dozen notebooks and workshop records by Leonardo and his colleagues. These documents abound with masterful drawings and elaborate notes on applied mechanics. Thanks to the software, visitors can browse them at leisure and find information on their authors and the machines depicted.

Another key attraction is the series of fifty spectacular working models of the most significant machines built or designed by Leonardo and the other artist-engineers of his time. The models were constructed with the same materials and techniques used by the Renaissance engineers. The devices showcase the consummate skills and high expectations of those pioneers, whose machines reflect the quest for innovation and development that marked their exceptional epoch.

Moreover, this unique gathering of original masterpiece drawings, instruments, sculptures, and paintings of the Renaissance engineers gives visitors an immediate grasp of the total integration of art, technology, and science in the work of these gifted "artificers."

The models of Renaissance machines, together with the other exhibits, turn the spectator into an active traveler on a journey filled with fascinating discoveries. At the end, the traveler will emerge with a new image of the Renaissance, richer and more elaborate than the conventional view.

One particularly evocative stage in the journey is the film shown at the exhibition. It offers a new reading of some of the main "monuments" of Renaissance civilization. As the film reminds us, these achievements were regarded – even at the time – as the product and eloquent expression of the profound technological changes that occurred in the fifteenth century, from Brunelleschi to Leonardo da Vinci.

The Florence show marks the logical conclusion of a decade-long program of research and exhibitions on Renaissance engineers begun in 1985. The first two milestones along the way were the *Léonard ingénieur et architecte* show organized in 1987 at the Musée des Beaux-Arts of Montréal with Jean Guillaume (curator of the section of the show devoted to architecture), and the 1991 show on the great Sienese engineers of the fifteenth century entitled *Prima di Leonardo: Cultura delle macchine a Siena nel Rinascimento*. The latter formed part of the University of Siena's celebrations of its 750th anniversary. The Florence exhibition is thus the outcome of extensive preparation, reflected in its entirely novel design and display concepts. Under the title *Les ingénieurs de la Renaissance: de Brunelleschi à Léonard de Vinci*, the show premiered in Paris at the cité des Sciences et de l'Industrie, where it won an enthusiastic reception from the public and critics alike. For the first time ever, visitors can admire the major

achievements of Brunelleschi, Taccola, Francesco di Giorgio, and Leonardo in context. Full use has been made of the many educational and expository features of the latest multimedia technologies, while hundreds of silk-screen enlargements of the Renaissance engineers' magnificent illustrations of machines provide a powerful leitmotiv. The show can also be visited by remote users through a World Wide Web site on the Internet.

An undertaking of such ambition and scope would have been impossible without the firm commitment and whole-hearted cooperation of many participants. My grateful thanks go, first of all, to Finmeccanica. The company's generous support – as the project's main sponsor – was yet another proof of its readiness, displayed on so many occasions, to help promote our cultural heritage. Finmeccanica has been particularly keen to help in projects that use new technologies to protect and enhance cultural assets.

I would like to express special thanks to the Mayor of Florence, Mario Primicerio, and the Municipal Councillor in charge of Cultural Affairs, Guido Clemente, who have worked hard to meet the considerable challenge of finding a suitable location for the exhibition. They have spared no effort to help organize the show in the context of an exceptional event for the city of Florence: the summit of the European Council.

My warm thanks go to the Cassa di Risparmio of Florence, which, once again, has provided generous backing for a large-scale cultural initiative; and to the Istituto Nazionale delle Assicurazioni for permission to use the prestigious Palazzo Strozzi as a venue for the show. This decision has revived the building's ideal function as a setting for major cultural events. May this natural role soon become a permanent one. Lastly, thanks are due to ISSC-IBM for the free loan of the interactive multimedia terminals installed along the exhibition itinerary.

The Prefect of Florence, Francesco Berardino, to whom we express our deepest gratitude, greatly facilitated the issuance of permits for the use of the Palazzo Strozzi.

The show was produced by the Istituto e Museo di Storia della Scienza in Florence. The organization's entire staff took part in the successive phases of the project. For their trust, my thanks go – first of all – to the Chairman, Ginolo Ginori Conti, and the Board of Trustees.

I am also grateful to Laura Manetti, who coordinated the show's organization, Franca Principe, who supervised the photography, and Marco Berni, who designed and produced the computer and multimedia products with the collaboration of Luisa Barattin and Monica Tassi. Elena Montali, Francesca Malagodi, Gianna Gheri, and Elisabetta Palazzi also made vital contributions. Our teamwork with Stefano Gris, the exhibition designer, and Peter Paul Eberle, the logo artist and graphic designer, proved extremely cordial and fruitful. Opera Laboratori Fiorentini, under the skillful coordination of Franco Ruggeri, built the exhibits and arranged transportation and assembly services. Another intensive and rewarding partnership involved the builders of the working machine models, architectural models, and relief maps. Without their fine craftsmanship, it would have been impossible to include such eloquent displays in the show. Comparable thanks are in order for the production of the film on the Machine-Town of the Renaissance, which we owe to the enthusiastic commitment of Valerio Castelli of Garage Cinematografica and his col-

leagues, as well as to the talent of the director Giampaolo Tescari. The countless other debts I have incurred in preparing this exhibition are too numerous to be listed in full. However, I cannot omit my thanks to Carlo Pedretti, who placed his immense scholarship on Leonardo at my constant disposal; and to Riccardo Dalla Negra, Francesco Gurrieri, and Salvatore Di Pasquale, who provided crucial assistance in preparing the Brunelleschi section, for which the Opera del Duomo di Firenze also offered unstinting help. My other special debts of gratitude are to Pierre Théberge, Director of the Musée des Beaux-Arts in Montréal, and Piero Tosi, Chancellor of the University of Siena, who willingly lent the models built for the exhibitions in their respective institutions. I am also extremely grateful to Sergio Giunti for having offered the total cooperation of his publishing group in this venture. Over the past two decades, the Giunti firm has produced a complete series of magnificent critical facsimile editions of Leonardo's manuscripts. In so doing, the company has rendered a service without which a project such as the present show would have been impossible. Intellectually, this exhibition is dedicated to three great scholars, all of whom, unfortunately, are no longer with us. The first is the Frenchman Bertrand Gille, who made fundamental contributions – including of a methodological order – to the history of technology. He was the first to point out the need to regard Leonardo not as a figure divorced from his epoch but as one of the many excellent engineers of the Renaissance. The second, also a Frenchman, is André Chastel, whose warm personality and immense learning I was fortunate to experience on many occasions. Among historians of Renaissance art, Chastel was one of those most sensitive to, and interested in, the technical dimension of artistic activity in that period. He was a profoundly acute student of Leonardo and of the close links between art, technology, and science in Leonardo's work. The third scholar is the Italian Eugenio Battisti, an unrivaled master in historical studies on the "arts" in the plural. Battisti tirelessly advocated research into artistic cultures, where he ably identified the essential and constant presence of the technical dimension. Moreover, Battisti had a loving knowledge of the evocative texts of the Renaissance engineers, which he edited with admirable skill.

Paolo Galluzzi

University of Florence
Istituto e Museo di Storia della Scienza,
Florence

Introduction

THE CONVENTIONAL view of the Renaissance usually gives little space to the protagonists of what may be defined as the "Renaissance of machines" – a phenomenon dwarfed and obscured by the period's literary and artistic achievements. The sole exception is Leonardo, who – since the rediscovery of his manuscripts in the late eighteenth century – has been obsessively extolled as a brilliant inventor.

Leonardo's champions credit him, above all, with being the first to engage in such an extraordinarily modern analysis of machines and mechanisms. This has led to a neglect of the complex, lengthy process that produced a full-scale revolution in the culture and practice of machines in the century leading up to Leonardo. The process was, in fact, marked by decisive phases and influential personalities.

In shedding light on this revolution, we need to reassess the traditional image of Leonardo as the pioneer of an approach to mechanical engineering guided by new methods and bold objectives. Instead, Leonardo now emerges as the culmination, as the most mature and original product of a collective development lasting several decades, to which many highly talented figures made sizable contributions. From such a vantage point, Leonardo ceases to be a visionary prophet in the desert. Rather, he appears as the man who most eloquently expressed – both with words and, above all, images – the utopian visions about the practical potential of technology that were enthusiastically shared by many "artist-engineers" of the fifteenth century.

First, one must try to understand the changing status of the artist-engineer, particularly in Italy – the geographical area on which we shall concentrate as the prime arena of this metamorphosis. One need only compare the image of the medieval engineers with the reputation that their most accomplished successors gradually acquired in fifteenth-century society. With rare exceptions, the medieval engineers have remained anonymous despite their key role in so many extraordinary achievements. These include the construction of the great Gothic cathedrals[1] and the Cistercian abbeys – centers of production and innovation – as well as the conquests of the so-called "medieval technological revolution,"[2] particularly in the military field (the horse stirrup and harness, and the catapult known as trebuchet) and in agriculture (the animal-drawn heavy wheeled plow and three-field rotation of crops).

By contrast, the artist-engineer of the height of the fifteenth century was a socially prominent and respected figure, commissioned by powerful and wealthy patrons, well paid, and often regarded as one of the brightest ornaments in sovereign courts. Italy's popes, princes, and republics vied for the services of the best-known engineers, particularly during the second half of the fifteenth century. The market began to feel the impact of demand from foreign rulers, especially the French monarchy. The activity of some engineers attracted interest even from the Ottoman sultans, notably Mohammed II. Many engineers – including Aristotele Fioravanti, Francesco di Giorgio, Leonardo, Filarete, Fra Giocondo, and Giuliano da Sangallo – had to undertake frequent, exhausting journeys to work on projects commissioned by Italian lords and French monarchs. These varied enterprises embraced the design and construction of palaces,

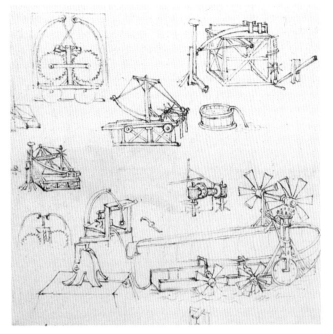

1. Anonymous, GDSU 4085A (detail). The leaf contains
sixteenth-century copies of Leonardo manuscript material,
now lost. The curious boat on the bottom may be
a reminiscence of Brunelleschi's patented vessel
2. Conjectural reconstruction of scaffolding inside the Florence
Cathedral dome by Giovan Battista Nelli (1668-1725)
3. The Duomo lantern, designed by Brunelleschi in 1436

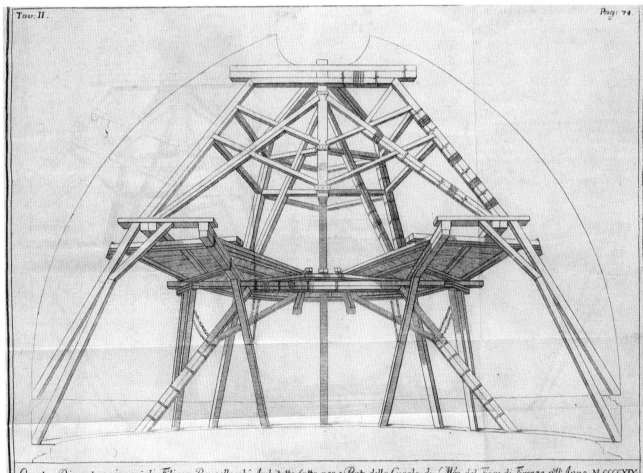

Tav: II. Pag: 74.

Questa Dimostrazione è di Filippo Brunelleschi Architetto fatta per e Bnti della Cupola di S.Mra del Fiore di Firenze nll.Anno M.CCCCXIX
e fu quella che mostro'quando fu lasciato in liberta'di dover esser Solo nell'operazione di d:'Cupola Senza il Ghiberti Suo Compagno
non avendola voluta dar fuori prima di non essere libero Architetto di d:'Opera, come Sentiranno nella Sua Vita Scritta da Diversi.
F.Brunelleschi inv. et del.

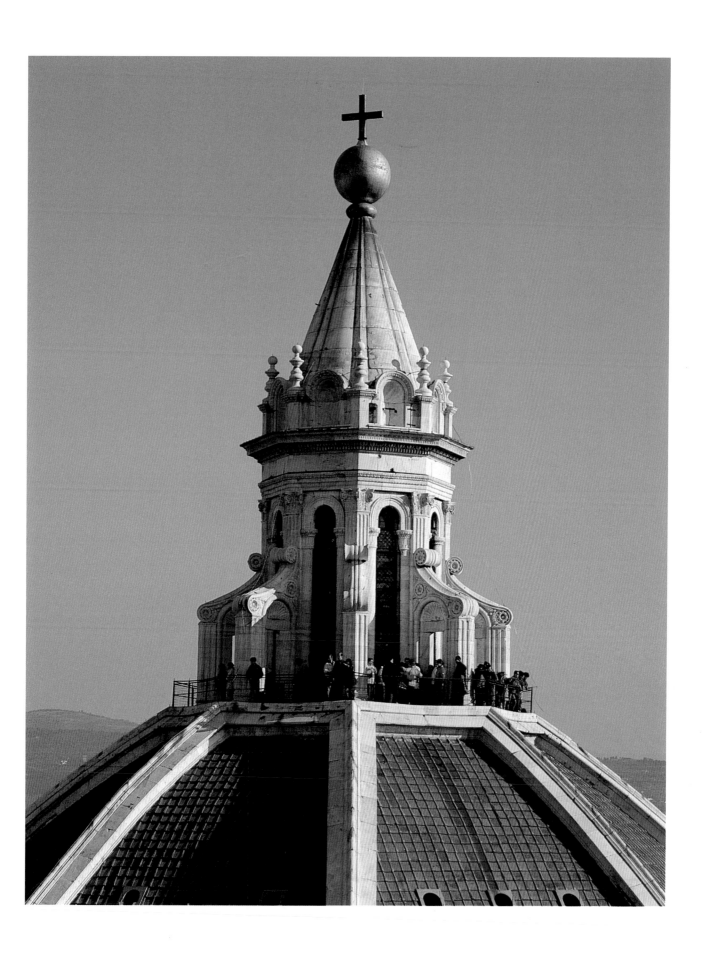

bridges, navigable waterways, dikes, fortifications, war machinery, and efficient aqueducts. Also in demand were machines and systems to improve specific production processes, and enhance the impact of theatrical events and court festivities through "special effects." More conventional commissions included paintings, sculpture, drawings, architecture, and decorative work.

In an age that witnessed continuous wars between the Italian States, the formation of the principal seignories, the rise of commerce and manufacturing, and intense urbanization, the engineers played an increasingly critical role. They offered manifold skills, continuously perfected in that laboratory for artistic and technical innovation, the Renaissance workshop. This process had two closely linked effects. First, the artist-engineer acquired a social prestige that echoed the honors bestowed by the rulers of antiquity on the most eminent engineers of their day. Such precedents included Dinocrates, the protégé of Alexander the Great, and Sosigenes, glorified by Caesar Augustus.

In turn, the social ascent of the artist-engineers stimulated them to improve their cultural credentials in order to draw closer to the cultural establishment – namely, the humanists who graced the sovereign courts and were capable of reciting elegant Latin speeches, discussing natural philosophy or Aristotelian logic, and deciphering the Greek and Latin classics. The artist-engineers' aspirations are readily visible in the efforts many of them made during the fifteenth century to transform themselves from unrefined, literarily "mute" mechanics into "authors" of reasonably well-structured texts. Their works were patterned on classical models (chiefly Vitruvius's *De architectura*); striving for literary elegance, they brimmed with quotations from classical sources – albeit often truncated or plainly inaccurate.

The engineers' writings provide a gauge of the radical transformation under way. Indeed, the engineer-author had been absent from the cultural scene of the Christian West at least since the distant age of Vitruvius (1st cent. B.C.) and Hero of Alexandria (1st cent. A.D.). The channels through which these new players entered the literary arena shed valuable light on the broader development of Renaissance culture. Although the engineers' actual writings are rarely well-organized or accurate, ex-

amples abound of planned, outlined, but unfinished works. In fact, none of the many literary efforts of the fifteenth-century Italian engineers was circulated in printed form. They were, however, very widely disseminated and cited – witness the abundant copies and derivative works surviving in libraries and archives around the world.

The impact of this new literary genre and its new authors was heightened by the novelty of the subject matter. In an age that venerated classical culture, the revival of machinery illustration (*machinatio*) along the lines of Vitruvius' *De architectura* also attracted interest. More decisive, however, was the new dimension these writings gave to the very concept of "text." Verbal description widened into an intense dialogue with a complex of extraordinarily rich and evocative images.

The most original contribution of the new authors lay in the systematic integration of images into discussions of architecture and machinery – indeed, the primacy of graphics over words. Taccola, Francesco di Giorgio, and – later and even more forcefully – Leonardo all emphasized the inadequacy of mere words, and the need to interweave them with pictures. Only the artist-engineer had the required competence and drafting skills to deal with architecture, mechanics, and – as Leonardo was to do – with anatomy, hydraulics, and geology. This claim was central to the new cultural agenda of the engineers who challenged the intellectual establishment. The culture of observation, action, and description was set off against the culture of eloquence, rhetoric, and sound. This defiant assertion of professional pride led Francesco di Giorgio to deride the authors of architectural and mechanical treatises who lacked basic drawing skills. This climate also explains some of Leonardo's proud references to himself as an "unlettered man." These should not be read as praise of ignorance, but rather as the assertion of the need to combine textual study with the observation of nature. Leonardo was underscoring the advantages of describing works of art and nature not with words alone but with drawings as well.

We shall return later to the centrality of the new technicians' belief in the innovative and expository function of images. At this point, however, it should be noted that the artist-engineers did not rely on their draftsmanship and practical skills alone to es-

tablish their reputation as literary authors. They were also busy mastering the technical and scientific domains of classical learning. Their antiquarian interest is clear in the many visits they made to Rome to gather the secrets of the city's revered ancient civilization from its surviving ruins.

The interplay between old and new was eloquently expressed in the engineers' search for "intermediaries" to help them comprehend antiquity. Their task was complicated by their ignorance of classical languages and lack of mathematical education: Archimedes and Euclid, for example, were beyond their reach. Throughout the fifteenth century, a deliberate and self-interested collaboration developed between the new breed of engineers and the more refined humanists – between Brunelleschi and Paolo dal Pozzo Toscanelli; Taccola and Mariano Sozzini; Francesco di Giorgio and Ubaldini; Leonardo and, on the humanist side, Luca Pacioli and Giorgio Valla. In his blend of engineering expertise and humanist scholarship, Fra Giocondo was an exception.[3]

The artist-engineer turned to the humanists for help in learning the culture of antiquity, particularly technical and scientific sources. The engineers' attitude, however, was not purely passive and deferential. On the contrary, they could reciprocate by offering humanists the vital contribution of their own experience for deciphering ancient descriptions of machines, mechanical devices, and architectural structures. Engineers could also translate the meaning of a verbal description into clear graphics. This translation was often crucial to a full understanding of classical texts such as Vitruvius's *De Architectura*, which verbally describes edifices and machines of which no images survived.

The cooperation between artist-engineers and humanists is a distinctive feature of fifteenth-century culture that has not received proper emphasis. The attempt to decipher *De Architectura* occupied many distinguished humanists, leading them to seek out the assistance of artist-engineers. Their partnership, however, soon proved highly effective for interpreting texts of classical and medieval optics as well: a vivid example is provided by the *Commentaries* of another leading artist-engineer of the fifteenth century, Lorenzo Ghiberti.[4] These sources played a key role in the emergence of linear perspective, which was to revolutionize the very con-

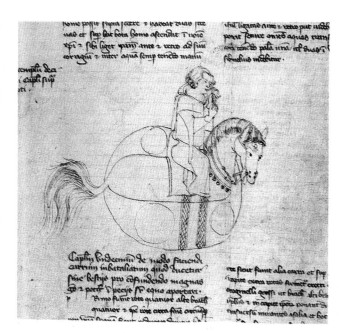

4. Guido da Vigevano, *Texaurus*, BNP, Ms. Lat. 11015, fol. 50r. Man crossing a river on horseback. Inflated leather bags help keep rider and mount afloat

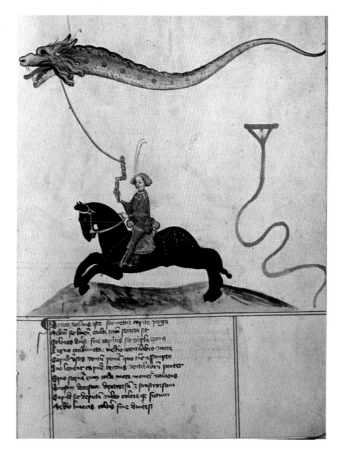

5. C. Kyeser, *Bellifortis*, NSUBG, Ms. Philos. 63, fol. 105r. The horseman is flying a dragon-shaped kite to frighten the enemy

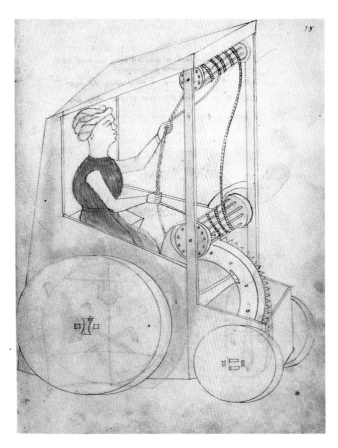

6. G. Fontana, *Bellicorum instrumentorum liber*, BSBM, fol. 18r.
Catedra deambulatoria, a rudimentary automobile

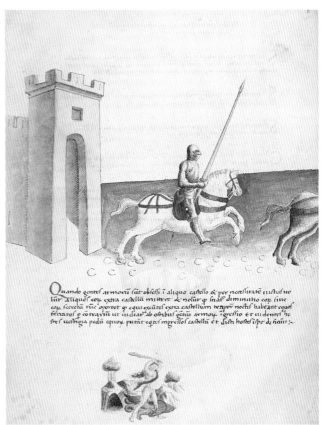

7. P. Santini (after Taccola, *De machinis*), BNP, Ms. Lat. 7239,
fol. 10r. At night, unseen by the enemy, soldiers ride out
of the fortress on horses whose shoes have been fitted
backward, fooling besiegers into believing that reinforcements
have arrived

cept of pictorial representation. The same approach was used for mechanics (Archimedes and the medieval *scientia de ponderibus*, the "science of weights") and for the masterpieces of Greek geometry (Euclid and, again, Archimedes). Both corpuses of ancient texts were soon perceived as crucial in transforming the work of engineers from a purely practical, experience-based activity into a discipline resting on a set of axiomatically defined theoretical premises, implemented by means of rigorous calculation and measuring methods.

The metamorphosis of the image and role of engineers was a long and not always linear process. Its main theater was, unquestionably, Italy between the late fourteenth and early sixteenth centuries. True, other important figures were active in France and southern Germany during the same period.[5] The artist-engineer-author – combining multiple skills in military matters, mechanics, hydraulics, architecture, art, and other fields – emerged in the latter half of the fifteenth century. He was to have a

widespread, resounding success in European courts during the sixteenth century. His persona embodies a new category of intellectual writing elegant, richly illustrated treatises that almost always combined theory and practice. Even the few non-Italian exemplars bear witness to the profound, European-wide impact of the redefinition of the engineer's professional practice and expertise – a process that unfolded in fifteenth-century Italy. The show entitled *Renaissance Engineers: From Brunelleschi to Leonardo* presents some of the major protagonists and episodes of that story, from among the many offered by the fifteenth century. The exhibit comprises three parts, each focusing on a key individual or group: Brunelleschi, the Sienese engineers, and Leonardo. This division takes visitors through the basic stages in the artist-engineer's emancipation from the culturally subordinate role discussed above.

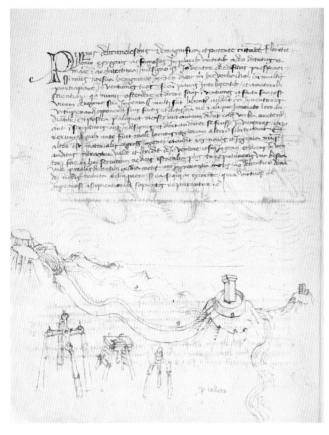

8. Taccola, *De ingeneis I-II*, BSBM, Cod. Lat. Monacensis 197 II, fol. 107v. Taccola's record of his conversation with Brunelleschi.

9. Taccola, *De ingeneis III-IV*, BNCF, Ms. Palat. 766, fol. 48r. Saint George and the dragon

The Brunelleschi episode marks the emblematic start of the engineers' break from their traditional role as mere practitioners, with no literary ambitions, and often working anonymously. His uneven but stunning success paved the way for social recognition and the definition of a new professional identity for artist-engineers in later generations. The Sienese engineers (Taccola and, above all, Francesco di Giorgio) show the initial results of the effort to turn the artist from a hands-on operative into an "author" – which Brunelleschi was not, nor sought to be.

The artist-engineers of Siena had grasped the tremendous interpretative and expository potential of graphics. They made a mature, knowledgeable use of the medium to enhance the demonstrative power and expressiveness of their texts. Thus was born a new literary genre, a form that rejuvenated the models of remote antiquity, among which Vitruvius was by far the most influential.

Leonardo – the subject of the third section – illus-trates the momentous implications of the process. With Leonardo, the artist-engineer ceased to be a mere author and no longer contented himself with practical proficiency. He used the instruments at his disposal or the new ones he was arduously learning (drawing, observation, mastery of mechanics, geometrical expertise) to interpret nature, unveil its secrets, and harness it to man's advantage by imitating its procedures. In the utopian spirit that pervades so many of Leonardo's writings and drawings, the artist-engineer was transmuted into the true "philosopher," the only learned individual capable of revealing nature's complex and necessary mechanisms.

With Leonardo, the goals expanded out of all proportion, and the metamorphosis of the medieval technician was complete – but not to the point of justifying the claim that Leonardo's experience differed radically from that of the artist-engineers immediately prior to him. On the contrary, Leonardo voiced the same conflicts and aspirations as his

forebears – albeit more eloquently and incisively, and with a boundless confidence in the potential of technology. He thus personified the culmination of a slowly maturing process of which he was fully aware. In other words, Leonardo was not a miraculous manifestation in an age unready to welcome his powerful inventive spirit – a long-repeated assertion that endures in the popular cliché of Leonardo as a prophetic, misunderstood genius. Our exhibition, we trust, will go some way toward correcting this mythical image of Leonardo. Visitors will in fact be introduced to the fascinating evidence of Leonardo's manifold activities only after having become familiar with the achievements of Brunelleschi (which greatly impressed Leonardo himself) and the sophisticated technological skills of the Sienese engineers. This approach in no way diminishes the exceptional character of Leonardo's work. On the contrary, it enables us to identify and appreciate those many areas – and they were far from marginal – where he made a truly outstanding contribution, opening up totally novel paths.

I. Brunelleschi and the construction of the dome of Santa Maria del Fiore

The saying "His works are his only witnesses" applies to no one better than to Filippo Brunelleschi (1377-1446). Of his writings – if ever he put pen to paper – not a single line survives, although a few sonnets attributed to him demonstrate a certain literary verve.[6] Nor do we possess any autograph drawings by him, despite the fact that he must have prepared a great number of them for the many ambitious construction projects that he masterminded.

The works, however, still stand, although some of them raise questions that await definitive answers. One such question surrounds the claims about his skill as clockmaker, mostly cited by his first biographer, Antonio di Tuccio Manetti,[7] but for which we lack corroboration or direct documentary evidence. By contrast, Brunelleschi's activity as a goldsmith is well-known and documented. In this field, he faced such outstanding rivals as Donatello and Ghiberti. In fact, Brunelleschi's first competition against Ghiberti was an unsuccessful bid to obtain the commission for the door panels of the Baptis-

tery of San Giovanni. Another consistent, documented tradition credits Brunelleschi with a experiment that proved crucial to the introduction of linear perspective in painting.[8]

Of Brunelleschi's activity as military engineer, we have many first-hand accounts and, more conclusively, a few actual examples – notably the fortifications of Vico Pisano. In this field, he also suffered a major setback, from which we learn, however, that one of his technical specialties was hydraulics. In 1428, Florence was at war with Lucca. Despite their long siege of the enemy town, the Florentine troops had failed to obtain its surrender. Brunelleschi was asked to implement the project of diverting the Serchio River in order to flood Lucca. This extremely costly venture ended in disaster, as the river's waters, leaving their natural bed, flooded not Lucca but the Florentine army camp![9]

Other documents show Brunelleschi involved in designing a boat (fig. 1) to sail up the Arno to the gates of Florence. The vessel was intended to allow easy transportation from Carrara of the heavy marble slabs for the dome of Santa Maria del Fiore. In 1421, Brunelleschi applied successfully to the Florence authorities for what may be regarded as the first recorded patent in history. Even this venture, however, failed. The boat sank in 1425 with its load of 100 tons of white marble, and Brunelleschi was forced to pay for the substantial losses.[10]

Brunelleschi also applied his mechanical skills to the construction of "special effects" for civil and religious ceremonies and pageants. The most documented instance, thanks to Vasari's detailed description,[11] is the system set up in 1439 for the Annunciation festival in the church of San Felice.[12] Using sophisticated contraptions, Brunelleschi staged a vivid make-believe Paradise. Under the church roof, a swarm of angelic figures (played by real children) moved as if floating in air, amid a display of dazzling lights and fireworks accompanied by heavenly music. This type of performance, fairly common in the fifteenth century, was quite accident-prone, often ending in violent fires and sometimes even the death of the actors.

From these few examples, we can begin to grasp the central, mediating role of Brunelleschi between the late fourteenth and early fifteenth centuries in Florence. The city was busy completing and enlarging the bold architectural and urban projects

10. Taccola, *De ingeneis III-IV*, fol. 42r. Saint Dorothy with the Infant Jesus

11. Taccola, *De ingeneis III-IV*, fol. 8v. Man with donkey

conceived as far back as the late thirteenth century. It was intent on asserting and consolidating its position not only as a center of commercial excellence on an international scale, but as a cultural capital and "civil laboratory" for the entire West. Florence also aimed to serve as the engine for the widely desired reunification of Christianity – then split by multiple schisms and heresies – in order to make the Church an effective bulwark against the Turkish peril.

In a word, the city was eager to expand and to make its mark on the international scene. Like his contemporary colleagues – Donatello, Ghiberti, Battista d'Antonio, and others – Brunelleschi offered Florence challenging but not extravagant projects, and, above all, the practical means to realize them. Our earlier comment on Leonardo applies to Brunelleschi as well: he was not a lone genius but the most brilliant, most successful representative of a host of talented engineers who operated in Florence and the rest of Italy in the same period.

We have already mentioned Lorenzo Ghiberti – Brunelleschi's keenest, most formidable rival in rearly every field. Rival and partner would be a more accurate description. There is much evidence that the design of the work for which Brunelleschi is rightly most famous, the dome of Santa Maria del Fiore, was in fact a largely collective enterprise. The initial plans dated back to the mid-fourteenth century. Brunelleschi was not the only person to play a decisive role in its specifications. Substantial contributions were also made by Ghiberti, as well as by many other less prominent experts whose advice was repeatedly sought. The latter responded to calls for bids from the town authorities. Their ideas and proposals, often quite sensible, went into the vast "melting pot" of the dome project, and were certainly exploited by Brunelleschi.

The story of the dome's construction has been adequately described elsewhere.[13] The main documents were published by Cesare Guasti.[14] Other studies, particularly since that edition, have helped to identify the basic stages prior to the start of construction in summer 1420. The project had been preceded by public invitations to tender and hearings in which many engineers – not only from Florence – took part. There is specific documentary evidence of the municipality's long-standing wariness and concern about Brunelleschi's plan to vault

the dome without wooden centering. The authorities surely appreciated that his solution would save considerable timber (and thus money) and take less time to build, but they feared that a structure so massive would not be self-supporting. In the event, the management of the project was initially assigned not to Brunelleschi alone – despite his

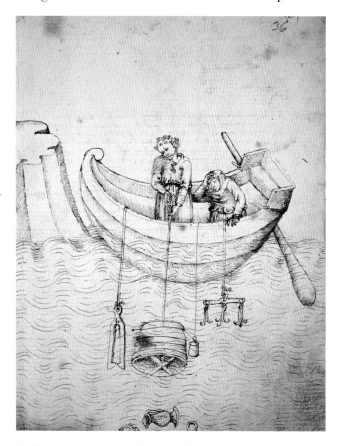

12. Taccola, *De ingeneis III-IV*, fol. 36r. Salvaging a sunken treasure

being the originator of the approved design – but to Brunelleschi and Ghiberti jointly. The two men received equal pay, which meant equal authority. Over the years, as trust in the feasibility of Brunelleschi's design increased, Ghiberti gradually faded from the scene and Brunelleschi assumed full, undivided responsibility.

The dome was completed up to the upper eye (*oculus*) in the amazingly brief span of fifteen years. The models and multimedia programs in this show clearly illustrate the physical structure of the dome, which has been fully understood for some time. By contrast, a lively debate persists over Brunelleschi's method of performing the complex masonry

work in order to maintain the preset radii of curvature (a "pointed fourth" for the outer shell, a "pointed fifth" for the inner cupola). The hypothesis that Brunelleschi used a dense mesh of plotting ribs is, in the present author's view, highly plausible. This suggestion is made in a recent study by Francesco Gurrieri,[15] who takes up in fuller detail the classic analysis by Sanpaolesi.[16] Even on this issue, however, we have to admit that we are in the realm of coherence and probability, not that of conclusive demonstrations. Gurrieri offers an up-to-date review of the main theories about Brunelleschi's design methods,[17] together with an analysis of the principles governing the equilibrium of masses in such a highly complex structure during the successive construction stages. The question remains whether Brunelleschi was aware of the theoretical principles of structural stability. Naturally, he could not have known any of the models of theoretical analysis that were to be developed several centuries later – models that accurately explain the dome's statics. Yet, to the observer, the dome's construction instinctively appears to embody a plan based on geometrical analysis and mechanical, quantitative mechanical specifications. Admittedly, these have not survived in the documentary sources. This issue has crucial implications, especially for the broader question of the respective contributions of practice and theory to the birth of modern technology. The Church's vast worksite is, unfortunately, silent. It cannot recount its own history and answer our queries.

Another aspect of this exceptional project is particularly important from the standpoint of technological culture: the design and organization of the construction site.

A few key figures are worth recalling. The weight of the dome, from the impost (resting-block) on the tambour up to the eye, is estimated at some 37,000 metric tons. If we add the weight of the scaffolding, the workmen, their implements, the water to mix cement and wet the masonry, the machinery, and so on, the total weight surely exceeded 40,000 metric tons. The dome impost stands more than 50 meters above ground level, the closing eye at 90 meters. The masonry work was performed for an average 200 days a year, allowing for winter breaks due to bad weather, maintenance, holidays, and so on. This leaves about 3,000 working days from the

start of masonry work to the closure of the *oculus*. In other words, an average of more than thirteen metric tons of materials had to be lifted daily on the dome's indoor and outdoor scaffolding during the construction period.[18] But lifting earth to the scaffolding was not the only task. Materials had to be distributed once they reached the scaffolding. Loads had to be shifted to allow the accurate positioning of blocks, the marble ribbing elements, and the oculus – a ring of stones weighing about 750 kilograms apiece. Allowing for these additional operations, the total load hoisted daily was even more colossal.

The statistics above highlight the crucial role played by the design, organization, and extreme efficiency of the worksite in ensuring the successful completion of the dome.[19]

On the scaffolding arrangements, we can only make conjectures (fig. 2). The boards must have rested on the same basic masonry structure from which the heads of their supporting irons still protrude today. In all likelihood, Brunelleschi did not introduce radical innovations in the scaffolding, but merely adapted the proven techniques of Gothic construction work to the novel and more complex situation – namely, a masonry surface that was not vertical but at a continuously increasing slope. For the lantern, we have an impressively detailed drawing that shows the "castle" built to repair lightning damage in 1601. The solution may reproduce, at least in part (see below, pp. 110-11), the structure of the scaffolding set up to build the lantern, an element planned by Brunelleschi but erected only after his death.

A far less arduous task – thanks to an abundance of sources, including illustrations – is the reconstruction of the main machines designed or improved by Brunelleschi and used in successive construction stages.

The pioneering investigations in this area were conducted by Ladislao Reti,[20] with later additions and enhancements by Gustina Scaglia[21] and Frank Prager.[22] In 1976, Salvatore Di Pasquale built the first working models of the machines. Thanks to these various efforts, Brunelleschi's worksite machinery is now fully documented. Working models of many of the devices, specially built for this show using historically plausible techniques and materials, are on display in Section I. For over half a cen-

tury, these machines were in continuous, efficient operation at the worksite. The project's final element, the gilded copper sphere with the cross at its top above the lantern, was not actually placed until the early 1470s (fig. 3).

Perhaps the most striking feature of Brunelleschi's construction machines is the close interrelation-

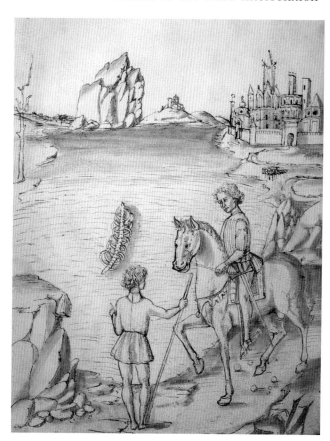

13. Anonymous, BNCF, Ms. Palat. 767, p. 120. Idealized portrait of Leon Battista Alberti, who attempted to recover a Roman shipwreck from the bottom of Lake Nemi

ship between their structure and the worksite's operating requirements and physical characteristics. One cannot help thinking that, in Brunelleschi's mind, the definition of the structural arrangement of the project and the design of the main construction machines proceeded on parallel, strictly symmetrical tracks. From the formulation of the project concept, he must have moved directly to defining the techniques and instruments needed to achieve it economically, quickly, and safely. Witness, for example, the solution adopted for the construction of the lantern. It is hard not to marvel at the rationality and economy of the Brunelleschian concept –

14. P. Santini (after Taccola, *De machinis*), BNP, Ms. Lat. 7239,
fol. 6v. *De tempore incipiendi bellum secundum astrologiam*
(on the right time to begin war, according to astrology)
15. "Collection of Greek Mathematicians," BNP, Ms. Grec. 2442,
fol. 5r. Articulated siege ladders
16. Vegetius, *De re militari*, Erfurt 1512-13, pl. XXXIV.
The model for this drawbridge was taken from Valturius

illustrated in the show by the scale replica of the
worksite using models and multimedia demonstra-
tions. The lantern crane is perfectly suited to the
structure to be built. In fact, the device served not
so much to lift elements as to position them accu-
rately. In the first stage – the construction of the
octagonal base – the crane is placed inside the
masonry, while its eight lower supports jut out
from the perimeter of the edifice through the eight
purpose-built windows. Thanks to these eight ver-
tical openings, the machine can be gradually raised
by means of screw mechanisms as the masonry
reaches higher.
The second stage involved the construction of the
cone-shaped lantern spire, followed by the place-
ment of the copper sphere and the cross. For this

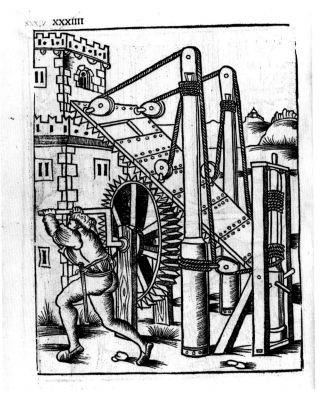

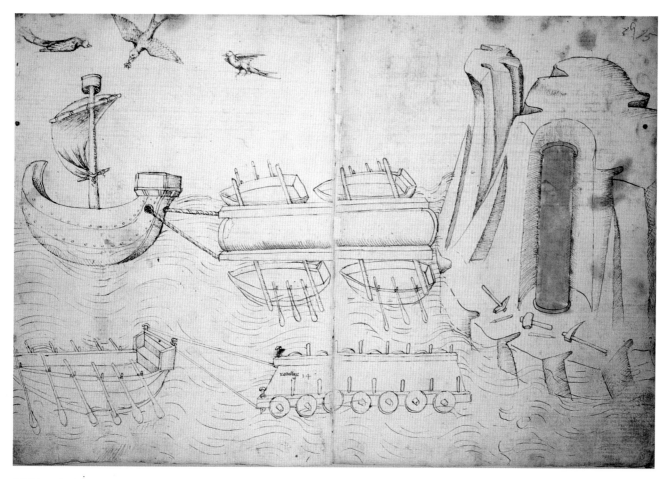

17. Taccola, *De ingeneis III-IV*, fols. 14v-15r. Quarrying, overland conveyance, and shipment of a column

purpose, the same machine – fitted with a horizontal-shaft winch and a mobile line block – was set up to position the elements not outside but inside its base perimeter (see below, p. 109).

In contrast to what we stated about the dome's design and construction, there is much documentary evidence to suggest that Brunelleschi was entirely responsible for planning and organizing the entire worksite, as well as its main machines. For these, he was repeatedly – and sometimes handsomely – rewarded. They were clearly seen as bold innovations capable of speeding the project's completion while affording substantial cost savings.

The Florentine authorities were particularly generous to Brunelleschi for his setting up a machine referred to in the sources as *colla grande* (the great crane).[23] This is the apparatus accurately illustrated in drawings by Bonaccorso Ghiberti (Lorenzo's nephew),[24] Leonardo da Vinci, and Giuliano da Sangallo. The massive, ground-based elevator hoist-

ed supplies to the masonry sites. Only one was in operation, but several units may have been built. The exhibit shows a working model complete with specifications of its features and performance (see below, pp. 100-101). This sturdy, powerful machine was capable of lifting loads of more than one ton. Most important, it was flexible, as it could operate at three lifting velocities corresponding to three different workloads. Also, it could run on a continuous cycle: thanks to an ingenious mechanism, the shafts' rotation could be reversed (i.e. switched from lifting mode to lowering mode) without unhitching from the yoke and re-hitching in the opposite direction the pair of oxen that provided the driving power.

Among the surviving sources is a document of 1421 recording payment for supplies needed to build the machine.[25] The itemized receipt gives an interesting insight into the materials used by Brunelleschi and his contemporaries. The crane's anchoring

structure and framework (designed to withstand long exposure to bad weather) were made of chestnut; the beams were made of rugged elm, while the gear parts were made of oak, a highly compact, friction-resistant wood. To lessen friction wear and so prolong the gears' life, Brunelleschi devised pivoted gear teeth fixed to the wheel by sturdy metal pegs. These teeth, which the sources refer to as *palei*, were made of oak or bronze. The model exhibited in this show was built following the exact materials specifications in the 1421 document.

In just a few decades, the machine hoisted the colossal quantities of supplies needed to edify Brunelleschi's mighty structure. Many sources mention the regular maintenance operations performed on the crane.

Other machines presumably invented by Brunelleschi are documented in drawings by engineers of later generations. The illustrations, by and large, are consistent even in their details. One notable machine in this group is the monumental yet elegant revolving crane, apparently a fragile apparatus. The scale data on the surviving drawings suggest the device may have been as much as 20 meters tall. The drawings of Bonaccorso Ghiberti and Leonardo show the crane lifting a stone, recognizable as one of the marble slabs of the lantern base.[26] The crane's *modus operandi* is clear, as shown by the working model on view here. More than the counterweight – which was standard at the time – the machine's distinctive feature is its accurate positioning capability, facilitated by a set of leveling instruments. Indeed, precise load positioning seems to have been in this case a more important specification than lifting capability. The designer also appears to have been concerned to prevent load sway, which could have made the machine dangerously unstable. The crane's actual movements on the worksite are hard to establish. Presumably, however, it operated on a central scaffolding set up near the eye of the dome to construct the closing octagonal ring. The latter structure consisted of a large number of stone blocks, each of which had to be placed with extreme precision. Heavy materials of this type were raised onto a side platform by hoists operating outside the dome. The revolving crane would then pick up the elements and position them.

These two machines, like the many others illustrated in the show, each possessed unusual specific capabilities. They help us to understand the magnitude of the Duomo project – and shift the focus of our admiration from the elegance of the consummate architectural structure to the logistical bravura of the construction itself. The dome's conception, the development of suitable construction methods, the overall worksite planning (an integral part of the project and its success), and the design of the individual machines – all these stages add up to a complex undertaking in which Brunelleschi expressed his proficiency as an engineer. Indeed, his work marks the starting-point of a supremely innovative period.

It is not surprising, therefore, that Brunelleschi's machines – as well as many other of his technical enterprises – were regularly recorded in the writings of all the greatest artist-engineers of later generations, including Leonardo. In fact, they seem to have been more impressed by the machinery than by the dome. They obviously saw the vestiges of the Duomo worksite as a monument to record for posterity, a concrete lesson to study and apply. In the same spirit, Brunelleschi's fellow Florentines – who had often voiced doubts and skepticism about the success of the project while its construction was still under way – placed an epitaph on his tombstone composed by the humanist Carlo Marsuppini. The inscription praised Brunelleschi chiefly as an inventor of extraordinary machines (*plures machinae divino ingenio ab eo adinventae*) – almost a new Daedalus. There was an initial plan to decorate his tomb with marble slabs depicting the machines he had invented, but the project, sadly, was never carried out.[27] Had it been, the gesture would probably have marked the very first appearance of machines in funerary symbolism. Even the unfulfilled intention was an eloquent sign of the radical change in the cultural climate, as well as of the rapid metamorphosis in the social image of the artist-engineer.

II. *The Sienese engineers*

Between the late fourteenth and the mid-sixteenth centuries, technology was the focus of continuous interest and activity in the Republic of Siena.
Scholars of Siena's complex history in the fifteenth

century often encounter "multi-disciplinary" engineers, typically linked to humanist circles or artists' workshops. Such contacts were actively pursued, for example, by Mariano di Iacopo (1382-1458?), known as Taccola (i.e. jackdaw, most probably because of his aquiline nose), and, later, Francesco di Giorgio (1439-1501).

These outstanding personalities reflected the aspirations and capabilities of a small town that nurtured extravagant projects. Thanks to bold construction work, Siena had remedied its chronic water shortage. Its ambition was to build a cathedral of unprecedented size, and it also sought an outlet on the sea in order to compete with Genoa and Naples in trade. Making these dreams come true required more than the wealth accumulated through flourishing commercial and financial activities. A well-prepared ruling class was needed and – even more important – the presence of technical experts who could take up Siena's challenges by building the structures it wanted.

A vivid example is the construction, between the thirteenth and fourteenth centuries, of the extraordinary underground water network (*bottini*) and fountains[28] – as well as many other projects, sometimes of breathtaking boldness – designed to secure Siena's water supply. In this context, one can hardly be astonished by the high caliber of applied hydraulics expertise displayed by Taccola and Francesco di Giorgio. Nor is it surprising that the Republic of Siena, endowed with rich mineral deposits on its territory, should have developed professional specializations in the field of sidearms, armor, bells, artillery, and firearms – alongside high-quality manufacturing of cast metal artwork.[29] Siena offered many opportunities for encounters and dialogues between the exponents of the new humanist culture – who were using the sharp tools of philology to rediscover ancient learning – and craftsmen and artists. As in the better-studied environment of contemporary Florence, these exchanges fostered prolific partnerships in the construction sciences, in research on the theory of vision applied to painting, and in the reflections on the science of weights (*de ponderibus*). Siena was home to a flourishing Studio frequented by leading figures in the renaissance of classical studies.[30] The town's libraries, while no rival to those of Florence, abounded with treasures.[31]

18. Anonymous (after Taccola, *De ingeneis I-II*), BNCF, Ms. Palat. 767, p. 22. Method for calculating the slope of a tunnel by measuring its entrance and exit elevations

Siena's artist-engineers were thoroughly involved in the intensive technical and production activities, the continuous succession of wars (or, more often, skirmishes), the construction projects, and the large-scale decoration work that characterized Sienese life in the fifteenth century.

The careers of these men exhibit similarities with patterns found elsewhere. By the mid-fourteenth century, the compilation of illustrated technical writings had become the ever more enthusiatic pursuit of personalities such as Guido da Vigevano,[32] who worked in France at the court of Philip V and Charles the Fair, and Conrad Kyeser,[33] a learned officer of Bavarian Franconia with ties to Robert, Elector Palatine and King of Germany. Guido and Kyeser were not professional engineers, but physicians who devoted themselves to illustrating mechanical devices, particularly of a military nature,

19. Taccola, *De ingeneis III-IV*, fols. 6v-7r. Conveying water from a spring to a fishery via a bridge-aqueduct

for the sovereigns who employed their services. A prominent figure in the fifteenth century was the physician and humanist Giovanni Fontana. In his *Bellicorum instrumentorum liber* (book of the instruments of war), Fontana drew on many classical sources and displayed an acquaintance with Arab authors as well.[34]

The texts of the Sienese artist-engineers are preserved in finely illuminated manuscripts (figs. 4-6), typically dedicated to their patrons or other distinguished personalities. These works were reproduced in many copies, ensuring their authors a long-lasting reputation. Such manuscripts projected the world of technology into literary circles from which it had hitherto been excluded. They portrayed machines as worthy of attention for their curiosity value and even for their appearance rather than for their specific utility. A close parallel was suggested between the engineer and the "magician": technical skill (*ingegno*), like magic, bends

nature to the whims and needs of humans.

Another striking feature of these texts is their effort to employ a refined language and literary style. They are written in good Latin, contain many direct and indirect quotations of ancient and modern authors, and take clear positions on political and religious issues (Guido da Vigevano, for example, even conceived his *Texaurus* of 1348 as a powerful propaganda instrument for the planned crusade of Philip V). These texts not only illustrate devices for purely military use, but offer solutions of great value to the community and its welfare in peacetime – notably mills, hoists, and water-raising systems.

The authors were, by and large, "open" in their approach, which was often explicitly pedagogic. Their stated goal was to promote the recognition of the utility and timeliness of serious research into machines and mechanical devices. They stressed the attention devoted to technology by many illustrious figures of the much-admired Greco-Roman world.

This literature catered not to the courts of medieval princes, but to the educated circles that gravitated around the new Italian lords or that served as the ruling classes of the flourishing, wealthy republics. All these audiences were keenly interested in the continuous advancement of military technology – which, in fact, was undergoing rapid change at the time. Readers also appreciated the new engineers' potential practical contributions to the ambitious projects for urban renewal and embellishment.

Another, ever more visible phenomenon was the attempt to revive the quest for innovative methods of analysis and experimentation. By the early fifteenth century, a new breed of technical specialist had clearly emerged in Italy: they were both antiquarians and inventors, admirers of the great engineers of antiquity yet consciously engaged in a civilized competition with those illustrious forebears. This duality also looms large in the career and writings of Mariano di Iacopo, known as Taccola, the self-styled "Archimedes of Siena."[55] This sobriquet is, in itself, revealing. Since Taccola was not particularly indebted to the famous geometrical and mathematical writings of the Syracusan, the self-chosen designation refers to Archimedes as the paradigm of the inventor. This aspect of the "myth" focused on the talent of Archimedes for devising unusual systems such as the machinery with which he long thwarted the powerful Roman army led by Marcellus. Taccola's choice is therefore a self-celebration of his inventive talent and, at the same time, a tribute to the ingeniousness of the ancients. Indeed, for Taccola, the aim of stimulating a fresh, creative approach to technology was tied in with the effort to rediscover the technical knowledge of antiquity. This can help us to understand the curious blend of practical, experimental material and the frequent citations of examples from the classical tradition. Taccola regarded himself as both an inventor and a restorer of ancient knowledge: "discovery" and "rediscovery" both imply for him the activation of a process of invention.

To achieve the complete recovery of ancient technical know-how, the "engineer" (*ingeniarius*) had to overcome a major obstacle: the need to understand texts that were often extremely difficult to decipher and, as a rule, bereft of illustrations. For Taccola, comprehending an ancient technical text and making it intelligible meant translating it visually, "rein-

carnating" it in an image that would then become the very centerpiece of the expository system. Taccola clearly articulates the key role of graphics as the specific tool of a philology applied to recovering the technical tradition of antiquity. He was motivated by the same concerns that drove so many of his illustrious humanist contemporaries to an intensive retrieval of classical knowledge. His figures illustrate texts whose sources are often identifiable

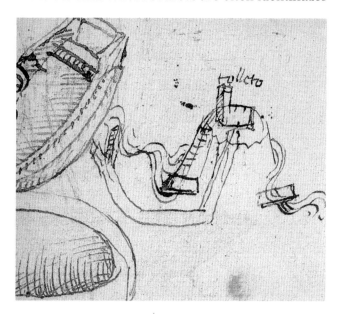

20. Taccola, *De ingeneis I-II*, fol. 72v. The inverted siphon of the Roman aqueduct at Toledo

(one set of drawings, for example, was inspired by the *Stratagemata* of Frontinus; fig. 7). But the text-image combination turned the texts into something new – a genuine "invention." Many of Taccola's writings underscore not only the centrality of images, but also their limits, which were in fact the limits of his skill as a draftsman.

The corpus of Taccola's writings (four books of *De ingeneis* and the *De machinis*)[36] contains a document (fig. 8)[37] that shows that two of the foremost figures in the renaissance of machines of the first half of the fifteenth century were aware of the novelty of their professional experience. The document is Taccola's transcript of a conversation with his "colleague" Filippo Brunelleschi in Siena at an unspecified date, probably around 1430. Taccola's account shows that the two men were chiefly concerned about the status and underprotected rights of the new engineer-inventors. Inviting his colleague to heed his own bitter experiences,

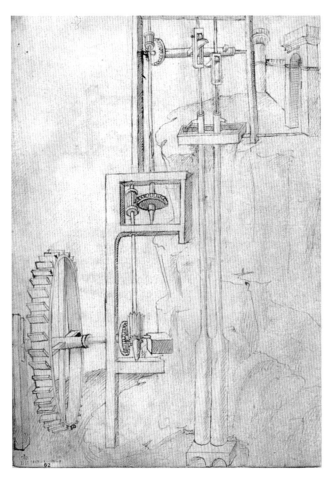

21. Francesco di Giorgio, *Opusculum de architectura*, BML, Ms. 197.b.21, fol. 60v. A waterwheel drives a pump that supplies water to a town whose gate carries the inscription "Toledo"

Brunelleschi inveighed against those who begin by denigrating other people's inventions only to appropriate them later.

Taccola's record of the Brunelleschian diatribe indicates the highly precarious position in which inventive engineers – especially in "democratic" regimes such as Florence and Siena – now found themselves as a result of the brisk recovery in construction activity since the fourteenth century and the quickening pace of technological innovation. The new experts paid a personal price for the lack of a patent system to safeguard their inventions. Another negative factor was the concentration of decision-making, even on strictly technical matters, in the hands of political authorities. As mentioned earlier, inventors were forced to disclose their ideas publicly in order to secure their approval. To guard against this vulnerability, Brunel-

leschi devised a system – the first that we know of – for publicly protecting the rights accruing from the use of his "invention" of a boat to transport marble.[38] Incompetence and bad faith forced the engineer into discretion. Brunelleschi was a prime example of this, as he systematically avoided making verbal or visual descriptions of his many pioneering projects. Taccola was only five years younger than Brunelleschi and survived him probably for a little more than a decade. Despite the small difference in age, Taccola clearly regarded Brunelleschi as an authority and treasured his suggestions. Indeed, in many passages of his writings, Taccola remains deliberately vague about certain devices, stating that he did not want to risk being dispossessed of them. Fortunately for us, however, Taccola's easier-going personality kept him from observing his colleague's injunction of secrecy too strictly. In fact, Taccola compiled hundreds of pages of notes and drawings, from which we can almost always reconstruct the machinery down to the minutest details. In at least some of his surviving texts, we can clearly discern his attempts to organize the presentation of his research into a well-structured treatise – a series of accurate drawings, each complete with a description in words. In a few cases, Taccola also gives the exact date and place of communication of his manuscript pages to identified persons, sometimes recording the reactions of the latter to the systems described. Lastly, Taccola prepared a dedicated copy of *De ingeneis libri III-IV* for Sigismund of Hungary, inserting a sophisticated literary discourse in which he offered the Emperor his services as hydraulic engineer and miniaturist.[39]

Along with their many resemblances, therefore, we should not overlook the differences in attitude between Brunelleschi and Taccola. The great Florentine architect personified the attitudes and commitment to personal secrecy typical of the medieval guilds, which would also survive in the tradition of formula registers and "workshop books" (*libri di bottega*) until the seventeenth century. Taccola, by contrast, was mainly interested in carving out a central role for the *ingeniarius*-inventor. His motive was not only self-promotion, however. He also regarded that role as vital to one of his main priorities: the recovery, analysis, and dissemination of the major writings of antiquity. Unlike Brunelleschi, therefore, Taccola felt the need to become an

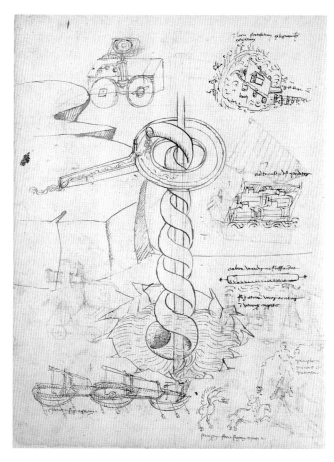

22. Taccola, *De ingeneis I-II*, fol. 38v. In this vertical position, the Archimedes' screw will not work

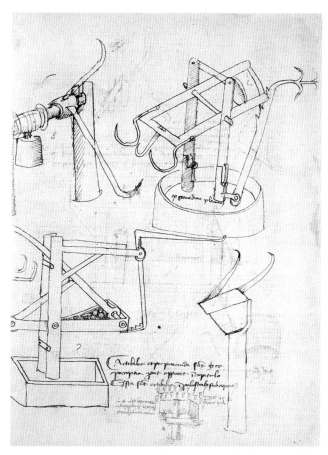

23. Taccola, *De ingeneis I-II*, fol. 7v. Counterweighted hull-piercing devices

"author." He was a man who straddled borders – who reconciled, or sought to reconcile, the conflicting roles of author and inventor in a world that was witnessing profound cultural and occupational changes, particularly in regard to engineers. The scarce biographical data seemingly corroborate Taccola's status as a border-crosser.[40] He began as a notary public, then gave up this highly regarded and rewarding profession. At the same time, he moved in cultural circles dominated by two groups. The first group consisted of artists – notably Iacopo della Quercia[41] – with whom he cultivated friendship and cooperation. A proficient draftsman, Taccola himself worked as an artist.[42] Some of his drawings, such as Saint George and the Dragon (fig. 9) and Dorothy with the Infant Jesus (fig. 10), are truly graceful, while his sketches of toiling laborers are suffused with empathy (fig. 11). Taccola was also capable of constructing compositions and depicting poses laden with complex allusive mean-

ings, such as the famous portrait of the Emperor Sigismund (see below, p. 158).

The second Sienese cultural milieu with which Taccola was certainly acquainted was the distinguished group of scholars of the Sienese Studio. Between 1424 and 1434, Taccola held the office of Camerarius of the Domus Sapientiae ("House of Learning"), which had turned from a welfare institution to a hostel for impecunious students.[43] During his tenure there, he must have had contacts with the resident faculty, including such illustrious figures as Filelfo. The Studio also hosted eminent visiting scholars such as Panormita, who later returned to Siena several times as a high-ranking diplomat.[44] The most illustrious faculty member was Mariano Sozzini, with whom Taccola was friendly. A beacon of the Studio, Sozzini attracted many students through his reputation as a jurist.[45] During the years of Taccola's maturity, Siena was visited by many well-known humanists, including

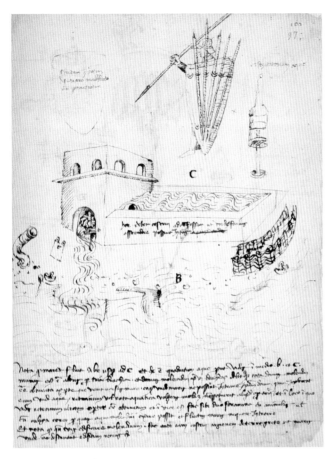

24. Taccola, *De ingeneis I-II*, fol. 97r. Tide mill with horizontal waterwheel

Leon Battista Alberti, who spent an entire month there in 1443 as a member of Pope Eugene IV's suite. A man of Alberti's curiosity would have been interested in the world of arts and technology, and we can easily imagine the engrossing conversations that he might have had with Taccola. It is hard to resist the temptation to read an echo of their possible Sienese encounter in Taccola's recurrent speculations about devices for diving and breathing under water (see below, pp. 124-26), and about methods for retrieving sunken columns and treasures (fig. 12) – a full-scale exercise in underwater archeology.[46] A few years later, in 1444, Alberti actually tried to raise an entire Roman ship from the muddy bottom of Lake Nemi. For this undertaking, he employed techniques very similar to those illustrated by Taccola, with the decisive help of divers sent from Genoa.[47] Alberti's attempt caused a widespread sensation, recorded in many manuscripts inspired by the Sienese tradition of machines. One example is a portrait of a man on horseback – pre-

sumably an idealized likeness of Alberti – to whom a peasant is showing the hulk of the Roman ship resting on the lake bed (fig. 13). The picture occurs in a manuscript collection of copies of drawings by Taccola and Francesco di Giorgio.

Other surviving documents show Taccola's familiarity with another outstanding humanist, Ciriaco d'Ancona, an intellectual who acted as an intermediary between the Moslem East and the Christian West.[48] Ciriaco made several visits to Siena, and may have been responsible for forwarding a superb copy of Taccola's *De machinis* to the library of Sultan Mohammed II (fig. 14).[49] The Sultan, with whom Ciriaco maintained a cordial relationship, was fond of richly illuminated manuscripts. He was particularly attentive to Western writings on engineering and military architecture, such as the codex containing Valturius's *De re militari*, sent to him by Sigismondo Malatesta via Matteo de' Pasti.[50] The patterns discernible in Taccola's sparse intellectual biography help shed light on an issue of crucial importance – not only for understanding the role and career of Sienese engineers, but also for comprehending the central motives that drove all Italian engineers of the fifteenth century, from Brunelleschi to Leonardo. One motive was their demand for equal status with the cultural establishment. Another important, persistent force was the attempt to foster a productive cooperation between the two domains of expertise that had hitherto remained virtually extraneous to each other. Taccola, it should be recalled, was not an illiterate technician. He wrote not in the vernacular (Italian) but in Latin, quoting classical authors. Reciprocally, many humanists were interested in the illustration of ancient technical and scientific texts. For example, Giovanni Aurispa, a prominent humanist, pointed out the iconographic value of a Greek codex, today in the Bibliothèque Nationale in Paris, containing the writings of the so-called "Greek mathematicians" (these texts, in fact, deal with technology, mostly in the military sphere; fig. 15). The manuscript at once became keenly sought after by engineers and artists (including Ghiberti), precisely for its exceptional wealth of illustrations.[51]

What remains to be assessed is the effective value and originality, in the strictly technical domain, of Taccola's contribution. When they were rediscov-

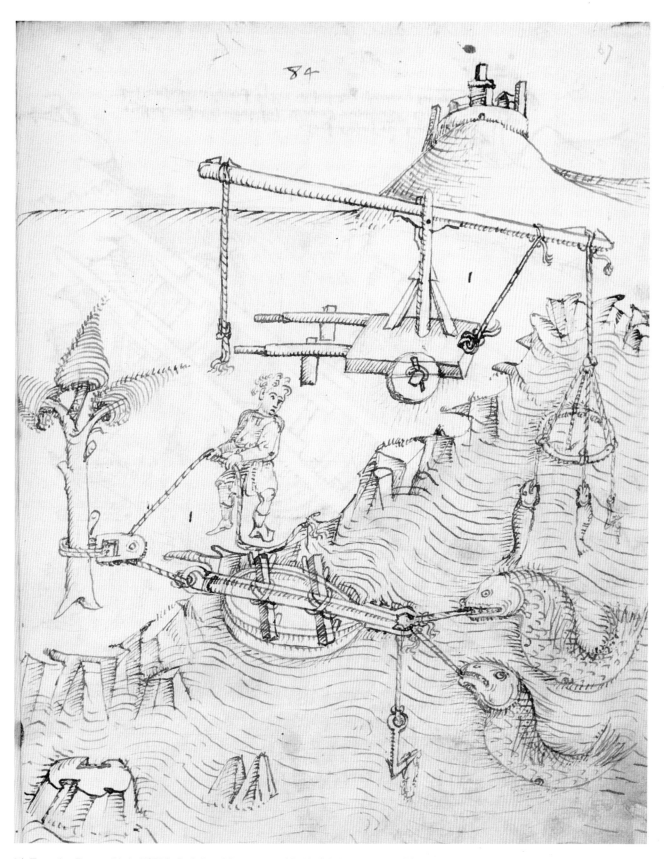

25. Taccola, *De machinis*, BSBM, Cod. Lat. Monacensis 28800, fol. 84r. Advanced fishing technology

26. Francesco di Giorgio, in Taccola, *De ingeneis I-II*, fol. 130v.
Copy of drawings and notes from Taccola's *De ingeneis III-IV*

ered in the second half of the eighteenth century, his writings caused a certain sensation because of the military systems they described.[52] Today, after the considerable advances in military history, scholars are much more cautious about claiming an innovative role for Taccola in military engineering – a discipline that underwent radical change during his lifetime.[53] In fact, Taccola was not a military engineer, and his knowledge of the art of war was not particularly up to date. His attempts to compete in that arena were stimulated by praise from patrons who gave priority to military applications. Also, many of his endeavors in military technology appear to be a careful exercise in interpretation and popularization using images from classics like Vegetius (fig. 16)[54] and Frontinus, with which Taccola was extremely familiar.

Other areas of Taccola's technological output deserve a different assessment. To begin with, we need to separate from the corpus of his notes and drawings some obvious references to Brunelleschi's

technological devices and solutions, on which Taccola probably obtained information directly from the inventor.[55]

In addition to depictions of Brunelleschi's crane (see below, p. 103), Taccola's manuscripts contain a visual representation of Brunelleschi's patented boat for transporting marble. Taccola devotes three pages to the invention, illustrating the process of production, loading, and conveyance by land and water of heavy marble columns (fig. 17).[56] Working from the summary verbal description given to him by Brunelleschi, Taccola demonstrates his grasp of the central concept of load continuity. This is evidenced in the drawing, where the wagon that transports the column from the quarry to the waterway is converted into a floating raft.

Taccola appears to have displayed his greatest originality in hydraulic applications, which make up a considerable proportion of his technological corpus. Taccola clearly attached particular significance to his professional accomplishments in this field – as we can infer from several statements about inventions that he claims to have developed, and from the emphasis on his proficiency in hydraulics in his proposal of services to Emperor Sigismund.[57]

The autograph manuscript evidence of Taccola's considerable specialization in hydraulics should not come as a surprise, however. In the fields of water control and water conveyance (*de aquis stringendis*), Sienese engineers had acquired expertise and obtained results that few other towns could match. It is therefore entirely understandable that Taccola should showcase the most innovative aspects of what could be defined as Siena's distinctive technological culture. The prime impetus for its formation and development was the demand for water in the city center. To solve the chronic, severe water shortage, Sienese engineers built the monumental network of underground water canals (the so-called *bottini*) between 1200 and 1400 – one of the most impressive achievements of Siena's entire civilization. Although Taccola does not seem to have been directly involved in its construction, he must have been familiar with the vitally important system through his friendship with Iacopo della Quercia, who collaborated with Taccola's workshop not only on the decoration of the Fonte del Campo but also in the management of the under-

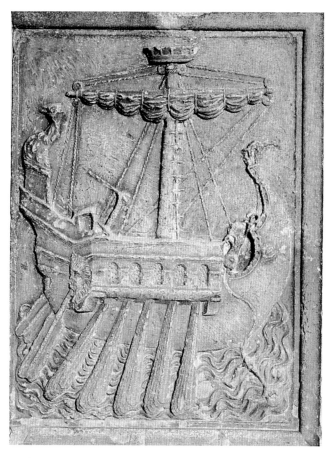

27. *Quinquereme* (ship with five sets of oars). Stone tile, Palazzo Ducale, Urbino, n. 86

28. Panoply. Stone tile, Palazzo Ducale, Urbino, n. 51

ground water network. Many of his hydraulic sketches may be read as the signs of his desire to make his hydraulic engineering skills available to the community. His services would help develop solutions to increase the quantity of water available for individual citizens and for the local economy.

The sketches on water-conveyance systems and the analysis of hydraulic devices in his manuscripts are informed by a consistent desire – or dream: that of finding the machine or system capable of delivering water at will to any required location. Taccola accurately recorded the techniques and implements used to build the underground water network, including measurement and excavation techniques, as well as the methods and instruments to ensure a constant gradient of the water canals (fig. 18).[58] At the same time, he would choose pastoral landscapes as the settings for siphons of unlikely dimensions (see below, p. 139) or daring aqueducts to carry water from a source to a fountain, a watermill, or a fish farm (fig. 19) over a nat-

ural obstacle. These studies were probably linked to the quest for a viable system to convey water to Siena from the Merse River thirty kilometers away.[59]

The same blend of engineering dream and search for practical solutions informs the sketches of Toledo (fig. 20), depicted, like Siena, as a hilltop town supplied with water from the inverted siphon of the ancient Roman aqueduct.[60] Taccola must have learned about the structure not only from classical sources, but perhaps also from one of the many Catalans working in the Sienese Republic as managers of trading companies at the port of Talamone. Thus, the Siena-Toledo analogy proceeds from the now familiar combination of antiquarian curiosity and the quest for useful applications.[61]

Taccola's insistence on siphons is probably linked to his recommendation of the device for inclusion in – or as an alternative to – the gravity-driven system used in the *bottini* network. Taccola demonstrated his knowledge of the workings of the siphon

(see below, p. 139), but grossly exaggerated its performance. Even in the use of the Archimedes' screw, Taccola made some mistakes. He sometimes positions the device vertically (fig. 22), showing his ignorance of the fact that the screw will operate only on an inclined plane.

Siena's needs and ambitions are powerfully present in many other drawings by Taccola. For instance: water buffalo are clearly (and rightly) preferred to oxen and horses for their ability to swim and move through mud. The buffalo images allude to the vast marshlands of the Maremma plain – a relatively recent Sienese conquest – where the animal abounded. In other likely evocations of the same area, many of Taccola's pictures show systems for draining swamps and lagoons to reclaim marshlands. Taccola probably had the marshes around Talamone and Orbetello in mind when depicting shallow-draft fishing boats capable of sailing in them, amphibious carts, and hull-piercing devices for shallow waters (fig. 23). In his detailed discussion of the latter, Taccola explicitly notes their suitability for marshes (*in paludibus*). This, we may assume, is an allusion to contemporary efforts by Sienese engineers to fortify the port of Talamone and the surrounding lagoons and to protect them from pirates. Another sign of local concerns is the illustration of a mercury mill, presumably inspired by the large deposits of the metal in the Amiata mines (see below, p. 178). Of the few mills depicted by Taccola, only a fraction are of the waterwheel type, but as many as five are tide mills (fig. 24)[62]. Lastly, even the charming and obsessively recurrent fishing scenes (fig. 25) allude to a specific preoccupation of the Sienese community that captured the engineer's imagination. The plentiful "technological" hauls illustrated by Taccola are clearly metaphors for catches from the fish farms that abounded in the Republic and have left many traces in local place-names. It is tempting to link this series of drawings with the projected construction of a large artificial reserve in the Maremma to solve another of Siena's historical problems: the need to import massive quantities of fish from Lake Trasimeno. The drawings probably refer to the project, conceived as early as the fourteenth century, of creating an artificial fish-stock lake by means of a dam on the Bruna River near Giuncarico, not far from Grosseto.[63]

Another important aspect of Taccola's career is his

29. Francesco di Giorgio, *Codicetto*, BAV, Ms. Lat. Urbinas 1757, fol. 118r. Column hoist

tenure as public procurement officer (*stimatore*), documented in his 1453 income statement.[64] The officer's duties consisted in drafting calls for bids, preparing cost estimates, surveying (for example, to determine property boundaries accurately), performing what we would now call structural analysis, and making sure public projects were completed to specifications and as economically as possible.[65] The procurement officer was also responsible for community purchases of consumer goods, as well as setting and managing workers' pay. Taccola makes repeated, specific references to surveying methods and instruments, which may be connected with his procurement duties. However, his manuscripts contain hardly any of the calculations typical of the practical and applied mathematics that flourished in Siena from the Middle Ages to the Renaissance – a field in which procurement officers had to be proficient.[66]

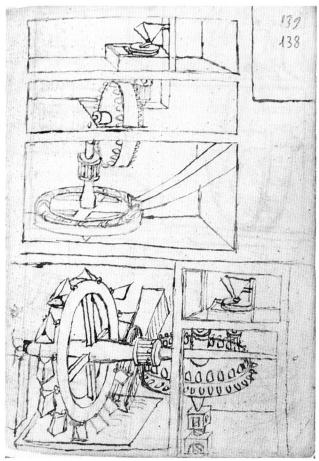

30. Francesco di Giorgio, *Codicetto*, fol. 151r. Complex pump system for raising water and powering a mill

31. Francesco di Giorgio, *Codicetto*, fol. 138r. Mills with horizontal and vertical waterwheels

* * *

The final pages of Taccola's autograph manuscript of *De ingeneis I-II* carry a series of notes and drawings in the hand of Francesco di Giorgio (fig. 26).[67] No document better expresses the continuity of the Sienese tradition of machine studies. They offer us a snapshot, so to speak, of the actual moment when that heritage was passed on from Taccola to Francesco di Giorgio. In fact, Francesco's notes and sketches are literally transcription of drawings and notes by Taccola in Ms. Palatino 766 (*De ingeneis III-IV*).

This indicates that Francesco was involved in a close scrutiny of Taccola's texts. Although we cannot date these notes and sketches accurately, we can safely assign them to the start of his successful engineering career. They may even indicate a brief apprenticeship of Francesco with the elderly Sienese engineer, which in chronological terms is not impossible. Indeed, the earliest documents on Francesco's career show that he began with a careful assessment of Taccola's literary achievement.

The most eloquent evidence on this point is the so-called Vatican *Codicetto*, a tiny notebook that Francesco filled with notes and sketches.[68] No precise dating is possible for the *Codicetto* either, but it is generally regarded as Francesco's earliest manuscript. Of the surviving sources, it is also the only one – apart from the *Opusculum de architectura*[69] – in which the notes and drawings are entirely in Francesco's hand. This was manifestly a compendium for personal use, a pocket notebook whose only unusual feature is the parchment sheets, which would normally have been quite extravagant for such a purpose. The sheets, however, show every sign of repeated recycling. Francesco presumably began compiling the *Codicetto* in the

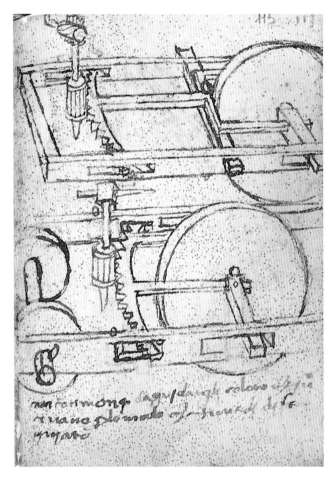

32. Francesco di Giorgio, *Codicetto*, fol. 115r. Carts with steering gear

mid-1460s and probably continued to fill it with notes and drawings until the mid-1470s.[70]

By comparison with Francesco's autograph annotations at the end of the original manuscript of Taccola's *De ingeneis I-II*, the *Codicetto* exhibits many analogies and some significant innovations. Many of the 1,200-odd drawings and practically all the notes are, in fact, derived from Taccola's manuscripts. But hardly any of the drawings or notes are slavish copies. The texts are Italian paraphrases of Taccola's Latin, often freely rendered and sometimes containing personal comments by Francesco. The drawings are obviously modeled on Taccola, but Francesco often adds or omits details, and in some cases introduces significant changes. In other words, the manuscript shows evidence of a transcription-assimilation process consistent with the method of training through observation, imitation, and proof that characterized the transmission of knowledge in the fifteenth-century artist's work-

shop. Other people's ideas and procedures were shamelessly plundered even by artists like Francesco, who later inveighed against plagiarists. Indeed, Francesco, even as Taccola's leading popularizer, never mentioned the name of his source in the works he later authored.

To complement the evidence of Francesco's youthful critical transcription and assimilation of Taccola's work, some additional information on Francesco's formative period and early career may be useful.[71]

The Sienese artists' workshops – like those of Florence – traditionally specialized in many different areas. The little we know of Francesco's early work reflects that variety of skills and occupations, which was to be his trademark throughout his career. The earliest surviving document on Francesco refers to his activity as a painter in 1464. No reliable data are available until 1469, when the artist, aged thirty, was commissioned in partnership with Paolo d'Andrea as contractor (*operaio*) for the underground water network (*bottini*).[72] In 1470, Francesco was paid for a painting of Monte Vasone, for which he relied on the survey carried out by the procurement officer (*stimatore*) Mariano di Matteo.[73] The painting is lost, but the significant point is that the commission enabled Francesco to establish cooperation with a practitioner of applied mathematics.

The last documentary evidence of Francesco's technical activities in the first Sienese period dates from July 25, 1476. The Republic may have asked him to accompany Sano di Pietro on an inspection of the fish-stock lake built a few years earlier on the Bruna River.[74] We cannot be sure, however, that the request was addressed to Francesco. The visit may have been connected to the need to decide on a method for repairing the breach of about five meters' width that developed in the dam wall in September 1475. Buttresses had been added as a stopgap measure to avert a collapse.[75] This would be the earliest documentary reference to Francesco's employment as architect and to his involvement in the ill-fated Sienese project of the Bruna River dam.

Later sources indicate Francesco's participation in the so-called Colle Valdelsa war of 1475 between Siena and Florence. Siena formed part of a coalition headed by Pope Sixtus IV, the Duke of Calabria (Alfonso of Aragon, personally present in the field), and Federico da Montefeltro, Duke of Urbino, whose troops were led by his son Antonio.

We have no specific information about Francesco's part in these events. It is, however, assumed that in the siege of Castellina he would have contended with another brilliant engineer on the Florentine side, Giuliano da Sangallo.[76] This would have marked Francesco's début as a military architect, propelling him into an extraordinarily successful career in which Siena's allies during the war – the two *condottieri* princes Federico da Montefeltro and the Duke of Calabria – were to play a decisive role.

Indeed, in 1477, Francesco moved to Urbino.[77] The new environment proved a powerful stimulus, and the Duke himself struck up a warm relationship with him. The effects were immediate. Francesco soon became Federico's ambassador to Siena, while the Duke's esteem and trust dramatically enhanced his standing among his fellow citizens. It was in Urbino that Francesco, among other pursuits, began to work on fortifications. He also contributed to the frieze on the art of war in the Palazzo Ducale, where the use of machines as motifs in architectural decoration (figs. 27-28) is recorded for the first time.

The change of environment and relationships also had an obvious impact on Francesco's literary output, as evidenced by the small nucleus of notes and sketches on military architecture in the Vatican *Codicetto* dating from his first stay in Urbino.[78]

To the already impressive array of Francesco's specialties, one has to add his involvement and that of his workshop in the manufacture of firearms. His most faithful and longest-serving co-worker, Iacopo Cozzarelli, who followed him to Urbino, was an excellent and highly productive manufacturer of bombards and firearms.[79] Francesco's collaborators also probably included Giovanni delle Bombarde, son of Giovanni da Zagabria, a Hungarian master-bombardeer who had settled in Siena in 1432 as a member of Emperor Sigismund's following.[80] Also worth recording is the activity of one Giovanni di Francesco, master-bombardeer, referred to in many documents of the 1480s. "Di Francesco" might be taken to mean "a co-worker of Francesco": this would be consistent with the rather widespread custom in Renaissance workshops of adding the master's surname rather than the worker's surname to the given name.[81]

Significantly, the earlier-mentioned Ms. Palatino 767 contains illustrations of two signed bombards (see below, p. 162). The first carries the inscription "Opus Dio. Vit.," which identified its builder as Dionisio da Viterbo, a well-known mechanic and clockmaker whose activity is documented in Siena in the 1460s.[82] The other weapon displays the Orsini coat of arms and is signed "Opus Francis[ci]" – in all likelihood a proof of its manufacture by Francesco di Giorgio, who worked for Virginio Orsini as military engineer in 1490.[83] There is another piece of evidence to corroborate Francesco's involvement, or, at all events, that of his workshop, in the manufacture of firearms: in the later version of the *Trattato di architettura* (see below, p. 161),[84] he added a discussion on the bombard and its origin, as well as a classification of artillery by shape and weight of ordnance.

This is not the suitable occasion for discussing Francesco di Giorgio's highly prolific output of paintings, sculptures, and miniature illustrations during the same period. His achievements in these domains were presented and analyzed in exhaustive detail by the recent Francesco di Giorgio exhibitions held in Siena in 1993.

The Vatican *Codicetto* faithfully reflects the gradual maturing of Francesco's engineering skills. Alongside the corpus of work derived from Taccola – in itself a highly distinctive complex – Francesco visibly strove to formulate ideas of his own. From the central pages of the small manuscript onward, in the series of drawings and notes based on Taccola's manuscripts, we find an increasingly frequent occurrence of devices not dealt with by Taccola. The drawings are carefully drafted, without annotations, and clearly focus on four topics: machines for shifting and lifting weights (fig. 29), devices for raising water (fig. 30), mills (fig. 31), and wagons with complex transmission systems (fig. 32). There is a fairly perceptible continuity in the sequence of drawings within each category, despite some occasional interruptions when Francesco inserts sketches and notes transcribed from Taccola.

This arrangement is difficult to interpret. Indeed, there is something illogical and incomprehensible about the abrupt switches between the series of faithful reproductions from Taccola and the presentation of a multitude of innovative projects. For these are not only "new" machines but devices of far more advanced mechanical design than Taccola's. Francesco systematically incorporates here the

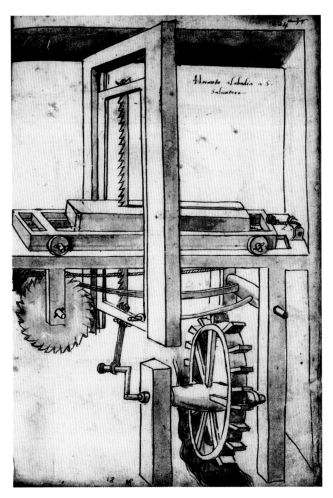

33. Anonymous Sienese Engineer, BLL, Ms. Additional 34113,
fol. 224r. Hydraulic saw-mill

34. Anonymous Sienese Engineer, Ms. Additional 34113,
fol. 189v. Flying man

worm screw and often uses metal racks. His de-
vices feature complex gear mechanisms, whose
careful and highly varied arrangements are calcu-
lated to transmit to any level and at any desired ve-
locity the motion produced by any source. As we
know of no precedents that could have inspired
Francesco, we are led to assume that they are his
original contribution.[85]

The sizable grouping of drawings of machines to
lift and move columns and obelisks is particularly
unusual, if only for the obvious fact that these de-
vices were so seldom used on worksites. France-
sco's interest in these gigantic contraptions was
probably stimulated by the feat of his contempo-
rary, the legendary Bolognese engineer Aristotele
Fioravanti, who, in 1455, began to move and
straighten towers in several Italian towns.[86] Fiora-
vanti was repeatedly consulted by Popes Nicholas V

and Paul II about the feasibility of shifting the
obelisk of Julius Caesar to Saint Peter's Square. The
project, which Fioravanti had deemed feasible, was
eventually abandoned because of various prob-
lems. Nevertheless, in 1452, in Rome the Bolognese
engineer had moved four heavy monolithic antique
columns from their locations to the new choir of
Saint Peter's.

Francesco's almost morbid interest in these devices
could be linked to an early visit to Rome – for which,
however, we have no evidence – or, more likely, it
may be due to a long-distance rivalry with his cele-
brated colleague from Bologna, the reports of
whose achievements had impressed Francesco. A
significant pointer in this direction is the presence
of a hauling device (*tirare*: see below, p. 168) in his
series of machines to hoist columns and obelisks.
Francesco uses the device to move a tower,[87] and it

35. Anonymous Sienese Engineer, Ms. Additional 34113, fol. 200v. Man with parachute

is hard not to interpret this as a visual reference to the undertaking that had made Fioravanti famous. In all likelihood, these drawings were also intended as a series of studies in the archeology of machines. In other words, Francesco may well have meant them as reconstructions of the methods used by the Romans to convey heavy obelisks from the valley of the Nile to Rome, and to erect them in squares.[88] This would be another example of the blend of antiquarian exercise and spirit of innovation that we have pointed out in Taccola's work and that recurs in the output of Francesco di Giorgio and so many other architect-engineers of the fifteenth century.

All the material contained in the *Codicetto*, together with some significant additions from Valturius and an Italian translation of Philo's *Pneumatica* (3rd cent. B.C.),[89] is also found in the manuscript of the so-called Anonymous Sienese Engineer, now in the British Library[90] (Francesco's acquaintance with Valturius is attested by the few but specific references in his Vatican manuscript[91]). In this most important document, the nucleus of "new" devices that first appeared in the *Codicetto* has been typically injected into the virtually complete technological corpus of Taccola (the Italian translations or paraphrases do not coincide with those of Francesco's Vatican manuscript). The one, puzzling absence is the series of pumps.

The Anonymous Engineer mentions "Maestro Francesco da Siena"[92] three times and reveals his own familiarity with the Sienese Republic at least in his drawing of the hydraulic saw mill, which he claims to have seen in operation at Abbadia San Salvatore (fig. 33).[93] The references to Francesco make it plausible that the unknown author had access to Francesco's writings. However, one point still unexplained – in addition to the already-mentioned absence of pumps – is the presence in the British Library manuscript of some significant "inventions" not found in Francesco's corpus, such as the famous drawings of the flying man (fig. 34) and the parachute (fig. 35), with their pre-Leonardian flavor. The anonymous author might therefore have been a member of Francesco's workshop,[94] where he would have been able to examine the *Codicetto* and, presumably, the autograph manuscript of Taccola's *De ingeneis I-II*.

The two corpuses of Taccola's engineering designs and Francesco's original machines were perfectly merged for the first time in the more than 160 drawings that form the magnificent *Opusculum de architectura* preserved in the British Museum.[95] The *Opusculum* exhibits major innovations with respect to the *Codicetto*, and not only in format and arrangement. In the Vatican manuscript, Taccola's drawings and the devices presumably authored by Francesco were juxtaposed and thus easy to tell apart. In the *Opusculum*, the two corpuses have been completely merged. The result is a sequence of perfectly executed drawings with no textual commentary (fig. 36). Alongside the now familiar series of Francesco's "inventions," we have no trouble recognizing the sober, elegant, and figuratively more mature reproduction of a series of illustrations from Taccola.

The codex lacks the first leaf, which carried the dedication to Federico da Montefeltro (perhaps because the text was reused as a model for another dedication). This supports the assumption that the manuscript dates from Francesco's move to Urbino in 1477, on which occasion the Sienese artist may have felt the need to demonstrate, by means of a suitable gift, his competence in various domains of applied technology. The presence in the *Opusculum* of a certain number of plans of fortresses would have appeared a particularly appropriate offering to a warrior-duke like Federico. In sum, the *Opusculum* depicts the wide array of fields in which Francesco claimed special technical expertise. It is, in its way, a luxurious promotional brochure showcasing the technical performances provided by the Sienese engineer and his workshop.

As a vivid, highly effective graphic compendium of Sienese technical specialties, the *Opusculum* enjoyed a resounding success. I know of no other technical work that was so often copied in its entirety or partially plundered, or that acted as such a long-standing source of inspiration for the imagination of engineers, illustrators, and publishers of printed technical texts.[96]

The dedication letter of the *Opusculum*, fortunately preserved in a sixteenth-century copy, indicates the evolution of Francesco's research program.[97] The Sienese engineer clearly aimed to compete with the masters of antiquity. The tribute to the Duke of Urbino, whom Francesco compares to Alexander the Great and Caesar, includes a self-serving,

flattering analogy between the Sienese artist and Dinocrates and Vitruvius – the great architects patronized and honored by those magnificent princes of antiquity.

The evidence of the author's knowledge of Vitruvius is especially worth emphasizing. While the Taccola-Francesco corpus would later undergo only marginal modifications, the function of the machine collection was to change continuously in Francesco's successive works. The effort to become an "author" led Francesco to develop a characteristically Vitruvian project. In keeping with the central role assigned by the Roman architect to the illustration of machines (*machinatio*), Francesco highlighted his vast collection of devices, establishing them in a balanced relationship with a set of general precepts, rules, and insights into the nature of man and his place in the universe. According to Francesco, these notions are as necessary as technical knowledge to properly design a house, temple, fortress, or city.

Space precludes a detailed discussion here of the complex issues regarding the dating and arrangement of the many extant versions of Francesco's *Trattato*. These are documented by a corpus of manuscripts – none of them in Francesco's hand – that has gradually been expanded in recent years. Many studies over the past two decades have built up a highly detailed picture of the stages in the development of Francesco's *Trattato*, although scholars continue to differ on many points.[98]

Two aspects of this complex history should be stressed here. First, careful consideration should be given to Francesco's criterion for classifying machines in the earliest surviving draft of his *Trattato di architettura* (*Trattato I*). In this text, which dates from around 1480, Francesco introduces sections of notes and drawings on underwater foundations and dike construction (see below, pp. 142-3).[99] Some of these were absent from the *Opusculum*, and therefore indicate a subsequent incorporation of technical solutions illustrated by Taccola in *De ingeneis*. Francesco also introduces an important section on measuring heights and distances (fig. 37), which, although fuller and better organized than Taccola's notes and drawings on the subject, rehearses some of the themes discussed by his predecessor. This section was lacking in both the *Codicetto* and *Opusculum*.[100] Then, Francesco goes

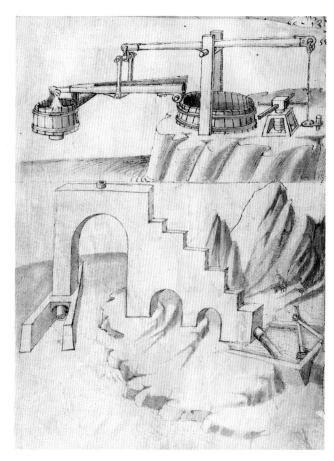

36. Francesco di Giorgio (after Taccola, *De ingeneis I-II*), *Opusculum*, fol. 58r. Mechanism with jack, lever, and tub-and-counterweight system to draw water (top); siphon conveying water to fountain (bottom)

on to arrange in an orderly, coherent sequence the four categories of devices – mills, pumps, "pulling and lifting machines" (*tirari e alzari*), and wagons – that featured as far back as the *Codicetto* and were reproduced, virtually unchanged, in the *Opusculum*. The innovations with respect to the *Opusculum* are the inclusion of text commentaries on single drawings, the appendix containing a series of devices outside the four categories previously illustrated,[101] and the addition of a fifth section on the art of war and offensive weapons (fig. 38).[102] The latter section demonstrates, yet again, Francesco's propensity to combine antiquarian pursuits with inventive analysis and proposals. On the one hand, he describes traditional techniques through the usual plundering and reworking of Taccola's drawings (trebuchets, wagons, hull-piercing devices, *balistae*, siege ladders, etc.). At the same time, he displays an interest in firearms, dwelling on sys-

37. Francesco di Giorgio, *Trattato I*, BMLF, Ms. Ashb. 361, fol. 31r. Methods for measuring distances

38. Francesco di Giorgio, *Trattato I*, BRT, Ms. Saluzz. 148, fol. 64r. Shelters for troops besieging fortresses

tems to transport and protect mortars and bombards and to make them easier to aim. He then gives a series of recommendations on how to construct safe, effective bombards, and discusses their various designations according to the shape and weight of their ordnance.[103]

The four basic categories of Francesco's machines exhibit some interesting new features. First, the inclusion of written commentaries enhances the graphic representations of the devices with lexical information of major interest, data on materials and dimensions, special construction hints, and specific applications for which Francesco recommends their use. The author even refers to the tests he has performed on certain devices. In some drawings of mills (fig. 39), he introduces quantitative analysis on the relationships between teeth, wheel and pinion diameters, and grinding velocity. He gives some general advice on, for example,

ways to reduce friction wear. These annotations are important evidence of Francesco's maturity as engineer and of his now considerable experience. In addition to a classification of the machines by broad category, he introduces a certain order in the sequence of devices within each category. In the section on mills, for example, Francesco begins by analyzing water mills, followed by windmills, human-powered mills, and animal-powered mills.

Admittedly, there are some exceptions to this attempt at a systematic classification of machines. The author was clearly intent, however, on defining criteria to organize his material – a concern virtually absent not only from Taccola's work and Francesco's early writings, but also from all prior books about machines. It is equally evident that Francesco found the stimulus and model for his organizational effort in Vitruvius: the Roman author followed a specific order in illustrating the various

39. Francesco di Giorgio, *Trattato I*, Ms. Ashb. 361, fol. 37v.
Text and illustrations describing five mills

40. Francesco di Giorgio, *Trattato I*, Ms. Ashb. 361, fol. 42v.
Text and illustrations describing five pumps

types of waterwheels and in the description of machines in *Liber X*.

Together with the adoption of verbal commentary, the search for a systematic approach required Francesco to rework his material in progressively more obvious ways. In the first draft of his treatise (*Trattato I*), the numerical proportions of the various categories of illustrated devices were substantially modified with respect to the *Codicetto* and *Opusculum*. The section on mills was the most heavily expanded, reaching 58 separate items. This was due to the author's attempt at an exhaustive analysis by structural type and energy source. The chapter on pumps was similarly expanded in the *Trattato I*, which discusses a vast range of this kind of device (fig. 40). Conversely, the section on carts and "pulling and lifting devices" was reduced by comparison with the *Codicetto* and *Opusculum*. In particular, the number of machines for lifting and

moving columns and obelisks was drastically cut. The tendency to narrow the discussion to basic examples of each machine type gathered considerable momentum in the so-called second draft of the work (*Trattato II*). In the manuscript containing the later draft, all categories were substantially reduced. Only ten illustrations of mills survived, but now they were strictly arranged by energy source: overshot bucket waterwheel (one example), horizontal paddle (*a ritrecine*) wheel (one ex.), horizontal-axis windmill (one ex.), crank-shaft (*a frucatoio*) mill with a flywheel bearing metal spheres (two ex.), human-powered and animal-powered mills (three designs, with different transmission systems), and, lastly, the horse-powered treadwheel (two designs, one in which the animal moves the wheel from the inside, the other in which the animal applies pressure on the outer rim).

This simplification process goes hand in hand with

Francesco's attempts to achieve a more organized, synthetic approach in the other chapters of the *Trattato*. His efforts are eloquent testimony to the new interpretation he was trying to give during these years to the meaning and nature of *machinatio*. Between the machines of the *Trattato* and those of the *Codicetto* and *Opusculum*, the basic difference lay not in their technical conception, which was already largely defined in the *Codicetto*. Rather, the change consisted in the gradual emergence of criteria for describing machines by type and category based on the identification of common principles.

Francesco was thus moving away from the workshops' well-established tradition of coping with every technical challenge and every mechanical device as an isolated case. In the workshop approach, the proficiency of a craftsman was measured by the number of "cases" he was able to master: for each of these, he was required to offer a precise illustration and an individual analysis. The successive drafts of the *Trattato* therefore chart the evolution of Francesco's technological method from a potentially infinite series of *exempla* to the definition of a limited number of "types." Each of these embodied the basic principles of a specific technical system, which could then vary *ad infinitum* to suit the craftsman's needs.

In this respect, the machine descriptions in *Trattato II* took on quite another meaning than that of the manifold devices in the *Codicetto*, some of which differ only in minor variants of their parts arrangements. Francesco himself recognized this change after supplying the illustrations of a very small number of devices in the chapter on machines for lifting and moving weights in the *Trattato II*: "and with these we conclude the section on instruments for pulling weights in construction work, since from these one can easily derive the others."[104]

The other important feature of the sections on machinery in Francesco's *Trattato* is the new relationship between the introductory text and the illustrations. In particular, the *Trattato I*, as preserved in the copies of Florentine and Turinese provenance, is highly innovative in two respects: first, as regards the definition of the methods of depicting machines; second, in the page layout, designed to provide intuitive links between the text and the corresponding images. This is a far cry from the solutions used, for example, in the abundant manuscript tradition of Valturius's *De re militari* (solutions that were passed on directly into the first printed editions of the text),[105] or the first printed editions of technical works. The latter run from the early illustrated edition of Vegetius[106] to Fra Giocondo's elegant illustrated *editio princeps* (first edition) of Vitruvius, published in 1511 (fig. 41).[107] There is no explicit evidence of any plans for a printed edition of the *Trattato*. If it had been produced using the layout of the two manuscripts mentioned above, it would have represented an extraordinary innovation in publishing.

As regards the methods of depicting machinery, one should stress the complexity of the graphic rules adopted by Francesco to highlight the basic structural details of the devices shown.[108] Francesco's presumable pride in the results he achieved in machine illustration was entirely justified. It explains his insistence on his clearcut graphic – and hence conceptual – primacy over those who lacked proficiency and experience in drawing. In his later writings, Francesco's criticism of authors of unillustrated technical and architectural texts became truly scathing. He distinguished himself from writers – among whom he almost surely included Alberti – who engaged in a purely theoretical reconstruction of Vitruvius and, more generally, of classical technology and architecture. "Make the drawing match the words"[109] became his war cry against those who harbored the illusion that they could "restore the discourse of the most ancient authors to its pristine strength, as it were, only by dint of Greek and Latin grammar."[110] The indecipherable text of Vitruvius's *De architectura*, which Francesco himself felt the need to tackle,[111] stood as an example of the impotence of pure philology.

Francesco reintroduced into architecture the technical know-how that the non-architect Taccola had developed on a virtually independent basis. Despite the attempt at systematic organization and at compiling a treatise of universal significance, the various extant versions reflect Francesco's pride in Sienese technological specializations. The section on metals, for example, illustrates the expertise that Francesco had built up through his acquaintance with the many entrepreneurs who exploited the Sienese Republic's abundant mining resources. Similarly, it is hard not to make a specific connec-

tion between the various methods for damming rivers and constructing solid foundations on the seafloor (fig. 42) and lake and river beds – newly illustrated by Francesco in the *Trattato I* – and the actual engineering projects in which he was involved with his Sienese colleagues. In 1485, Francesco worked on the reconstruction of the Macereto bridge on the Merse River.[112] He laid the foundations of the new supporting pillars by anchoring them to the remains of the older pillars swept away by a flood. His solution won praise from the commissioners in charge of assessing the completed work.

Francesco was also involved in the project to build a dam on the Bruna River to create a fish-stock lake.[113] In all likelihood, he only took part in the attempts to ensure the stability of the structure, which was designed and built by Pietro dell'Abaco and other engineers. In the pages of the *Trattato* devoted to underwater foundations and fish farms, Francesco certainly incorporated the information and engineering rules he had obtained through his knowledge of fish-farm construction – a highly flourishing activity in the Sienese Republic.[114]

The most explicit link, however, between the description of machines in the *Trattato* and Sienese technological specialties is found in the sections on water-conveyance methods. Indeed, in the *Trattato I*, Francesco draws on his personal, repeated experience as contractor for the *bottini* network. He furnishes detailed verbal and graphic information on the method of building underground tunnels to convey water; he describes the techniques for maintaining a constant tunnel diameter during excavation; he clarifies the purpose of the wells or "manholes" (*smiragli*); he explains how to obtain a constant gradient of two feet per hundred by means of a level, plumbline, and carpenter's square; he discusses his use of a mine compass to keep the tunnel excavation in the right direction; lastly, he illustrates how to distribute properly treated water from the underground network to the city fountains, either by sending the water through settling tanks or by forcing it through filters composed of very fine clay and ultra-fine gravel (see below, p. 123).[115] In the pages immediately following, devoted to measuring distance and height, Francesco shows how to use an astrolabe to calculate the difference in level between a water source and the destination – a fountain or a mill wheel.[116]

These examples show the fairly close relationship between the development of some of Francesco's research interests and the needs and pursuits of his native Siena. His resounding success as a military architect had made the most powerful lords of Italy eager to employ his specialist services. For the Sienese, however, Francesco remained – above all – a hydraulic engineer, the man who could prevent the dreaded collapse of the Bruna River dam and

41. Vitruvius M.P., *De architectura, per Jocundum castigatior factus cum figuris ...*, Venice, 1511, fol. 100v.
Bucket waterwheel

maximize the supply of water to the city's fountains. It is hardly surprising, therefore, that the governors of Siena petitioned the Duke of Calabria on September 11, 1492, to allow Francesco to return home. At the time, Francesco was employed by the Duke to strengthen fortifications in the region of Otranto against a possible attack by the Turks. The Sienese officials offered two powerful reasons for their request: "first, the fountains, which have been very short of water, owing to the lack of maintenance of the aqueducts; second, our lake, which, as winter draws near, needs some improvements."[117] The assimilation of Taccola's technological corpus by Francesco di Giorgio marks the birth of a Sienese tradition expressed and disseminated in

two media: treatises on architecture with a strong emphasis on machines; and albums consisting of drawings – with no text – of devices and *ingegni* for civilian and military use.

The success of this tradition was immense. The model of the album containing drawings of machines only (derived from the *Opusculum* archetype) met with greater success than the more sophisticated integration of the Vitruvian *machinatio* into the successive versions of Francesco's *Trattato di architettura*. Nonetheless, these versions circulated widely and attracted the attention of Leonardo,[118] Giuliano,[119] and Antonio il Giovane (the Younger) da Sangallo,[120] among others.

In the sixteenth century, this area of research was efficiently promoted by the new generations of Sienese engineers including Baldassarre Peruzzi,[121] Pietro Cataneo,[122] the prematurely deceased Oreste Vannoccio Biringucci,[123] and Vannoccio Biringucci, who makes several proud references to this home-grown tradition in his immensely popular *Pirotechnia*.[124] After Siena's capture by Cosimo I de' Medici, the tradition was further propagated by leading Florentine artists, men of letters, and engineers.[125] It also won a considerable following in the Venetian and Roman regions, thanks in part to the interest shown in Sienese devices by the authors of the best-selling printed "theaters of machines."[126] But the many authors who routinely reproduced the inventions of Taccola and Francesco were unaware of their creators' identity.

The slow process in which these crucially important documents were reattributed to their rightful authors began in the late-eighteenth century thanks to the joint efforts of two groups of researchers: the first were scholars engaged in the first archival investigations into the careers of Renaissance Sienese artists; the second were a small circle of students of military history seeking texts and documents to illustrate the early history of firearms.[127] This rediscovery has yielded an accurate portrait of these extraordinary figures, highlighting their work against the background of tensions, aspirations, and research methods characteristic of Renaissance culture in Siena and other Italian cities. Contrary to a long-held belief, this movement did not begin with Leonardo. Viewed as a tradition rather than as the achievement of a disparate group of outstanding individuals, this com-

plex of engineering pursuits is emerging ever more forcefully as a key aspect of Renaissance culture – an aspect that has not received proper attention from scholars of that period.

III. *Leonardo da Vinci: from technique to technology*

a. *The question of Leonardo's manuscripts*

The enormous body of literature on Leonardo still betrays a striking hesitancy to characterize him with precision as an artist, architect, inventor, philosopher, or scientist. For a long time, the vastness of Leonardo's interests led to his being perceived as the very incarnation of genius – a visionary who ignored the boundaries between disciplines and roamed freely through the immense realms of knowledge. And yet a careful study of Leonardo's surviving papers and manuscripts makes it difficult to escape the impression that, in fact, most of his energy was devoted to what – in today's language – would be called scientific and technological pursuits.

Admittedly, uncertainties still abound in Leonardo's biography. It is clear, however, that his main source of livelihood came from his work as an engineer in the service of various patrons. Indeed, the commissions he earned from painting merely complemented his practically constant earnings as an engineer. Leonardo had no independent means, and his income as a technician enabled him to have a fairly comfortable lifestyle and some savings.[128]

To reach a balanced assessment of the significance of Leonardo's engineering studies, we must begin by addressing the fundamental and arduous problem of sources. In essence, we need to find the proper way of navigating within the enormous, chaotic bulk of Leonardo's extant papers. The slightly less than six thousand pages in Leonardo's hand that have come down to us correspond to about one-third of the papers that Leonardo bequeathed to his pupil Francesco Melzi at his death at Amboise in 1519.[129] In spite of this heavy mutilation, these papers constitute the most extensive, detailed, and revealing documentation that we possess on Renaissance technology.

In recent decades, several scholars have called attention to the fact that several of Leonardo's sensa-

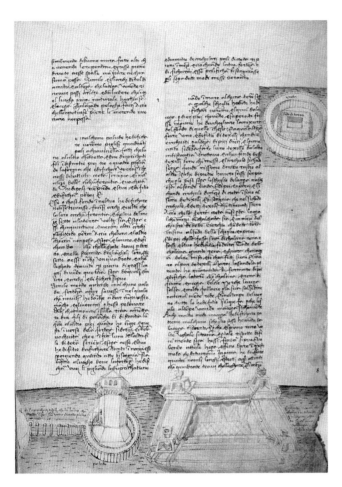

42. Francesco di Giorgio, *Trattato I*, Ms. Ashb. 361, fol. 8r.
Methods for laying foundations underwater

tional inventions are illustrated in manuscripts and iconographic sources that unquestionably predate him. At the same time, rigorous criteria have been devised for reading Leonardo's drawings and accompanying captions. Today, they are accepted as is. In other words, the temptation to correct or complete them on the grounds that this or that decisive detail had been intentionally omitted by Leonardo to protect his discovery is resisted.[130] This more recent approach has revealed that a significant number of his designs may be technically daring and sometimes brilliant, but depict machines of doubtful viability. His studies for a flying machine offer a particularly illuminating example of this. A substantial segment of Leonardo's technical research is thus coming to be seen not so much as actual projects for devices that were to be immediately constructed, but rather as a technological "dream," the product of a highly fertile imagination. His manu-

scripts – but also those of other Renaissance engineers – are full of technological dreams of this kind. Leonardo's imaginings are of great interest. They attest to a faith in the development, through technology, of unheard-of powers in man: to fly like a bird, to live underwater like a fish. Leonardo thus gave voice to the enthusiasm and quest for innovation of an entire age marked by sensational discoveries and the continual expansion of geographical horizons. It is not by chance that Leonardo's technological dreams often have a prophetic tone or are accompanied by provocative reflections on human nature, as in some of his studies of flight or in the famous note in which he states that he wishes to keep secret his invention of a way to breathe and swim underwater to prevent its being used as an instrument of death.[131]

It should also be stressed that a considerable part of Leonardo's technical studies records the intense activity of an engineer who, throughout his long life, was in the service of powerful patrons from whom he constantly received requests and specific commissions in exchange for a project fee or a regular salary. On his own initiative, Leonardo designed technical solutions that he knew would be useful to his influential patrons and would thus, he hoped, bring him substantial rewards. This category includes almost all of Leonardo's studies of military technology, his most important investigations in applied hydraulics, several large artistic projects involving complicated technical challenges (such as the equestrian monuments for Francesco Sforza[132] and Gian Giacomo Trivulzio, with their extremely delicate casting problems), his spectacular designs for court festivals and theatrical performances,[133] and his designs for special technical apparatus such as the mechanism to provide hot water for the bath of the Duchess Isabella of Aragon.[134] Also in this category are many of Leonardo's technical studies aimed at the most efficient use of energy sources and the mechanization of certain production processes. These studies are consistently characterized by an empirical approach similar in style and method to that of the engineers of his time.

Another major group of Leonardo's technical investigations is of a different nature. These studies, which cannot be directly related to specific commissions from patrons, are evidence of a self-motivated

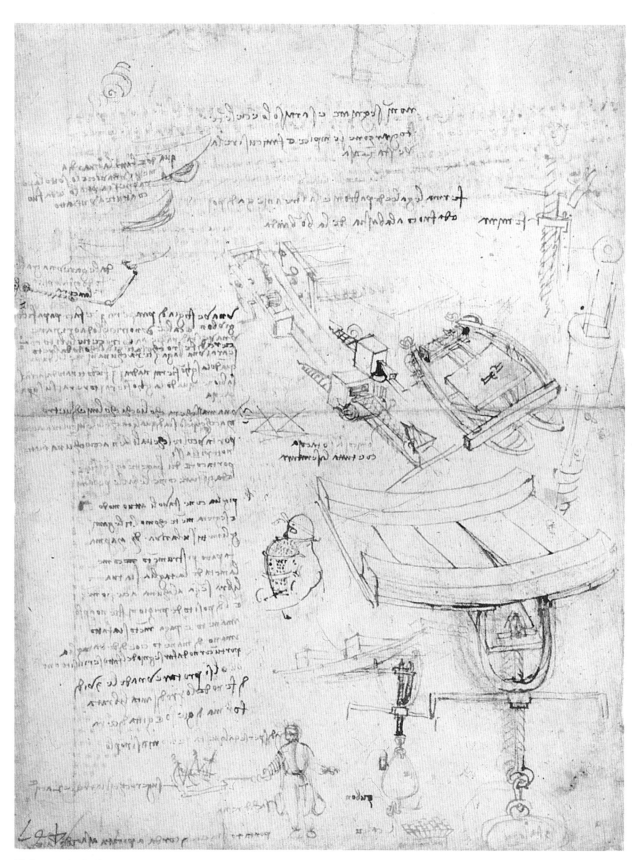

43. Leonardo da Vinci, BAM, Codex Atlanticus, fol. 909v. Underwater attacks and devices for breathing underwater

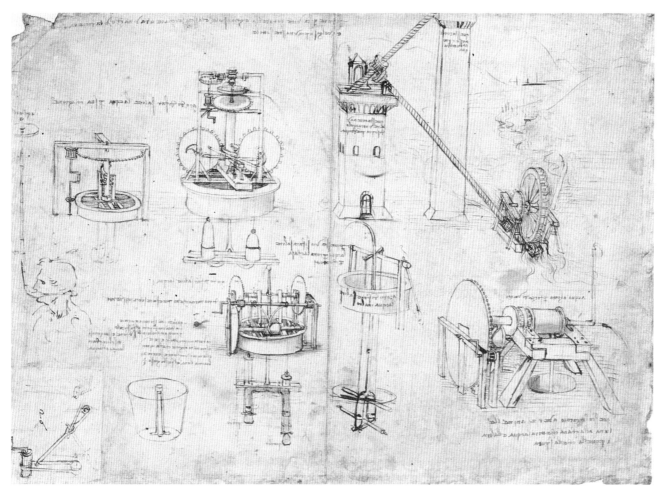

44. Leonardo da Vinci, Cod. Atl., fol. 1069r. Water-raising machines

professional re-training for which Leonardo, at a certain point, felt the need. These are more comprehensive explorations that reflect Leonardo's increasing efforts after 1490 to establish a connection between general principles – derived from an assiduous observation and imitation of nature – and practical applications. Indeed, in his maturity, Leonardo was to devote himself ever more intensely to this task. For Leonardo, the good engineer, like the good painter, had to grasp the ironclad laws that govern every natural process. Hence inventiveness meant the ability to reproduce. In these studies, one could say that Leonardo seems to have turned from a "technician" into a "technologist."[135]

The rough classification of Leonardo's technical studies into the three categories outlines above (technological dreams, specific commissions, and studies on theoretical foundations) omits a number of engineering projects belonging to a fourth distinct group. These studies include notes and drawings of machines and devices derived from the experiences of others. The group comprises "quotations" from contemporary and earlier authors (including the ancients), the recording of technical solutions that Leonardo had witnessed in the course of his many travels, and memoranda regarding operational methods or devices of which he had learned from engineers of his acquaintance or who worked under him. Today we possess a long list of texts that Leonardo used as sources (including Archimedes, Euclid, Vitruvius, Philo, Valturius, Alberti, Francesco di Giorgio, and others).[136] It has proved considerably more difficult to identify the studies recording solutions or devices that had impressed Leonardo or had inspired him to suggest improvements.

One basic priority is therefore to define, as accurately as possible, the links between Leonardo's technical studies and the stimuli provided by his

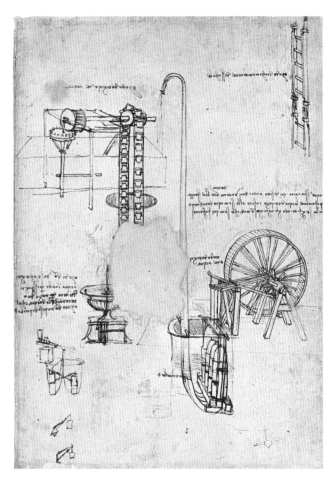

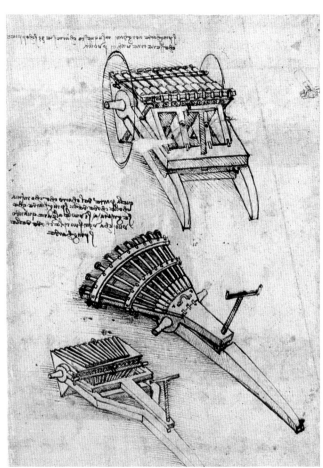

45. Leonardo da Vinci, Cod. Atl., fol. 7r. Water-raising machines

46. Leonardo da Vinci, Cod. Atl., fol. 157r. Multi-barreled firearms

working environment. Another crucial task is to establish at least a rough chronological sequence of his drawings and notes.

The second requirement is particularly vital to understanding Leonardo's career as engineer and scientist. In the bulk of his surviving writings, the documentary nucleus of greatest size and importance is the monumental Codex Atlanticus. The term "codex" is a misnomer here, for it suggests a coherence that is totally lacking. In fact, the gathering comprises more than a thousand pages of various sizes, whose contents are very largely of a technical and scientific nature. The collection was put together at the end of the sixteenth century by the sculptor Pompeo Leoni,[137] who took apart the many Leonardo notebooks in his possession with the intent to separate the technical-scientific material from the artistic and figurative documents, including the anatomical studies. The latter were placed by Leoni in a second compilation, now in the Royal Library at Windsor Castle.[138] The Codex Atlanticus groups together sheets dating from all stages of Leonardo's career. They are arranged in no apparent thematic or chronological order. Leoni's misguided attempt was truly a disaster, making the historian's task of critical reconstruction excruciatingly difficult.

A landmark in the effort to date the Codex Atlanticus sheets was Gerolamo Calvi's volume of 1925,[139] which established the chronological boundaries of the then known Leonardo manuscripts in terms still largely accepted today. Calvi devoted special attention to the Codex Atlanticus. In particular, he identified a sizable number of sheets from the early phase of Leonardo's career. Further progress has been made in recent decades, particularly by Carlo Pedretti, who has carried out sophisticated, coordinated investigations of the three miscellaneous compendia of Leonardo's manuscripts that have come down to us: the Codex Atlanticus,[140] the Windsor Collection,[141] and the Codex Arundel.[142]

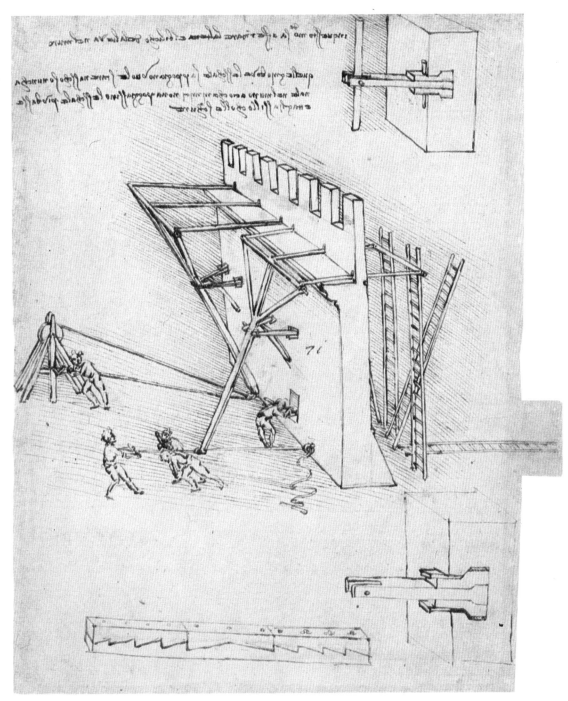

47. Leonardo da Vinci, Cod. Atl., fol. 139r. Lever to repel siege ladders

b. *Leonardo's début as an engineer*
(Florence 1469-82)

Leonardo's professional début as an artist and engineer dates from his move to Florence in the late 1460s. Of the few known facts about his early career, one of the most salient is his apprenticeship in Verrocchio's workshop, which, along with that of the Pollaiolos, was the largest and busiest in Florence at that time.[145] We have no direct documentary evidence concerning Leonardo's activities during his apprenticeship. There is, however, the testimony of Vasari, who speaks of the emergence, in those years, of a keen interest in technological questions:

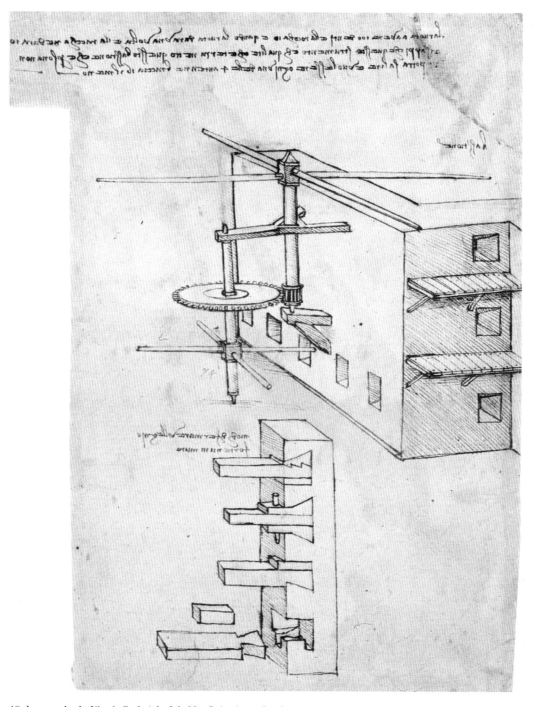

48. Leonardo da Vinci, Cod. Atl., fol. 89r. Spinning wheel to sweep away assailants

"And he practiced not one branch of art only, but all those in which drawing plays a part; and having an intellect so divine and marvelous ... he not only worked in sculpture ... but in architecture also... and he was the first, although but young, who suggested reducing the River Arno to a navigable canal from Pisa to Florence. He made designs of flour mills, fulling mills, and engines that might be driven by the force of water, but he wished his profession should be painting."[144]

The Leonardo manuscripts that have survived in their entirety all date from his Milanese years or later, so they cannot shed light on his early work as an engineer. The only traces of his activity in this

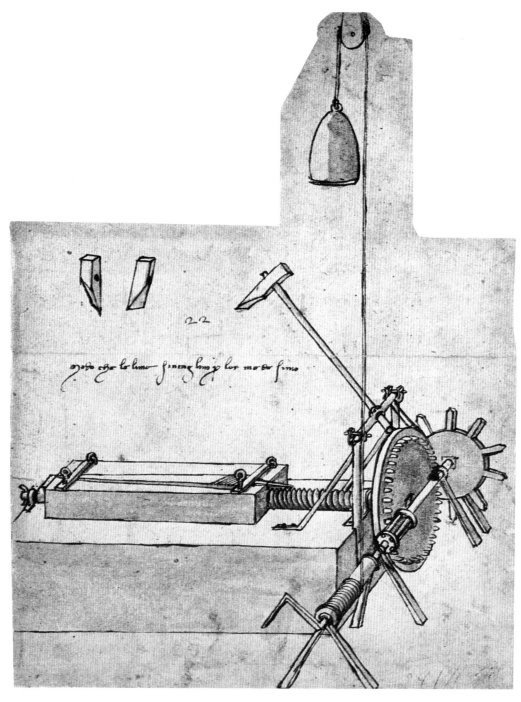

49. Leonardo da Vinci, Cod. Atl., fol. 24r. Automatic file-making machine

field during his first stay in Florence are recorded in a few loose sheets and, more explicitly, in numerous drawings and notes of the Codex Atlanticus, identified by Calvi in 1925.[145]

By the time Leonardo arrived in Florence, the construction of Brunelleschi's dome on Santa Maria del Fiore was complete, including the lantern, placed in 1461. The only operation still to be carried out was the placement of the large, heavy sphere of gilded copper atop the lantern. The construction site, a large portion of the machinery, and the scaffolding were presumably still in place for that task when Leonardo entered Verrocchio's workshop. In fact, the latter had been commissioned to build the

large sphere and to fix it securely to the top of
the edifice, some one hundred meters from the
ground. This arduous assignment was carried out
between 1468 and 1472. Proof of any direct partici-
pation of Leonardo in the project is lacking, but we
have an autobiographical note from a much later
date (after 1510) in Ms. G: "Keep in mind how the
ball of Santa Maria del Fiore was soldered togeth-
er."[146] At any rate, this achievement of the work-
shop where he was apprenticed surely gave Leo-
nardo the opportunity for direct contacts with the
most advanced building technology of the entire
Renaissance. There are many evident traces of the
profound impression that Brunelleschi's worksite
made on the young Leonardo. He was attracted by
the ingeniousness of the hoisting machines and, as
mentioned earlier, he made careful drawings of
many of them.

This particular group of drawings and notes high-
lights the impact of Brunelleschi on Leonardo's
early career as an engineer. For the inexperienced
young apprentice, Brunelleschi must surely have
been a model. Indeed, other documents from these
years indicate Leonardo's interest in Brunelleschi
and the pains he took to familiarize himself with his
works. Leonardo appeared to be particularly inter-
ested in finding new applications for the screw,
extensively used in Brunelleschi's machinery. For
Leonardo, the graceful movements of the screw
coils seemed to reproduce the living forces of Na-
ture itself, the force of whirlwinds and winds, of the
water vortexes that Alberti had compared to a
"liquid drill."[147] As in Brunelleschi's machines, the
screw held the promise of an endless multiplication
of power. And its applications were universal. A fa-
mous sheet of the Codex Atlanticus from the early
years of Leonardo's first Milanese period carries
drawings and notes on "underwater attacks" and
devices for breathing underwater (fig. 43).[148] Leo-
nardo refers here to an invention from which he ex-
pected to derive considerable financial gain. The
text and drawings are deliberately obscure – he is
protecting his secret – and it is unclear whether he
is thinking of frogmen or of a submarine vessel that
would allow men to go unseen beneath the hulls of
enemy ships and sink them with a drill-like instru-
ment of which there are several sketches on the
sheet. Leonardo writes: "An impression must be
taken of one of the three iron screws of the Opera

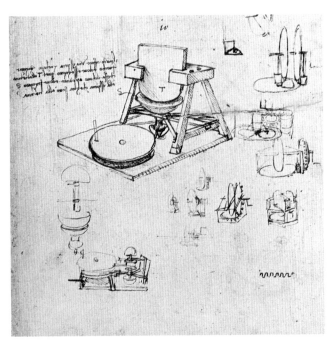

50. Leonardo da Vinci, Cod. Atl., fol. 17v. Machine to fabricate
concave mirrors

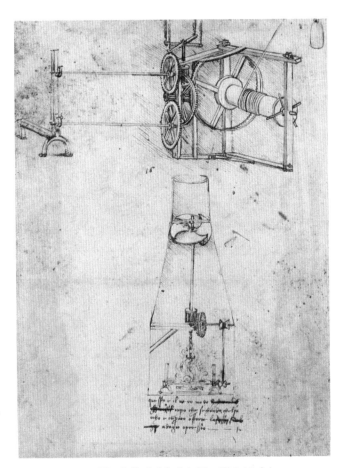

51. Leonardo da Vinci, Cod. Atl., fol. 21r. Weight-driven
and air-powered roasting spits (top and bottom resp.)

(administration) of Santa Liberata: the mold in plaster and the cast in wax." Santa Liberata is Santa Maria del Fiore (Florence Cathedral), and the reference, as confirmed by the drawing, is to Brunelleschi's turnbuckles.[149] Thus we have here an original use of the screw and another eloquent reference to the influence of Brunelleschi.

Another likely echo of this influence is in a Leonardo project mentioned by Vasari, which consisted in raising the Baptistery (Temple of San Giovanni) adjacent to the Cathedral and place steps under it without damaging the building. According to Pedretti, Leonardo intended to dig carefully until the building's foundations were exposed, then construct underneath it a firmly attached platform to be raised with use of powerful screws.[150] Here again we have a Brunelleschian project – although Leonardo may also have been inspired by the achievements of Aristotele Fioravanti – and in which the technology of the screw plays a decisive role.

Vasari also tells us of the young Leonardo's projects regarding the Arno River, both to make it navigable from Florence to Pisa and to use it as a source of energy for industrial purposes.[151] No studies by Leonardo from this period on the canalization of the Arno have survived, but Pedretti has drawn attention to a sheet of sixteenth-century copies of Leonardo drawings that include a paddle-wheel boat, possibly a memory of Brunelleschi's patented riverboat (fig. 1).[152] Another, more specific echo of Brunelleschi, this time related to problems of river canalization, is in Ms. B,[153] which contains studies from the early years of Leonardo's first Milanese period (1485-90). Amid a series of drawings and notes on military technology and strategy (in particular on the way to deviate the natural course of a river), Leonardo mentions the ill-fated attempt to deviate the Serchio River to flood Lucca and force it to surrender – a project implemented by Brunelleschi in 1428 during the war between Florence and Lucca.[154]

There is further evidence of Leonardo's early interest in hydraulics. In a memorandum probably written in 1482, shortly before he moved to Milan, Leonardo listed a series of works including "certain instruments for ships" and "certain water instruments."[155] The "instruments for ships" may be related to the studies of underwater attacks mentioned earlier.

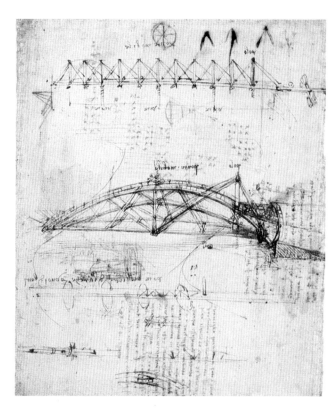

52. Leonardo da Vinci, Cod. Atl., fol. 855r. Mobile bridge

As for the "water instruments," many sheets of the Codex Atlanticus dating from Leonardo's first Florentine period attest to his early interest in such devices. One of the sheets contains a great number of hydraulic machines (fig. 44).[156] There are various types of pumps and an illustration of the combined use of two long Archimedes' screws activated by a wheel driven by a river current; the screws raise the water to the tops of two towers. Leonardo studied the problem of raising water from wells or rivers in order to then use its fall as a source of energy. He was beginning to experiment with new graphic techniques: he shows, as in an X-ray, the underground mechanisms of the pumps, and renders with great precision complex gear mechanisms that transformed a constant circular thrust into an alternating motion. Another contemporary sheet reflects the same interests: a siphon, a double-action pump activated by a large paddlewheel that can raise water to a great height, and a machine to raise water from a well by means of the continuous movement of a conveyor belt with buckets that are filled by immersion in the well and emptied into a reservoir placed above (fig. 45).[157]

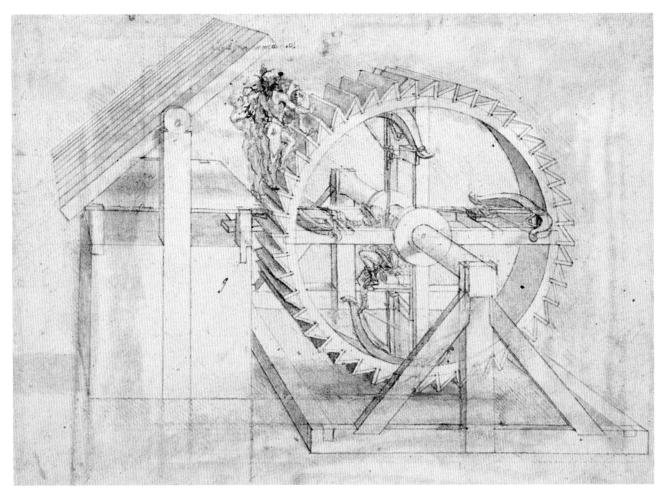

53. Leonardo da Vinci, Cod. Atl., fol. 1070r. Treadmill-powered multiple crossbow

Another area of interest that clearly emerges from Leonardo's early manuscripts is military technology. Although, as Pietro Marani has shown,[158] Leonardo's intense pursuit of military architecture dates from his Milanese stay, he had begun to focus on the subject while still in Florence. From this period we have studies of articulated mounts and drawings of mortars and small bombards (*schioppetti*) of various kinds (fig. 46).[159] Leonardo studied not only systems of attack, but also the use of mechanical devices for defense. To this category belong two studies, dating from about 1480, of techniques for defending a fortress against an enemy scaling its walls. Leonardo constructs a cinematic sequence. He begins by showing how to push away the enemy ladders by means of a movable protective railing (fig. 47).[160] Then, in the event that the enemy soldiers succeed in overcoming this first obstacle, he indicates how to sweep them off the walls by rapidly rotating horizontal poles (fig. 48).[161] As in so many other cases, the novelty here consists in the recycling of well-known devices for a new purpose. In this instance, Leonardo relies on the motive mechanism of a mill.

Other sheets in the Codex Atlanticus dating from Leonardo's early years in Florence show that he was observing and analyzing various industrial machines. One well-known example is the plan of the file-making machine, dating from about 1480 (fig. 49). While we have no proof that this was an invention of Leonardo's, it attests to his interest in the mechanization of traditional manual production methods. Other studies, probably dating from 1478-80, depict machines to produce concave mirrors for use as burning mirrors to solder metals (fig. 50). Also worth noting are the hoists and screw mechanisms for bending catapults on the verso of an Uffizi sheet from 1478,[162] and the well-known draw-

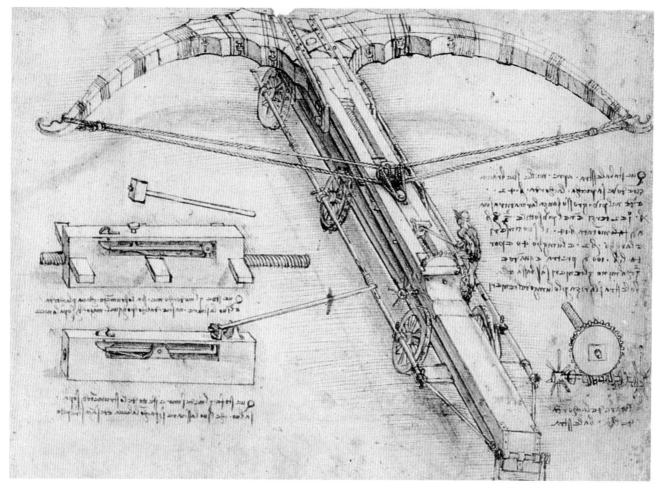

54. Leonardo da Vinci, Cod. Atl., fol. 149Br. Crossbow with lever-and-screw loading mechanism

ing of two roasting spits, one activated by a weight and the other by hot air (fig. 51).[163] The latter devices show Leonardo's fascination with complex rotary systems that could adapt any energy source to any conceivable use.

Leonardo's technical studies in this period do not display a coherent pattern. Rather, they seem to be a series of individual, unrelated case studies. Leonardo's approach resembles that of the engineers who operated in the fascinating but limited world of the Renaissance workshop. They had learned by experience to employ natural and animal power, but did not attempt to understand the laws that governed that power or to define quantitative principles for its use. Not even the great Brunelleschi had broken out of this mold, despite the fact that he had felt the need on several occasions to tap the theoretical knowledge and geometrical skills of a learned humanist like Paolo del Pozzo Toscanelli, one of

the key figures in the fifteenth-century Archimedean revival.[164]

c. Leonardo in Milan (1482-99): continuity and renewal

In 1482, for reasons that are not entirely clear, Leonardo left Florence and entered the service of the largest, most active, and most powerful court of Italy: that of Ludovico Sforza, Duke of Milan, known as "Il Moro" (The Moor). His territory was endowed with natural resources and flourishing industries. Its capital was already a fully developed metropolis of 200,000 inhabitants, more than twice the size of Florence. The Duchy of Milan could thus offer an ambitious, eclectic young man like Leonardo the opportunity to prove his brilliance in many areas. Arriving in Milan as an artist with a good reputation but not yet a celebrity, he soon suc-

55. Leonardo da Vinci, IFP, Ms. B, fol. 33r.
Study for a steam cannon

ceeded in making his talents known. The Duke gave Leonardo duties and specific commissions as artist and engineer. We do not know the stipend Leonardo received until 1499, or the exact terms of his contract with Ludovico. He is mentioned in the documents as *ingeniarius ducalis* and *ingeniarius camerarius*. It is also certain that he was allowed to accept commissions from private parties, and in fact he took on several, both of an artistic and of a technical nature.[165]

Year by year, Leonardo's activity becomes easier to reconstruct. The available documentation increases and, in addition to the early sheets of the Codex Atlanticus, we have other precisely datable manuscripts that present a greater consistency of subject matter. This is the case of Ms. B and the Codex Trivulzianus,[166] both compiled in the second half of the 1480s. The two manuscripts are also similar in terms of their core topics. Both give prominence to studies in architecture and military technology,

confirming that Leonardo took very seriously his duties as technical-military advisor, which was the prime capacity in which he had offered his services to Ludovico. These famous studies have come under close scrutiny even in recent years, and Leonardo emerges from their analysis as a rather non-innovative military engineer.[167] His draftsmanship has become more mature and, at the same time, we see increasing evidence of his references to classical sources and contemporary authors. One important example of the latter was the treatise by Valturius, first published in Latin in 1472. Leonardo used it – in the Italian edition of 1483 – for information on ancient war machines as well as for a vast range of technical terms.[168] The military-engineering drawings dating from Leonardo's first decade in Milan form a precise, graphic commentary on the letter (of 1482?) in which he offered his wide-ranging technical expertise to Ludovico.[169] The reference in that letter to "extremely light, strong bridges" is echoed in the sketches of bridges in Ms. B and the Codex Atlanticus (fig. 52).[170] The same manuscripts also contain a considerable number of studies of weapons and instruments of attack, some of which were derived from Valturius ("I shall make bombards, mortars and light ordnance of fine and useful forms, out of the common type," Leonardo had written to the Duke). These studies are of interest for their attempt to increase the firing pace, facilitate loading, lessen recoil, and improve methods of rapid aiming. Leonardo's engineering talent comes into play in the automation of operations. This is evident, above all, in the spectacular studies for the huge wheel activated by manpower that permits the rapid discharging of the four powerful crossbows with which it is equipped (fig. 53); or in the gigantic crossbow with complex methods of loading and activating the release (fig. 54). These studies – which include the *architronito* or steam cannon masterfully elucidated by Reti (fig. 55)[171] – belong to the group of technological dreams. Through his vivid, dynamic drawings, Leonardo was able to create the impression that these often far-fetched mechanisms would work reliably. Such was the case with the extremely heavy armored car ("I shall make covered chariots safe and immune to attack," he had promised the Duke),[172] whose model is presented in all the museums as Leonardo's invention, ignoring the nearly identical drawings in

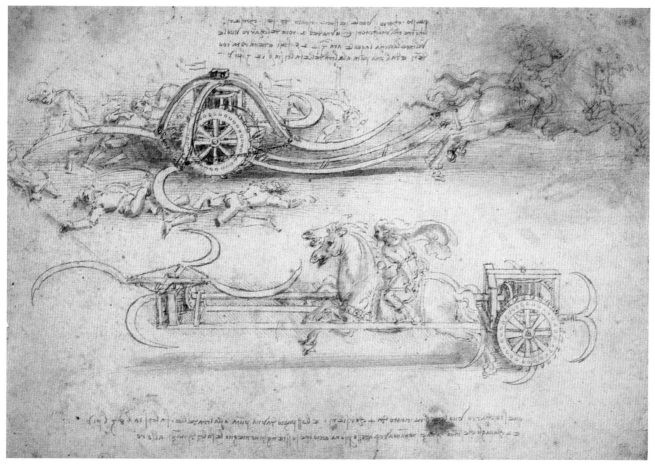

56. Leonardo da Vinci, BRT, n. 15583. Scythed chariots

many earlier manuscripts by others. The same may be said of Leonardo's sinister chariots fitted with scythes: his drawings illustrate their deadly effects in the enemy ranks (fig. 56), but Leonardo himself admitted that they "often did no less injury to friends than to foe."[173]

Leonardo also worked on systems to manufacture firearms, such as a hydraulic milling machine that produced barrel segments to be welded together in sequence to obtain large-sized artillery pieces (fig. 57).

As he had promised Ludovico Sforza, Leonardo could provide "many machines most efficient for attacking and defending vessels" in the event of war at sea. His studies of submarine warfare and devices for breathing underwater have been mentioned earlier. These designs were probably intended to help the Duke in his efforts to defend Genoa, which came under his dominion in 1487, against continual pirate raids. On a sheet of the Codex Atlanticus, along with various interesting but unoriginal devices for breathing underwater, we find sketches and notes that seem to indicate a project for an underwater vessel – "Leonardo's submarine," as it was promptly baptized.[174] Carlo Pedretti has conjectured that Leonardo was thinking of immersing a hermetically sealed, fully watertight vessel by releasing the air from the leather bags placed along its sides to keep it afloat. To bring the vessel back to the surface, air would have had to be pumped back into the bags from the surface.[175] This is probably another of Leonardo's technological dreams, based on the unstoppable development of a chain of daring ideas that led him to materialize, in his imagination and on paper, designs beyond the engineering possibilities of his time.

Leonardo's work as a hydraulic engineer during his first Milanese period is hard to assess accurately. Recent scholarship has tended to challenge the central role, traditionally assigned to Leonardo, in

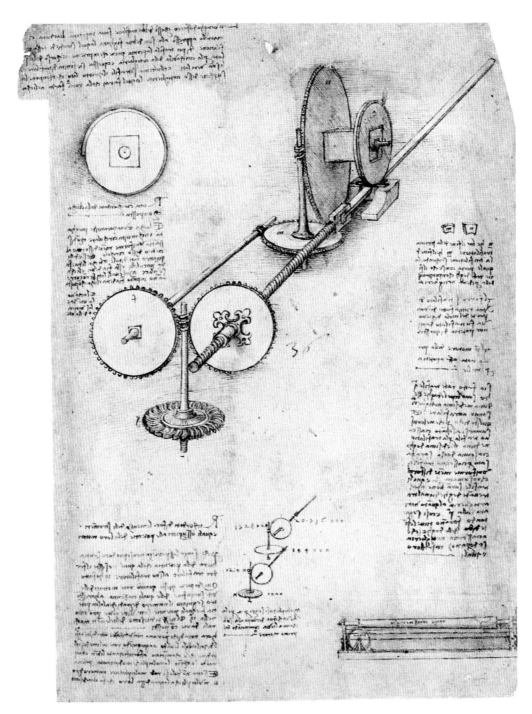

57. Leonardo da Vinci, Cod. Atl., fol. 10r. Water-powered rolling mill for the production of iron staves for cannons

the design of the extensive canalization works undertaken around Milan in the late fifteenth century. Leonardo apparently experienced difficulties in this field during his early Milan years. True, he had experience in coping with a capricious, unpredictable river like the Arno. But he lacked the necessary resources and know-how to deal efficiently with a complex system comprising rivers of constant flow (the Adda and Ticino), numerous tributaries, lakes, and canals designed for to be used as a communication and merchandise transportation network for a city – Milan – that lay far from the main waterways. When Leonardo arrived in Milan, the city's canal system was already largely in place.

The Martesana Canal, built by Bertola da Novate between 1457 and 1469, linked Lake Como and Milan via the Adda River. Another network of canals, via the Naviglio Grande (Grand Canal), linked Milan to the Ticino River, on whose banks stood Pavia – the second-largest city of the Duchy of Milan – with its famous Studio.[176] Leonardo's attention was caught by many of the technical solutions used in these vast projects: basins, lock systems, dredges to keep the canals clean, adjustable apertures in the banks of the canals to supply water, and so on. Understandably, one of Leonardo's main concerns seems to have been to find his bearings within this system. We have evidence of his efforts to grasp the main coordinates of this unfamiliar territory by carrying out personal expeditions, taking measurements, and compiling sketch-maps. Obviously, he concentrated on the navigable network, as attested by the rough map of Milan drawn in 1493 (fig. 58).[177] One of the tasks the Duke assigned to Leonardo was to draw up an ambitious plan for the enlargement of the city of Milan, rejuvenating the medieval structure of the city by making the most of the plentiful water supply. There are traces of these studies in Leonardo's evocative drawings of the "ideal city" in Ms. B, in which he highlights the urban, economic, hygienic, and sanitary benefits of a perfectly regulated network of waterways (fig. 59).[178]

In 1490, Leonardo went to Pavia with Francesco di Giorgio in connection with the project to build the Cathedral there. In Pavia, he was certainly fascinated by the multiple locks of the Naviglio Bereguardo. Leonardo's first drawings of locks and gates in the Codex Atlanticus (fig. 60) and Ms. B[179] may date from these visits or earlier ones (possibly in 1487-88), and may reflect an original project for movable lock-gates to regulate the flow of water in canals.

Leonardo's manuscripts from the 1490s show a growing interest in hydraulic technology. There are many references to canals and Milanese localities linked by the waterway system. And he continually mentions problems awaiting satisfactory solutions: how to keep a constant level of water in the canals; how to design high-capacity locks (like the ones with their gates at an angle); how to construct efficient machines for dredging existing canals and excavating new ones; how to operate efficient devices for drawing precise quantities of water from the apertures in the banks of the canals (an impor-

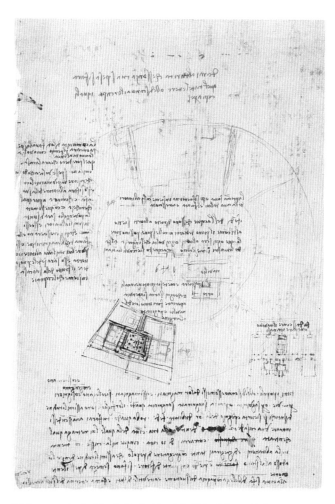

58. Leonardo da Vinci, Cod. Atl., fol. 184v. Map of Milan, ca. 1493

tant problem, since the water supply granted by the Duke was based on a payment per volume drawn). It is more difficult to establish the extent to which this impressive series of drawings and notes represents original ideas or is merely a record of facilities that Leonardo witnessed in operation. Indeed, for quite some time, Leonardo seems to have been busier learning hydraulics than teaching it. He sought contacts with Lombard waterworks experts, of whom he had innumerable questions to ask: "find a master in waterworks, and get him to explain to you their repair and what it costs."[180] But while he was striving to learn from the experience of the masters, he was elaborating a highly personal method, which becomes increasingly evident in his papers. Between the late 1480s and early 1490s, in fact, Leonardo's engineering career took a decisive turn. His studies in hydraulics were

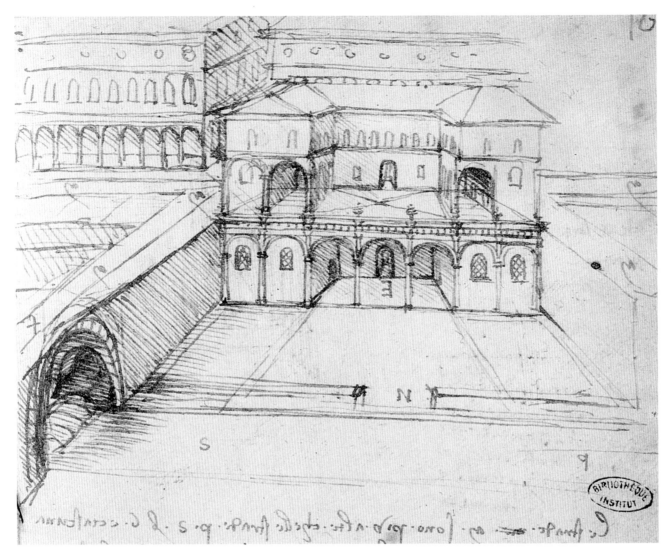

59. Leonardo da Vinci, Ms. B, fol. 16r (detail). Study for an urban redevelopment project in Milan

a driving force in his change of method. He became convinced that experience could help him only up to a certain point. To solve the problems posed by flowing rivers, canals, locks, and water supply for domestic and agricultural uses, the engineer had to be well acquainted with water as an element. He needed to grasp its laws in order to harness it to man's use by means of suitable mechanical instruments. Leonardo's earliest "theoretical" studies date from this period, and their constant object was water. Ms. A (1490-92)[181] contains the first relatively consistent outline of his study of water: the "beginning of the treatise on water" (ca. 1490).[182] This is a seminal statement, the first evidence that Leonardo intended to compile a treatise. The fact that Leo-

nardo meant it not as a compendium of practical precepts but as a comprehensive text is also clear from his declared aim of returning to and elaborating on what the ancients had already written on the topic. This was a very ambitious project. In Leonardo's fertile brain, it already appeared as the principal section of a vast encyclopedia that would encompass other closely related chapters: on "motion and weight," human anatomy, and the Earth. For Leonardo, water is a universal factor. He defines it as "nature's carrier": it carves out valleys; it circulates in the bowels of the Earth, giving rise to springs; it flows as blood through the human body; and everywhere its incessant movement is subject to ironclad laws. It is not by chance that Leonardo's

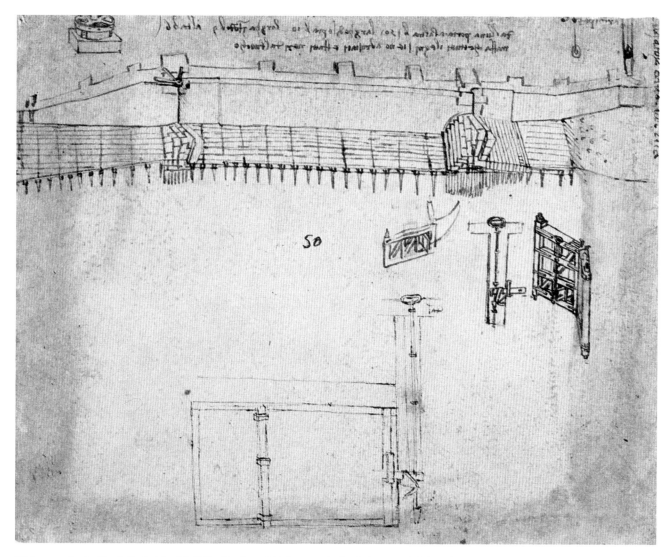

60. Leonardo da Vinci, Cod. Atl., fol. 935r. Design of high-capacity lock (center right) with gates at an angle

very first mention of a treatise on water in Ms. A explicitly draws an analogy between the human body and the Earth: "Man has been called by the ancients a lesser world, and indeed the term is rightly applied, since, as man is composed of earth, water, air, and fire, this body of the Earth is similar."[183] Hence, Leonardo saw a unity between the animate and inanimate worlds, and so believed in the validity of a strictly mechanical investigation of man. This led him to conduct a series of systematic dissections that began precisely during his first stay in Milan. In so doing, he constantly underlined the relationship between man and the Earth (respiration, circulation of humors, and so on), largely based on analogies whose central element was water. Dur-

ing these same years, he stepped up his theoretical studies of optics and mechanics. A powerful motive here was his calling as an artist intent on achieving a perfect imitation of Nature – a task that required a thorough knowledge of Nature's laws. The same pattern was at work. Leonardo began by studying classical and medieval sources: evidence remains of his search for important texts, mainly Archimedes, works on the medieval science of weights (*de ponderibus*), and the classical texts on the physical theory of *impetus*. He then established fruitful contacts with living experts, such as the Marlianis[184] and Fazio Cardano.[185] Lastly, he attempted to establish the general mechanical principles involved, testing them in concrete applications. Leo-

61. Leonardo da Vinci, IFP, Ms. H, fol. 65v. Sketches of water stairs

nardo soon discovered that the basic unifying tool for these researches was geometry, of which he was almost totally ignorant. So he enthusiastically dedicated himself to filling this gap in his knowledge. The first signs, found in a memorandum of 1489, show Leonardo's usual method of searching for texts and seeking out expert friends: "Get Messer Fazio [Cardano] to show you about proportionality"; "Get the master of abacus to show you how to square a triangle"; "the proportions of Alchino [Al Kindi] with Marliani's notes: Messer Fazio has it"; and "Try to get Vitolone [Witelius], which is in the library at Pavia, and which treats of mathematics."[186] In 1497, Leonardo had the good fortune to meet Luca Pacioli, another of the many Tuscans attracted to the Sforza court. Pacioli became his friend and gave him a thorough course in geometry based on a reading and commentary of Euclid's *Elements*.[187]

This turning-point – which we shall discuss at greater length below – was to have a direct, momentous impact on his engineering work. By the mid-1490s, Leonardo had already outlined his theory of "Nature's four powers" – movement, weight, force, and percussion – upon which every physical phenomenon depends. From that point on, he described air and water as powerful natural forces in perennial motion that man could harness and turn to his own benefit. Leonardo later increasingly equated air and water, partly as a result of his study of bird flight.[188]

Yet glaring contradictions remain between Leonardo's programmatic statements and the actual course of his studies, which proceeded in a piecemeal manner, by "cases."

After the formulation of a project as ambitious as the study of water, the studies in Ms. A are disappointing. Leonardo concentrated on waterways. He sought to determine the changes in the velocity of their various levels in terms of the roughness of their beds. He explored the relation between the changes in waterway flow and the variation in the width and depth of the bed and in current velocity. He studied the effects of the impact of water on bodies immersed in it and on the banks.[189] In sum, Leonardo outlined the contents of ambitious theoretical works, yet continued to undertake a series of disconnected observations.

Although Leonardo never actually compiled the *summae* so often solemnly promised, his efforts to base practical applications on general principles led to considerable changes in his technical activities. The first evidence of this change is found in a series of drawings and notes from 1494 relating to hydraulic projects. In that year, Leonardo was at Vigevano, the birthplace of Ludovico Sforza and the setting for major Sforza projects. In his notebooks, Leonardo recorded several observations on the town's canals and on the water stairs used at the Sforzesca, the duke's model farm, to drain a marshland and keep the sloping meadows green (fig. 61). Among the many pages of Madrid Ms. I (1490-99) and contemporary pages of Ms. H referring to this visit, the material on the Vigevano mills is of particular interest.[190] Leonardo took precise measurements of the grain mills he observed (fig. 62); he calculated the cost of building one, estimating its daily production capacity.[191] He examined the defi-

ciencies of the Lombard mills, suggesting remedies based on general principles of hydraulics and hydrodynamics.

Elsewhere in Madrid Ms. I, Leonardo investigates the causes that make a fall of water more or less efficient, experimentally analyzing the effect of four falls of water from four equal openings made at different heights in a container full of water (fig. 63).[192] His analysis rests on a theoretical argument based on the conviction that the power of a jet of water depends on the combined effect of the weight of the water and its percussion. By virtue of its *impetus*, the percussion is proportional to the height of the fall. Leonardo concludes that the four falls "should be of equal power," noting that "where the force of percussion is lacking, the weight compensates."

These notes are telling evidence of Leonardo's change in method due to his espousal of theoretical

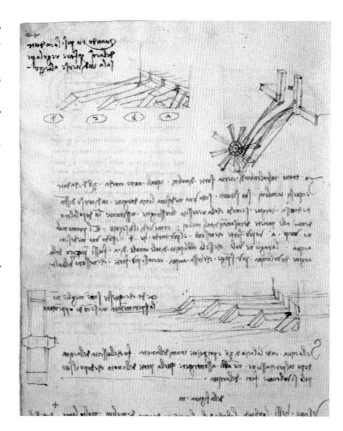

62. Leonardo da Vinci, BNM, Madrid Ms. I, fol. 151v (detail). Notes on optimizing efficiency of vertical-wheel mill
63. Leonardo da Vinci, Madrid Ms. I, fol. 134v. Notes on water jets from tank pierced at different heights

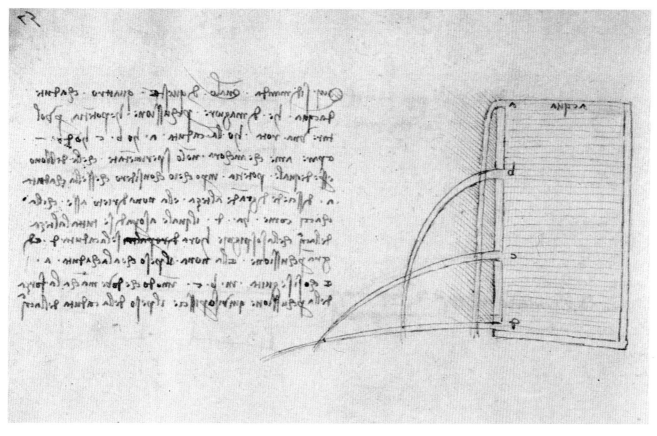

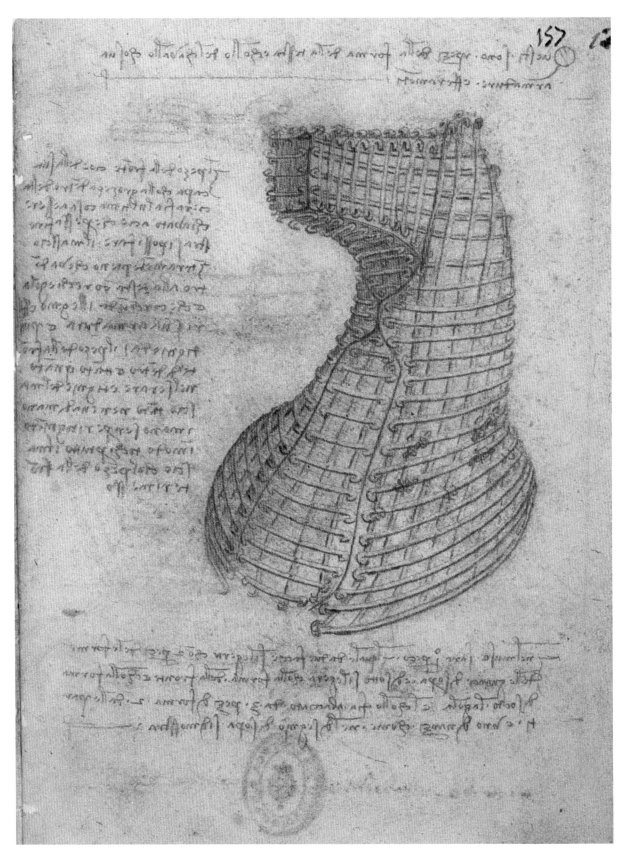

64. Leonardo da Vinci, BNM, Madrid Ms. II, fol. 157r. Form for casting horse's head on Francesco Sforza monument

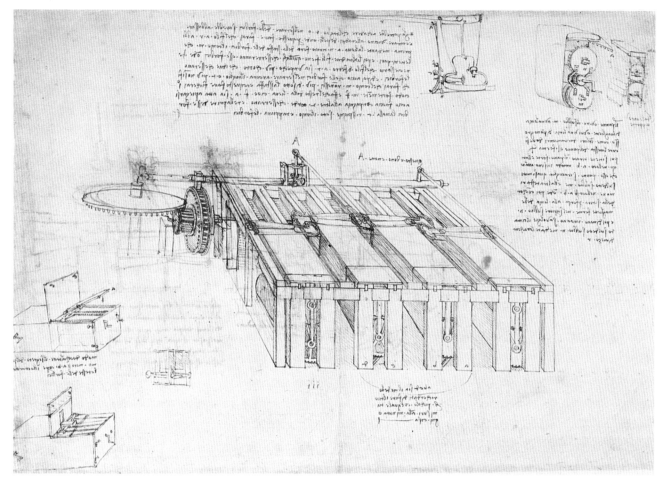

65. Leonardo da Vinci, Cod. Atl., fol. 1105r. Automatic cloth-shearing machine

analysis. This approach opened up new perspectives for his engineering work, enabling him to design mills with higher output and to calculate the relationship between the quantity of water flowing out of canal apertures and the height of the apertures. It is no accident that, in these studies, Leonardo advances his proposals solely on the strength of his theoretical forecasts, stating explicitly that he has not tested them: "I believe that these will be better. I have not tested it, but I believe so."[193] These are truly "thought experiments," as Leonardo's faith in the theoretical foundations from which the predicted effects derive makes experimental verification perfectly useless.

This intellectual duality was new for Leonardo. The self-styled "disciple of experience" was immersed in the study of mathematics, solid and fluid mechanics, anatomy, and geology. He was striving to enrich and refine his vocabulary, to improve his knowledge of Latin, and to measure up to the great minds of the past.

Alongside these signs of innovation, there are other technical studies from the last years of Leonardo's first Milanese period that retain the traditional character of ingenious solutions to special problems, based on practical experience. One example is the series of studies for the casting of the gigantic horse for the equestrian monument to Francesco Sforza commissioned by Ludovico (fig. 64).[194] In the event, Leonardo was unable to test the efficacy of his solutions, since the enormous amount of bronze necessary for the process was diverted for the manufacture of bombards by Ercole d'Este, the Duke's ally against the French.[195]

Also typical of Leonardo's habitual method of analysis is the series of strikingly effective drawings of machines and devices for the textile industry, all dating from ca. 1495-99 (fig. 65). The Duchy

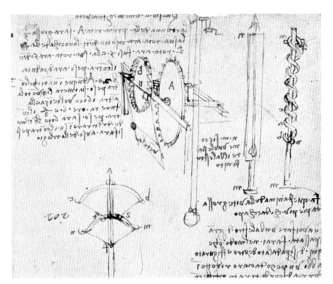

66. Leonardo da Vinci, Cod. Atl., fol. 754r (detail).
Studies on pendulum escapement

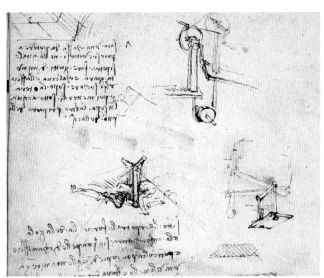

67. Leonardo da Vinci, Ms. B, fol. 79v (detail).
Flying machine

of Milan possessed a flourishing textile industry, but we know very little about the development of techniques in this domain. Leonardo may simply have recorded the most advanced solutions personally observed by him.[196] However, he may have followed his habit of taking the functional deficiencies reported to him by the machines' operators as his starting-point to suggest effective remedies. By and large, this series of projects represents an attempt to automate manufacturing processes in order to increase efficiency. The quest for automation is an abiding feature of Leonardo's mechanical designs, and he has rightly been called the "prophet of automation."

The same type of interpretation may be applied to the many studies of mechanical clocks in Madrid Ms. I. Silvio Bedini maintained that they are works of considerable interest.[197] But – with the possible exception of the pendulum escapement to regulate a weight-driven clock (fig. 66) – the devices cannot be considered sensational anticipations of modern inventions. The precision technology of the clock incited Leonardo to perform a skillful exercise in automation. Predictably, his attention focused on systems for transmitting and regulating movement. In fact, not all these studies may relate to clock mechanisms. We should not forget that clocks and automatons (machines capable of carrying out a series of predetermined movements) were regarded as belonging to the same category and were usual-

ly produced by the same craftsmen. Leonardo also devised automatons for festivals at the Sforza court and, in 1515, he produced for the Republic of Florence a self-propelled mechanical lion whose breast opened to release lilies.[198]

Before concluding this summary of Leonardo's first Milanese period, we should mention his study of flight. Leonardo had already become interested in the subject during his years in Florence,[199] but his studies underwent considerable progress in Milan, as can be seen in the many pages of Ms. B and the Codex Atlanticus that contain projects for flying machines. Raffaele Giacomelli was the first to demonstrate that in his initial studies Leonardo concentrated on full-fledged flying machines with movable wings, illustrated in many splendid drawings in Ms. B.[200]

In some the flier is prone and moves the wings with his arms (fig. 67). In others, the flier's lower limbs provide the thrust, or else the flier is upright and uses his arms and his legs to generate the thrust (fig. 68). These intriguing designs seem to have led Leonardo to believe that such machines might actually work. There is evidence that he proposed an attempt from the roof of the Ducal Palace and subsequently recommended a safer location: "You will try this machine over a lake, and wear a long wineskin around your waist, so that if you should fall you will not drown."[201]

The flying machines designed by Leonardo during

these years have beating wings with extremely complicated devices for operating them. Leonardo also considered using springs continually rewound in flight. He seems to concentrate on mechanical systems for efficiently transmitting the constant thrust of the motor into an alternating motion like that of beating wings. These are powerful, heavy machines, to which Leonardo attached ridiculous shock absorbers as a protection in the not unlikely event of a fall.[202] It seems impossible that he could really have believed a man could fly with one of these devices. Yet all the evidence indicates that for several years he worked feverishly and with great expectations on this project. He appeared convinced that man could imitate with his craft the natural equipment of flying animals: "The bird is an instrument that operates according to mathematical laws, an instrument that it is in man's power to reproduce." More than any other of his studies, Leonardo's designs of flying machines seem informed by his belief in the fundamental mechanical uniformity of Nature. In other words, the mechanical formulas and principles used by Nature in its creatures, such as birds, could be imitated and reproduced by man.

Leonardo broke off his studies of flight at the end of the 1490s – possibly because he realized the insuperable obstacles involved – then resumed them around 1505, compiling an extraordinary manuscript known as the Codex on the Flight of Birds (fig. 69). By this time, through a careful comparison between the muscular power of birds and that of man, as well as between the weight of the bird mechanism and that of the flying machine, Leonardo had concluded that man could not lift a device so heavy. From then on, he abandoned the concept of flying machines with beating wings and devoted himself to another, far more realistic possibility: that of glider-like "sail flight" (fig. 70).[203] While this new attempt failed to produce concrete results,[204] it led Leonardo to productive investigations into the mechanics of bird flight, the nature of air, and the formation and role of winds and air currents. These studies occupied much of Leonardo's time between 1500 and 1514. In them, the analogy between air and water, swimming and flying, fish and birds became increasingly important: "Write of swimming underwater and you will have the flight of birds through the air."[205]

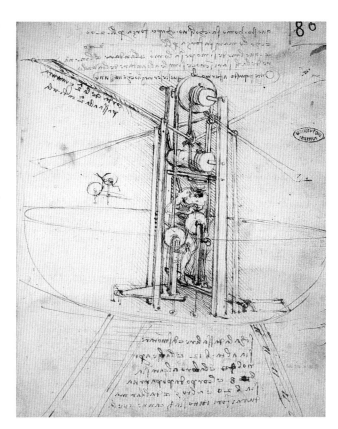

68. Leonardo da Vinci, Ms. B, fol. 80r. Flying machine

d. *Continual wanderings (1500-1519)*

Leonardo's first Milanese period came to a close when the victory of the French army in late 1499 brought the Sforza domination of Milan to a tumultuous end. By early 1500, he had settled in Venice with his friend and mathematics teacher Luca Pacioli. There, he wrote a note on the cover of Ms. L worthy of Machiavelli for its concision and bluntness: "The Duke lost his State, his property, and his freedom, and none of his works was completed for him."[206]

For Leonardo, there followed a period of continual, exhausting travel in search of new patrons who could guarantee him the freedom to study and the comfortable life he had enjoyed while in the service of Ludovico Sforza. Among the few traces of Leonardo's brief stay in Venice are his studies for a series of fortifications on the Isonzo River.[207]

When he left Venice, again with Pacioli, Leonardo headed south. In March 1501 he was in Florence, where he stayed until the summer of 1502. Leonardo's return after a twenty-year absence does not ap-

pear to have aroused any particular emotion in the city, now under a republican government. Nor does he seem to have found great work opportunities there. In a letter dated April 3, 1501, Pietro da Novellara, an agent of Isabella d'Este, described Leonardo as lacking in commissions and hence free to devote himself – in accord with his own inclinations – to those same scientific researches that had occupied a large part of his later years in Milan: "he is hard at work on geometry, and cannot bear to touch a paintbrush."[208]

This lack of commissions led Leonardo to abandon his pleasant pastimes and to accept, in the summer of 1502, the invitation of Cesare Borgia – the notorious Duke of Valentinois – to join him as Architect and General Engineer in the military campaign through which Borgia aimed to carve out a vast dominion in central Italy with the support of his father, Pope Alexander VI. Leonardo traveled with Cesare through the Marches, Umbria, and Romagna, inspecting strongholds and proposing improvements to defense systems.[209] He took part in the capture of Urbino, delving into the treasures collected by the Montefeltro family in their famous library, which Cesare sent to Rome. Leonardo must have searched there for the scientific texts he had begun to collect so ardently during his years in Milan. "There is a complete Archimenides in the possession of the brother of Monsignor of Santa Giusta in Rome – he wrote in a note of 1515 – the latter said that he had given it to his brother, who lives in Sardinia. It was formerly in the library of the Duke of Urbino, and was carried off from there in the time of the Duke of Valentinois."[210] Wherever he went, Leonardo took notes and measurements, recording a diversity of observations in Ms. L.[211] His most important achievement in this period is the famous map of Imola, now at Windsor.[212] The document reveals the proficiency Leonardo had attained in mapmaking, a fundamental tool of urban planning and military architecture (this particular map was made for the latter purpose). Here Leonardo adopted and perfected the geometrical surveying methods used by Alberti in the *Descriptio Urbis Romae*. The town of Imola is inscribed in a circle radiating from a precisely defined spot. From this central point, the town spreads out in a minutely detailed drawing, which – thanks to fairly accurate direct measurements – preserves the exact

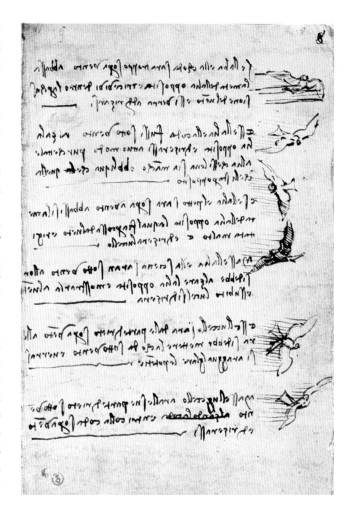

69. Leonardo da Vinci, BRT, Codex on the Flight of Birds, fol. 8r. Drawings and notes on the flight of birds

proportions of streets, squares, and buildings. Leonardo also used several colors to distinguish streets from squares, waterways, and houses.[213]

After serving Cesare Borgia, Leonardo returned to Florence in the late spring of 1503, at the height of the war between the Florentine Republic and the city of Pisa. This circumstance led to his first technical commission from the Florentine government. He was asked for an opinion on how to deviate the course of the Arno in order to flood Pisa and force it to surrender. It is not clear what part Leonardo played in this project of an unmistakably Brunelleschian flavor, in which other engineers were also involved. The digging of the deviation canals began in the summer of 1504 with the use of powerful equipment and some two thousand workers. But the results were disappointing and work was soon abandoned. We can relate to this project sev-

eral plans and relief maps of the Pisan territory in Madrid Ms. II (fig. 71).[214] As usual, Leonardo incorporated his territorial engineering projects into a scrupulous cartographic, hydrographic, and orographic survey of the region in question.

It is possible that the two drawings of excavating machines in the Codex Atlanticus may also be linked to the same project. As Carlo Pedretti has established, the two sheets were originally joined and show the different operation of two gigantic excavating machines working on the same canal.[215] In this way, Leonardo could easily demonstrate the clearcut superiority of his model (fig. 73)[216] over the conventional machine (fig. 72).[217]

Alternatively, the design for the new machine might be connected with another series of studies, also from 1503, on a project to canalize the Arno in order to circumvent the winding, unnavigable section between Florence and Empoli.[218] The project called for the construction of a canal extending from Florence along the plain between Prato and Pistoia, skirting around the Arno's tortuous bends between Montelupo and Empoli, and rejoining the course of the river near Vico Pisano. The new, semicircular route (fig. 74)[219] would have required major civil engineering works, such as a tunnel through the hill at Serravalle, near Pistoia.[220] In order to keep a steady flow of water in the canal, Leonardo envisaged the construction of a large reservoir in the Val di Chiana.[221] At a certain point he must have submitted the project to the Florentine authorities, as suggested by several notes in which he insisted on the economic benefits that would accrue from the drainage of wide areas along the planned route.[222]

Much of Leonardo's energies were absorbed by the important artistic commission he received from the Florentine Republic in 1503: the painting of a fresco to commemorate the victory of the city's army over the Milanese troops at Anghiari in 1440. But Leonardo did not neglect his beloved study of geometry. Meanwhile, a new commission – this time from Iacopo IV Appiani, Seigneur of Piombino – took him away from Florence in 1504. Leonardo was appointed consultant on military fortifications to Iacopo, presumably with the encouragement of his ally, the Florentine Republic.[223] When Leonardo returned to Florence, he once again immersed himself in geometry and the preparation of the *Battle of Anghiari* fresco. In 1505 he eagerly returned to his study of anatomy. The Codex on the Flight of Birds also dates from 1505.[224] In May 1506, he was once again forced to interrupt his studies when the French governor of Milan, Charles d'Amboise, summoned him to take up commissions for works of painting and architecture. During 1506 and 1507, Leonardo shuttled between Milan and Florence to settle a litigation suit with his brothers over their uncle's estate; he was also being pressured by the Florentine government to finish the *Battle of Anghiari*. Such conditions made it hard for him to achieve any significant progress in his studies.

Leonardo spent the final months of 1507 and most of 1508 in Florence. This was his most intense, fruitful period for the study of anatomy, and he took advantage of his access to the hospital of Santa Maria Nuova. While disassembling the vital organs of the human machine to unveil its secrets, Leonardo also turned his attention to the machine of the Earth – in search of solid proof of the close correspondence between man (the "lesser world") and the cosmos.[225] By now, geometry and mechanics, anatomy and geology – in a continual exchange of concepts, principles, and analogies – were Leonardo's preferred field of activity, as can be seen in his manuscripts from this period: the Codex Leicester,[226] the anatomical sheets at Windsor,[227] and the Codex Arundel.[228]

During these restless years, Leonardo's interest in applied technology seems to have dwindled. His propensity for theoretical studies grew with his conviction that all knowledge presupposes the mastery of geometry. He displayed the same tendency in Milan, where he moved at the end of 1508 after his final departure from Florence. In Milan, he pursued the anatomical and geological studies begun in Florence, always emphasizing the close links between cosmos and microcosm. He renewed his pledge to compile treatises on these subjects. Leonardo maintained his strong interest in geometry – especially in geometrical transformations, which he regarded as a formidable tool for the art of painting and the investigation of solid bodies. Indeed, he constantly used such transformations in his study of myology (the lengthening and shortening of muscles) and hydrodynamics (the flow of blood in the arteries and valves of the heart, but also the flow of water in winding rivers).[229]

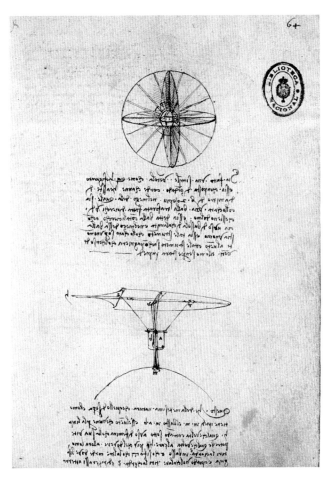

70. Leonardo da Vinci, Madrid Ms. I, fol. 64r. Notes on manned glider

Leonardo's attempt to derive practical applications from theoretical premises is evident in his projected treatise on water, the key element in his dynamic universe.

The table of contents of the treatise shows that the first chapters were to deal with theoretical questions, from which the sections on hydraulic engineering would be derived ("Book 10: Of the ways to repair river banks; Book 11: Of conduits; Book 12: Of canals; Book 13: Of machines turned by water; Book 14: Of raising water").[250] Only occasionally do Leonardo's studies from these years contain special-purpose technical projects of the kind so often encountered before 1500. His progressive involvement in theoretical issues seems to have diminished his interest in practical applications. This shift is reflected even in the celebratory scholarship that sees Leonardo as the sensational inventor of every modern device: indeed, all of the discoveries

assigned to him by that literature date from before the end of the fifteenth century.

Henceforth, Leonardo worked on specific technical projects only at his patrons' request. One example is the canal he designed between 1508 and 1510, probably by order of Louis XII of France, to bypass the narrow portion of the Adda River near the Tre Corni at Paderno. From the project's surviving elements, we can reconstruct the complex solutions developed by Leonardo: they were perhaps unrealizable, and, in the event, were never built.[251] Taking advantage of the generous patronage of the King of France, who left him much free time, Leonardo was able to pursue his "calling," which seems no longer to have been that of engineer, but rather that of scientist and scholar.

This pattern persisted in Leonardo's remaining years after his forced departure from Milan in 1513, due to the French defeat and the return of Massimiliano Sforza as Duke. Now an old man, Leonardo once again set out on tiring travels in search of new patrons. After stopping in Florence, where his old patrons, the Medici, had returned to power, he went to Rome, in the service of one of the members of that family, Giuliano de' Medici, the brother of Pope Leo X. In exchange for a salary and protection, Leonardo placed his skills as a hydraulic engineer at Giuliano's disposal, advising him on the project to drain the Pontine marshes (fig. 75). This was later carried out, but it is unlikely that Leonardo played a significant role in it. In Rome, Leonardo supervised the fabrication of large parabolic mirrors assembled from many pieces of glass. He also designed rope-making devices, which appear among his last drawings in the Codex Atlanticus (figs. 76-77): one of these bears the Medici symbol of the diamond ring, a clear proof that he received the commission from Giuliano. This sporadic return to practical activities was dictated by the pressures of everyday demands. As soon as possible, however, Leonardo returned to his favorite study of geometry, optics, and anatomy. The latter led him to frequent the Roman hospital of Santo Spirito, which at a certain point he was forbidden to visit because of an accusation of necromancy.

In the summer of 1516, the lily of France once again brought good fortune to Leonardo. The new king, François I, invited Leonardo to follow him to France, offering him exceptional rewards and hon-

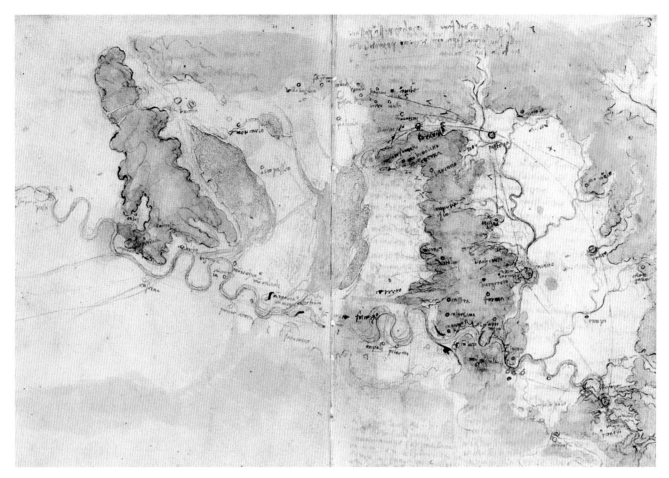

71. Leonardo da Vinci, Madrid Ms. II, fols. 22v-23r. Map of the Arno Valley near Pisa

ors. Leonardo's main activity during these years was the project for a new royal palace at Romorantin, combined with an extensive plan to canalize the local waterways.[252] None of these projects was ever carried out. In reality, Leonardo's activity in France was not particularly intense. His mere presence in a court that attracted talents of every kind – with a predilection for Italian artists – justified the princely treatment he received and the payment of a pension as "chief painter and engineer and architect to the King." Antonio de Beatis, who came to France with Cardinal Luigi of Aragon and visited Leonardo on October 10, 1517, describes a man admired not so much for his present activities – impeded by old age – as for the prodigious knowledge he had acquired in every field of learning.[253] The eyewitness accounts of Leonardo in his last years paint a picture of a wise, learned old man, not of a busy but socially modest engineer. In a passage describing the extraordinary affection of François I

for Leonardo, Benvenuto Cellini, correctly interpreting the metamorphosis that had taken place, calls the aged Leonardo "a very great philosopher":

> King François, who was extremely taken with his great virtues, took so much pleasure in hearing him speak, that he was separated from him only for a few days a year ... I do not wish to neglect to repeat the words I heard the king say of him, which he said to me ... that he believed there had never been another man born in the world who knew as much as Leonardo, not only about sculpture, painting, and architecture, but as a very great philosopher.[254]

e. *From the anatomy of machines to the man-machine*

Theoretical analysis and quantitative methods thus came to dominate Leonardo's mechanical studies, as he endeavored to identify universal principles of Nature. This shift in approach is patently visible in

the complex of studies dealing with the planned treatise on the "elements of machines" (*elementi macchinali*) to which Leonardo repeatedly refers.[235] Admittedly, there is no trace of a comprehensive treatise fitting that description in Leonardo's surviving papers. However, the sensational discovery in 1966 of two Leonardo manuscripts in Madrid offers valuable new evidence about the mysterious planned work.[236] Madrid Ms. I, in particular, is entirely devoted to mechanics. It contains two fairly distinct sections, one on theoretical mechanics, the other on applied mechanics and mechanisms.

Ladislao Reti, who played an important role in the discovery, prepared an edition of the two Madrid manuscripts that was published shortly after his death in 1974. In several essays, Reti stated his belief that the first section of Madrid Ms. I (which is in fact the second in chronological order), was a near-final draft of a coherent treatise on "mechanisms."[237] Reti identified this draft with the treatise on the "elements of machines."

Reti saw Leonardo's "elements of machines" as an orderly series of reflections on mechanisms – reflections based on logical models that would not be formally defined until three centuries later at the École Polytechnique in Paris, finding their ultimate canonization in Franz Reuleaux's *General Theory of Machines* in the mid-nineteenth century.

In reality, Leonardo's many direct references to the "elements of machines" show that his intended treatise was not solely devoted to the analysis of mechanisms. In a text in the Codex Atlanticus (ca. 1500), he states that a body that descends along a 45° angle "becomes half its natural gravity, as I proved in the fifteenth conclusion of the fourth book of the elements of machines composed by me."[238] In another passage of the same Codex (ca. 1504), we read: "Of two cubes which are double the one of the other, as is proven in the fourth [book] of the elements of machines composed by me";[239] and again: "Elements of machines. Of a weight proportional to the force that moves it, we must consider the resistance of the medium in which that weight is moved, and I shall write a treatise on this."[240] We find other references in Ms. I (1497-99),[241] the Codex on the Flight of Birds,[242] and the anatomical studies at Windsor,[243] especially between 1508 and 1510. Leonardo refers to a division of the treatise into two parts, one theoretical and one practical.

The work included sections on the duplication of the cube, the theory of centers of gravity, levers, and the inclined plane. In particular, the fourth book – the one Leonardo mentions most frequently – discussed questions of general and theoretical mechanics, while the only reference to practical applications is in the passage of the Codex Atlanticus that suggests the interfering influence of the medium should be taken into account when calculating force and resistance.[244]

In all likelihood, therefore, the "elements of machines" is the title under which Leonardo intended to collect the entire series of his reflections on mechanics. Following the model of classical and medieval statics, the role of geometrical analysis was crucial in the treatise. Further sections would have dealt with the theory of Nature's four "powers" (motion, weight, force, and percussion), reflections on the centers of gravity and the methods for calculating them, and an analysis – also of a traditional type – on simple machines. Such is the outline of the theoretical section, insofar as it can be reconstructed. The section on applied mechanics would have described single and combined uses of mechanical devices and the features to optimize their use, as well as the machines to manufacture them.[245]

The very expression *elementi macchinali* (elements of machines) precisely reflects this projected approach. Indeed, the term echoes Euclid's "elements of geometry," where "elements" denotes "foundations" or "principles."

Having clarified the true nature of Leonardo's treatise on the "elements of machines," we must admit that Reti was entirely justified in stressing the extreme originality and penetration with which Leonardo analyzed the principles, operating criteria, and basic components of machines in Madrid Ms. I.[246] The most remarkable section of the manuscript is certainly the first part, in which Leonardo analyzes in detail a series of mechanical devices (see below, pp. 192-224), lingering over their specifications, evaluating their power and resistance, construction materials, and methods of application. He also devotes great attention to friction, attempting to devise solutions for reducing it. This is truly an "anatomy" of machines.

The idea of "dissecting" machines was, in fact, very clear in Leonardo's mind:

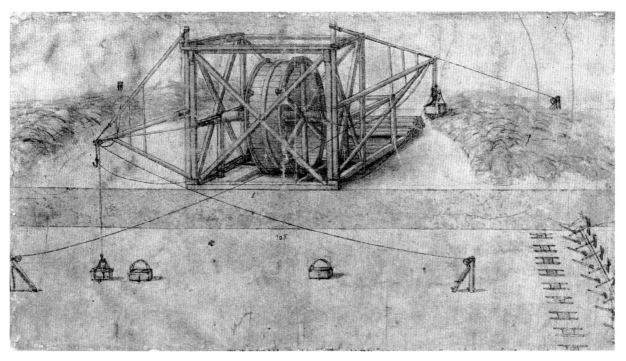

72. Leonardo da Vinci, Cod. Atl., fol. 3r. Excavating machine

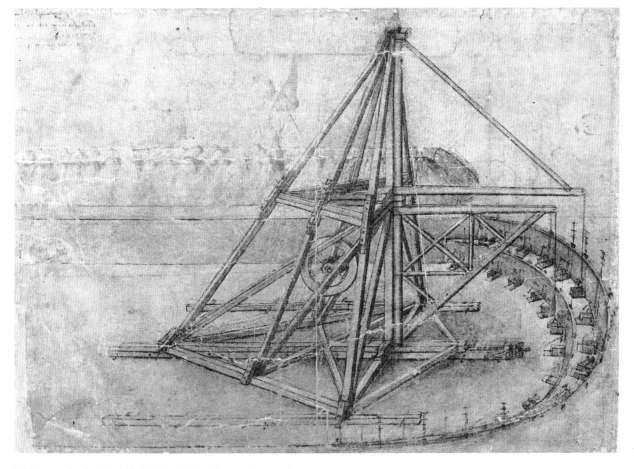

73. Leonardo da Vinci, Cod. Atl., fol. 4r. Excavating machine

74. Leonardo da Vinci, Royal Collection, RLW, 12279. Project for canal to make the Arno navigable between Florence and Pisa

All such instruments will generally be presented without their armatures or other structures that might hinder the view of those who will study them. These same armatures shall then be described with the aid of lines, after which we shall discuss the levers by themselves, the strength of the supports, and their durability and upkeep.[247]

Drawing plays a key role here. It allows Leonardo to skillfully analyze these devices and to reassemble them with an effective range of illustration techniques based on an exceptional mastery of perspective. The devices are seen from several points of view, in exploded views, and in geometrical diagrams.[248] Leonardo attempts to break down into a numerically finite catalogue the component "organs" that combine to produce the infinite variety of machine-organisms:

Once the instrument is created, its operational requirements shape the form of its members. They may be of infinite variety, but will still be subject to the rules of the four volumes.[249]

The extraordinary, almost rhetorical power of these drawings and notes, which Leonardo arranged with such care on the page, should not lead us to take for granted that these manuscripts contain sensational discoveries. We must be extremely cautious in crediting Leonardo with the invention of devices such as the ball bearing[250] or universal joint.[251] The most we can say is that Madrid Ms. I contains their first illustration.

Leonardo's true originality lies in his approach and "style." No one before him had ever attempted to incorporate such a wealth of details on practical applications into a treatise on mechanics. Nor had anyone tackled mechanical applications with such a determination to derive them from general principles and to subject them to rigorous quantitative analysis and geometrical schematization. Madrid

75. Leonardo da Vinci, Royal Collection, 12684. Bird's eye view of Tyrrhenian coast, in connection with the project to drain the Pontine marshes

Ms. I bears witness to Leonardo's achievement, in the mid-1490s, in reconciling two mechanical traditions that until then had proceeded along largely separate paths: the first was classical and medieval mechanics, which – with the partial exception of the "cases" of Aristotelian mechanics – had basically ignored applications; the second was the mechanics practiced in workshops by craftsmen unacquainted with the texts on geometrical statics. Leonardo had started out as one of these "unlettered" craftsmen. But he made an enormous effort to improve his professional skills.

He came into contact with the sources of the great mechanical tradition and strove to assimilate the "elements" of geometry. Yet he never forgot the practical requirements of the workshop. For that very reason, he sought to enlarge the boundaries of the science of mechanics to include real machines that produced friction, encountered obstacles in their operating medium, and were made of materi-

als with limited resistance.[252] It is this attempt that we should appreciate, rather than Leonardo's concrete results, which were not always extraordinary and were even – sometimes – incorrect. Leonardo's implicit agenda was a radical change in the engineering profession, and clearly indicates how distant he now was from so many of his admittedly able, esteemed colleagues.

These mechanical investigations were not destined to remain an end in themselves. In the more than ten years between the last notes and drawings of Madrid Ms. I and Leonardo's death, his "anatomy of machines" provided a model that he steadfastly attempted to transfer to other fields of research. Not by coincidence, references to the "elements of machines" become more frequent in his papers after 1500. By then, he had come to see the four powers of Nature as the cause behind every effect. Leonardo also strove to achieve a complete geometrical analysis, concentrating on dynamic processes and

the mechanical instruments with which to implement them. Leonardo applied this method to his architectural studies, where he introduced the laws of the "elements of machines" to quantify the lateral thrusts of arches (fig. 78).[253] He analyzed buildings, their construction, and their components as a "machine" – not a static structure based on precise proportions, but living organisms in dynamic equilibrium. Hence the evocative analogy between the physician and the architect – a *topos* widely used by Renaissance architects and taken up by Leonardo. In his version, however, the emphasis was shifted from correspondences and analogies between the human body and buildings to their common dependence on the same mechanical laws:

> Just as doctors ... should understand what man is, what life is, what health is ... and with a good knowledge of the things mentioned above, he will be better able to repair than one without it... The same is necessary for an invalid building, that is, a doctor-architect who has a good knowledge of what a building is, and from which rules good building derives, and the origin of those rules and into how many parts they are divided and what are the causes that keep a building together and make it last and what is the nature of the weight and the thrust of the force.[254]

Even the Earth appeared to Leonardo as a huge living, breathing organism traversed by a constant circulation of humors, where every ebb and flow, every rise or fall of water follows mechanical laws and models. In the animal world, the study of the bird-machine revealed the mechanical secrets governing the marvel of flight, which Leonardo often referred to as "balancing in the air," while he compared the action of wings to that of a wedge:

> The hand of the wing is what causes the impetus and then the elbow is lowered and set slantwise, thus making oblique the air upon which it rests almost into the form of a wedge.[255]

After 1500, man became Leonardo's preferred field of mechanical investigation. Leonardo outlined his program for a universal mechanical geography – a new, amply illustrated encyclopedia based on a handful of mechanical principles and on rigorous geometrical analysis. In so doing, he explicitly and repeatedly referred to Ptolemy's cosmography as his model. Leonardo radically transformed the en-

cyclopedic ideal of the Renaissance. He no longer saw it as a system of universal correspondences and harmony of proportions, but as a unity of processes and functions – a unity based on motion, with constant mechanical laws and models for every type of organism: machines, buildings, the Earth, animals, and man. Obviously, man occupied a prominent place in this ambitious project, and Leonardo devoted some of his most striking drawings and writings to the description of the marvelous human machine.

In the superb series of anatomical drawings from the first decade of the 1500s, Leonardo's mechanical approach, influenced by the model of the "elements of machines," becomes dramatically evident (see below, pp. 228-35). In essence, Leonardo's study of human anatomy appears to be largely derived from his study of machines, which preceded it both conceptually and chronologically. His anatomical studies are indebted to his mechanical investigations not only for their general principles, but also for certain characteristic features of vocabulary, graphic techniques, and many expressive analogies. The collection of Leonardo's anatomical studies at Windsor abounds in explicit statements of their dependence on the mechanical model:

> Arrange it so that the book on the elements of machines with its practice precedes the demonstration of the movement and force of man and other animals, and by means of these you will be able to prove all of your propositions.[256]

And again, in a note with the heading "On machines":

> Why Nature cannot give movement to animals without mechanical instruments, as I demonstrate in this book...[257]

Leonardo's anatomical investigations present the human body as a remarkable ensemble of mechanical devices: "It does not seem to me that coarse men with lewd habits and little reasoning power deserve so beautiful an instrument or so many varieties of mechanism."[258] He continually stresses the need to look beneath the "armatures" of the human body, exactly as he had suggested doing with machines: "break the jaw from the side, so you can see the uvula";[259] and "I want to remove

that part of the bone which is the armature of the cheek... to reveal the breadth and depth of the two cavities that are hidden behind it."[260]

Leonardo presents the human body's many articulations as revolving axles (*poli*). There is a very close parallel between the shoulder joint[261] and the universal joint or *polo* studied in Madrid Ms. I.[262] Again, Leonardo systematically uses the term *polo* to denote the axis of rotation of the ankle in a passage that stresses the analogy between human organs and mechanical devices: "The fulcrum [*polo*] *a* is the one where a man balances his weight through the tendons *mn* and *op*, which are to the shank of the leg above the said fulcrum what the shrouds are to the masts of ships."[263] Here we find the mechanical analogy of the ship's mast with its supporting stays, which Leonardo later used extensively in his magnificent studies of the spinal column.[264] As in the treatise on the elements of machines, the study of joints and *poli* led Leonardo to look for anti-friction mechanisms in the human body, which he found in the "glandular bones": "Nature has placed the glandular bone under the joint of the great toe of the foot because, if the tendon to which this sesamoid bone is joined here were without the sesamoid, it would be severely damaged by the friction made under so great a weight."[265]

Leonardo frequently compared the action of the muscles to a wedge (*cuneo*). Moreover, he habitually rendered muscles as lines of force, calling them "powers" (*potenze*). He also routinely used the terms "lever" and "counterlever" to explain the various motions of the upper and lower limbs.[266]

Further evidence attests to the fact that the "elements of machines" were an explicit model for Leonardo's analysis of the human machine. In fact, he examined individually many of the devices and mechanisms of the human body using the technique he had tested in Madrid Ms. I. This approach is manifest in the drawings of single teeth, whose respective shapes and functions, according to Leonardo, derive from their mechanical actions.[267] This is also true of a group of drawings of various components of the man-machine – nerves, sinews, veins, arteries, and muscles – each of which is associated with a specific function.[268] And Leonardo often resorted to geometrical diagrams of organic functions in order to illustrate the mechanical laws that govern them, as in the actions of the intercostal muscles,[269] or in the comparison of the motions of the jaw to those of a lever: "That tooth has less power in its bite which is more distant from the center of its movement."[270]

The mechanical geography of man, the "lesser world," also offers striking analogies with the treatise on the "elements of machines" in terms of the role played by drawing. The complexity of the subject – man – impelled Leonardo to extend and perfect his drafting techniques. He increased the number of views, made continual use of exploded views, and refined the techniques of see-through illustrations of structures. Leonardo also introduced a new technique, preparing series of drawings of successive strata down to the bone – or vice versa, from the skeleton to the skin. Adopting a rule he had formulated in Madrid Ms. I about removing the "armatures" of machines so they will not impede the view of the inner workings, Leonardo replaced the muscles with lines of force,[271] recommending that they be rendered not as lines but as cords so as to show their disposition in three-dimensional space.[272]

Fully aware of the graphic proficiency he had attained, Leonardo was carried away by his enthusiasm:

> And you who wish to describe with words the figure of a man with all the aspects of the formation of his limbs, do away with such an idea, because the more minutely you describe, the more you will confuse the reader... Therefore it is necessary to draw as well as to describe.[273]

In another note, Leonardo returned to the fundamental role of illustration:

> This depiction of mine of the human body will be demonstrated to you just as if you had the real man in front of you... Therefore it is necessary to perform more than one dissection; you will need three in order to have a full knowledge of the veins and arteries ... and three more for a knowledge of the tissues and three for the tendons and muscles and ligaments and three for the bones, which should be sawn through to show which is hollow and which is not, which has marrow and which is spongy...
>
> Therefore through my plan you will come to know every part and every whole ... just as if you had that member in your hand and were turning it over from one side to the other...[274]

76. Leonardo da Vinci, Cod. Atl., fol. 12r. Rope-making machine

The final remark about turning over in one's hands the member itself, as the object of study, suggests extending the confines of illustration from the two-dimensional to the three-dimensional level, where the perfect illustration becomes actually superior to a three-dimensional model. Leonardo made many such models during these years, for example of the lower limb (with the lines of force of the muscles schematically materialized by copper wires),[275] the eye (fig. 79),[276] and the aorta.[277] But Leonardo built models in other areas as well – including architecture, sculpture, mechanics, and hydrodynamics. It was the extraordinary power of the man-machine analogy that inspired Leonardo to use graphic techniques such as lines of force. This is even more true for the construction of anatomical models, which translated the organ into a functioning mechanical device. Carlo Pedretti[278] has rightly related the project for an automaton recorded in the Codex Atlanticus (fig. 80)[279] to the theme of the model. It is hard to say whether this can be considered the ultimate outcome of Leonardo's rigidly mechanistic approach to anatomy.

There remains the extreme coherence with which, taking the anatomy of machines as his starting-point, Leonardo – for more than a decade – conducted an analysis of the human body based on direct observations and yet strongly conditioned by a strict interpretative framework. At a certain point,

he was even tempted to extend this approach (as indeed Descartes was to do) to the analysis of human passions: "And would that it might so please our Creator that I were able to demonstrate the nature of man and his customs in the way that I describe his shape."[280]

However, here and there in the tight fabric of Leonardo's mechanicism some cracks appear through which the awareness of an irreducible distinction between machines and human beings tries to break forth:

> Although human ingenuity in various inventions with different instruments yields the same end, it will never devise an invention either more beautiful, easier, or more rapidly than does Nature, because in her inventions nothing is lacking and nothing is superfluous, and she *does not use counterweights* but places there the soul, the composer of the body...[281]

This passage seems written purposely to contrast the human body with the automaton, that is, to oppose natural creatures to artificial devices. But then Leonardo reacts violently to this:

> This discussion does not belong here, but is required for the composition of the bodies of animals. And the rest of the definition I leave to the minds of the friars, fathers of the people, who by inspiration know all secrets.[282]

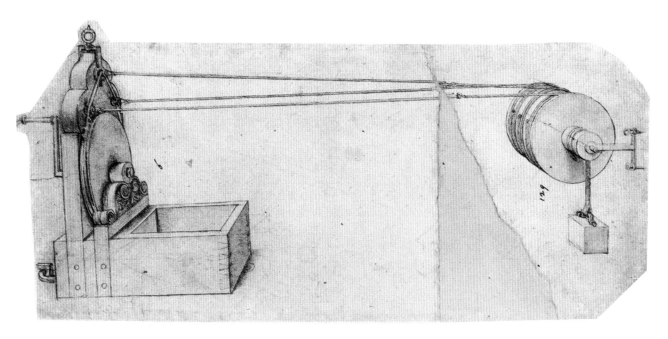

77. Leonardo da Vinci, Cod. Atl., fol. 13r. Rope-making machine

It was precisely when confronted with a doubt that seemed to shake the very foundation of his tenaciously pursued plan of unification that Leonardo reasserted the legitimacy of a strictly mechanistic study of man. He could thus emphasize, once more, that the engineer and the physician, like the artist and the architect, were all guided by the same principles discovered through a diligent observation of Nature.

f. *Leonardo and the engineers of the Renaissance*

After centuries in which Leonardo was extolled as a lone genius, many scholars in recent decades have suggested revising the traditional view of Leonardo's achievements as an engineer and inventor. Basing their work on a series of major studies of manuscripts of the many engineers who were active before and during Leonardo's time, these scholars have shown that many of his presumed sensational discoveries can be found in earlier works. Indeed, many of Leonardo's designs illustrate elements found not only in the work of Brunelleschi, Taccola, and Francesco di Giorgio, but sometimes even in French and German medieval manuscripts, which in turn echoed the great classical tradition. This holds true for the diving suit, the automobile, the parachute, the crankshaft, the tank, and the multi-barreled cannon. Beck[285] and Feldhaus,[284] the

first major historians of Renaissance technology, had already indicated this was the case, but their arguments went virtually unheard. More recently, other scholars have produced evidence too conclusive to be ignored.

At the same time, proof has been sought and found in Leonardo's manuscripts that he carefully attempted to master the technical solutions introduced by the engineers of antiquity and by the most prominent engineers of his own time. Suffice it to mention his fruitful contacts with Francesco di Giorgio and the evidence of Leonardo's attention to the work of the great Sienese engineer. In fact, Leonardo copied several passages of Francesco's *Trattato II* in Madrid Ms. II.[285] At one point, Leonardo also had at his disposal a magnificent copy of Francesco's *Trattato di architettura* (*Trattato I*), on which he made a few manuscript annotations.[286]

A milestone in this historiographical revision was the book on Leonardo published in 1964 by Bertrand Gille, the distinguished French philologist and historian of technology.[287] Gille sought to highlight the similarities between Leonardo and other engineers of his time, through a wide-ranging investigation of medieval and Renaissance technological sources. The merits of Gille's study are immense. His indisputable achievement, and the debt that Leonardo scholars owe him, justify the dedication of this exhibition to his memory. However, we

should not overlook the fact that Gille's strong and warranted polemic stance against the adulatory tradition drove him to the opposite excess. In Gille's work, the distinctive features of Leonardo's engineering disappear into an undifferentiated, unchanging amalgam of technical solutions, working methods, and professional activities typical of all the Renaissance engineers.

In other words, while they help us understand Leonardo in his contemporary setting, Gille's conclusions fail to grasp the essential tension that marks Leonardo's intellectual development. In addition to suffering from an excessively linear conception of the evolution of the history of technology, Gille's study shows the limits of interpreting Leonardo's texts without their indispensable chronological ordering. Gille's analysis also exhibits the distorting effects of his fairly rigid distinction between Leonardo's studies in applied technology (machines and mechanical devices) and his theoretical or "basic" scientific research, which Gille did not take into account. Following Gille, other scholars have reasserted the substantial similarities between Leonardo's technical contribution and that of the other great Renaissance engineers.[288]

The account of Leonardo's engineering career outlined in this introduction gives a more balanced view – as does the presentation of his achievements, in this show, alongside those of the leading engineers of his day. Leonardo's early career is unquestionably characterized by attitudes, practices, interests, and investigative techniques common to many other engineers of the same period. The evidence of his workshop training is incontrovertible, as is his initial choice of Brunelleschi as a model. But in the course of nearly half a century, his career underwent an evolution that must be taken into account. As we have seen, a few years after Leonardo moved to Milan, his manuscripts began to record an intensive effort to enhance his professional skills. This tendency became increasingly marked over the years, involving not only engineering but all his other areas of activity. Indeed, it was as a painter that Leonardo first raised the fundamental issues.

Other Renaissance engineers, it is true, displayed the same intellectual tension and traveled on a similar path: witness Francesco di Giorgio's efforts, in his maturity, to elaborate a comprehensive analysis

of machines. But none of Leonardo's contemporaries set goals as ambitious as those he defined for himself in the last years of his life. As pointed out

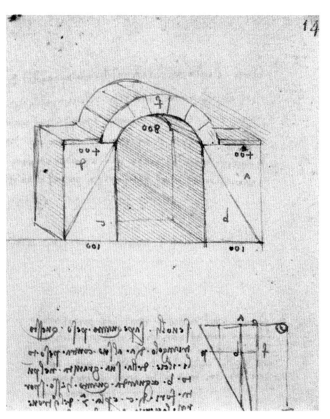

78. Leonardo da Vinci, Madrid Ms. I, fol. 143r (detail). Calculation of lateral thrust of an arch

earlier, Leonardo did not always succeed. He promises to write theoretical treatises in many basic fields, drafting many solemn introductions and ambitious tables of contents. In practice, however, he never escapes the limitations of his practical training, maintaining to the end the characteristic workshop style of fragmentary, haphazard jottings. Leonardo never regretted that training, proudly declaring himself an "unlettered man" and a "disciple of experience." But one has to recognize that the shortcomings of such an education – coupled with the gigantic scale and extraordinary complexity of his goals – made it impossible for him to accomplish his bold reform project.

However, if Leonardo invested so much energy in this undertaking, it was because he was assailed by requests that he could not refuse. And that is precisely what sets Leonardo apart from the many other engineers of his time. It is likely, as had been ar-

79. Leonardo da Vinci, IFP, Ms. D, fol. 3v. Notes and drawings on a model of the eye

80. Leonardo da Vinci, Cod. Atl., fol. 579r. Studies of mechanisms for an automaton

gued, that some of Leonardo's colleagues were superior to him as military engineers, builders of mechanical devices and machines, and hydraulic engineers. And certainly most of them kept their commitments with greater regularity. But none of them ever seems to have sensed the need – as Leonardo fervently did – to provide a more solid foundation for their activity, which continued to rely largely on practices acquired in the exercise of their art.

From this vantage point, we can see the considerable differences between Leonardo and other engineers of his time or of earlier generations. It was not by chance that this hesitating, unreliable, moody man was the most sought after and honored by patrons used to treating their engineers in a very different manner, by paying them only for specific tasks. Perhaps the only Renaissance intellectual who bears comparison to the mature Leonardo – albeit with obvious, major differences – is Leon

Battista Alberti.[289] Not surprisingly, Alberti was not an unlettered technician but a highly learned humanist who had written influential treatises and had used his vast knowledge of the classics to show the profession of architect-artist in all its complexity. He emphasized how this occupation required not only a proficiency in drawing but also geometrical knowledge, complex technical know-how, an accurate grasp of statics, and notable capacities for creating "forms" imbued with precise symbolic connotations. The latter prerequisite reflected Alberti's awareness of the unity of principles and forces, which led to his recurrent insistence on the unvarying analogies between man, buildings, and the universe. There is much evidence to show that these Albertian themes attracted Leonardo, who at a certain point must have recognized in the eminent humanist a model to follow after his earlier mentor Brunelleschi.

What sets Leonardo apart from other engineers of his time, however, is not only the evolution and importance of his investigation of general causes and laws, or its impact on his approach to practical applications. As even a summary comparison between Leonardo's manuscripts and those of his contemporary colleagues demonstrates, his technical drawings have an utterly unique character and power. In this field as well, Leonardo's studies clearly reveal a progress from his early drawings of machines, with their still hesitant use of perspective, to the gradual definition of a precise method of illustration, culminating in the mid-1490s. During those years, Leonardo actually achieved a full-scale revolution in technical draftsmanship.[290] In some respects, that revolution was based on the definition of graphic techniques and conventions still in use today.

But there is another, fundamental aspect that we must not overlook. Leonardo's entire graphic *œuvre* – not just his "anatomical" studies of machines and the living world – expresses his intention to use design as a medium to illustrate natural and human creations not in their visible manifestations, but as the necessary embodiment of universal laws in action. For Leonardo, drawing is more capable than models – too rigidly objective, in his view – of rendering, via strictly controlled and codified transformations, the essence and universal constancy of Nature's laws in machines as in man, in architecture as in the macrocosm.

Only drawing can convey what Leonardo defines as "whole cognition,"[291] namely, the true knowledge that derives from the combination of observation and reflection on causal processes. Such knowledge, he argues, is a basic prerequisite for the perfect imitation of nature.

For Leonardo, verbal exposition is no match for graphic illustration when it comes to describing the works of man and Nature:

> O writer, with what letters will you describe with such perfection all that is depicted here in drawing? Because of your lack of information, you write confusingly and give little notion of the true shape of things, with which, deceiving yourself, you believe you can fully satisfy your listener ... But I want to remind you that you shouldn't get entangled in words – unless you have to talk to the blind – or, if you insist on making your point with words for men's ears rather than for men's eyes, then talk about things, substances, and natures; don't try to convey to the ears those things that pertain to the eyes, because the painter will be vastly better at it than you.[292]

What passage could better illustrate the metaphor suggested by Lucien Febvre, the great historian of the French *Annales* school, on the transition from the primacy of the ear to the primacy of the eye? Febvre saw that transition as one of the distinctive features of the shift from medieval culture, based on the purely verbal model of commentary, to the new Renaissance culture, strongly marked by the visual processes of artistic activity.[293]

And where could one find a more eloquent proof of Leonardo's close integration of scientific research and painting?

The claim to superiority for the painter is echoed in Leonardo's *Libro di Pittura* (Treatise on Painting),[294] which offers abundant, vivid examples of the importance he attached to basic scientific knowledge (in mechanics, optics, theory of vision, natural sciences, and anatomy) for the training of a painter worthy of the name. The primacy that Leonardo claimed for painting over all other disciplines rested on two assumptions: first, a conception of painting as a compendium of all forms of knowledge; second, the peremptory assertion of the superiority of the eye over the ear, that is, of "figuration" over purely verbal description.

The eye of the "universal" painter theorized by Leonardo is, however, a "mind's eye," which penetrates beyond superficial appearances to capture dynamic processes and precarious equilibria – whether in landscapes, artificial machines, or the physical and mental attitudes of human beings. In man-made structures, as in the great machines of the body and the world at large, the artist uses drawings as a medium to capture and reproduce the models and processes of Nature. He represents these not as statically completed effects but as processes in which the viewer can recognize the living action of "motors."

Leonardo's protracted, exhausting endeavor to illustrate machines was not an end in itself – nor did he leave it at that. It was the outcome of a bold attempt at unifying Nature under a small number of universal laws; but it also resulted from an intensive study of the definition and purpose of repre-

sentation. In this research, Leonardo's experience and new conceptualization of the art of portraying machines played a crucial role. As we have shown, Leonardo directly transferred his theoretical analysis and drafting techniques from mechanics to anatomy, as part of his program to renew knowledge through the development of a systematic and mature strategy of graphic representation. At the same time, Leonardo repeatedly stressed the crucial importance of anatomy in the training of the perfect painter. However surprising – indeed provocative – it may seem at first sight, it is therefore hardly improper or inaccurate to define the whole complex of Leonardo's intellectual experience as that of an "artist of machines." No other Renaissance engineer could legitimately claim that title.

Notes

1. *Bâtisseurs* 1989.

2. Bloch 1969; White Jr. 1962 and 1967.

3. Fontana 1988.

4. Ghiberti 1912 and 1947.

5. See Bert Hall's introduction to the edition of the controversial manuscript by the so-called Anonymous of the Hussite Wars (Hall 1979).

6. Of the huge literature on Brunelleschi, I shall only mention, for their comprehensive interpretations of his work, the classic study by Sanpaolesi (1962), the profound and well-documented analysis by the late Eugenio Battisti (1975), the thoughtful reconstruction by Ragghianti (1977), and the pioneering essay by Prager and Scaglia (1970).

7. Manetti 1970 and 1976.

8. Kemp 1990, pp. 9-21.

9. Uzielli 1904 and Reti 1964², pp. 114-16. The episode is also mentioned by Niccolò Machiavelli in *Istorie fiorentine* (book IV, chap. XXIII).

10. Prager and Scaglia 1970, pp. 111-23, where the documents on the project are also published; see also Pedretti 1978, pp. 15-16.

11. Vasari 1878-81, II, pp. 175-76.

12. Battisti 1975, pp. 300-307, which also illustrates a working model of the apparatus.

13. For the most recent reconstruction based on extensive archival research, see Saalman 1980.

14. Guasti 1857.

15. Gurrieri (ed.) 1994.

16. Sanpaolesi 1962.

17. Among the important studies published in recent years, see Rossi 1977, Di Pasquale 1984, Ricci 1983, and Bartoli 1994. They diverge, however, over the interpretation of Brunelleschi's method of performing the masonry work.

18. Rossi 1977, pp. 107-11.

19. On aspects of Renaissance construction sites, see Lamberini ("Costruzione e cantiere"), in *Rinascimento* 1994, pp. 479-91.

20. Reti 1964².

21. Scaglia 1966. Before Reti's study of 1964, Scaglia had written a lengthy dissertation, of which Reti was aware, on Bonaccorso Ghiberti's *Zibaldone*, in which she showed that the manuscript contained descriptions of machines employed on Brunelleschi's worksite.

22. Prager and Scaglia 1970. Prager, it should be noted, had studied Brunelleschi's machines as early as 1950 (see Prager 1950).

23. Reti 1964², pp. 103-6.

24. See below, pp. 109-13.

25. Reti 1964², pp. 117-19.

26. See below, pp. 104-6.

27. Battisti 1975, p. 16.

28. In addition to the classic study by Bargagli Petrucci 1906, see *Bottini* 1993.

29. See Angelucci 1869-70, who devotes the entire second volume of his history of Italian firearms to Siena. On the Sienese background, see also Galluzzi 1991, pp. 15-17.

30. Zdekauer 1894 and Fioravanti 1980-81.

31. Scaglia 1985, pp. 30-36.

32. Gille 1972, pp. 30-36 and 69-71; Hall 1976, pp. 11-52; see also Galluzzi (ed.) 1991, p. 181, and Ostuni 1993.

33. Gille 1972, pp. 61-81 and Kyeser 1967; see also Galluzzi (ed.) 1991, pp. 182-83.

34. Clagett 1976; Battisti and Saccaro Battisti 1984; see also Galluzzi (ed.) 1991, p. 184.

35. In the initial text of Taccola's *De machinis* (New York Public Library, Spencer Ms. 136) the Sienese introduces himself as "Ser Mariano Taccole alias archimedes vocatus de magnifica ac potente civitate Senarum"; see Scaglia 1971 and Galluzzi (ed.) 1991, p. 195.

36. For a description of Taccola's literary output and its circulation, see Galluzzi (ed.) 1991, pp. 191-98.

37. The document was first mentioned by Thorndike 1955. See also Galluzzi 1991, pp. 19-20 and Battisti 1975, pp. 20-21.

38. Prager 1946; Prager and Scaglia 1970, pp. 111-23.

39. *De ingeneis libri III-IV* (BNCF, Ms. Palatino 766, fol. 42r.), where Taccola announces his plan to move "in partibus vestris Ungariae... et ibidem dies suos finire et in omnibus aquarum edifitiis attendere et in codicibus omnia facta et gesta per vos Reges Ungarie... describere... et in dictis codicibus in principio marginis designare ac miniari storias."

40. The most informative biography of Taccola remains Prager and Scaglia 1972; see also James Beck's preface to his publication of all the documents on Taccola then known (Mariano di Iacopo 1969). Chironi 1991, p. 471, provides a number of new documents about Taccola.

41. Beck 1969; Prager and Scaglia 1972, pp. 160-89. The reference work for an assessment of Taccola as artist is Degenhart and Schmitt 1982, esp. pp. 103-31.

42. Beck 1969; Degenhart and Schmitt 1982, plates 43-50. See also Galluzzi 1991, pp. 21-22.

43. Zdekauer 1984, pp. 96 and 108; Prunai 1950; Prager and Scaglia 1972, p. 8.

44. Corso 1953. For example, in 1436, Panormita stayed in Siena, where he was received with full honors, as the envoy of Alfonso of Aragon.

45. On the relations between Taccola and Sozzini, see Galluzzi 1991, pp. 22-23, where Sozzini's scientific and technical interests are also mentioned.

46. See below, pp. 125-26.

47. Ucelli di Nemi 1940, pp. 7-8.

48. Mitchell 1962, pp. 285-87; Bertelot and Campana 1939, pp. 365-67; Galluzzi 1991, p. 23.

49. The copy is now BNP, Ms. Lat. 7239; see Galluzzi (ed.) 1991, pp. 196-97; see also Scaglia 1971, pp. 47-50. Military topics predominate in the *De machinis*.

50. Soranzo 1909 and 1910; Campana 1928, pp. 106-8; Scaglia 1971, pp. 49-50.

51. The manuscript recovered by Aurispa is now BNP, Ms. Grec. 2442; see Galluzzi (ed.) 1991, p. 175.

52. The first of Mariano's manuscripts to be "rediscovered" was the copy of *De machinis* in BMV; see Galluzzi (ed.) 1991, p. 198.
53. Galluzzi (ed.) 1991, pp. 47-56.
54. Galluzzi (ed.) 1991, p. 179.
55. Galluzzi 1991, pp. 25-26.
56. *De ingeneis I-II*, fols. 14v, 15r and v.
57. Galluzzi 1991, pp. 26-28.
58. See below, p. 122.
59. Bargagli Petrucci 1906, pp. 35-38.
60. Smith 1976, esp. pp. 66-68.
61. Francesco di Giorgio took up the example of Toledo, based on Taccola's model (*Codicetto*, fol. 8r). But he makes also a different reference to Toledo's aqueduct in a different form. He describes a system in which an undershot waterwheel drives a two-piston pump that raises water from the bottom of a valley to a hilltop town identified as Toledo (*Opusculum*, fol. 60v; fig. 21). Francesco was obviously trying to reconstruct a plausible system for the famous Roman aqueduct of Toledo. In other words, he was combining his keen archeological curiosity with the results of his pioneering analysis of pumps. It should be emphasized that Taccola – and, later, Francesco, drawing inspiration from his predecessor's model – focused considerable attention on the floating mill, described in the vertical-wheel version and in the horizontal paddle-wheel version: see, for example, *De ingeneis III-IV*, fol. 29r and BMLF, Ms. Ashb. 361, fol. 35v. Once again, this may not be so much a design for actual use as a visual reference to the project of Belisarius (537 A.D.), recounted by Procopius. During their siege of Rome, the Goths tried to starve the city into surrender by cutting off the aqueducts that supplied water to the Roman mills. Belisarius thwarted their attempt by installing a series of floating mills on the Tiber.
62. On the possible significance of the presence of tide mills in Taccola's manuscripts, see, for example, pp. 182-83 below; also Galluzzi 1991, p. 27.
63. Adams 1984, pp. 768-70 and Galluzzi (ed.) 1991, pp. 319-29.
64. Beck 1969, pp. 30-31.
65. For the job description of the *stimatore*, see Adams 1985.
66. Franci and Toti Rigatelli 1985.
67. Michelini Tocci 1962 and Galluzzi 1991, pp. 29-30.
68. BAV, Ms. Lat. Urb. 1757; see Francesco di Giorgio 1989 and Galluzzi (ed.) 1991, p. 202.
69. BML, Ms. 197.b.21; see Galluzzi (ed.) 1991, p. 203.
70. Francesco di Giorgio 1989.
71. Chironi has demonstrated that Francesco di Giorgio's father was not (as previously believed) a poultry-dealer but a civil servant; see Chironi 1991, p. 471. On Francesco's biography, see the classic Weller 1943. A wealth of information is contained in the catalogues of the shows on Francesco di Giorgio, artist and architect, held in Siena in 1993 (*Francesco di Giorgio* 1993[1] and *Francesco di Giorgio* 1993[2]).
72. Chironi 1991, pp. 472-73; Weller 1943, pp. 340-45; Bargagli Petrucci 1902.
73. Chironi 1991, p. 472 and Weller 1943, p. 341.
74. Romagnoli 1976, IV, p. 767; see also Chironi 1991, p. 474.
75. Adams 1984, p. 773.
76. Weller 1943, p. 10.
77. On Francesco's first stay in Urbino, see Weller 1943, pp. 134-210, and Maltese 1965. In the *Trattato II* Francesco states that the Duke had put him in charge of "one hundred and thirty-six structures (*edifici*) where work continued incessantly." The term *edificio* was used at the time to denote a machine, especially of a hydraulic or military kind. See Galluzzi (ed.) 1991, p. 207; see also Fiore 1993.
78. Francesco di Giorgio 1989, "Introduction," pp. 13-89.

79. On Giacomo Cozzarelli, see Romagnoli 1976 (V, pp. 214-16), Milanesi 1854-56 (II, p. 458), and Bacci 1932. See also Sisi in *Beccafumi* 1990 (pp. 540-47); Angelini 1993[1]; and, for documents on his activity as firearms caster, Angelucci 1869-70, II, pp. 564 ff.
80. See Horvath 1925, generally overlooked by Francesco di Giorgio scholars.
81. As was the case with Piero di Cosimo, among others. On Girolamo del Pacchia, long confused with Pacchiarotti, see now Angelini in *Beccafumi* 1990, pp. 276-89.
82. Prager and Scaglia 1972, pp. 198-200. On Dionisio da Viterbo as clockmaker, see also Morpurgo 1950, pp. 58-59.
83. Chironi 1991, p. 478 and Weller 1943, p. 376.
84. BNCF, Ms. II.I.141, fol. 48r.
85. Scaglia, who describes these projects as a "machine complex" or "gear, pump and mill complexes," doubts they can be attributed to Francesco. In her view, Francesco probably compiled many of these designs, already developed by the late 1460s, "in workshop booklets prepared by carpenters and millwrights" (Scaglia 1988[1], p. 93). However, the complexity of many of these devices, which would have been very hard to put into actual use, seems to rule out the possibility that they were elaborated by engineers seeking purely concrete applications.
86. On Fioravanti, see the essential Beltrami 1912, together with Tugnoli Pattaro 1976 and, especially, Oechslin 1976, excellent and meticulously documented.
87. *Opusculum de architectura*, fol. 26r. Interestingly, this is one of the few devices in the *Opusculum* not previously illustrated in the *Codicetto* (where the same machinery is used to move an obelisk, not a tower). This may be a sign that Francesco heard about Fioravanti's work after compiling the *Codicetto*. Moreover, in 1482, Francesco was involved in a project similar to those of Fioravanti: he lifted the roof of the church of San Francesco in Siena without damaging the walls (Papini 1946, I, pp. 176-77).
88. Dibner 1952.
89. Prager 1974, pp. 112-24 and Galluzzi (ed.) 1991, p. 174.
90. Prager and Scaglia 1972, pp. 199-201; see also Scaglia 1988[1], pp. 93-94.
91. See, for example, the Archimedes' screw on fol. 145v, the modular paddle-boat on fol. 124r (which seems to be a reworking of the engraving in the 1472 first edition of Valturius) and the grating-smasher on fol. 169r.
92. Fols. 17v, 129r, and 194v.
93. Scaglia 1981, pp. 16-32, and Galluzzi (ed.) 1991, pp. 433-35.
94. Scaglia 1971, I, pp. 30-31.
95. Galluzzi (ed.) 1991, p. 203.
96. Impressive evidence of this is provided by the list in Scaglia 1991[1] of manuscripts, drawings, and prints derived from the *Opusculum*.
97. The complete text is in "Appendice III" of Scaglia 1991[3], pp. 79-80. The copy containing the dedication letter is BRT, Ms. Serie Militare 383.
98. For a full discussion of the historiography, with much new information, see Mussini 1991; also Mussini 1993 and Scaglia 1991[1].
99. *Trattato I* (BMLF, Ms. Ashb. 361), fols. 6v-8v.
100. *Ibid.*, fols. 26r-32v.
101. *Trattato I* (BRT, Ms. Saluzz. 148), fols. 66r-67r. This section is missing in Ms. Ashb. 361.
102. *Ibid.*, fols. 55v-64r.
103. *Ibid.*
104. *Trattato II* (BNCF, Ms. II.I.141), fol. 94r.
105. Galluzzi (ed.) 1991, pp. 199-201.
106. *Ibid.*, p. 179.

107. *Ibid.*, pp. 176-77.

108. Kemp 1991, pp. 105-12.

109. *Trattato II* (Ms. II.I.141), fol. 88r: "but if such authors matched the drawing with the words, it would be much easier to form an opinion by seeing the sign along with the meaning, and so any obscurity would be removed" (Francesco di Giorgio 1967, II, p. 489).

110. *Ibid.*, fol. 1r (Francesco di Giorgio 1967, II, p. 295).

111. Scaglia 1985.

112. Papini 1946, I, p. 178.

113. Adams 1984.

114. *Trattato I* (Ms. Ashb. 361), fols. 6r-8v.

115. *Ibid.*, fols. 25r-27r.

116. *Ibid.*, fol. 31v.

117. Chironi 1991, p. 479, and Weller 1943, p. 383. In their earlier letter to Francesco of July 7 of the same year, the Republic's representatives requested his return, reminding him of his duties as contractor for the underground aqueduct and pointing out that "especially after your departure ... all the fountains are short of half their water supply" (*ibid.*, pp. 382-83).

118. Galluzzi (ed.) 1991, p. 215.

119. *Ibid.*, p. 212.

120. *Ibid.*, pp. 246-47; also Scaglia 1991[2].

121. Galluzzi (ed.) 1991, pp. 328-29.

122. *Ibid.*, p. 224.

123. *Ibid.*, p. 227.

124. *Ibid.*, p. 239. The work was first published in Venice in 1540.

125. See Lamberini's entries in Galluzzi (ed.) 1991, pp. 229-38.

126. *Ibid.*, pp. 241-43; see also Reti 1963.

127. For the story of Francesco's manuscripts, see Scaglia 1991[1] and Mussini 1991. On Taccola, see Prager and Scaglia 1972; Scaglia 1971; Mariano di Iacopo 1984, I, pp. 7-55.

128. The most articulate and critically discerning intellectual biography available is Kemp 1982. See also the essays in Galluzzi (ed.) 1987 and the catalogue of the 1989 Leonardo show at the Hayward Gallery, London (*Leonardo da Vinci* 1989[5]). These titles contain full bibliographies, to which we refer the reader.

129. On the complex history of the dispersion and transmission of Leonardo's manuscripts to the present, see Marinoni 1954 (pp. 231-74) and Pedretti 1964 (pp. 252-59). For an account of the Madrid manuscripts, rediscovered in 1966, see Pedretti 1977 (II, pp. 393-402), who also provides a summary table of manuscripts and loose sheets in Leonardo's hand, with their respective dates (I, pp. 93-97).

130. This attitude informed, for example, the giant Leonardo exhibition in Milan in 1939, whose organizers did not hesitate to reconstruct – in total disregard of philological standards – dozens of working models of extraordinary inventions credited to Leonardo. A major motive behind the show was the celebration of Leonardo as the epitome of Italic genius, a self-serving propaganda theme for the Fascist regime.

131. Codex Leicester (now property of Bill Gates; formerly of Armand Hammer), fol. 22v.

132. Brugnoli 1974.

133. Steinitz 1969.

134. Pedretti 1978, pp. 328-29.

135. The definition was suggested by Koyré 1966.

136. On Leonardo's sources, there have been no thorough studies since Solmi 1908. On Leonardo's "library," however, see Maccagni 1970 and Garin 1961, in addition to Reti ("La biblioteca di Leonardo") in Leonardo da Vinci 1974 (III, pp. 91-109). Both Pedretti 1977 and Kemp 1982 also continually refer to Leonardo's sources.

137. On the history of the Codex Atlanticus, see the introduction by Marinoni to vol. I (pp. 9-17) of the transcriptions in Leonardo da Vinci 1973-80.

138. On the history of Leonardo's drawings in the Royal Library at Windsor, see Clark 1968, pp. ix-lxv. See also Leonardo da Vinci 1978-80.

139. Calvi 1925. Calvi had previously produced a splendid edition of the Codex Leicester (Leonardo da Vinci 1909).

140. Pedretti 1978-79.

141. Pedretti, "Commentary on the reassembled sheets and their chronology," in Leonardo da Vinci 1978-80, III, pp. 789-897.

142. Pedretti 1960.

143. Kemp 1982 (pp. 13-76); Pedretti 1976 and 1978 (pp. 9-17).

144. Vasari 1878-81, IV, pp. 19-20.

145. Calvi 1925, pp. 9-77.

146. IFP, Ms. G, fol. 48v; see Leonardo da Vinci 1989[3].

147. Pedretti 1978, pp. 9-12.

148. BAM, Cod. Atl., fol. 909v.

149. Pedretti 1978, pp. 9-12.

150. Pedretti 1976.

151. See above, note 144.

152. See above, p. 18, and Pedretti 1978, p. 15.

153. IFP, Ms. B, fol. 64r; see Leonardo da Vinci 1990[2].

154. See above, p. 18 and Reti 1964[2], pp. 114-16.

155. Cod. Atl., fol. 888r; see Pedretti 1978, p. 32.

156. Cod. Atl., fol. 1069r.

157. Cod. Atl., fol. 7r.

158. Marani 1984.

159. Cod. Atl., fol. 157r.

160. Cod. Atl., fol. 139r.

161. Cod. Atl., fol. 89r.

162. GDSU, 446Av; see Leonardo da Vinci 1985.

163. Cod. Atl., fol. 21r.

164. On Toscanelli, see Garin 1967.

165. Kemp 1982, pp. 77 ff.

166. BTM; see Leonardo da Vinci 1980.

167. Marani 1984.

168. On Leonardo's use of Valturius, the fundamental study remains Marinoni 1944 (especially II, pp. 236-67).

169. The letter, not in Leonardo's hand, is in Cod. Atl., fol. 1082r.

170. On Leonardo's abiding interest in bridges and on the Pera bridge project, see Pedretti 1994 and Olsson 1994. Both studies are connected with the major exhibition on *Leonardo's Bridges* organized by Pedretti and held in Malmö in fall of 1995. See *Leonardos* 1995.

171. Reti 1956-57, pp. 1-31.

172. British Museum, Drawings and Prints Collection, n. 1860-16-99.

173. Ms. B, fol. 10r.

174. Cod. Atl., fol. 881r.

175. Pedretti 1978, pp. 28-29.

176. See the catalogue of the Milan exhibition (*Leonardo e le vie d'acqua* 1984).

177. Cod. Atl., fol. 184v.

178. Firpo 1987; see also Garin 1971.

179. Ms. B, fol. 64r.

180. Cod. Atl., fol. 611Ar.

181. IFP, Ms. A; see Leonardo da Vinci 1990[1].

182. Ms. A, fol. 55v.

183. *Ibid.*

184. Brizio 1954, pp. 9-26.

185. Fazio was the father of the better-known Gerolamo Cardano; see Pedretti 1978, p. 27.

186. Cod. Atl., fol. 611Ar.

187. On Leonardo's study of Euclid and his relations with Pacioli, see Marinoni 1982.

188. BRT, Codex on the Flight of Birds; see Leonardo da Vinci 1976.

189. Brizio 1954.

190. See Reti's comments in Leonardo da Vinci 1974, III, pp. 41-43.

191. BNM, Madrid Ms. I, fol. 151v; see Leonardo da Vinci 1974.

192. *Ibid.*, fol. 134v.

193. *Ibid.*, fol. 151v.

194. They are contained in the final gathering (fols. 141r-157v) of Madrid Ms. II.

195. Brugnoli 1974.

196. In his study of 1953, which is otherwise extremely valuable for its technical analysis of Leonardo's drawings, Strobino unhesitatingly credited Leonardo with inventing all the texile devices described in his manuscripts.

197. Bedini 1974.

198. Kemp 1982, pp. 327-28.

199. See, for instance, Cod. Atl., fol. 1069r.

200. Giacomelli 1936.

201. Ms. B, fol. 74v.

202. *Ibid.*, fol. 89r.

203. Pedretti 1991, pp. 20-21.

204. Recently, however, some attempts have been made to fly with Leonardo's "glider"; see Pidcock 1994.

205. Cod. Atl., fol. 571Ar.

206. Kemp 1982, pp. 195 ff.

207. Cod. Atl., fol. 638Dv.

208. Pedretti 1982, pp. 11-23.

209. Pedretti 1953, pp. 165-200.

210. Cod. Atl., fol. 698Br.

211. IFP, Ms. L; see Leonardo da Vinci 1987².

212. RLW 12284.

213. Kemp 1982, pp. 211-13. Leonardo's authorship of the Imola map was challenged by Mancini 1979, who argues that Leonardo merely updated some details of a map compiled by Danesio Maineri, an engineer employed by the Sforzas. Mancini's hypothesis was endorsed by Marinoni 1988. In contrast, both Marani 1985² and Pedretti subscribe to the view that the entire map is in Leonardo's hand; see *Lasciapassare* 1993, pp. 34-37.

214. Madrid Ms. II, fols. 1-4, 8-10, and 15-19; see Reti, in Leonardo da Vinci 1974, III, p. 54.

215. Pedretti 1978, pp. 180-81.

216. Cod. Atl., fol. 4r.

217. *Ibid.*, fol. 3r.

218. Pedretti 1978, pp. 180-81.

219. A spectacular drawing of it by Leonardo survives in RLW 12279.

220. This tunnel-boring project is illustrated in Madrid Ms. I, fol. 111r.

221. Heydenreich 1974, pp. 143-47.

222. Cod. Atl., fol. 127r.

223. Heydenreich 1974, pp. 152-65.

224. Leonardo da Vinci 1976.

225. During these years, Leonardo's anatomical studies are interwoven with his studies on geology and physical geography. The latter fill many leaves of the Codex Leicester.

226. Codex Leicester; see Leonardo da Vinci 1987¹.

227. Notebooks on anatomy; see Leonardo da Vinci 1978-80.

228. BLL, Cod. Arundel; see Leonardo da Vinci 1923-30. A new edition of the Codex Arundel, edited by Carlo Pedretti, will be published shortly.

229. Kemp 1982, pp. 276 ff.

230. Cod. Leicester, fol. 15v.

231. Zammattio 1974, pp. 204 ff., and *Leonardo e le vie d'acqua*.

232. Pedretti 1972.

233. Beltrami 1919, document 238. See also Chastel 1987.

234. Cellini 1968, p. 859.

235. The first scholar to address the issue of the identification of Leonardo's treatise on the "elements of machines" was A. Uccelli 1940.

236. See Reti's "official" account of the discovery in Leonardo da Vinci 1974, III, pp. 9-21.

237. See esp. Reti 1974.

238. Cod. Atl., fol. 444r.

239. *Ibid.*, fol. 161r.

240. *Ibid.*, fol. 220v.

241. IFP, Ms. I; see Leonardo da Vinci 1986², fol. 22v.

242. Codex on the Flight of Birds, fol. 12v.

243. Leonardo da Vinci 1978-80, K/P 143r and 147v.

244. Cod. Atl., fol. 220v.

245. For an overall assessment of Leonardo's work in mechanics, see the "Leonardo da Vinci" entry in *DSB* 1970-80, VIII, pp. 215-34 (especially Clagett's section on "Mechanics"); see also Galluzzi 1989.

246. Reti 1974.

247. Madrid Ms. I, fol. 82r.

248. Leonardo's drawings of the "elements of machines" are displayed and analyzed in the third section of this show (see below, pp. 192-224).

249. Madrid Ms. I, fol. 96v.

250. *Ibid.*, fol. 20v; see below, pp. 208-9.

251. *Ibid.*, fol. 100v; see below, p. 206.

252. On these issues, see Galluzzi 1989.

253. Madrid Ms. I, fol. 143r.

254. Cod. Atl., fol. 730r.

255. Codex on the Flight of Birds, fol. 15v.

256. K/P 143r.

257. K/P 153r; on the close links between mechanics and anatomy in Leonardo's work, see Keele 1983; see also Galluzzi 1987².

258. K/P 80v. On the analogy between the machine and the human body, see section III of this show (below, pp. 228-35).

259. K/P 134v.

260. K/P 43v.

261. K/P 141v.

262. Madrid Ms. I, fol. 100v.

263. K/P 102r.

264. K/P 58r and 179v.

265. K/P 135r.

266. K/P 140r.

267. K/P 42v.

268. K/P 148v.

269. K/P 149v and 154v.

270. K/P 44r.

271. K/P 134r.

272. K/P 137v; see Keele 1983, pp. 267-88.

273. K/P 144v.

274. K/P 154r.

275. K/P 152r; see Keele 1983, pp. 274-75.

276. IFP, Ms. D, fol. 3v; see Leonardo da Vinci 1989¹.

277. K/P 115v.

278. Pedretti ("Commentary on the reassembled sheets and their chronology"), in Leonardo da Vinci 1978-80, III, pp. 868-71.

279. Cod. Atl., fol. 579r.

280. K/P 154r.

281. My italics.

282. K/P 114v.

283. Beck 1900.
284. Feldhaus 1913.
285. Reti, in Leonardo da Vinci 1974, III, pp. 85-88.
286. Francesco di Giorgio 1979. There is also much evidence of Leonardo's interest in the work of Sienese engineers. In at least one case, we can even identify the use of material from Taccola in Leonardo's manuscripts (see Galluzzi 1989, pp. 12-13). Leonardo visited Siena in 1503. On his relations with the Sienese tradition, see Pedretti 1991.
287. Gille 1980[1].
288. See, for example, the analysis by Marinoni (*Laboratorio su Leonardo* 1983, pp. 11-35, and Marinoni 1987, pp. 111-30).
289. On Alberti as Leonardo's "model," see Garin 1971, pp. 324-25.
290. On this crucial point, see Pedretti 1987, pp. 1-21, and Galluzzi 1996.
291. K/P 113r.
292. K/P 162r.
293. Febvre 1942, p. 403.
294. See the annotated edition of *Trattato della pittura*: Kemp (ed.) 1989; and the new critical edition of *Libro di Pittura* by Carlo Pedretti and Carlo Vecce (Leonardo da Vinci 1995[2]).

Catalogue

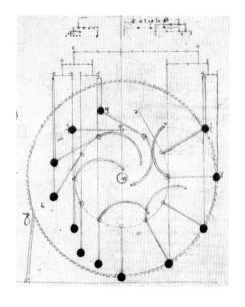

I.

Brunelleschi and the dome of Florence Cathedral

One of the most important architectural projects of the entire Renaissance is the construction of the spectacular dome atop the church of Santa Maria del Fiore, Florence Cathedral, by Filippo Brunelleschi (1377-1446). In the inner shell of the octagonal structure, the vertical ribs display a pointed fifth curvature, whose radius is equal to 4/5 of the diagonal of the base octagon. The work, begun in the summer of 1420, was finished – except for the lantern – by 1436. The dome was built without the use of a wooden centering to support the masonry. To carry out the project successfully and convince his skeptical fellow-Florentines, Brunelleschi devised several boldly innovative solutions that served three crucial purposes: to lighten the massive structure; to set up a worksite organization that could efficiently handle each successive construction stage; and to ensure the stability of the brickwork courses, whose inward slope increases continually from the base to the dome's closing stone ring, called the oculus *(the "eye").*

I.1A The dome structure

The dome's springing point stands 54.6 meters above ground level, while its height from the drum base to the top is about 33 meters. The distance between two opposite edges of the octagonal base is about 55 meters. The height of the lantern atop the dome is slightly more than 22 meters. The dome's weight may be estimated at 37,000 metric tons, and the number of bricks used in the structure might have been more than four million. The dome of Florence cathedral is the largest ever built without the use of a wooden centering.

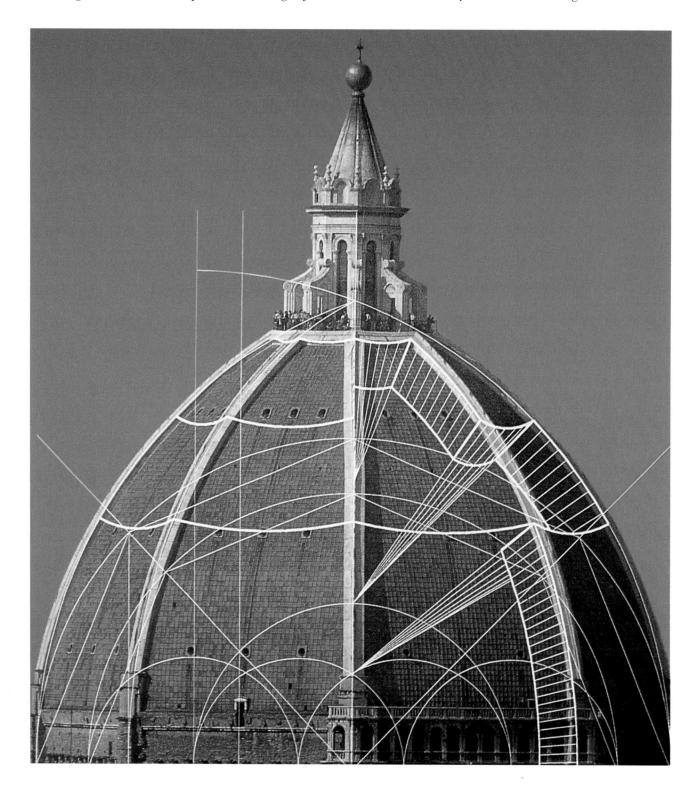

I.1A.1a
Model of dome and drum

Scale 1:20
Maple, Slovenia pearwood, beech, ash,
tropical wood, poplar, birch; 370 x 295 cm*
between opposite edges of octagonal base
Built by: Modelli di Architettura, F. Gizdulich,
Florence, 1995
Istituto e Museo di Storia della Scienza,
Florence

The model displays the eight sides of
the dome, connected by as many angle

ward slope of the brickwork courses, as
well as the slack-line curved profile (*a
corda blanda*) of the horizontal rows of
bricks between the angle ribs. The
model also highlights the function of the
spiral herring-bone arrangement of the
bricks, which made it possible to "block"
the masonry courses as they were built.
The bricks were thus prevented from
slipping away as a consequence of the
steep inward slope of the masonry beds.

I.1A.1b
Models of the masonry layering and of the geometrical structure of the dome

Scale 1:20
Beech, maple, tropical wood, and metal;
160 x 252 x 196 cm
Project: S. Di Pasquale, Dipartimento
di Costruzioni, University of Florence
Built by: Modelli di Architettura, F. Gizdulich,
Florence, 1995 and 1997
Istituto e Museo di Storia della Scienza, Florence

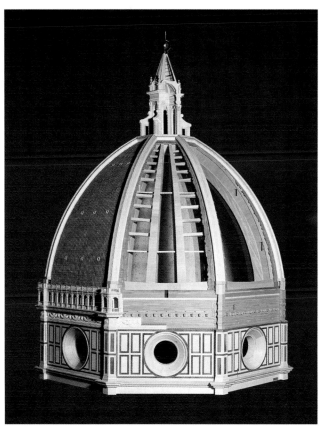

I.1A.1a

I.1A.2

ribs. Each side presents two vertical
ribs and nine transverse arches.
Through the cross-section of one of the
eight shells of the model, one can ob-
serve the openings made in the vertical
ribs to obtain four levels of walkways
linked by stairs leading from the tam-
bour to the lantern base. The eight an-
gle marble ribs visible from the outside
are purely decorative and provide
no structural support.
The model also shows that while the
inner shell (intrados) has an even
thickness, the outer shell (extrados)
becomes gradually thinner from the
base to the *oculus*. Another feature il-
lustrated in the model is the layering of
the masonry in one of the eight sides of
the dome. One can observe the steep in-

I.1A.2
ANTONIO DA SANGALLO IL VECCHIO
Design for a "herring-bone" dome
GDSU, 900A

Diagram showing rows of bricks in spi-
ral herring-bone arrangement for con-
structing domes without the use of
wooden centering.

The model presents a cross-section of
one side of the dome, including its two
rims and the beginning of the adjacent
sides, at a height of 30° from the
springing point over the drum. It dis-
plays the herring-bone spirals that
continually block the masonry work,
the empty spaces between the outer
and the inner shells, the inward slope
of the brick beds, and the slack-line
profile of the brick rows.
The metal model next to the masonry
model explains the method for tracing
the pointed-fifth curvature. It also
shows that the characteristic slack-line
profile of the brick beds between the
rims is due to their lying on the surface
of an inverted cone whose axis coin-
cides with that of the dome.

*Dimensions throughout the catalogue are
given in the following order: height, length,
width. One centimeter (cm) = 0.39 inches.

I.1B.1-10
IMPLEMENTS AND BRICKS

I.1B.1
Bricks and their molds
Built by: Fornace G. Manetti, Impruneta
(Florence), 1995

Copies of the four original molds in the
Museo dell'Opera del Duomo in Flo-
rence that served to make the bricks
(*conci*) used by Brunelleschi to build
the dome. The bricks have been made
by hand with the same techniques as in
Brunelleschi's time.

I.1B.2
Model of the tile covering
of the dome
Scale 1:1; 300×150 cm
Built by: Opera del Duomo and F. Gizdulich,
Florence, 1995
Istituto e Museo di Storia della Scienza,
Florence

Life-size model of the tile covering of
the dome. To keep the tiles from lifting,
each tile is fastened with a nail hidden
by the lower edge of the tile above. The
lower edge of the tile rests on plugs dri-
ven into the extrados of the outer shell.

I.1B.3
Turnbuckle
Copy of original in MODF
Iron; 100×15 cm
Built by: M. Mariani, Florence, 1995
Istituto e Museo di Storia della Scienza,
Florence

Full-scale model of a screw-operated
turnbuckle used for the accurate place-
ment of large, heavy structural ele-
ments.

I.1B.4
Turnbuckle
Copy of original in MODF
Iron and bronze; 130×93 cm
Built by: M. Mariani, Florence, 1995
Istituto e Museo di Storia della Scienza,
Florence

Full-scale model of another type of
turnbuckle used by Brunelleschi.

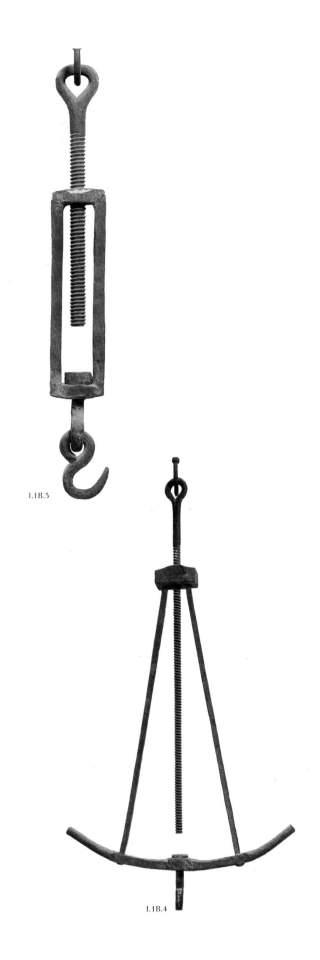

I.1B.3

I.1B.4

I.1B.5

BONACCORSO GHIBERTI
**Special hooks or turnbuckles
of the type used by Brunelleschi**
B.R. 228 (BNCF), fol. 117r

I.1B.6
Lewis
Copy of original in MODF
Iron; 20 x 20 cm
Built by: M. Mariani, Florence, 1995
Istituto e Museo di Storia della Scienza,
Florence

Full-scale model of a lewis with mobile
dovetail wedges. The two outer wedges
are inserted into the load to be lifted.
The middle wedge is then jammed
in between, forcing them apart. This
system provides a highly powerful and
secure grip. The load is easily released
by removing the middle wedge.

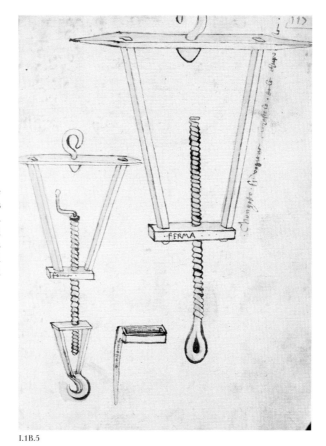

I.1B.5

I.1B.7

BONACCORSO GHIBERTI
**Vertical screw with triple
turnbuckle**
B.R. 228 (BNCF), fol. 119r

Center: lewis with dovetail wedges.

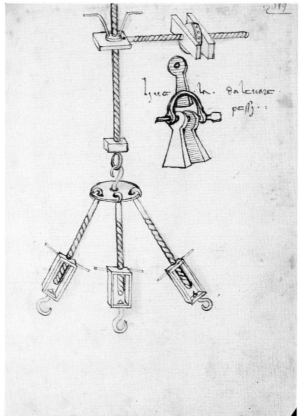

I.1B.7

I.1B.8a-b
GIULIANO DA SANGALLO
Two types of screw turnbuckles
Ms. S.IV.8 (BCS), fols. 48v-49r

I.1B.9
Iron pincers
Copy of original in MODF
Iron; 120 x 70 cm
Built by: M. Mariani, Florence, 1995
Istituto e Museo di Storia della Scienza,
Florence

Full-scale model of iron pincers to lift
stone or marble blocks.

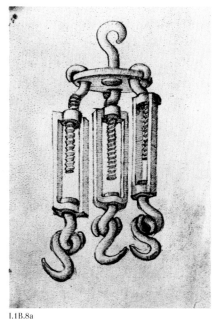

I.1B.8a I.1B.8b

I.1B.10
Pair of double pulleys
Copy of originals in MODF
Iron and bronze; 35 x 18 cm
Built by: M. Mariani, Florence, 1995
Istituto e Museo di Storia della Scienza,
Florence

Full-scale models of iron and bronze
double pulleys.

I.1B.9

I.2 Machines used on the dome worksite

Two factors played a crucial role in the dome's construction: efficient worksite organization, and the availability of machines capable of moving and lifting massive weights to great heights. Brunelleschi left no drawings or verbal descriptions of the machines he designed and used. However, the highly innovative features of his machines attracted the attention of the leading engineers of the fifteenth century – Taccola, Francesco di

Giorgio, Bonaccorso Ghiberti, and Giuliano da Sangallo – who recorded them extensively in their drawings. One of these engineers was the very young Leonardo, who, on his arrival in Florence in 1469, was apprenticed to Verrocchio's workshop. At the time, the latter was engaged in placing the heavy copper sphere atop the lantern. Leonardo's notebooks contain very detailed sketches of the main machines used by Brunelleschi.

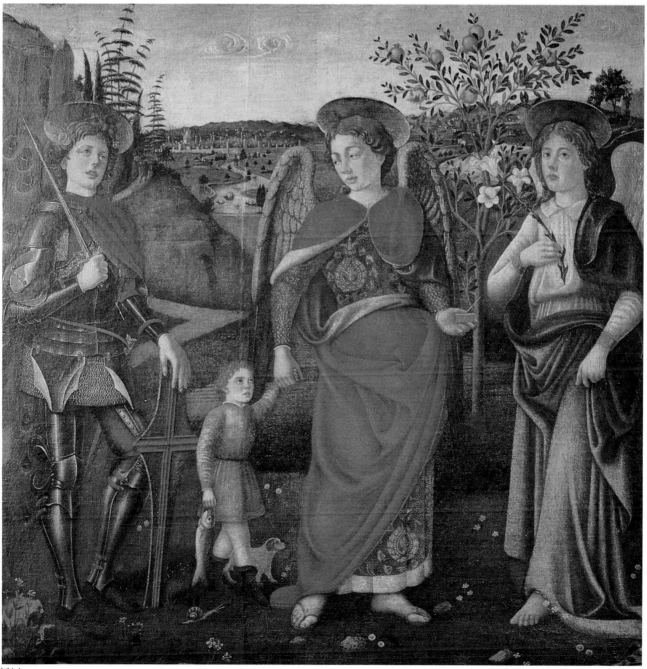

I.2A.1a

I.2A.1a

BIAGIO DI ANTONIO [?]
Tobias and the archangels
(ca. 1470)
Oil on canvas; 155 x 155 cm
Bartolini Salimbeni Collection, Florence

The background shows a view of Florence at the time of Leonardo's arrival (1469).

I.2A.1b

BIAGIO DI ANTONIO [?]
Tobias and the archangels (detail)
Oil on canvas; 155 x 155 cm
Bartolini Salimbeni Collection, Florence

Enlargement of the view of Florence. One can make out the scaffolding around the lantern of the cathedral dome. The structure appears to be complete. The only missing element is the gigantic copper sphere about to be sealed into place by Verrocchio's workshop.

I.2A.1b

I.2B.1a[1]

LEONARDO DA VINCI
Brunelleschi's three-speed hoist
Codex Atlanticus (BAM), fol. 1083v

General view of the hoist. Leonardo analyzed in detail another of Brunelleschi's innovations: low-friction gears (*palei*) with rotating cylinder bearings.

I.2B.1a[2]

Three-speed hoist
Working model after Leonardo da Vinci,
Codex Atlanticus (BAM), fol. 1083v
Ash, oak, elm, and chestnut; metal gears
101 x 220 x 150 cm
Built by: SARI and M. Mariani, Florence, 1987
Istituto e Museo di Storia della Scienza,
Florence

Invented by Brunelleschi ca. 1420, this device is assembled in a sturdy frame firmly anchored into the ground. Two joined horizontal wheels operate on an alternating basis. Each bears revolving cylindrical gears to reduce friction wear. Via the pair of wheels, a vertical shaft drives a horizontal cylindrical shaft of two different diameters. By means of a pinion and toothed wheel system, the vertical shaft also drives another horizontal cylindrical shaft of a third diameter. The ropes for lifting the load are wound around the horizontal shafts and pass through an overhead pulley. The horizontal shafts rotate at three different speeds, each providing a different force and selected according to the load to be lifted.

The machine is driven by a pair of oxen and is fitted with a safety device to prevent the shafts from rotating in the reverse direction.

A worm-screw mechanism at the base of the driving shaft serves to raise or lower the shaft. This causes one of the two horizontal wheels to mesh with the drum teeth. One can thus reverse the rotation of the horizontal cylindrical shafts (and hence shift from load-raising to load-lowering mode) without having to unhitch the animals from the yoke and re-hitch them facing the other way.

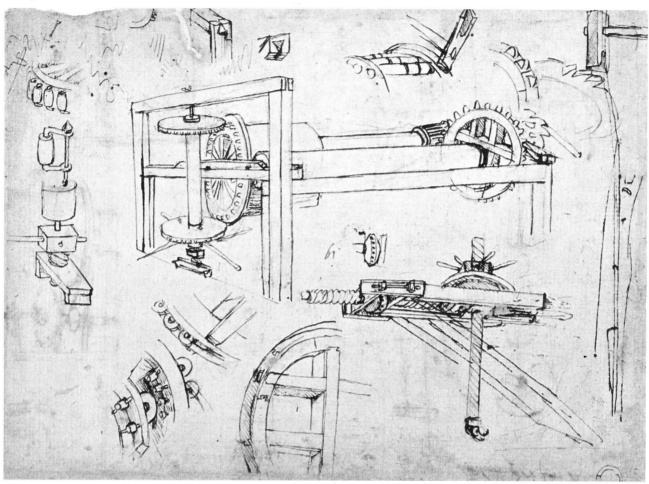

I.2B.1a¹

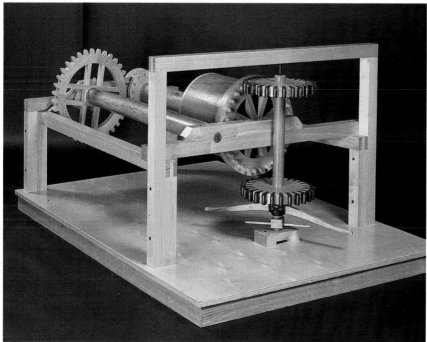

I.2B.1a²

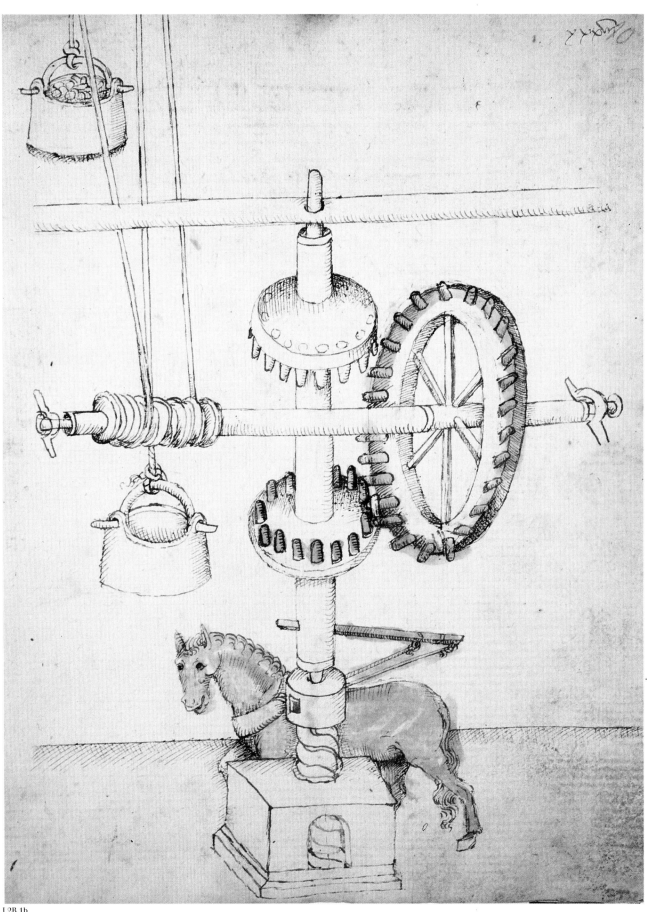

I.2B.1b

I.2B.1b
MARIANO DI IACOPO, called TACCOLA
**Horse-driven version
of the Brunelleschi hoist**
Ms. Palatino 766 (BNCF), fol. 10r

Unlike Brunelleschi's hoist, Taccola's
system operates at only one speed.

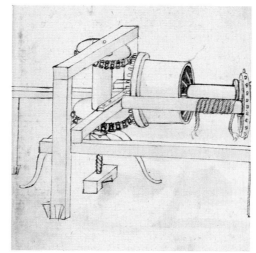

I.2B.1c-d
BONACCORSO GHIBERTI
**Two views, from different
perspectives, of Brunelleschi's
three-speed hoist**
B.R. 228 (BNCF), fols. 102r and 103v

I.2B.1c

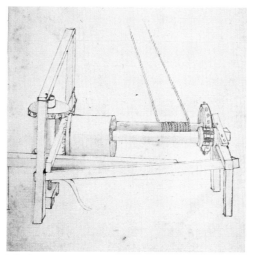

I.2B.1d

I.2B.1e
GIULIANO DA SANGALLO
Brunelleschi's three-speed hoist
Ms. S.IV.8 (BCS), fols. 47v-48r

Plan and elevated views of the hoist.

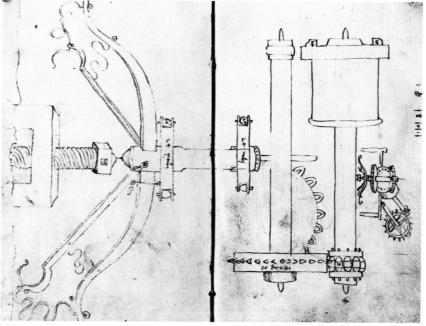

I.2B.1e

I.2B.1f
FRANCESCO DI GIORGIO
Motor of Brunelleschi's three-speed hoist
Ms. Ashburnham 361 (BMLF), fol. 44v (detail)

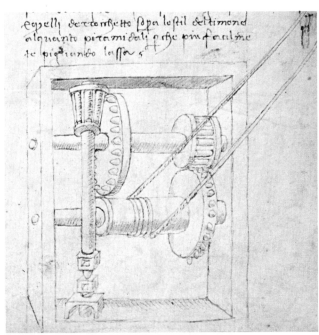

I.2B.1f

I.2B.2a¹
LEONARDO DA VINCI
Brunelleschi's revolving crane
Codex Atlanticus (BAM), fol. 965r

Leonardo made a detailed sketch (top left margin) of the vertical screw and lewis with dovetail wedges.

I.2B.2a²
Revolving crane
Working model after Leonardo da Vinci, Codex Atlanticus (BAM), fol. 965r
Beech, oak, and ilex; metal accessories
206 × 167 × 91 cm
Built by: SARI and Mariani, Florence, 1987
Istituto e Museo di Storia della Scienza, Florence

The revolving crane was at least 20 meters (65 feet) high. It was likely used to build the dome's *oculus* and to position the heavy stone blocks of the closing octagonal ring forming the lantern base. The crane's vertical shaft, guided by a long rudder, could rotate 360°. The load and counterweight were shifted simultaneously (in divergent or convergent mode) to keep the crane in constant balance on its vertical shaft. The wheel at the foot of the shaft helped reduce the friction caused by the rotation on the base platform. The load was raised or lowered by means of a vertical screw fitted with three turnbuckles to keep the load on a level plane. The crane required four teams of workmen: one to rotate the crane, two to turn the screws for the radial displacement of the load and counterweight, and one to operate the vertical screw. In the drawings of the crane by Leonardo and Bonaccorso, the load being raised is a marble block of the lantern.

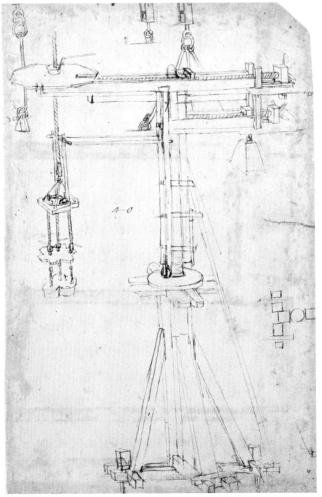

I.2B.2a¹

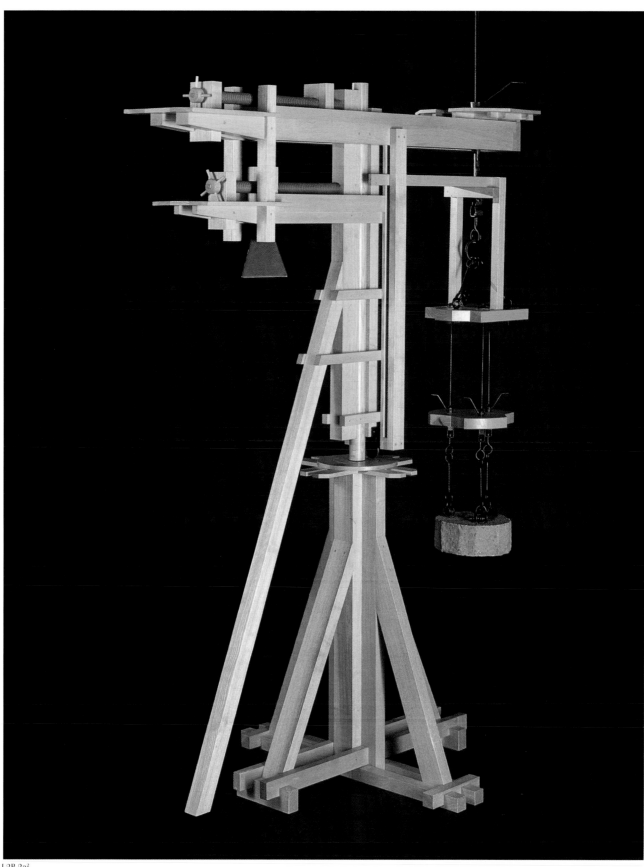

I.2B.2a²

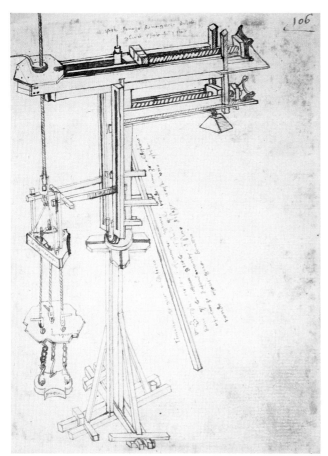

I.2B.2b

I.2B.2c

I.2B.2b
BONACCORSO GHIBERTI
General view of Brunelleschi's
revolving crane
B.R. 228 (BNCF), fol. 106r

I.2B.2c
LEONARDO DA VINCI
Detail of the vertical screw
of the revolving crane with
screw-operated triple turnbuckle
Codex Atlanticus (BAM), fol. 926v

I.2B.3a[1]
LEONARDO DA VINCI
Revolving crane for the lantern
(first version)
Codex Atlanticus (BAM), fol. 808v

The drawing clearly shows the screw
mechanism for raising the crane's base
platform. Leonardo also made a de-
tailed sketch (lower right) of the bell-
shaped roller that facilitates the crane
rotation.

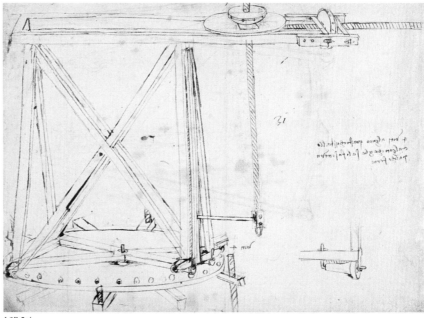

I.2B.3a[1]

I.2B.3a²
Revolving crane for the lantern
Working model after Leonardo da Vinci,
Codex Atlanticus (BAM), fol. 808v
Ash; metal accessories; 65 x 75 x 75 cm
Built by: Dipartimento di Costruzioni,
University of Florence, 1976
University of Florence

The dome lantern was built after Brunelleschi's death (1446), but using machines designed by him. The main device was a crane, of which two slightly different versions were employed. The first (reproduced here) was placed at the center of the dome's *oculus*, with its circular base inside the octagonal perimeter on which the lantern walls rested. The crane featured a fully-revolving arm with a screw system that allowed radial and vertical displacement of the load. The crane's supporting platform was raised by means of screws. The crane accurately positioned the marble blocks that formed the lower part of the lantern.

The second version of the crane featured – in addition to the revolving arm – a hoist and pulley-block for raising and positioning loads even inside the base platform. This variant model was used to construct the upper part of the lantern and to place the copper sphere and the iron cross on top of the structure. The crane's rotation was made possible by four bell-shaped bearings.

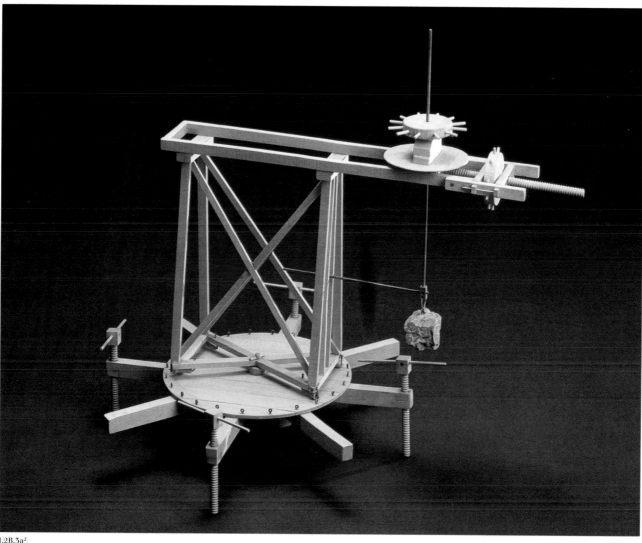

I.2B.3a²

I.2B.3b
BONACCORSO GHIBERTI
Revolving crane for the lantern
(first version)
B.R. 228 (BNCF), fol. 104r

Lower left: detail of screw-operated
triple turnbuckle.

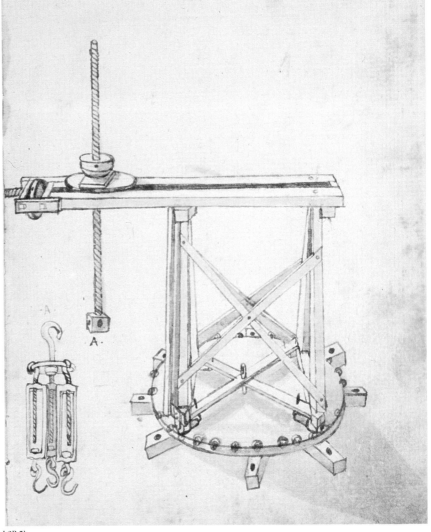

I.2B.3b

I.2B.3c
GIULIANO DA SANGALLO
Revolving crane for the lantern
(first version)
Ms. S.IV.8 (BCS), fol. 12r

Note the screw mechanism to lift the
crane platform. The caption reads
"How the dome lantern was built"
(*Chome si murò la lanterna della cupo-
la*).

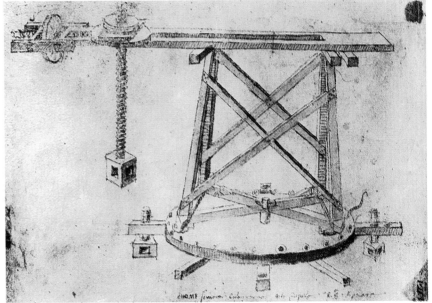

I.2B.3c

I.2B.3d
BONACCORSO GHIBERTI
**Revolving crane for the lantern
(second version)**
B.R. 228 (BNCF), fol. 105r

The crane hugs the lantern spire, already in an advanced phase of construction.

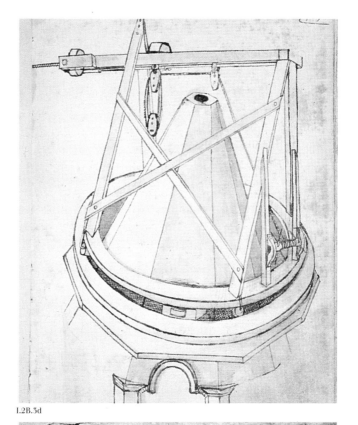

I.2B.3d

I.2B.3e
LEONARDO DA VINCI
**Brunelleschi's revolving crane
(second version)**
Codex Atlanticus (BAM), fol. 808r

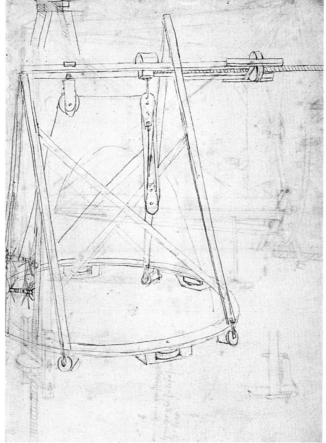

I.2B.3e

I.2B.3f
ALESSANDRO ALLORI [?]
Damage to the lantern from
lightning in spring 1601
Ms. II.I.429 (BNCF), fol. 33r

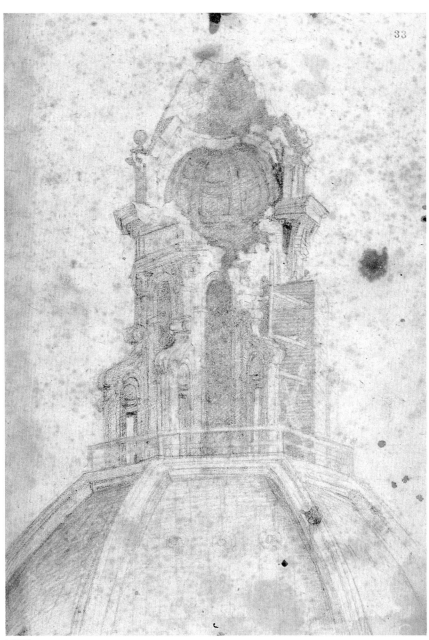

I.2B.3g
GHERARDO MECHINI [?]
Scaffolding and hoisting devices
used in 1601 to repair lighting
damage to the lantern
GDSU, 248A

I.2B.3f

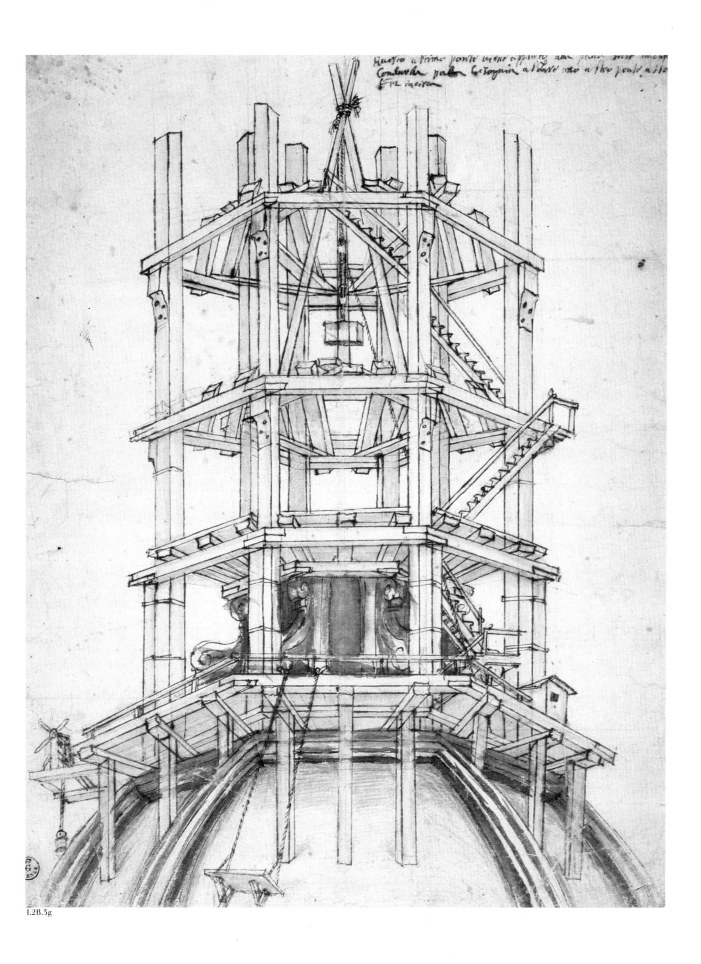

1.2B.3g

I.2B.4a¹

BONACCORSO GHIBERTI
Brunelleschi's light hoist
B.R. 228 (BNCF), fol. 95r

Explanatory notes are in cipher. Lower
left: detail of revolving cylindrical gear
of vertical wheel.

I.2B.4a²

Light hoist

Working model after Bonaccorso Ghiberti,
B.R. 228 (BNCF), fols. 95r and 98v
Chestnut, elm, oak, ilex; metal accessories
110 × 400 × 400 cm
Built by: Nuova SARI and FA-MA, Florence,
1995
Istituto e Museo di Storia della Scienza,
Florence

Designed by Brunelleschi to raise light
loads, this hoist consists of a horizontal
wheel driven by two rods powered by
four men. The shaft of the vertical
wheel moves the drum on which the
lifting rope is wound. The rope passes
through a pulley attached to the center
of the horizontal wheel. The wheel ro-
tates around the pulley, which is fixed.
The vertical wheel is fitted with Bru-
nelleschi's characteristic cylindrical re-
volving gears (*palei*) to reduce friction.

I.2B.4a¹

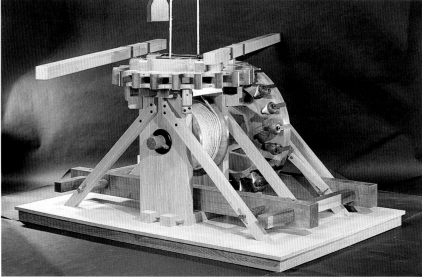

I.2B.4a²

I.2B.4b

BONACCORSO GHIBERTI
Driving wheel of the light hoist
B.R. 228 (BNCF), fol. 98v

The enciphered text explains the component's operation.

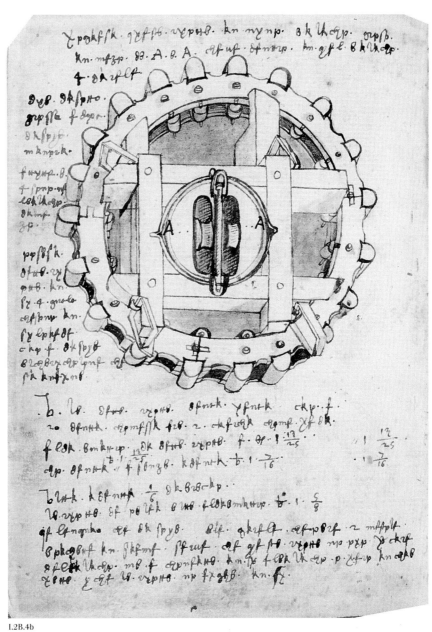

I.2B.4b

I.2B.4c

LEONARDO DA VINCI
Sketch of Brunelleschi's light hoist
Codex Atlanticus (BAM), fol. 105Bv (detail)

I.2B.4c

I.2B.5a[1]
BONACCORSO GHIBERTI
**Brunelleschi's revolving crane
with hoist**
B.R. 228 (BNCF), fol. 107v (detail)

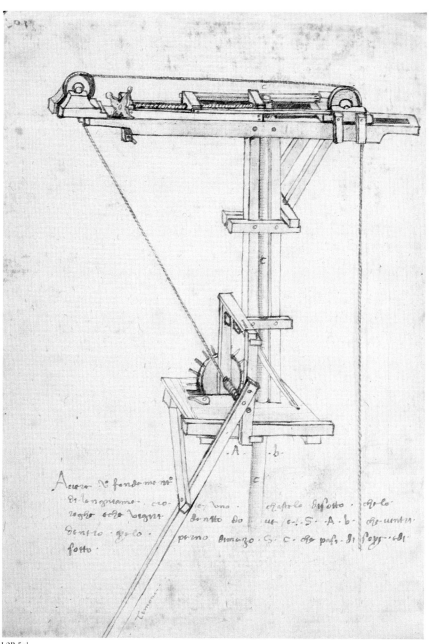

I.2B.5a[1]

I.2B.5a²

Revolving crane with hoist

Working model after Bonaccorso Ghiberti,
B.R. 228 (BNCF), fol. 107v
Ash and metal; 83×65×65 cm
Built by: Dipartimento di Costruzioni,
University of Florence, 1977
University of Florence

Another type of revolving crane, prob-
ably used on the scaffolding put up on
the inner and outer masonry. The ma-
chine is fitted with a vertical pin-gear
wheel that activates a jack for lifting
light weights and a screw-operated plat-
form for shifting the lifted load side-
ways.

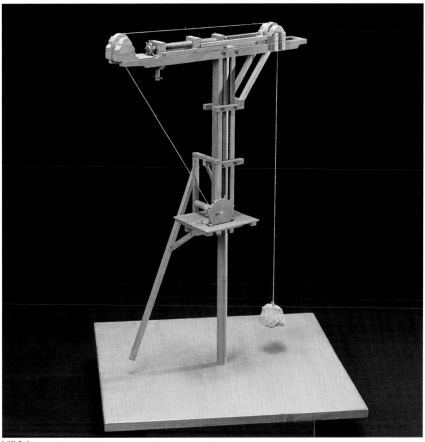

I.2B.5a²

I.2B.5b

LEONARDO DA VINCI

Revolving crane with hoist

Codex Atlanticus (BAM), fol. 105Bv

A slightly different version of Brunelle-
schi's revolving crane with hoist. The
hoisting device and pulley system at
the top of the machine was probably in-
troduced in order to modify the incli-
nation of the rope lifting the weight.

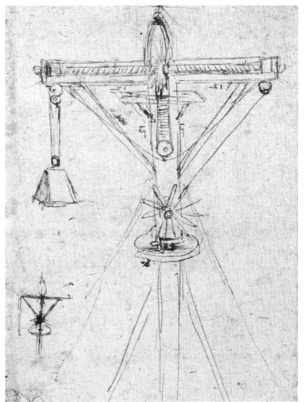

I.2B.5b

I.2B.5c

LEONARDO DA VINCI
Sketch of revolving crane with hoist
Codex Atlanticus (BAM), fol. 847r (detail)

Under the load being raised, Leonardo's caption reads: "lantern tendril"
(*viticcio di lanterna*).

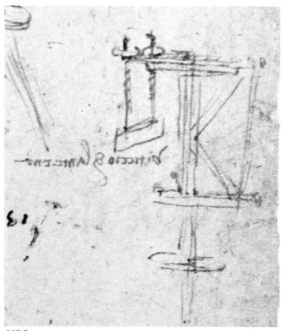

I.2B.5c

I.2B.6

LEONARDO DA VINCI
Brunelleschi's elevators
Codex Atlanticus (BAM), fol. 138r

The transportable and revolving hoisting device with pointed base on the
right is topped by a set of metal rings to anchor it securely by means of ropes.

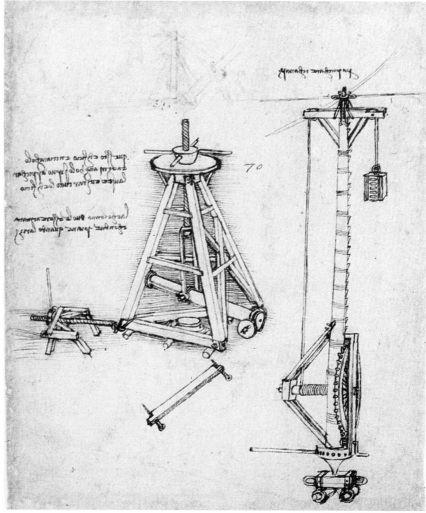

I.2B.6

II.

The Sienese engineers

*Between the Middle Ages and the Renaissance, Siena
not only invented new art forms such as the famous
"Sienese Gothic" style, but also developed a series
of technical specialities.
These were no less sophisticated than those
of the great artist-engineers of the city-state's neighbor
and traditional rival, Florence. The two most
prominent Sienese engineers were
Mariano di Iacopo, known as Taccola (1381-1458?),
and Francesco di Giorgio (1439-1501), who also
enjoyed a well-deserved reputation
as a master architect.
Siena's artist-engineers put their skills into practice
for their small republic (Francesco, however,
also worked for the leading Italian lords).
In a series of elegant manuscripts,
they demonstrated their newly-acquired yet
consummate skill in depicting machines
and mechanical systems.*

II.1 The manuscripts of the Sienese engineers

The fifteenth century saw an increased output of treatises dedicated to illustrations of machines for civil and military use. These works were inspired by illustrious classical forebears, such as Athenaeus, Philo of Byzantium, Vitruvius, and Vegetius. Among the most accomplished and earliest treatise-writers were Mariano di Iacopo, known as Taccola, and Francesco di Giorgio. These two Sienese artist-engineers compiled profusely illustrated texts that attempt to combine a revival of classical technology with the development of innovative methods and processes. Such texts ushered in a new literary genre: that of "engineer-authors". Their profound impact is attested by their widespread, long-lasting success.

II.1.a

MARIANO DI IACOPO, called TACCOLA
De ingeneis, Libri I-II
Cod. Lat. Monacensis 197 II (BSBM)
Facsimile; ca. 1419-50; 30 x 22 cm

This autograph paper manuscript, composed of 136 leaves and written in Latin, documents thirty years of Taccola's activities. The predominant themes and problems are civil and military engineering, the analysis of techniques and instruments to measure heights and distances, and studies of hydraulic devices (siphons, pumps and mills, sometimes tide-powered), as well as a series of quotations from ancient authors (especially Philo, Vegetius, and Frontinus).

fols. 90v-91r: Soldier fording a river on a horse with inflated leather bags attached to its saddle (left); man floating and swimming with the help of an oar and air-filled bags (right).

II.1.b

MARIANO DI IACOPO, called TACCOLA
De ingeneis, Libri III-IV
Ms. Palatino 766 (BNCF)
Facsimile; ca. 1431-33; 30 x 22 cm

This autograph paper manuscript, made up of 48 leaves, presents a series of Latin texts illustrated by accurate drawings, generally made on the two front pages. The interest in hydraulics is prevalent, as evidenced by the many water-driven devices and machines. A large section of the manuscript illustrates the instruments and techniques for measuring heights and distances. The manuscript is dedicated to Emperor Sigismund of Hungary.

fols. 14v-15r: Quarrying and transporting a column by land and sea.

II.1.c

MARIANO DI IACOPO, called TACCOLA
De machinis
Cod. Lat. Monacensis 28800 (BSBM)
Facsimile
ca. 1430-49; 29 x 22 cm

This 83-leaf autograph paper codex is missing its first 12 leaves, but these can be reconstructed with the aid of copies that were made while it was still intact. It includes a series of drawings of machines, described by a short Latin text. Military subjects (both traditional devices, such as siege-ladders, trebuchets etc., and the "new" fire-arms) predominate. Machines for civil uses and devices harnessing hydraulic power are also present.

fols. 37v-38r: Buckets operated by means of levers fill a cistern with water drawn from a river.

II.1.d

PAOLO SANTINI
(after TACCOLA)
De machinis
Ms. Lat. 7239 (BNP)
Facsimile
Second half of the 15th century; 35 x 24.5 cm

This 166-leaf vellum codex is the finest and most complete of the many surviving copies of Taccola's *De machinis*.
The vignettes are well executed and coloured in fine detail. At one point the codex was in the possession of the powerful Sultan Mohammed II, who received it as a sumptuous gift, probably from the famous humanist Ciriaco d'Ancona, an acquaintance of Taccola.

fols. 13v-14r: Soldiers and cavalry in battle.

II.1.e

FRANCESCO DI GIORGIO
Codicetto
Ms. Lat. Urbinas 1757 (BAV)
Facsimile: Belser-Verlag (Zurich 1989)
ca. 1465-70; 8 x 6 cm

This minuscule, autograph vellum codex contains 191 leaves, which include a series of free copies of texts and drawings by Taccola.
There is also a conspicuous group of studies that exhibit much more complicated mechanisms, probably the fruit of Francesco's own investigations. These innovative studies concern mills, pumps, carts and machines to lift and displace weights.

fols. 139v-140r: Floating mills (left); mill with horizontal wheel (above right) and mill with horizontal wheel working with the help of a bucket-pump.

II.1.f

FRANCESCO DI GIORGIO
Opusculum de architectura
Ms. 197.b.21 (BML)
Facsmile
ca. 1475-78
31 x 22 cm

This stupendous 80-leaf vellum codex contains a remarkable number of drawings with no explanatory text. The codex is the dedicatory copy given by Francesco to Duke Federico da Montefeltro when he entered the service of the Seigneur of Urbino. The codex includes a series of drawings of war-machines and copies from Taccola. There are also more drawings of mills, carts, pumps and machines to lift and displace weights, as well as numerous plans of fortresses.

fols. 60v-61r: Suction pump driven by water-wheel (left) and chain pump driven by an animal.

II.1.g

FRANCESCO DI GIORGIO
Treatise of architecture
and machines
Ms. Ashburnham 361 (BMLF)
Facsmile: Giunti (Florence 1979)
ca. 1480
38.5 x 26.5 cm

This magnificent 54-leaf vellum codex is the first version of Francesco's *Trattato*. The first part is taken up with drawings and reflections on architecture. The second part is devoted to machines, organised in a fairly systematic sequence. First are the instruments and techniques to measure distances, then mills, pumps, carts and machines to lift and move weights. The codex was owned by Leonardo, who made twelve autograph annotations.

fols. 37v-38r: Various types of water-mills, treadmills and animal-driven mills.

II.1.h
FRANCESCO DI GIORGIO
Treatise of architecture and machines
Ms. II.I.141 (BNCF)
Facsimile; ca. 1490; 43.5 x 29 cm

This remarkable paper manuscript of 252 leaves constitutes the second version of the *Trattato* of Francesco. By comparison with the first version, there are more citations of classical authors, while the section on architecture is more important than that on machines, of which there are fewer.
A series of drawings of military architecture and war-machines concludes the manuscript, which also contains Francesco's translation of Vitruvius's *De architectura*.

fols. 91v-92r: Hoisting devices.

II.1.i
ANONYMOUS SIENESE ENGINEER (after TACCOLA and FRANCESCO DI GIORGIO)
Book of machines
Ms. Additional 34113 (BLL)
Facsimile; late 15th century; 26 x 18 cm

This 261-leaf paper manuscript documents the first phase of dissemination of the drawings of Taccola and Francesco di Giorgio, from which many of the figures derive. There are explicit references to Francesco, and places in Sienese territory are mentioned which are clearly familiar to the author. The codex also contains a small number of drawings that cannot be traced back to such models.

fols. 189v-190r: Flying man and mobile siege-ladder.

II.1.j
ANONYMOUS (after TACCOLA and FRANCESCO DI GIORGIO)
Drawings of machines
Ms. Palatino 767 (BNCF)
Facsimile; late 15th century; 27 x 18 cm

This vellum codex of 268 pages presents a collection of drawings almost all of which are derived from the manuscripts of Taccola and Francesco di Giorgio. A small number of drawings (especially of mortars) seem to be original. The figures are drawn with care and with a steady hand, suggesting their attribution to an artist from the workshop of Francesco di Giorgio.

pp. 206-207: Counterweighted revolving elevator (left) and mobile trolley with variable settings.

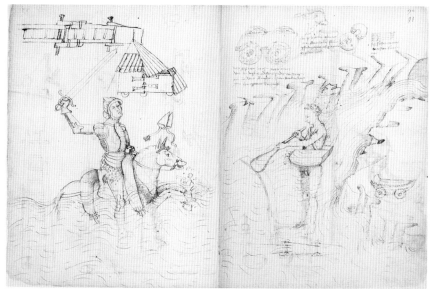

II.1.a

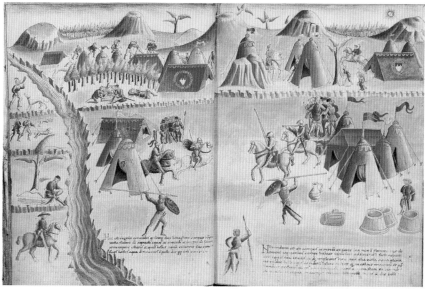

II.1.d

II.1.k
ANONYMOUS (after TACCOLA and FRANCESCO DI GIORGIO)
Drawings of machines
S.IV.5 (BCS)
Facsimile
End of the 15th century; 35 x 25 cm

This paper manuscript consists of 93 folios that contain a series of drawings of machines derived from models by Taccola and Francesco di Giorgio.
Another group of drawings, which cannot be matched with such models, shows impressive warships armed with heavy bombing-machines.

fols. 57v-58r: Sailing ship with catapult for firing incendiary material (left) and pontoon armed with mortar (right).

II.2 Mastering water

The manuscripts of the Sienese engineers attest their efforts to master the technology of water – a vital element for communities such as Siena, which developed far from waterways. These endeavors gave rise to a full-fledged local specialization that manifested itself in several ways: one was the extraordinary network of tunnels forming the underground water-conveyance network known as the *bottini*. Another was the care the Sienese lavished on the construction, embellishment, and hydraulic, legal, economic, and social organization of their public-fountain system.

The triumphs of Sienese engineers over adverse environmental conditions were echoed in the popular imagination by the legend of Diana, the mythical river of plentiful, crystal-pure water that flowed – so the Sienese believed – in the entrails of their city.

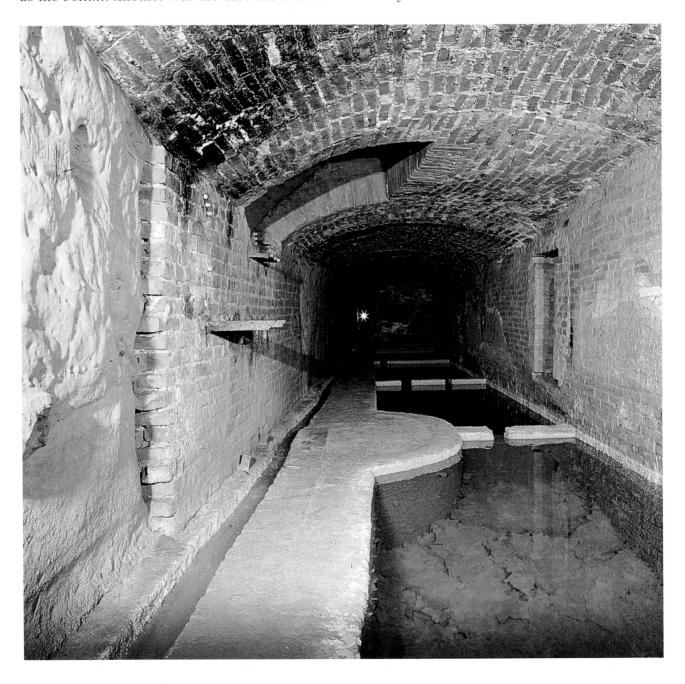

II.2A *Siena's underground water-supply system: the* bottini

The *bottini* are the underground water-conveyance system used in Siena until a few decades ago and still in partial use today. Construction began in the thirteenth century. The network was almost complete by the end of the fourteenth century, with about 25 km (16 miles) of underground tunnels. In the fifteenth century, engineers endeavored to increase the supply of water to the public fountains – the focal point of Siena's economic and social system from the Middle Ages to the Renaissance.

Once the *bottini* had been built, constant maintenance was needed to keep them in working order. This colossal task was assigned to a contractor known as *Operaio*. Francesco di Giorgio was appointed to the post in 1469 and again in 1492.

II.2A.1a

II.2A.1a-b

IACOPO DELLA QUERCIA
Acca Larentia and Rea Silvia
(detail of Fonte Gaia), 1414-19
Marble; Palazzo Pubblico, Siena

The two sculptures, placed on either side of the Fonte Gaia, in the Sienese Piazza del Campo, were completed in 1419.

II.2A.2

IACOPO DELLA QUERCIA
Fonte Gaia
Piazza del Campo, Siena

The fountain of Piazza del Campo; copy by Tito Sarocchi (1858). The fountain is fed by the so-called "main network" (*bottino maestro*) built in the first half of the fourteenth century.

II.2A.3
Bottini
Relief model; Scale 1:20
Wood, Plexiglas, and polyurethane foam
Built by: Studio Bossi e Bucciarelli, Florence, 1995
Istituto e Museo di Storia della Scienza, Florence

Relief model of an actual section of the network, featuring the presence of settling tanks called *galazzoni*. The section is located in the Antiporto district near the Porta Camollia, not far from the column put up to commemorate the meeting between the Emperor Frederick III and Eleanor of Aragon (ca. 1450).

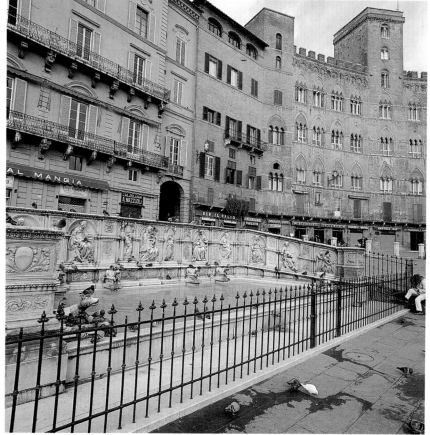

II.2A.2

II.2A.4

TACCOLA
Tunnel-boring
Ms. Palatino 766 (BNCF), fol. 33r

Equipment and methods for boring an
underground tunnel on a steady gradi-
ent, like that of the *bottini*.

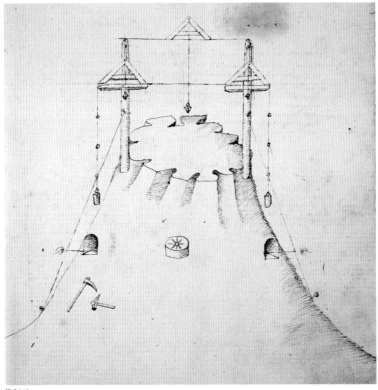

II.2A.4

II.2A.5

TACCOLA
Measuring elevations prior
to excavating a tunnel
for an underground water conduit
Ms. Palatino 766 (BNCF), fol. 34r

II.2A.6

FRANCESCO DI GIORGIO
Illustration of method used
to excavate the *bottini*
Ms. Ashburnham 361 (BMLF), fol. 26v

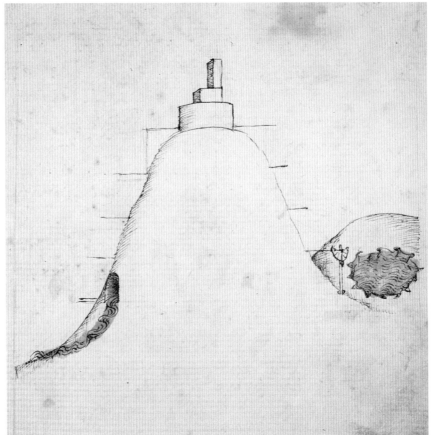

II.2A.5

II.2A.7
FRANCESCO DI GIORGIO
Triple-compartment
water-purification filter
for a fountain
Ms. Ashburnham 361 (BMLF), fol. 27r

This system facilitated the removal of
impurities from water through settling.

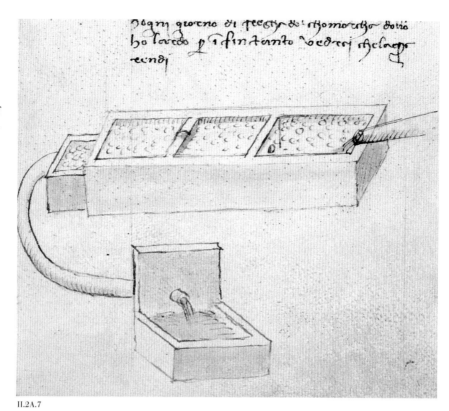

II.2A.7

II.2A.8
FRANCESCO DI GIORGIO
Gravel and sand filters to be placed
near a fountain
Ms. Ashburnham 361 (BMLF), fol. 25v

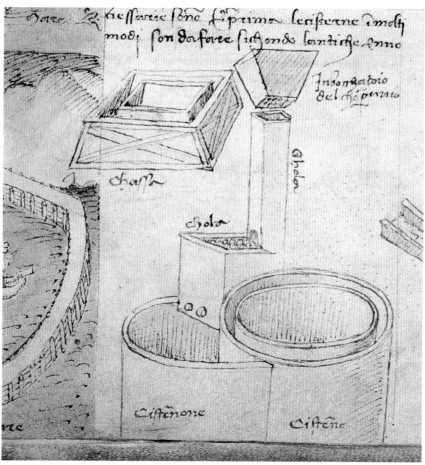

II.2A.8

II.2B *Above and under water*

The drawings by the Sienese engineers illustrate their persistent efforts to design systems that would enable persons to float and swim effortlessly in water, to remain in and under water for long periods, to build robust, long-lasting structures in water, and to construct safe, practical boats. Taccola and Francesco di Giorgio depicted many unusual prototypes of diving suits with amusingly shaped masks and visors, as well as human figures kept afloat by inflated leather bags.

These themes haunted the imagination of all the artist-engineers from the fourteenth century to Leonardo.

II.2B.1
PAOLO SANTINI (after TACCOLA)
Swimmer with oar and lifebelt blowing a horn
Ms. Lat. 7239 (BNP), fol. 82v

II.2B.2
TACCOLA
Soldier with heavy armor wading across a river on a horse floating with the aid of inflated leather bags
Cod. Lat. Monacensis 28800 (BSBM), fol. 78r

II.2B.3
FRANCESCO DI GIORGIO
Swimmer with oar and inflated leather bags
Ms. II.I.141 (BNCF), fol. 196v

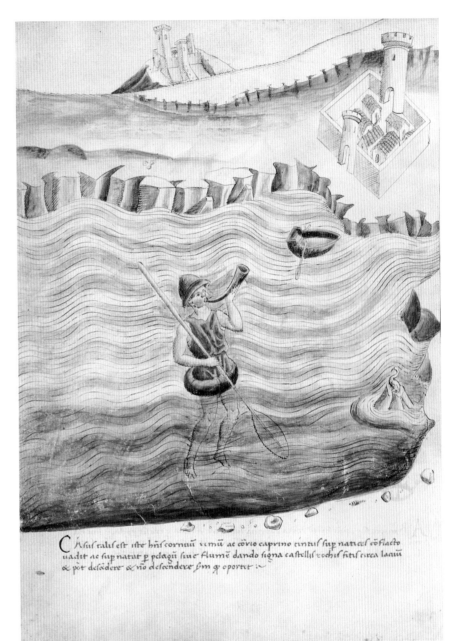

II.2B.1

II.2B.2

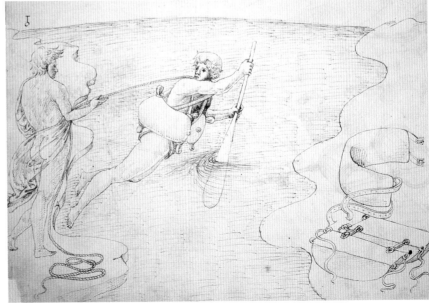

II.2B.3

II.2B.4
FRANCESCO DI GIORGIO
Swimmer and men walking
on water by means of inflated
leather bags and barrels
Ms. 197.b.21 (BML), fol. 55v

II.2B.5
TACCOLA
Underwater mask with breathing
tube
Cod. Lat. Monacensis 197 II (BSBM), fol. 57r
(detail)

II.2B.6
ANONYMOUS
(after FRANCESCO DI GIORGIO)
Diver with bellows for breathing
underwater and watertight lamp
Ms. Palatino 767 (BNCF), p. 9

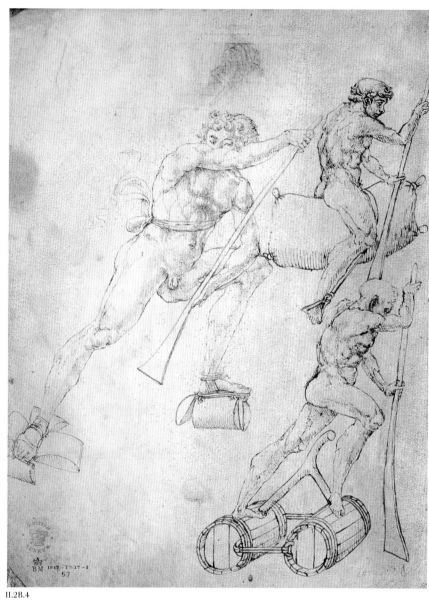

II.2B.4

II.2B.5

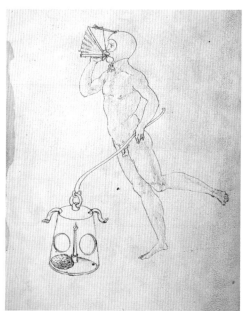

II.2B.6

II.2B.7

TACCOLA

Retrieving a sunken column
by means of two stone-laden barges

Ms. Palatino 766 (BNCF), fol. 18r

II.2B.8

ANONYMOUS

Raising a sunken ship

Ms. E.B.16.5ᴵᴵ (BNCF), fol. 76v

The sunken ship is tied with ropes to
two floating ships loaded with ballast.
The ballast is then jettisoned.

II.2B.9

PAOLO SANTINI (after TACCOLA)

Watertight caisson for underwater
casting

Ms. Lat. 7239 (BNP), fol. 13r

II.2B.10a

FRANCESCO DI GIORGIO

Mud extractor

Ms. Saluzziano 148 (BRT), fol. 64v (detail)

II.2B.10b

Mud extractor

Working model after Francesco di Giorgio,
Ms. Saluzziano 148 (BRT), fol. 64v
Durmast, chestnut, iron, and copper
128 x 250 x 205 cm
Built by: SARI, FA-MA and M. Mariani,
Florence, 1991
University of Siena

This machine is designed to clear grav-
el, mud, and earth from shallow ports.
The pair of linked boats operates in
combination with a raft (not shown by
Francesco), into which the four spoons
with cutting edges discharge the mat-
ter scraped up from the bottom. The
lengths of the four arms can be adjust-
ed to work at different depths.

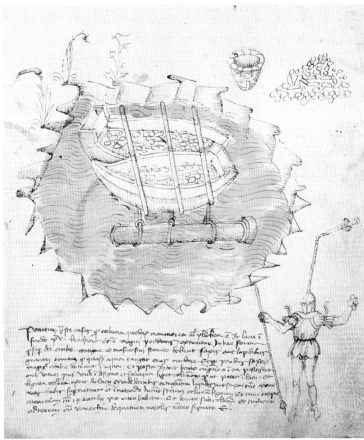

II.2B.7

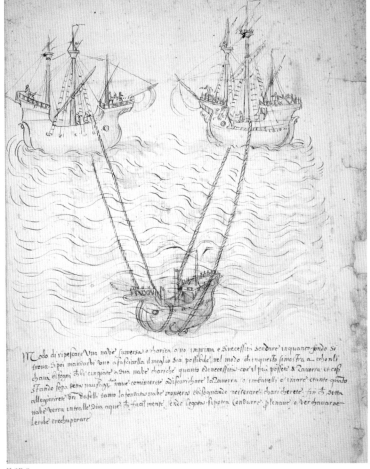

II.2B.8

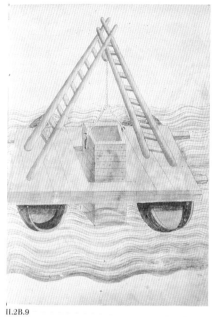

II.2B.9

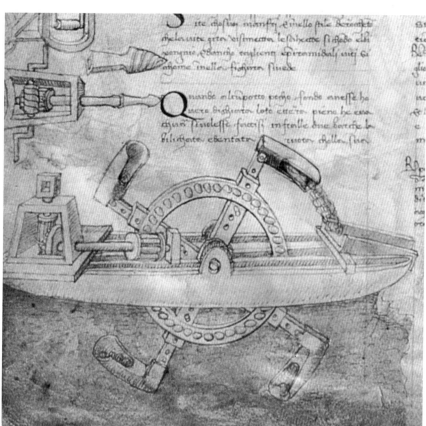

II.2B.10a

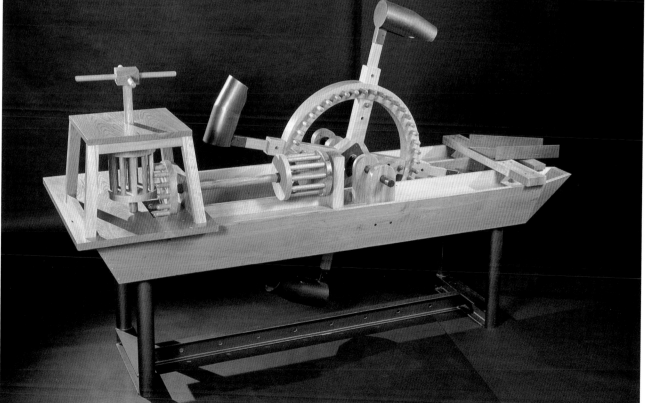

II.2B.10b

II.2B.11
ANONYMOUS
**Dredge with buckets driven
by two windlasses**
Ms. S.IV.5 (BCS), fol. 53r

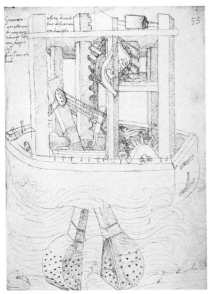

II.2B.11

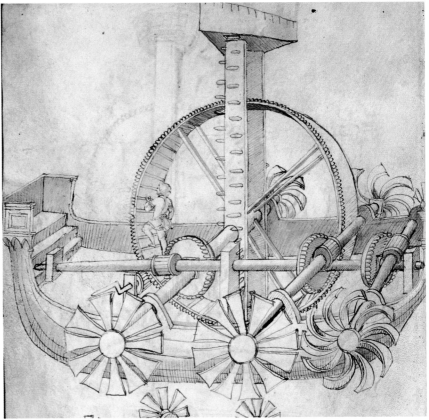

II.2B.12a

II.2B.12a
FRANCESCO DI GIORGIO
Paddle-boat
Ms. 197.b.21 (BML), fol. 43v (detail)

II.2B.12b
Paddle-boat
Small working model after Francesco di
Giorgio, Ms. 197.b.21 (BLL), fol. 43v
Durmast and iron; 55×85×61 cm
Built by: Nuova SARI, Florence, 1995
Istituto e Museo di Storia della Scienza,
Florence

The boat features three pairs of paddle-
wheels, all driven by a single shaft
powered by a large treadmill installed
in the middle of the ship's deck.

II.2B.13
ANONYMOUS
Paddle-boat
Ms. S.IV.5 (BCS), fol. 55v

A handle activates a wheel carrying
rollers that mesh with a worm screw.
The screw drives the paddle-wheel
axles via two pinions.

II.2B.14
PAOLO SANTINI (after TACCOLA)
**Boat navigating upstream
by harnessing the current**
Ms. Lat. 7239 (BNP), fol. 87r

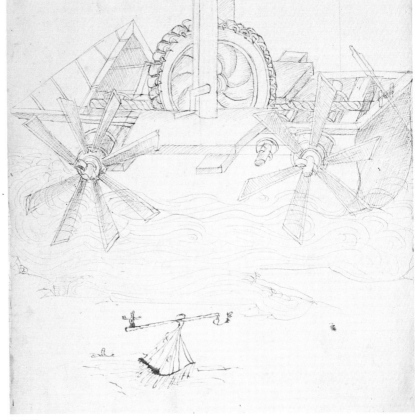

II.2B.13

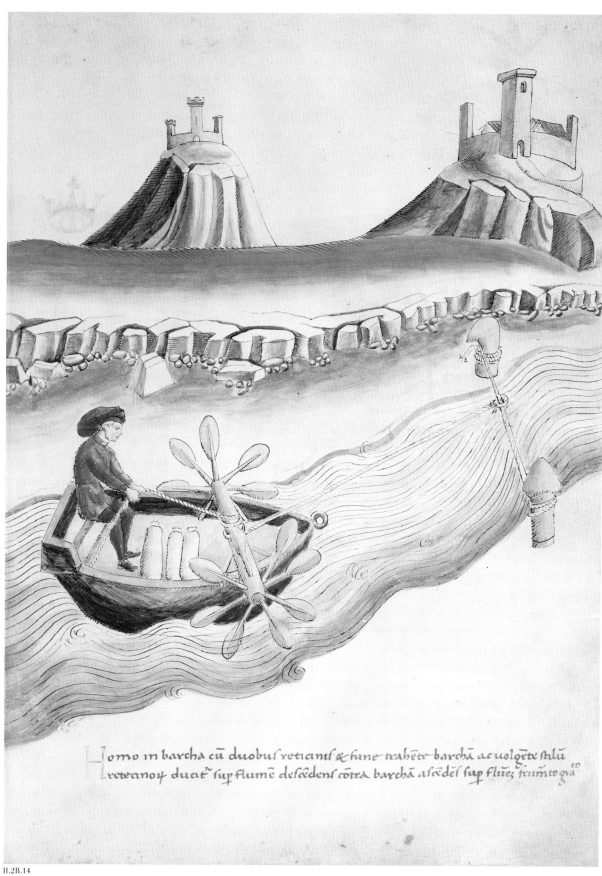

Homo in barcha cū duobuſ reticanīſ & fune trahēte barchā ac uolgēte ſtilū
rotearnoy ducāt ſup flumē deſcēdenſ cōtra barchā aſcēdeſ ſup fluuē; scrīto grā to

II.2C *Measuring distances*

Taccola and Francesco di Giorgio devoted special attention to measuring heights and distances by means of geometrical instruments and methods. Taccola concentrated on hydraulic applications, while Francesco illustrated a range of devices reflecting the architect's varied requirements.

The instruments depicted by the two engineers, such as the astrolabe, quadrant, and square, were in widespread use in the fifteenth century.

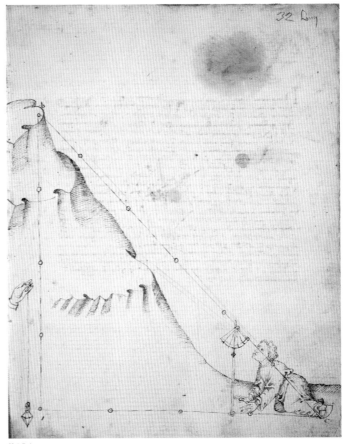

II.2C.1

II.2C.1
TACCOLA
Measuring height with a quadrant and plumb-line
Ms. Palatino 766 (BNCF), fol. 32r

II.2C.2
ANONYMOUS (after TACCOLA)
Measuring a slope with an astrolabe
Ms. Palatino 767 (BNCF), p. 23

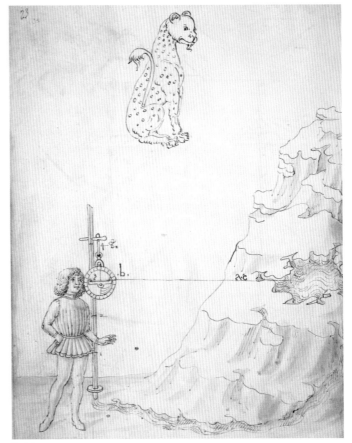

II.2C.2

II.2C.3
FRANCESCO DI GIORGIO
**Measuring distances
with a quadrant and square**
Ms. Ashburnham 361 (BMLF), fol. 31r (detail)

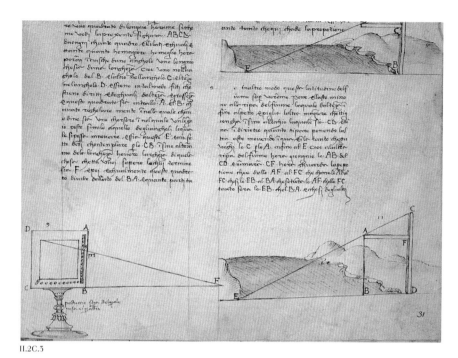

II.2C.3

II.2C.4
FRANCESCO DI GIORGIO
Measuring heights with rods
Ms. Ashburnham 361 (BMLF), fol. 29r

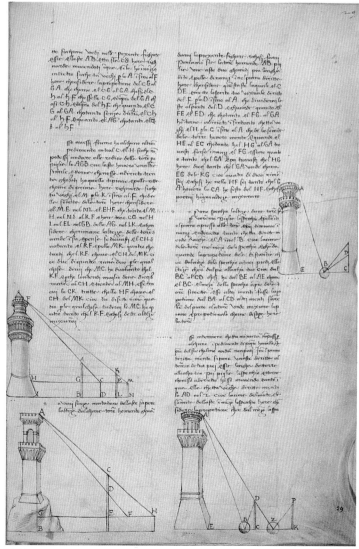

II.2C.4

II.2C.5

ANONYMOUS

Level

17th cent.; brass; 27 x 13 cm
Istituto e Museo di Storia della Scienza,
Florence, inv. 654

The level was used to measure angles
and as an instrument to prepare a
plumb-line, both in civilian and mili-
tary applications. The level played a
crucial role in the construction of the
bottini.

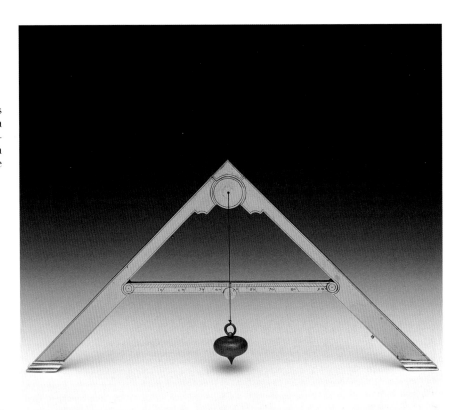

II.2C.6

CHRISTOPH SCHLISSLER

Astrolabe

1560; gilt brass; Ø 21.5 cm
Istituto e Museo di Storia della Scienza,
Florence, inv. 1114

The astrolabe was used for many as-
tronomical operations (*recto*) and to-
pographic applications (*verso*).

II.2C.5

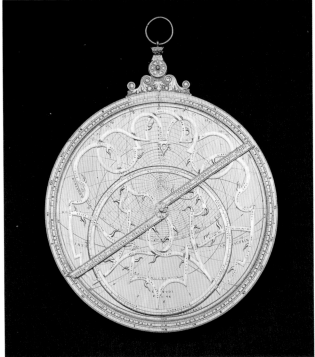

II.2C.6 (*recto*)

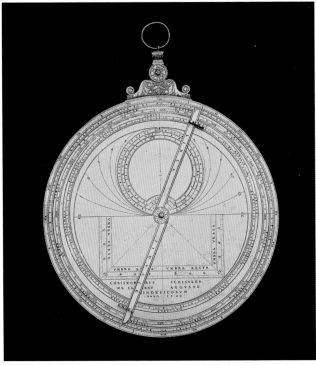

II.2C.6 (*verso*)

II.2C.7

GIROLAMO DELLA VOLPAIA
Quadrant
1570; brass; radius 35 cm
Istituto e Museo di Storia della Scienza,
Florence, inv. 239

The quadrant was widely used for measuring heights and distances.

II.2C.8

ANTONIO BIANCHINI
Compass
1564; gilt brass; length 37.5 cm
Istituto e Museo di Storia della Scienza,
Florence, inv. 2467

The compass was used for astronomical and cosmographic measurements.

II.2C.9

CHRISTOPH SCHLISSLER [?]
Jacob's rod
16th cent.; wood and gilt brass; length 91.5 cm
Istituto e Museo di Storia della Scienza,
Florence, inv. 3167

This instrument was used to measure distance and depth, as well as for architectural surveying.

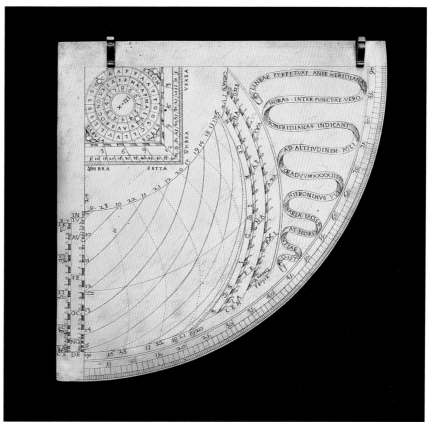

II.2C.7

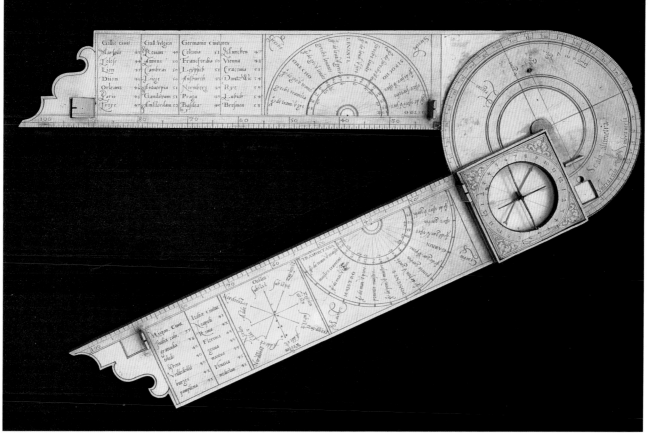

II.2C.8

II.2D *"Surprise" fountains*

In the manuscripts of the Sienese engineers, fountains recur with a frequency that underscores their importance in the life of the local community.

Taccola and Francesco devoted special attention to "surprise" fountains, i.e. capable of surprising the observer by their effects. These devices had been analyzed in depth by Hero of Alexandria (1st cent. A.D.) in his *Pneumatics* and by Philo of Byzantium in his *Pneumatics* (3rd cent. B.C.), a text with which the two Sienese engineers were familiar.

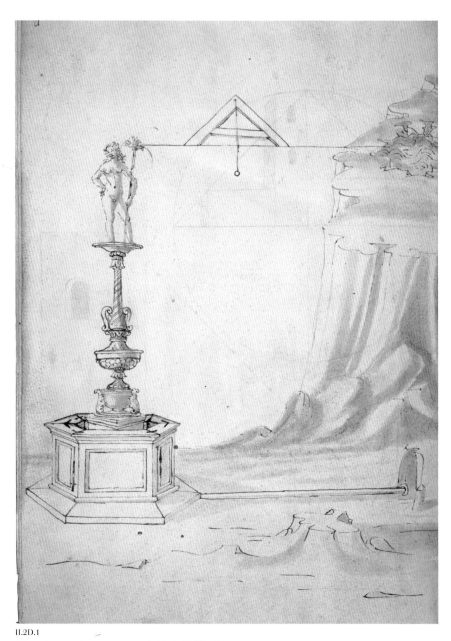

II.2D.1
ANONYMOUS (after TACCOLA)
Hexagonal-base jet fountain
with a measurement of the altitude
of its water source
Ms. Palatino 767 (BNCF), p. 21

II.2D.1

II.2D.2a
FRANCESCO DI GIORGIO
"Terminating" fountain
(*fonte a termine*)
Ms. Ashburnham 361 (BMLF), fol. 41r (detail)

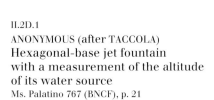

II.2D.2a

II.2D.2b
"Terminating" fountain (*fonte a termine*)
Working model after Francesco di Giorgio,
Ms. Ashburnham 361 (BMLF), fol. 41r
Glass; 90 × Ø 46 cm
Built by: A. Vezzosi and A. Rinaldi, Vinci
(Florence), 1991
Museo Ideale, Vinci (Florence)

In this type of fountain the water poured into the upper basin falls down a tube into the airtight lower compartment. The air expelled from the lower vessel rises through a second tube into the central compartment, filled with water. The water is thus forced to the

II.2D.3b
"Surprise" table fountain,
called "The Barmaid" (*Mescitrice*)
Working model after Anonymous, Ms. Palatino
767 (BNCF), p. 6
Bronze and copper; 76.5 × Ø 37 cm
Built by: A. Vezzosi, Vinci (Florence), 1995
Museo Ideale, Vinci (Florence)

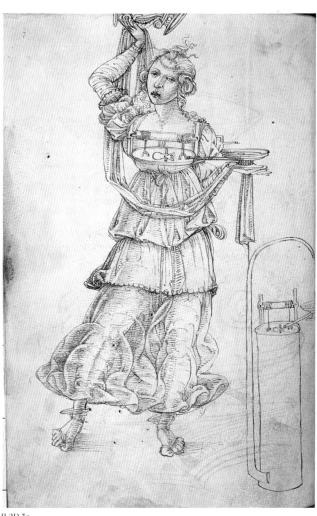

II.2D.3a

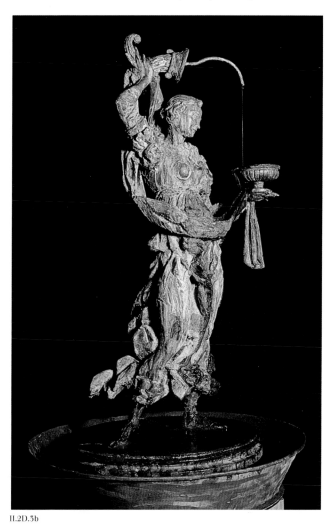

II.2D.3b

top where it emerges through the sprinkler. When the lower compartment is full, the sprinkle ceases.

II.2D.3a
ANONYMOUS
Barmaid. Drawing of a "surprise"
table fountain
Ms. Palatino 767 (BNCF), p. 6

The lower right sketch shows the fountain mechanism concealed under the female figure's dress.

The mechanism is concealed inside the sculpture. Gravity pushes a piston down a cylinder filled with water (or wine), forcing the liquid to rise into the sprinkler that passes through the barmaid's bent arm. The liquid flows from the pitcher to the cup carried by the hand, and then back into the cylinder. The mechanism is re-activated by winding up the weight with the handle protruding from the back of the figure.

II.2D.4
ANONYMOUS
"Terminating" sprinkler fountain
with mechanical drinking bird
Ms. Palatino 767 (BNCF), p. 2

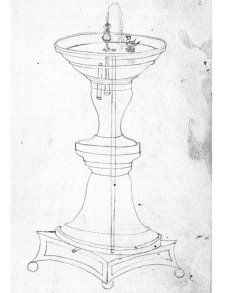

II.2D.4

II.2E *Water-raising systems*

Devices for raising and conveying water feature prominently in the manuscripts of the Sienese engineers. Francesco di Giorgio devoted much energy to innovations in pumping technology. He compiled an exhaustive classification of pumps, giving detailed notes of their specifications and performance. Water-raising contrivances were also essential for creating the artificial "waterfalls" or millraces to drive the waterwheels used on operating machinery.

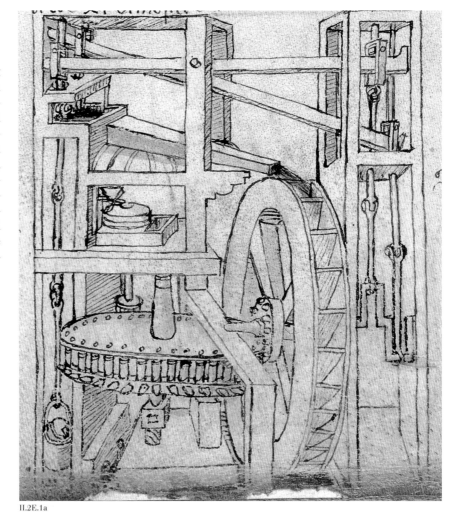

II.2E.1a

II.2E.1a
FRANCESCO DI GIORGIO
Recirculation mill
Ms. Ashburnham 361 (BMLF), fol. 36r (detail)

II.2E.1b
Recirculation mill
Working model after Francesco di Giorgio,
Ms. Ashburnham 361 (BMLF), fol. 36r
Durmast, elm, beech, metal, and crystal
271 x 185 x 105 cm
Built by: SARI and FA-MA, Florence, 1991
University of Siena

Working model of recirculating-water mill, defined by Francesco as a "still-water mill" (*mulino in acqua morta*). The system combines a mill driven by a vertical vane wheel and a walking-beam pump. The vane wheel drives a crankshaft that activates the pump rods, which, in turn, power the wheel. These machines, of limited practical efficiency, vividly illustrate Francesco's efforts to control the element water with sophisticated mechanical contrivances.

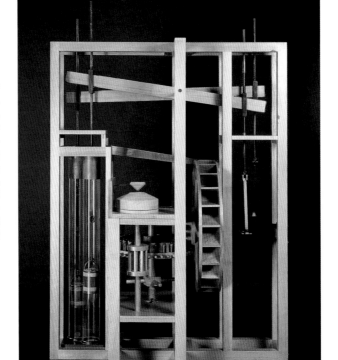

II.2E.1b

II.2E.2
PAOLO SANTINI (after TACCOLA)
**Treadmill-operated system
for raising water from a well**
Ms. Lat. 7239 (BNP), fol. 47r

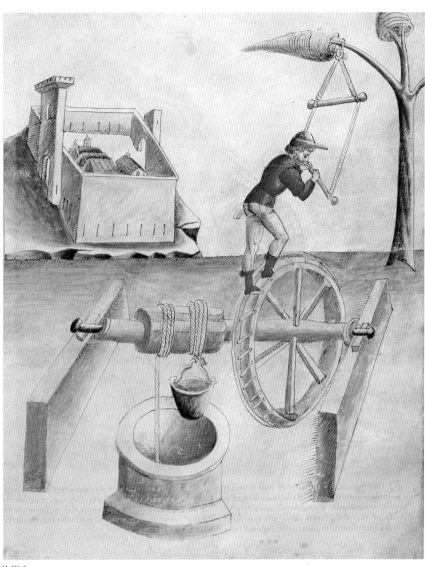

II.2E.2

II.2E.3
TACCOLA
**Water elevator with
counterweighted levers**
Cod. Lat. Monacensis 197 II (BSBM), fol. 92r

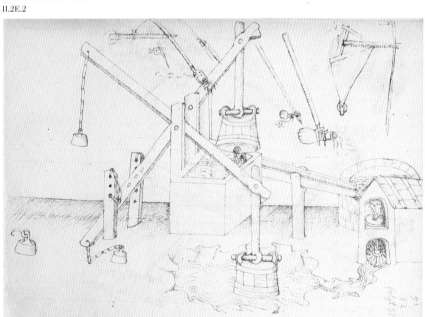

II.2E.3

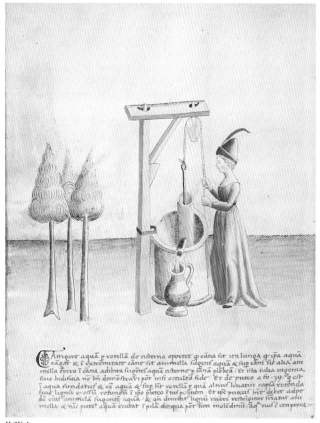

II.2E.4

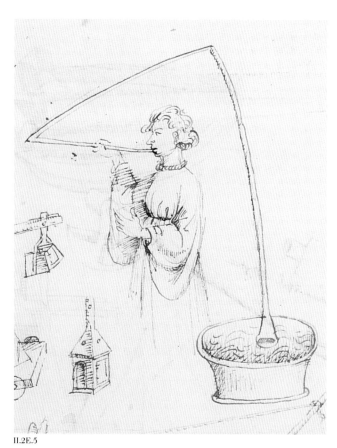

II.2E.5

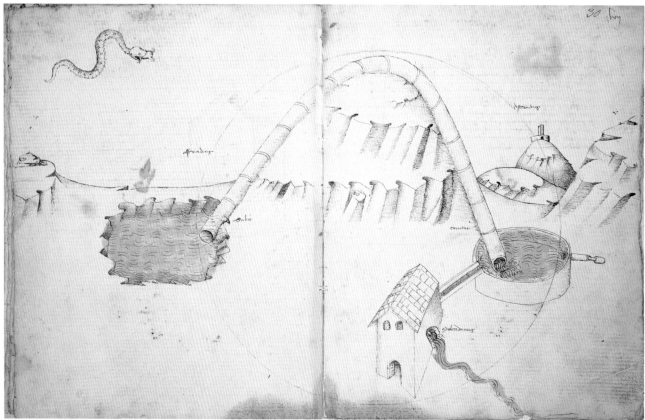

II.2E.6

II.2E.4
PAOLO SANTINI (after TACCOLA)
Device for raising water from
a well, operated by a female figure
Ms. Lat. 7239 (BNP), fol. 42v

II.2E.5
TACCOLA
Siphon
Cod. Lat. Monacensis 197 II (BSBM), fol. 68r
(detail)

Suction-powered siphon. The process
shown could never work in real life: for
a siphon to operate, its outlet must be
lower than the inlet.

II.2E.6
TACCOLA
Using a siphon to convey water
over a mountain range
Ms. Palatino 766 (BNCF), fols. 29v-30r

II.2E.7
ANONYMOUS
(after FRANCESCO DI GIORGIO)
Siphon supplying water for a mill
wheel
Ms. Getty (GCM), fol. 15r

II.2E.8
TACCOLA
Walking-beam pump
Cod. Lat. Monacensis 197 II (BSBM), fol. 88r

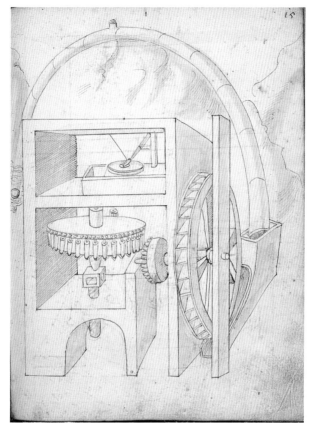

II.2E.7

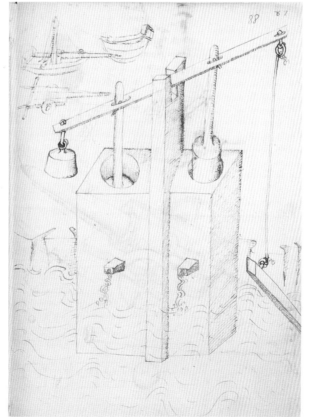

II.2E.8

II.2E.9
ANONYMOUS
(after FRANCESCO DI GIORGIO)
Chain pump activated
by an animal-powered horizontal
wheel
Ms. Getty (GCM), fol. 5r

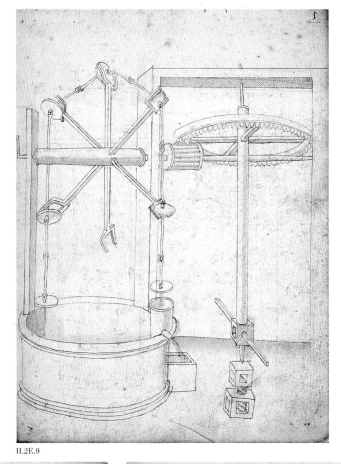

II.2E.9

II.2E.10a-b
FRANCESCO DI GIORGIO
Assortment of pumps with notes
on their operating modes
Ms. Ashburnham 361 (BMLF), fols. 42r and 43r

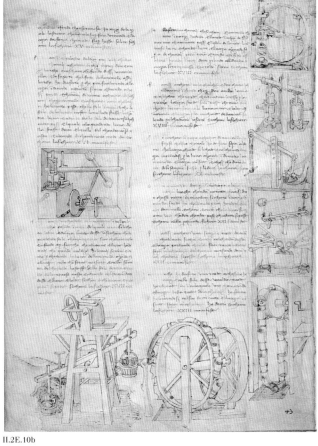

II.2E.10a II.2E.10b

II.2F *The dam on the Bruna River*

In 1468, the Sienese Republic launched a project to set up an artificial lake in the Maremma region by building a dam on the Bruna River near Giuncarico (not far from Grosseto).

The dam was intended to relieve the city from its heavy dependence on fish imports from the Lake Trasimeno by creating a fish-stock lake.

The project probably incorporated Taccola's concepts for dams and underwater foundations. When fears began to spread about the dam's imminent collapse, the Sienese authorities requested Francesco di Giorgio – then in Naples in the service of the Duke of Calabria – to hasten home and provide his expert assistance.

In December 1492, however, the dam collapsed, inflicting many casualties and heavy damage before the Republic had even begun to exploit the fish supply.

II.2F.2

II.2F.1
Dam on the Bruna River
Relief model; scale 1:500
Beech, cork, and Plexiglas; 25 x 140 x 90 cm
Built by: AREA, Florence, 1991
University of Siena

The project layout was reconstructed from present-day maps and historical research to identify topographic changes. Sources used include the maps of the Grand Duchy of Tuscany compiled in 1832 by Zuccagni Orlandini and the mapping records (1748 and 1500) in the National Archives in Florence.

II.2F.2
ANONYMOUS SIENESE ENGINEER
Dam with stepped buttresses
and spillway
Ms. Additional 34113 (BLL), fol. 98v (detail)

II.2F.3
TACCOLA
River dam made of masonry
with mobile sluice-gate
Cod. Lat. Monacensis 197 II (BSBM), fol. 114v

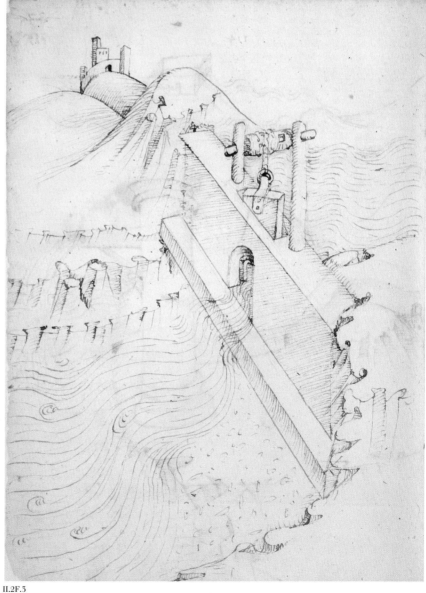

II.2F.3

II.2F.4

TACCOLA

Tide mill with sluice-gates
to control water inflow and outflow

Cod. Lat. Monacensis 197 II (BSBM), fol. 99v

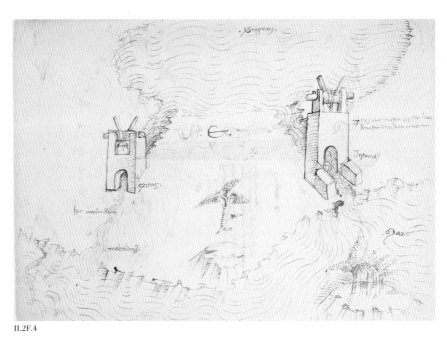

II.2F.4

II.2F.5

FRANCESCO DI GIORGIO

Wood river dam

Ms. Ashburnham 361 (BMLF), fol. 6v (detail)

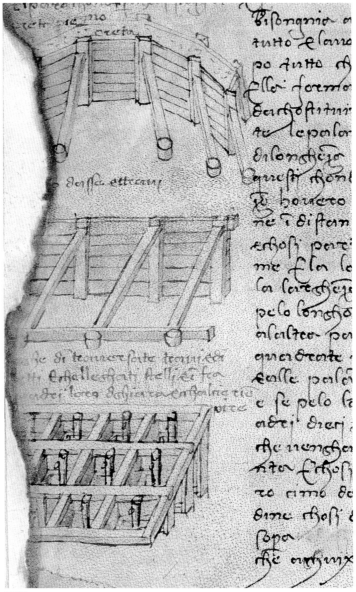

II.2F.5

II.2F.6
FRANCESCO DI GIORGIO
**Wood and masonry dam
with sluice-gate**
Ms. Ashburnham 361 (BMLF), fol. 6v (detail)

II.2F.7
TACCOLA
**Underground canal between
the sea and a fish-stock pond**
Cod. Lat. Monacensis 197 II (BSBM), fol. 99r

II.2F.8
PAOLO SANTINI (after TACCOLA)
Fishing scene in a fish-stock lake
Ms. Lat. 7239 (BNP), fol. 88r

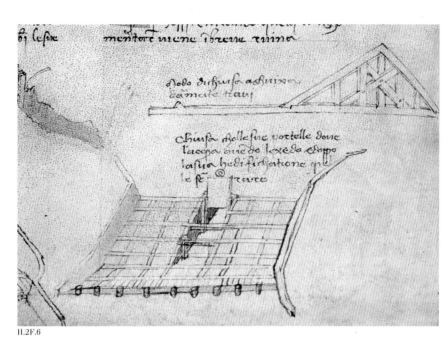

II.2F.6

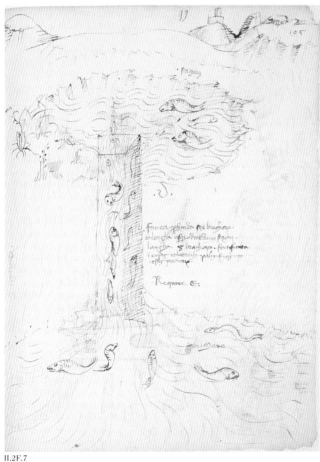

II.2F.7

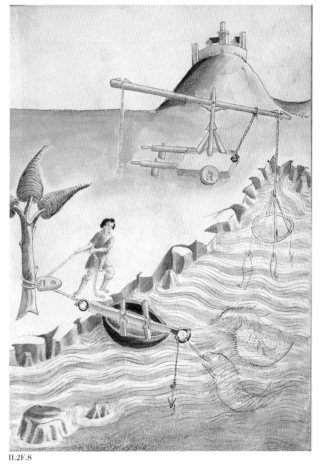

II.2F.8

II.2F.9a

II.2F.9b

II.2F.9 a-b
TACCOLA
Fishing scenes in a fish-stock lake
Cod. Lat. Monacensis 197 II (BSBM), fols. 101r
and 119r (details)

II.2F.10
TACCOLA
Night-time fishing with a lamp
Cod. Lat. Monacensis 197 II (BSBM), fol. 119v

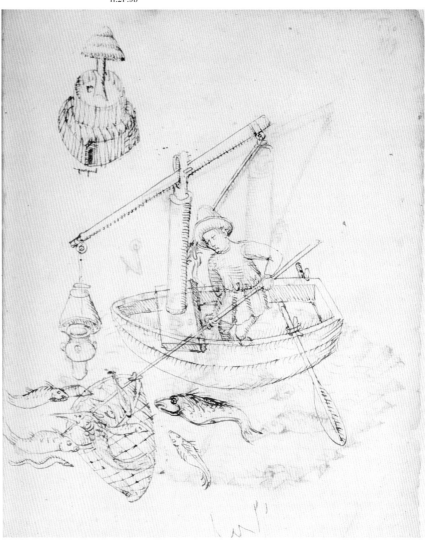

II.2F.10

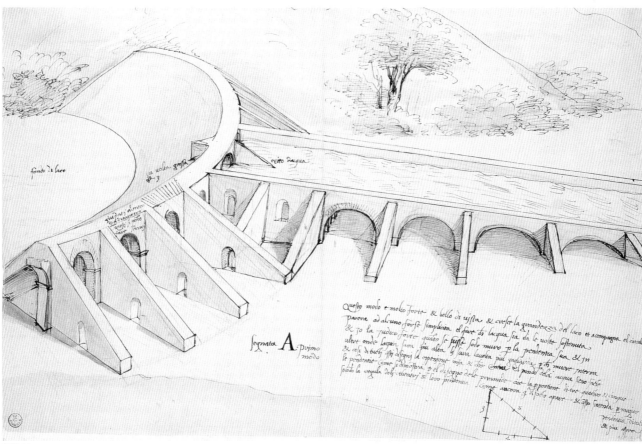

II.2F.11

II.2F.11-16
BALDASSARRE PERUZZI
Drawings of dams
Pen on paper
GDSU

Six drawings of river dams by the
Sienese architect Peruzzi (ca. 1530).
This is all that survives of a series of at
least eleven drawings, in all likelihood
connected with the Sienese Republic's
plan to rebuild the Bruna River dam af-
ter the original structure collapsed in
1492. Peruzzi envisaged very thick
walls and devoted great attention to the
regulation of water flow.

II.2F.11
The "first design" shows a dam with
a concave profile facing the water
basin
GDSU, 584A

II.2F.12
The "second design" resembles
the first except for the horizontal
structure
GDSU, 585A

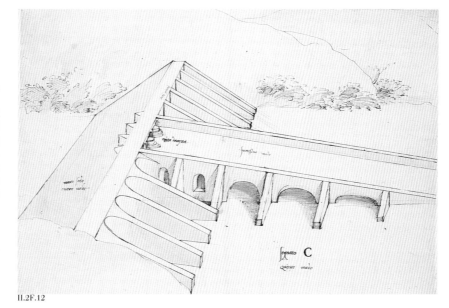

II.2F.12

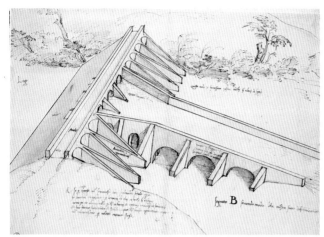

II.2F.13

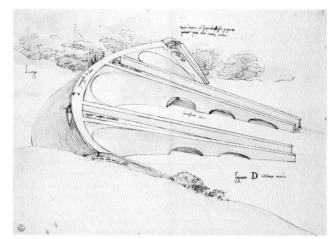

II.2F.14

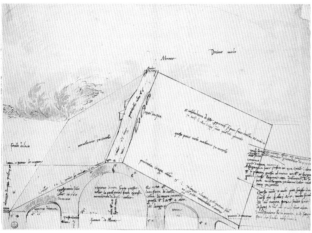

II.2F.15

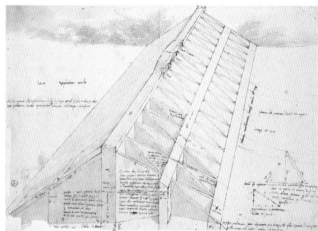

II.2F.16

II.2F.13
The "fifth design" is a variant
of the second, except that
the buttresses form a single structure
GDSU, 586A

II.2F.14
The "eighth design" consists
in a gravity dam with a convex
upstream profile and four spillways
GDSU, 587A

II.2F.15
The "tenth design" is a linear
structure with three spillways
and a continuous slope
for the water flow
GDSU, 588A

II.2F.16
The "eleventh design" is a straight
dam with three vertical parallel
walls spanning the entire width
of the structure
GDSU, 589A

II.3 Warfare

Military engineering is another major theme in the work of Taccola and Francesco di Giorgio. Taccola was seeking employment with Emperor Sigismund of Hungary, who visited Siena in 1432-33. Francesco, meanwhile, collaborated with two of the leading warrior-princes of the fifteenth century: Federico da Montefeltro, Duke of Urbino, and Alfonso of Aragon, Duke of Calabria.

Taccola and Francesco were living in a transitional period for military technology.

The devices and techniques of classical and medieval times were still in widespread use, while the advent of firearms and the bombard – defined by Francesco di Giorgio as a "diabolical invention" – posed an ever-greater threat.

II.3A.1a

II.3A.2a

II.3A *The Frieze of the Art of War*

In about 1475, Federico da Montefeltro conceived the project of decorating a long bench in front of the Palazzo Ducale of Urbino with 72 panels of carved stone.

The Duke clearly intended the iconography as a tribute to the valor of the warrior-prince, a role he personified to a consummate degree. Most of the panels are effectively devoted to military themes.

Francesco di Giorgio helped define the concept of the frieze. Many panels illustrate machines and systems taken from the drawings of the Sienese artist-engineer. Francesco thus imprinted the stamp of the Sienese engineering tradition on the façade of one of the most outstanding monuments of the Renaissance.

II.3A.1a-b
Three-speed hoist
After Francesco di Giorgio, Ms. Saluzziano 148 (BRT), fol. 51r (detail)
Museo Stoppani Buonamici, Urbino, n. 72
Plaster copy of carved stone panel; 84 x 69 x 5 cm
Made by: L. Becagli and C. Cecconi, Florence, 1995
Istituto e Museo di Storia della Scienza, Florence

II.3A.2a-b
Siege ladder mounted on a carriage
After Francesco di Giorgio, Ms. 197.b.21 (BML), fol. 70v
Museo Stoppani Buonamici, Urbino, n. 22
Plaster copy of carved stone panel; 84 x 69 x 5 cm
Made by: L. Becagli and C. Cecconi, Florence, 1995
Istituto e Museo di Storia della Scienza, Florence

II.3A.3a

II.3A.4a

II.3A.5a

II.3A.6a

II.3A.3a-b
Floating pile-driver operated by a treadmill
After Francesco di Giorgio, Ms. 197.b.21 (BML), fol. 48v
Museo Stoppani Buonamici, Urbino, n. 42
Plaster copy of carved stone panel
84 x 68 x 5 cm
Made by: L. Becagli and C. Cecconi, Florence, 1995
Istituto e Museo di Storia della Scienza, Florence

II.3A.4a-b
Noria
After Francesco di Giorgio, Ms. Saluzziano 148 (BRT), fol. 48r (detail)
Museo Stoppani Buonamici, Urbino, n. 35
Plaster copy of carved stone panel
84 x 68 x 5 cm
Made by: L. Becagli and C. Cecconi, Florence, 1995
Istituto e Museo di Storia della Scienza, Florence

II.3A.5a-b
Raisable rampart
After Francesco di Giorgio, Ms. 197.b.21 (BML), fol. 21v
Museo Stoppani Buonamici, Urbino, n. 48
Plaster copy of carved stone panel
84 x 68.5 x 5 cm
Made by: L. Becagli and C. Cecconi, Florence, 1995
Istituto e Museo di Storia della Scienza di Florence

II.3A.6 a-b
Clock-bell mechanism
After Francesco di Giorgio, Ms. 197.b.21 (BML), fol. 71v
Museo Stoppani Buonamici, Urbino, n. 52
Plaster copy of carved stone panel
84 x 69 x 5 cm
Made by: L. Becagli and C. Cecconi, Florence, 1995
Istituto e Museo di Storia della Scienza, Florence

II.3A.7a-b
Hydraulic saw-mill
After Francesco di Giorgio, Ms. 197.b.21 (BML), fol. 72v
Museo Stoppani Buonamici, Urbino, n. 44
Plaster copy of carved stone panel
84 x 69 x 5 cm
Made by: L. Becagli and C. Cecconi, Florence, 1995
Istituto e Museo di Storia della Scienza, Florence

II.3A.8a-b
Pyramid-raising device
After Francesco di Giorgio, Ms. Lat. Urbinas 1757 (BAV), fol. 167v (detail)
Museo Stoppani Buonamici, Urbino, n. 43
Plaster copy of carved stone panel
84 x 68.5 x 5 cm
Made by: L. Becagli and C. Cecconi, Florence, 1995
Istituto e Museo di Storia della Scienza, Florence

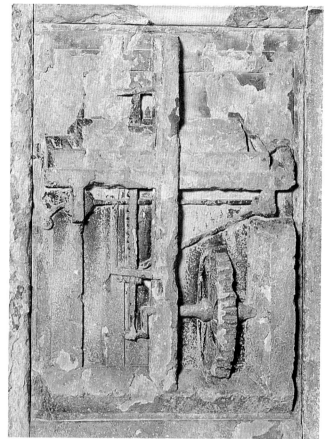

II.3A.7a

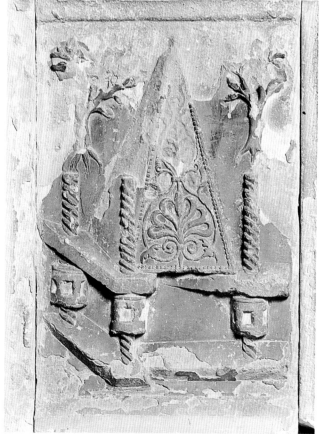

II.3A.8a

II.3B *Traditional technology of warfare*

The systems and weaponry of classical and medieval warfare predominate in Taccola's studies of military technology. His interest focused on siege machines, such as trebuchets and giant crossbows (*balistae*), articulated ladders to scale the steep walls of medieval fortresses, battering rams, and hull-boring devices. Francesco, as well, recorded the varied weaponry used in medieval warfare.

His manuscripts abound with visual quotations from classical authors, alongside the vastly more efficient firearms of recent invention.

II.3B.1a
TACCOLA
Trebuchet
Cod. Lat. Monacensis 197 II (BSBM), fol. 39v

II.3B.1b
Trebuchet
Working model after Taccola, Cod. Lat. Monacensis 197 II (BSBM), fol. 39v
Durmast, beech, chestnut, and metal
332 x 211 x 165 cm
Built by: SARI and M. Mariani, Florence, 1991
IBM Semea, Milan and University of Siena

The trebuchet, a siege weapon invented in the Middle Ages, was designed to hurl heavy stones to breach the walls of the enemy fortress. The rotating beam held a sling carrying the projectile at one end, and two stone-laden crates as counterweights at the other end.
The beam was swung sharply by lowering the counterweights, releasing the projectile. The device was loaded by means of the hoist.
The drawing by Taccola on which this model is based gives the trebuchet's precise dimensions. The actual machine would have stood at least 15 meters (50 feet) tall, by no means an uncommon height for a trebuchet.

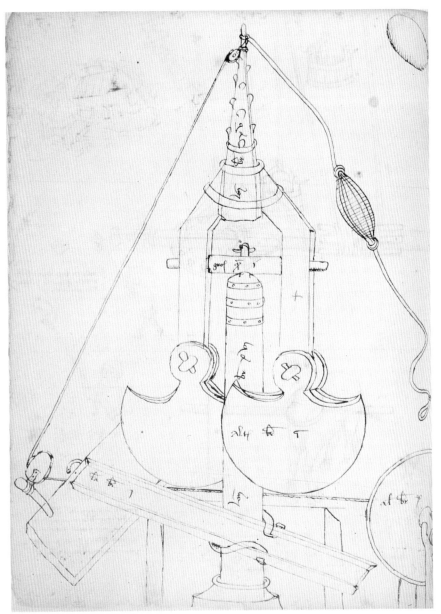

II.3B.1a

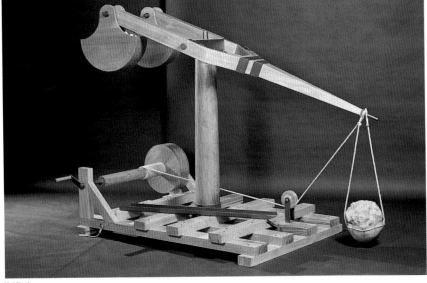

II.3B.1b

II.3B.2a
TACCOLA
Stop-motion trebuchet
Cod. Lat. Monacensis 197 II (BSBM), fol. 95r

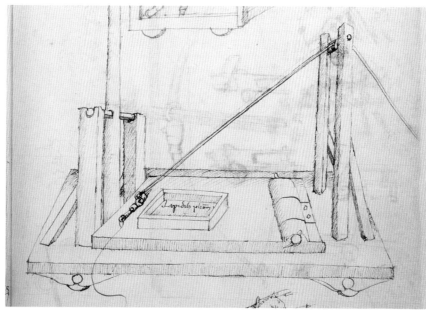

II.3B.2a

II.3B.2b

Stop-motion trebuchet

Working model after Taccola, Cod. Lat.
Monacensis 197 II (BSBM), fol. 95r
Durmast and metal; 60 × 40 × 90 cm
Built by: SARI and FA-MA, Florence, 1991
IBM Semea, Milan

The operating principle of this tre-
buchet differs from the preceding type.
The beam is powered by the stone-
filled counterweight crate, but its trav-
el is stopped short by a cross-beam,
causing the release of the projectile.

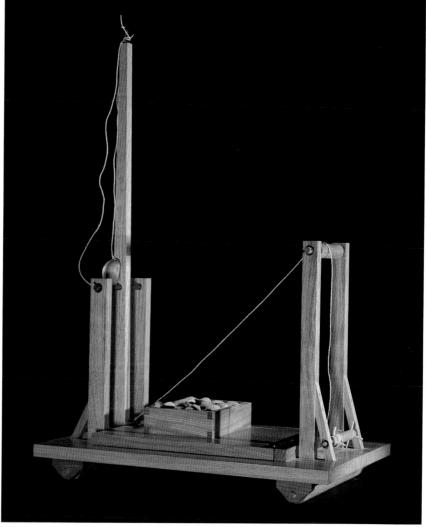

II.3B.2b

II.3B.3
TACCOLA
Swing-arm trebuchet
Ms. Palatino 766 (BNCF), fols. 40v-41r

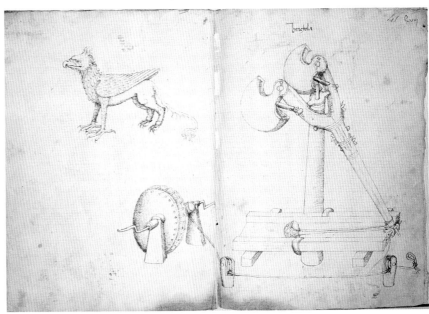

II.3B.3

II.3B.4
PAOLO SANTINI (after TACCOLA)
**Swing-arm trebuchet (center),
bombard, and incendiary barrels**
Ms. Lat. 7239 (BNP), fol. 22v

II.3B.4

II.3B.5
FRANCESCO DI GIORGIO
Swing-arm trebuchet
Ms. 197.b.21 (BML), fol. 3v

II.3B.6
FRANCESCO DI GIORGIO
Hammer trebuchet
Ms. II.I.141 (BNCF), fol. 194v

II.3B.7
FRANCESCO DI GIORGIO
**Trebuchet to rain stones
on attackers**
Ms. II.I.141 (BNCF), fol. 193r

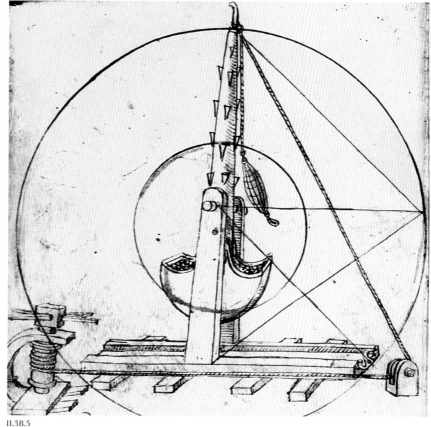

II.3B.5

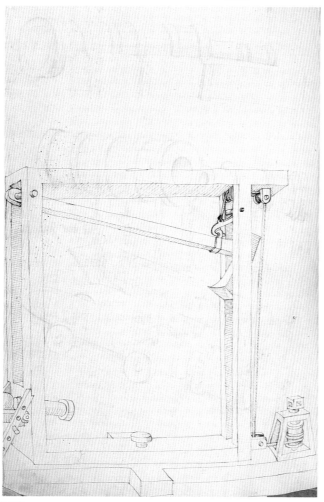

II.3B.6

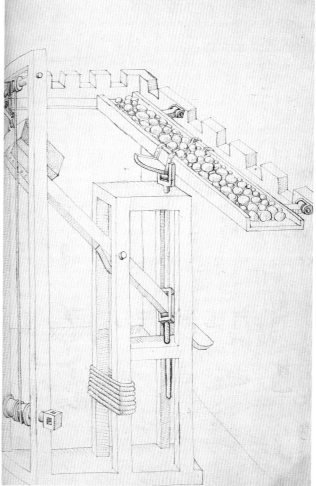

II.3B.7

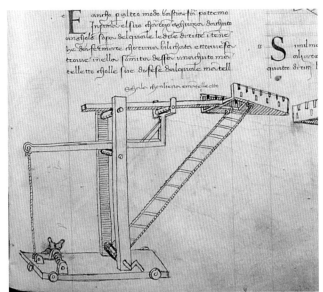

II.3B.8a

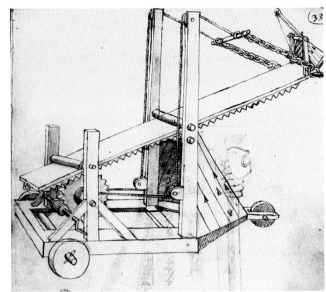

II.3B.9a

II.3B.8a
FRANCESCO DI GIORGIO
Transportable articulated ladder
Ms. Saluzziano 148 (BRT), fol. 63r (detail)

II.3B.8b
Transportable articulated ladder
Working model after Francesco di Giorgio,
Ms. Saluzziano 148 (BRT), fol. 63r
Durmast and metal; 90 x 130 x 38.5 cm
Built by: Nuova SARI, Florence, 1995
Istituto e Museo di Storia della Scienza,
Florence

The ladder is used to cross the moat commonly surrounding the medieval fortress. The articulations are controlled by one jack, while another keeps the rope ladder taught.

II.3B.9a
FRANCESCO DI GIORGIO
Mobile siege bridge
Ms. 197.b.21 (BML), fol. 33r (detail)

II.3B.9b
Mobile siege bridge
Working model after Francesco di Giorgio,
Ms. 197.b.21 (BML), fol. 33r
Oak and metal; 86 x 118 x 33 cm
Built by: Nuova SARI, Florence, 1995
Istituto e Museo di Storia della Scienza,
Florence

The bridge is operated by means of a crank that meshes with a toothed wheel. The wheel moves a toothed rack on the underside of the bridge, which travels between two rollers. The wheel motions are coordinated with those of a pair of ropes fastened to a chains-and-shaft frame. The bridge is fitted with a raisable protection shield.

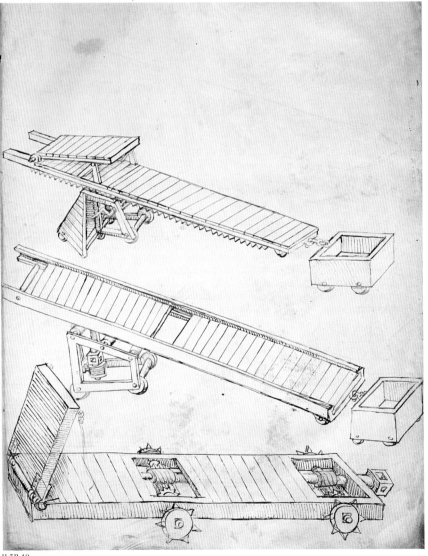

II.3B.10

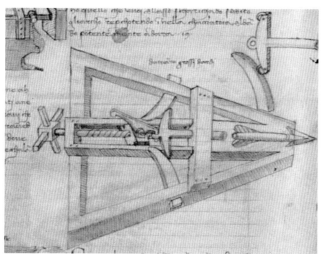

II.3B.11

II.3B.12

II.3B.10
FRANCESCO DI GIORGIO [?]
Mobile articulated siege ladder
Chigi Saracini Parchments, Siena

II.3B.11
FRANCESCO DI GIORGIO
**Crossbow with wooden
screw-loaded springs**
Ms. Saluzziano 148 (BRT), fol. 61v (detail)

II.3B.12
TACCOLA
**Galloping horse armed with sharp
spears**
Cod. Lat. Monacensis 28800 (BSBM), fol. 67r

II.3B.13
TACCOLA
**Night assault chariot with sharp
spears and lamp (lower drawing)**
Cod. Lat. Monacensis 28800 (BSBM), fol. 15r

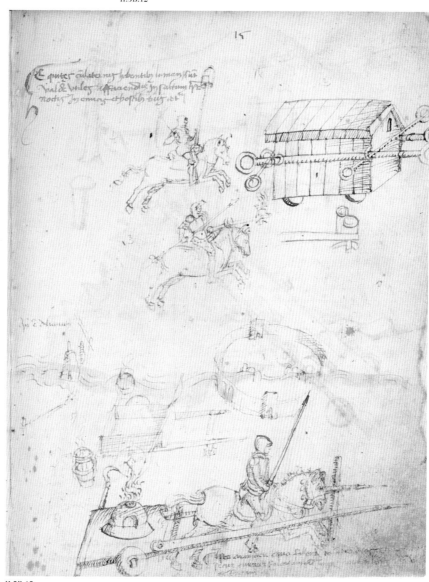

II.3B.13

II.3B.14
TACCOLA
Assault chariots, mobile shelters, and military devices
Cod. Lat. Monacensis 197 II (BSBM), fol. 82r

II.3B.15
FRANCESCO DI GIORGIO
Exterminating angel on scythed chariot
Ms. 197.b.21 (BML), fol. 32r

II.3B.16
PAOLO SANTINI (after TACCOLA)
Stratagem to defend a fort abandoned by its garrison
Ms. Lat. 7239 (BNP), fol. 77r

The dog, in trying to reach for the food and water, causes the tower bell to ring, giving attackers the impression that the fort is still occupied.

II.3B.17
ANONYMOUS (after TACCOLA)
Various types of counterweight-operated hull-piercing devices
Ms. S.IV.5 (BCS), fol. 40v

These devices were concealed under water at port entrances to prevent access by enemy ships.

II.3B.18
ANONYMOUS (after TACCOLA)
Counterweight-operated hull-piercing devices
Ms. S.IV.5 (BCS), fol. 45r

II.3B.19
ANONYMOUS (after TACCOLA)
Ship with hull-piercing device operated by a hoist and lever
Ms. Palatino 767 (BNCF), p. 140

II.3B.20
ANONYMOUS
Armored oar-boat with a pair of battering rams
Ms. S.IV.5 (BCS), fol. 49v

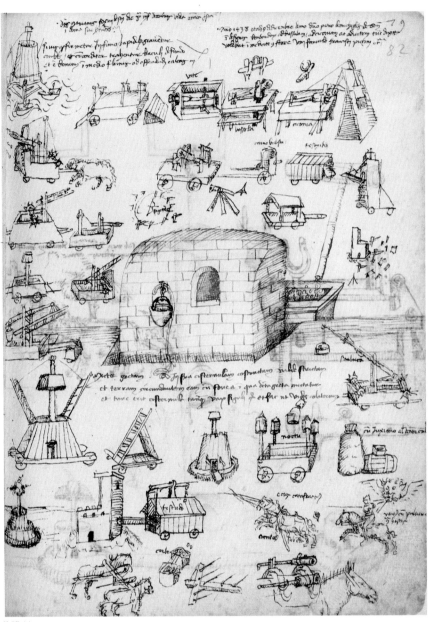

II.3B.14

II.3B.15

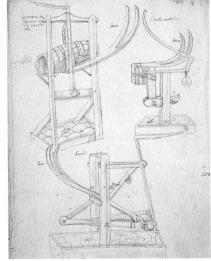

II.3B.17

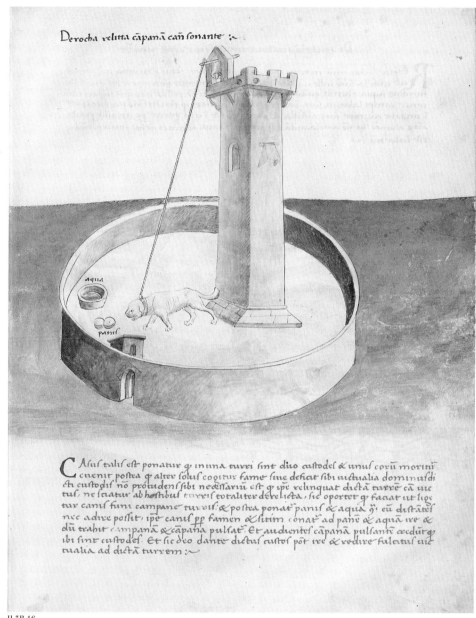

Derocha relicta cāpanā cañ sonante :~

CAsus talis est ponatur q̄ in una turri sint duo custodes & unus coru̅ mori̅tr̄
euenit postea q̄ alter solus cogitur fame sine deficit sibi uictualia dominusdi
& custodis nō prouidens sibi necessarium est q̄ ipe relinquat dictā turre̅ cã uic
tus, ne sciatur ab hostibus turris totaliter derelicta, sic oportet q̄ faciat ut lige
tar canis fini campane turris & postea ponat panis & aquā ñ eu̅ distāueī
nec adire possit, ipe canis pp famen & sitim conat̄ ad pane & aquā ire &
du̅ trahit campanā & cāpana pulsat. Et audientes cāpanā pulsantē cedu̅t q̄
ibi sint custodes. Et sic deo dante dictus custos pōt ire & redire fultatus uic
tualia ad dictā turrem :~

II.3B.16

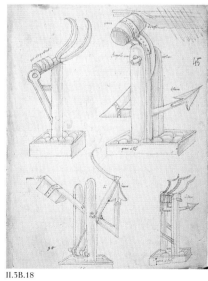

II.3B.18

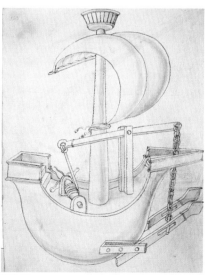

II.3B.19

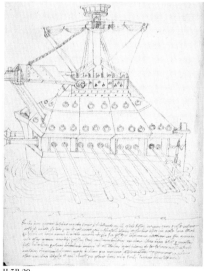

II.3B.20

II.3C *Firearms*

Taccola and Francesco di Giorgio were fascinated – not to say obsessed – with the military uses of incendiary mixtures ("Greek fire") and explosives. Both authors, for example, illustrate the preparation of a mine to blow up a fortress.

Francesco successfully exploded a mine in Naples in 1495.

Bombards, small cannons, and mortars recur in Taccola's works.

Francesco di Giorgio devotes special attention to the bombard. He classifies the different types of this new deadly weapon by size, shape, and projectile weight.

Unlike Taccola, Francesco actually engaged in firearms manufacturing, an activity in which Siena excelled in the second half of the fifteenth century thanks to the presence of many skilled craftsmen.

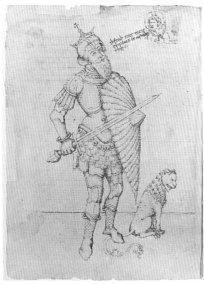

II.3C.2

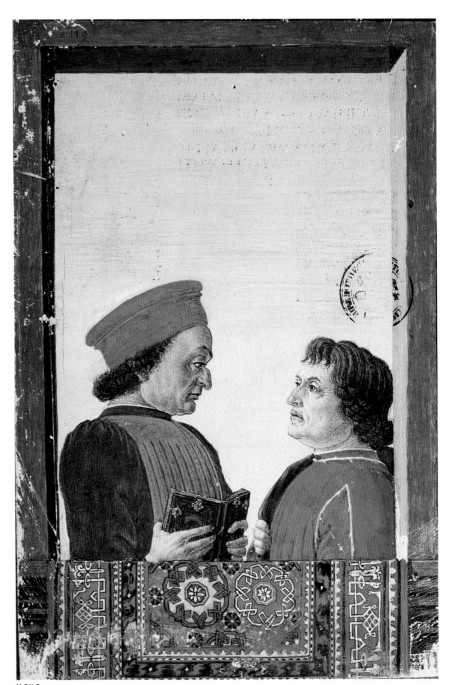

II.3C.3

II.3C.1

Frame of the Porta della Guerra
Palazzo Ducale, Urbino
Plaster cast; 435 x 270 x 15 cm
University of Siena

The Porta della Guerra (Gate of War) and Porta della Iole (Gate of the Skiff) of the Palazzo Ducale in Urbino record a group of war-related themes. There are several reasons for attributing the design of the motifs to Francesco di Giorgio, in particular the many similarities with the subjects depicted on the Frieze of the Art of War in the Palazzo Ducale.

II.3C.2
TACCOLA
Portrait of Emperor Sigismund of Hungary
Ms. Palatino 766 (BNCF), fol. 1v

The emperor, protector of the Ghibelline city-state of Siena, is shown crushing the tail of the seated lion (*marzocco*), symbol of the enemy Republic of Florence.

II.3C.3
ANONYMOUS
Presumed portrait of Federico da Montefeltro with Francesco di Giorgio
Ms. Lat. Urbinas 508 (BAV), verso of cover

II.3C.4

ANONYMOUS

Capture of Colle Val d'Elsa

Tavoletta di Biccherna (ASS), n. 39; 60 × 48 cm

This small painting celebrates the surrender of Colle Val d'Elsa in 1479 to the forces of the coalition formed by the Republic of Siena, the Pope, and the Kingdom of Naples against the Florentines after the Pazzi conspiracy.
Francesco di Giorgio took part in the military operations.

II.3C.4

II.3C.5

PAOLO SANTINI (after TACCOLA)

Horsemen and chariots with incendiary barrels

Ms. Lat. 7239 (BNP), fol. 19r

II.3C.6

PAOLO SANTINI (after TACCOLA)

Chariot with incendiary barrels and scythed chariot

Ms. Lat. 7239 (BNP), fol. 78r

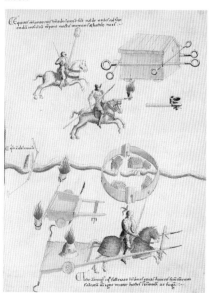

II.3C.5

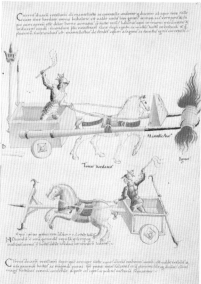

II.3C.6

II.3C.7

TACCOLA

Horseman with flaming spear

Cod. Lat. Monacensis 28800 (BSBM), fol. 68r

II.3C.8

TACCOLA

Horseman attacked by armored dogs carrying fire

Cod. Lat. Monacensis 28800 (BSBM), fol. 57r

II.3C.9

TACCOLA

Underground mine causing a fortress to collapse

Cod. Lat. Monacensis 28800 (BSBM), fol. 48v

II.3C.10

FRANCESCO DI GIORGIO

Underground mine causing a tower to collapse

Ms. Ashburnham 361 (BMLF), fol. 50r (detail)

II.3C.11

TACCOLA

Horseman with light musket

Cod. Lat. Monacensis 197 II (BSBM), fol. 21r

II.3C.12

ANONYMOUS

Incendiary cannonballs and petards

Ms. S.IV.5 (BCS), fol. 48v

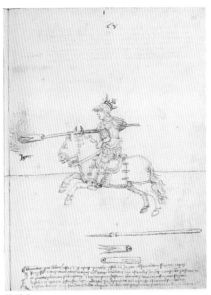

II.3C.7

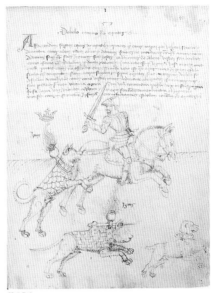

II.3C.8

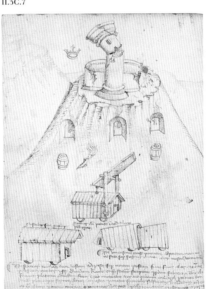

II.3C.9

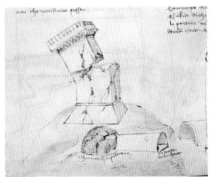

II.3C.10

II.3C.12

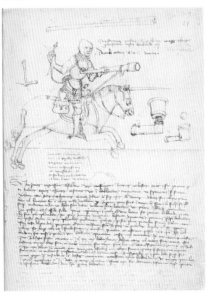

II.3C.11

II.3C.13
FRANCESCO DI GIORGIO [?]
Petards fired by bombards
Chigi Saracini Parchments, Siena

II.3C.14
FRANCESCO DI GIORGIO [?]
Petards for use on land and water
Chigi Saracini Parchments, Siena

II.3C.15
FRANCESCO DI GIORGIO
**Definition and classification
of different types of bombards**
Ms. II.I.141 (BNCF), fol. 48r

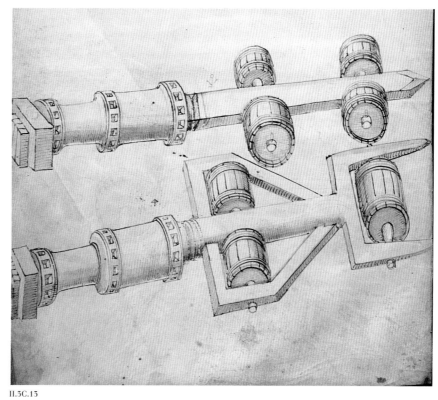

II.3C.13

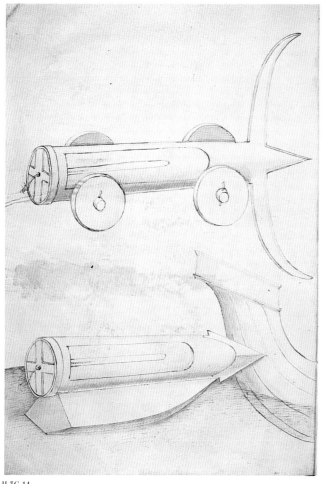

II.3C.14

II.3C.15

II.3C.16
ANONYMOUS
(after FRANCESCO DI GIORGIO)
Drawing of five different types
of bombards
Ms. Palatino 767 (BNCF), p. 163

II.3C.17
ANONYMOUS
(after FRANCESCO DI GIORGIO)
Bombard signed *Opus Francisci*
(Francesco di Giorgio?)
Ms. Palatino 767 (BNCF), p. 162

II.3C.18
FRANCESCO DI GIORGIO
Mobile shelters for bombards
Ms. Ashburnham 361 (BMLF), fol. 51v

II.3C.19
FRANCESCO DI GIORGIO [?]
Mechanized mobile shelters
for bombards
Chigi Saracini Parchments, Siena

II.3C.20
FRANCESCO DI GIORGIO [?]
Mobile shelters for soldiers
Chigi Saracini Parchments, Siena

II.3C.21
ANONYMOUS
Bombard unloaded from a ship
Ms. S.IV.5 (BCS), fol. 54r

II.3C.22
ANONYMOUS
Armored pontoon equipped
with a giant bombard
Ms. S.IV.5 (BCS), fol. 49r

II.3C.16

II.3C.17

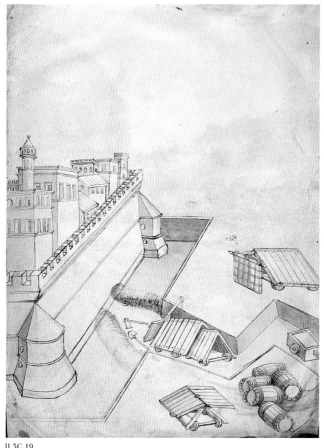

II.3C.19

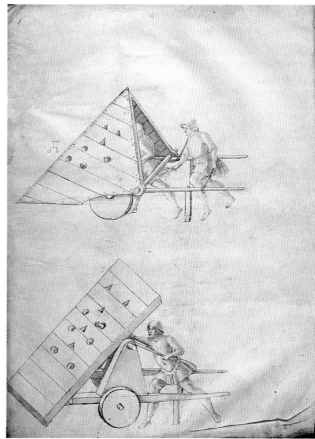

II.3C.20

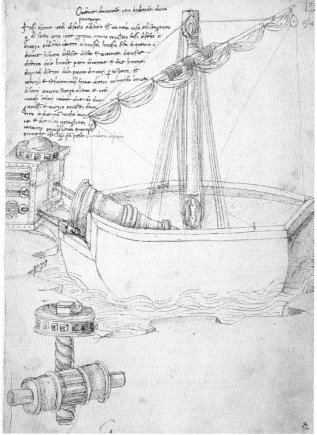

II.3C.21

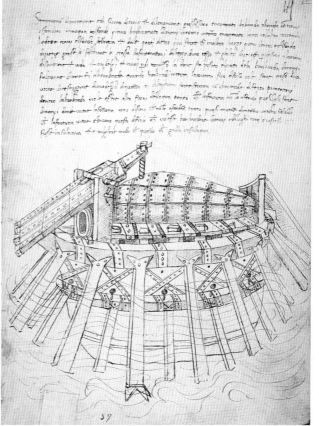

II.3C.22

II.4 Machines in the City

Machinery and devices for raising and moving construction materials are a recurrent topic in the manuscripts of the Sienese engineers. Taccola depicts many worksite machines, typically of conventional design.
He was clearly fond of small-sized equipment fitted on wheeled platforms. Francesco di Giorgio focused instead on gigantic machines with highly complex gears – toothed wheels, pinions, and, especially, worm-screw-and-rack systems – designed to raise and move columns, obelisks, and even towers.

II.4A *Moving columns, obelisks, and towers*

Francesco di Giorgio designed a series of prodigiously complex machines to move, raise, and position columns, obelisks, and even towers. These inventions are linked to the projects for shifting columns and obelisks initiated in Rome by Popes Nicholas V and Paul II. The equipment routinely incorporates the worm screw and toothed rack, two components absent from Taccola's designs. Francesco's drawings of this kind of machines were immensely successful, and were copied up to the early seventeenth century.

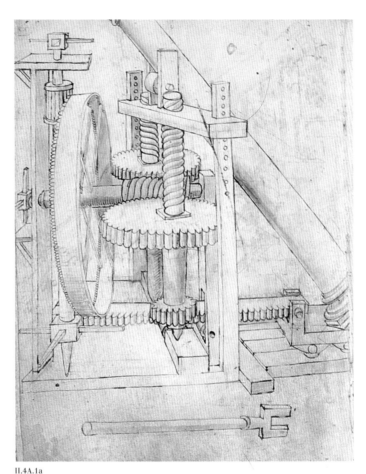

II.4A.1a
FRANCESCO DI GIORGIO
Column-lifter
Ms. 197.b.21 (BML), fol. 27v

II.4A.1a

II.4A.1b
Column-lifter
Working model after Francesco di Giorgio,
Ms. 197.b.21 (BML), fol. 27v
Durmast, elm, ilex, and metal
197 x 400 x 149 cm
Built by: SARI and FA-MA, Florence, 1991
University of Siena

This powerful machine was operated by hand. The column was raised by means of other devices beforehand, then placed on the horizontal slide. A system composed of a toothed wheel and pinion transmitted the motion via a worm screw to the horizontal toothed wheels and the parallel toothed wheels below. The latter meshed with a rack that pulled the wheeled platform on which the column base rested.

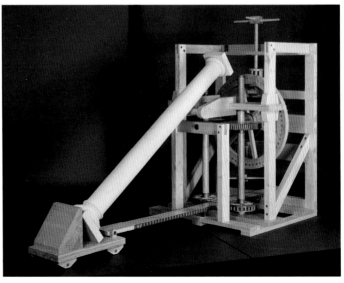

II.4A.1b

II.4A.2
FRANCESCO DI GIORGIO
Column-lifter
Ms. 197.b.21 (BML), fol. 27r

The machine is operated by a system
comprising a toothed wheel, pinion,
worm screw, and rack.

II.4A.3
FRANCESCO DI GIORGIO
Column-lifter
Ms. 197.b.21 (BML), fol. 8r

Its base resting on a wheeled platform,
the column is lifted by a bar-and-
shackle assembly raised by two worm
screws that mesh with two racks.

II.4A.4
FRANCESCO DI GIORGIO
Column-lifter
Ms. 197.b.21 (BML), fol. 7v

Raising a column with a cross-frame
operated by two screws and articulated
arms.

II.4A.5
FRANCESCO DI GIORGIO
**Column-lifter with platform raised
by two worm screws**
Ms. 197.b.21 (BML), fol. 30v

II.4A.6
FRANCESCO DI GIORGIO
**Column-lifter with jack-operated
lever beam**
Ms. 197.b.21 (BML), fol. 56r

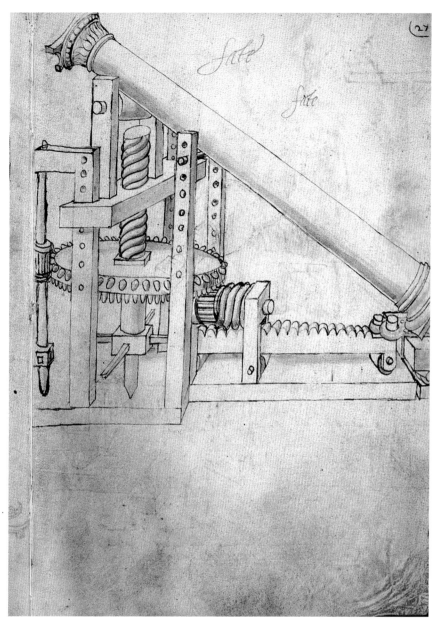

II.4A.2

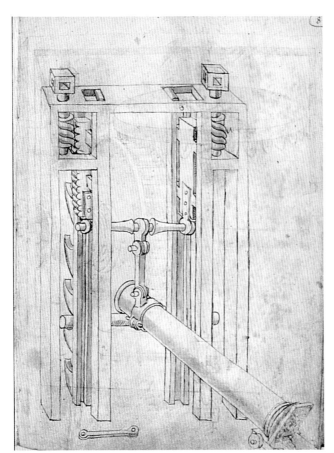

II.4A.3

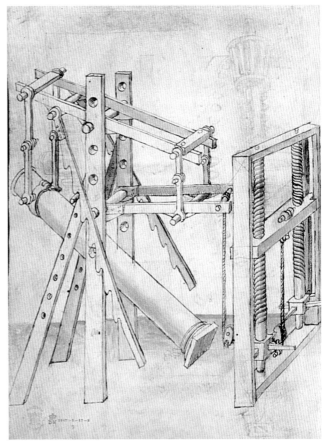

II.4A.4

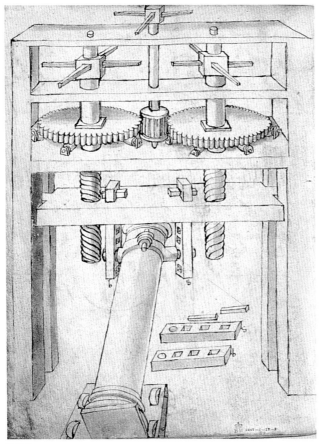

II.4A.5

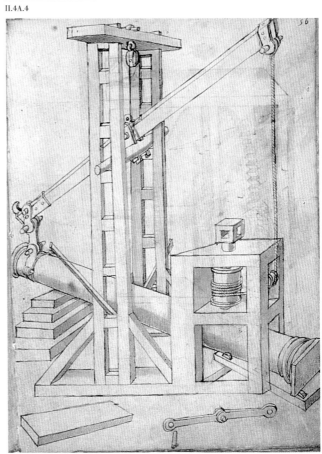

II.4A.6

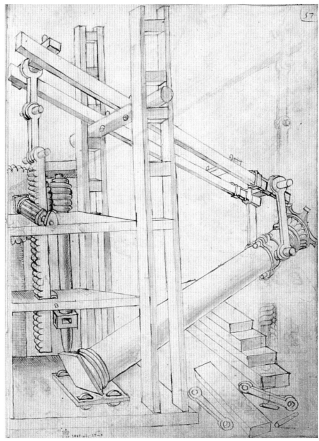

II.4A.7

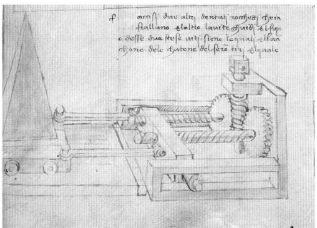

II.4A.8

II.4A.9

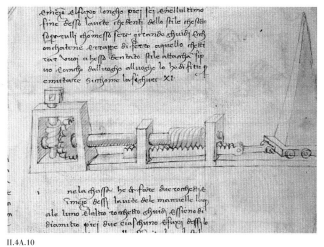

II.4A.10

II.4A.7
FRANCESCO DI GIORGIO
Column-lifter
Ms. 197.b.21 (BML), fol. 57r

The device consists of a pair of lever beams driven by a pinion, worm screw, and vertical rack.

II.4A.8
FRANCESCO DI GIORGIO
Obelisk-moving device
Ms. Ashburnham 361 (BMLF), fol. 45v (detail)

The obelisk is moved on a sliding platform driven by two worm screws.

II.4A.9
FRANCESCO DI GIORGIO
Various types of obelisk-moving devices
Ms. Ashburnham 361 (BMLF), fol. 45v

II.4A.10
FRANCESCO DI GIORGIO
Obelisk-moving device
Ms. Ashburnham 361 (BMLF), fol. 45r (detail)

The system comprises a toothed wheel, pinion, worm screw, and rack.

II.4A.11
FRANCESCO DI GIORGIO
Obelisk-raising device
Ms. Ashburnham 361 (BMLF), fol. 46r (detail)

The obelisk is raised by means of two
vertical racks driven by two worm
screws.

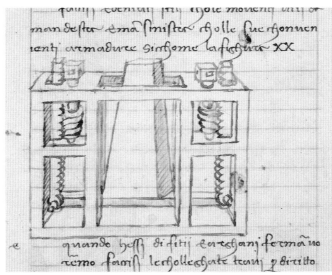

II.4A.11

II.4A.12
ANONYMOUS
(after FRANCESCO DI GIORGIO)
Moving a tower
Ms. Getty (GCM), fol. 33r

The tower is moved by means of a rack
driven by a worm screw. The lower
drawing gives a detailed view of the
mechanism to loosen the tower from
its foundations.

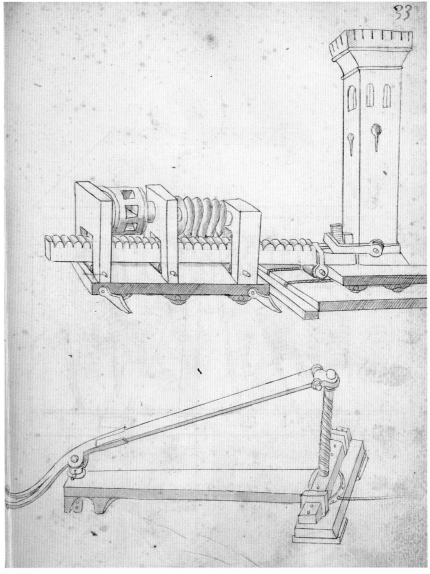

II.4A.12

II.4B *Construction machinery*

Brunelleschi's worksite for the construction of the dome of Florence Cathedral was, in a way, a "real-life school" for several generations of engineers. Obvious echoes of Brunelleschian machinery can be found in the works of Taccola and Francesco di Giorgio.

However, the two Sienese engineers also designed smaller, less innovative equipment that was easy to handle and highly efficient.

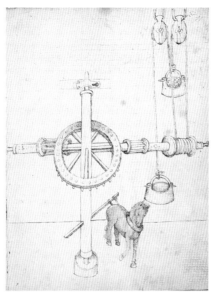

II.4B.1

II.4B.1
TACCOLA
Brunelleschi's reversible hoist
Ms. Palatino 766 (BNCF), fol. 11r

The change from load-raising to load-lowering mode is here obtained via the radial shift of the horizontal shaft.

II.4B.2
FRANCESCO DI GIORGIO
Mobile crane on rollers with hoist
Ms. 197.b.21 (BML), fol. 6v

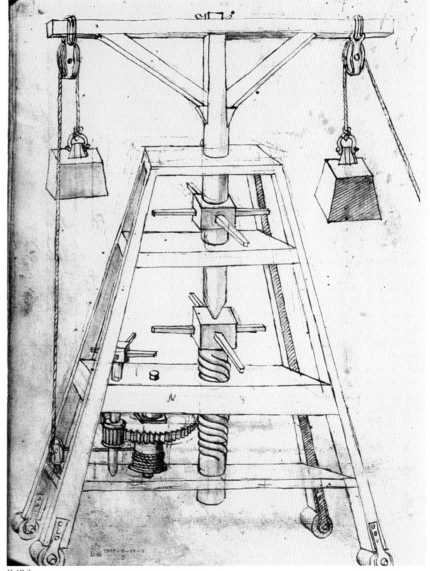

II.4B.2

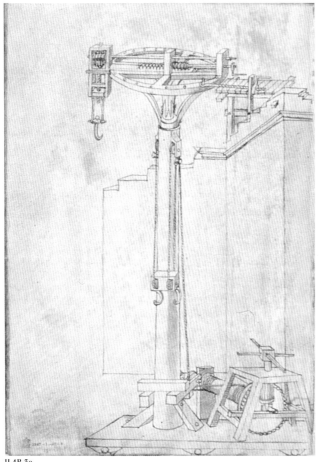

II.4B.3a

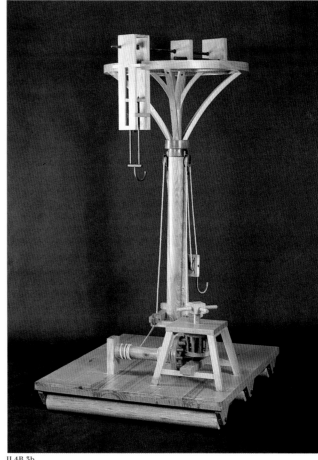

II.4B.3b

II.4B.3a

FRANCESCO DI GIORGIO
Transportable crane with hoist
Ms. 197.b.21 (BML), fol. 11v

II.4B.3b

Transportable crane with hoist
Working model after Francesco di Giorgio,
Ms. 197.b.21 (BML), fol. 11v
Durmast, ilex, elm, and metal
231 x 158 x 100 cm
Built by: SARI and FA-MA, Florence, 1991
University of Siena

The hoist on the ground raises the load
up the crane shaft by means of ropes
and pulleys. The load is then picked up
by the crane, which deposits it in the
required location. The crane is maneu-
vered by the vertical and horizontal
screws on the circular platform atop
the machine. The crane possesses a
modest rotating capability. The device
is significant for its mobility and be-
cause it performs functions that usual-
ly required two separate machines, a
hoist and a crane.

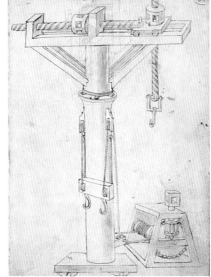

II.4B.4

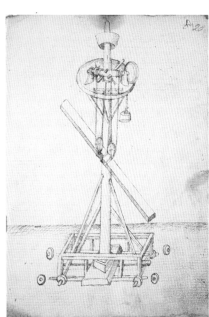

II.4B.5

II.4B.4
FRANCESCO DI GIORGIO
Transportable crane with hoist
Ms. 197.b.21 (BML), fol. 12r

II.4B.5
TACCOLA
Mobile lifting device
Ms. Palatino 766 (BNCF), fol. 20r

II.4B.6
TACCOLA
Lifting device with pincers
Cod. Lat. Monacensis 28800 (BSBM), fol. 30r

II.4B.7
TACCOLA
Bell-lifting device
with counterweight
Cod. Lat. Monacensis 28800 (BSBM), fol. 42v

II.4B.8
FRANCESCO DI GIORGIO
Transportable lifting device
Ms. 197.b.21 (BML), fol. 12v

II.4B.9
FRANCESCO DI GIORGIO
Screw-operated lifting devices
Ms. 197.b.21 (BML), fol. 2v

II.4B.10
FRANCESCO DI GIORGIO
Lifting device on wheeled frame
with inverted screw-powered
system to adjust height
Ms. Ashburnham 361 (BMLF), fol. 46r (detail)

II.4B.11a
FRANCESCO DI GIORGIO
Pile-driver
Ms. 197.b.21 (BML), fol. 19v

II.4B.11b
Pile-driver
Working model after Francesco di Giorgio,
Ms. 197.b.21 (BML), fol. 19v
Durmast and metal; 115 x 64 x 32 cm
Built by: Nuova SARI, Florence, 1995
Istituto e Museo di Storia della Scienza,
Florence

The hoist, by means of two ropes, con-
trols the vertical travel of the two hooks
that alternately raise the drop ham-
mer. When the carrying hook reaches
the maximum height, it is forced to re-
lease the hammer. The other hook is
then positioned to pick up the hammer,
and the cycle is repeated.

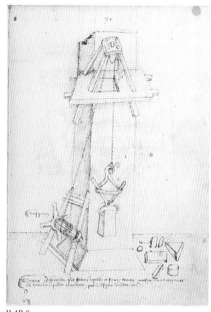

II.4B.6

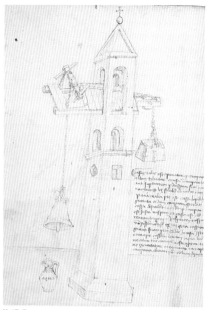

II.4B.7

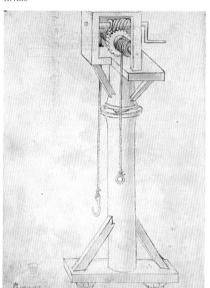

II.4B.8

II.4B.9

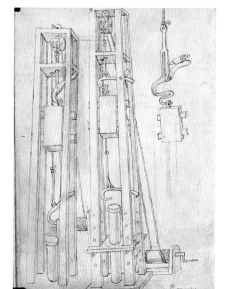

II.4B.11a

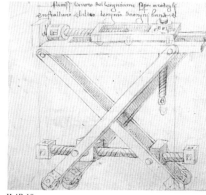

II.4B.10

II.5 Energy for machines

Harnessing energy is a key aspect of all technological systems. Taccola paid special attention to machines operated by human and animal power. His mill designs include many examples of tide mills and floating mills.

Francesco di Giorgio carried out a detailed analysis of the mill, describing no fewer than 58 kinds, including waterwheel mills, recirculation mills, windmills, weight-driven mills, human-powered mills, and animal-powered mills. Francesco's mills feature highly complex systems for transmitting motion.

Both Taccola and Francesco illustrate equipment that uses the crank-and-rod system. The manuscripts of the Sienese engineers make relatively few references to mill-operated machines.

II.5A *Living energy sources*

In the technical world of Taccola and Francesco, the basic energy sources are humans and animals. Human power is used for those operations that require continuous variations in velocity, non-programmable stops, and high precision.

Francesco designed gigantic carriages fitted with unusually complex systems for transmitting motion.

These vehicles, he imagined, could be operated by human power. The carriages were intended to create special effects in court festivities and ceremonies. They could also be used to bring soldiers safely up to the foot of enemy walls.

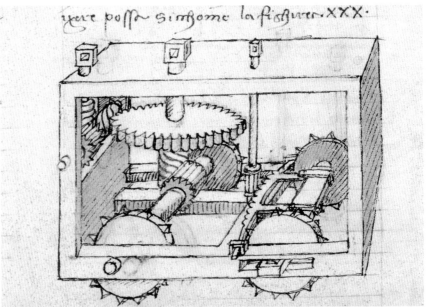

II.5A.1a

II.5A.1a
FRANCESCO DI GIORGIO
Carriage
Ms. Ashburnham 361 (BMLF), fol. 46v (detail)

II.5A.1b
Carriage
Working model after Francesco di Giorgio,
Ms. Ashburnham 361 (BMLF), fol. 46v
Durmast, ilex, chestnut, metal, and Plexiglas
188×245×156 cm
Built by: SARI and FA-MA, Florence, 1991
IBM Semea, Milan

Francesco describes the carriages as vehicles to "pull without animals but with ingenuity."

His drawing shows a four-wheeled vehicle. One pair of wheels is the driving pair, while the other is the steering pair. The device has two gear couplings, both of which appear to be meshed. It

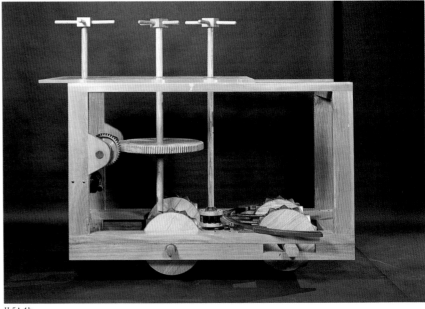

II.5A.1b

requires at least three persons to oper-
ate: two to set it in motion, and one to
maneuver the steering mechanism via
a pinion meshed with a curved rack.
The wheels are ringed with an iron belt
carrying diamond-tipped studs to grip
the soil in muddy terrain.

II.5A.2
FRANCESCO DI GIORGIO
Steering carriage with three wheels
(only one driving wheel)
Ms. 197.b.21 (BML), fol. 23v (detail)

II.5A.3
FRANCESCO DI GIORGIO
Steering carriage with three wheels
(only one driving wheel)
Ms. 197.b.21 (BML), fol. 24r (detail)

II.5A.4
FRANCESCO DI GIORGIO
Steering carriage with four driving
wheels
Ms. Ashburnham 361 (BMLF), fol. 46v (detail)

II.5A.5
FRANCESCO DI GIORGIO
Steering carriage with four wheels
(two driving wheels)
Ms. Ashburnham 361 (BMLF), fol. 46v (detail)

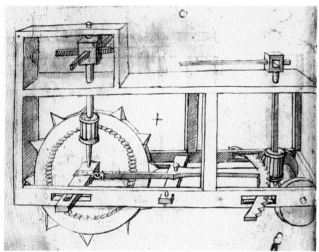

II.5A.2

II.5A.3

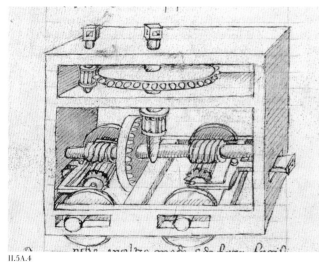

II.5A.4

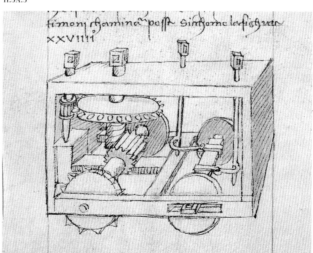

II.5A.5

II.5A.6

FRANCESCO DI GIORGIO
Steering carriage with four wheels
(two driving wheels)
Ms. Ashburnham 361 (BMLF), fol. 46v (detail)

II.5A.7

FRANCESCO DI GIORGIO
Steering carriage with four
independent driving wheels
Ms. Ashburnham 361 (BMLF), fol. 46v (detail)

II.5A.8

FRANCESCO DI GIORGIO
Steering carriage with four wheels
(two driving wheels)
Ms. Ashburnham 361 (BMLF), fol. 47r (detail)

II.5A.9a

FRANCESCO DI GIORGIO
Hoeing machine
Ms. 197.b.21 (BML), fol. 5r (detail)

II.5A.9b

Hoeing machine
Working model after Francesco di Giorgio,
Ms. 197.b.21 (BML), fol. 5r
Durmast and metal; 48 x 87 x 32 cm
Built by: Nuova SARI, Florence, 1995
Istituto e Museo di Storia della Scienza,
Florence

The model shows a farming applica-
tion of Francesco's carriage, whose
characteristic curved rack-and-pinion
steering system is recognizable here.
The worm screw of the crank-operated
driving shaft meshes with a vertical
toothed wheel. The wheel is fitted on
both sides with eight evenly spaced
pegs that raise each hoe in turn.

II.5A.10

FRANCESCO DI GIORGIO
Plow
Ms. 197.b.21 (BML), fol. 22v (detail)

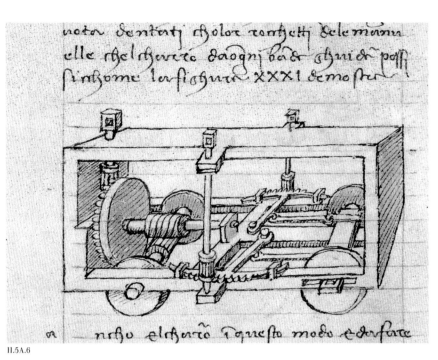

II.5A.6

II.5A.7

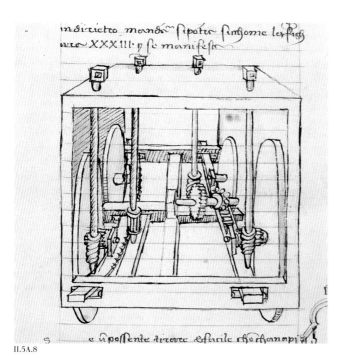

II.5A.8

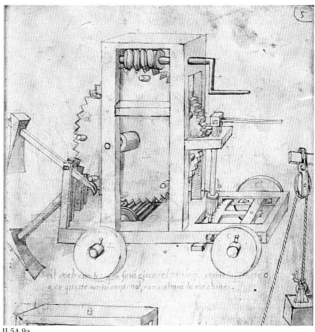

II.5A.9a

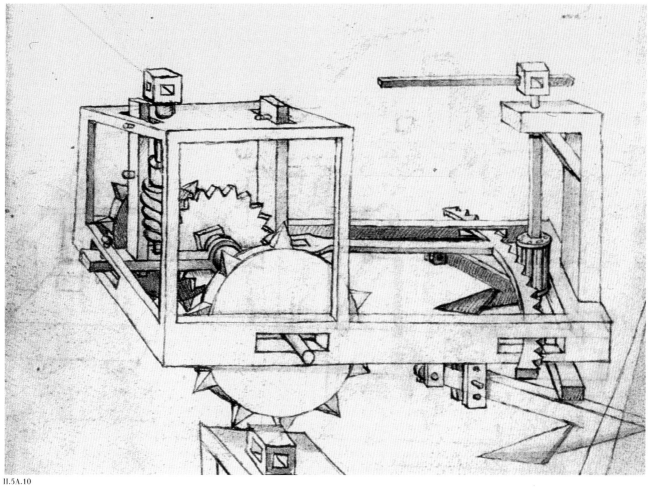

II.5A.10

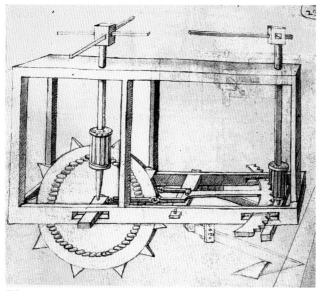

II.5A.11

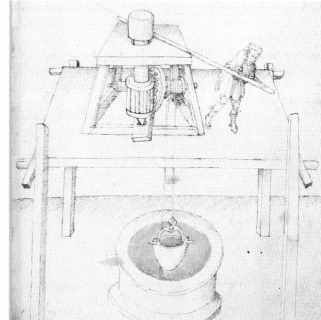

II.5A.12

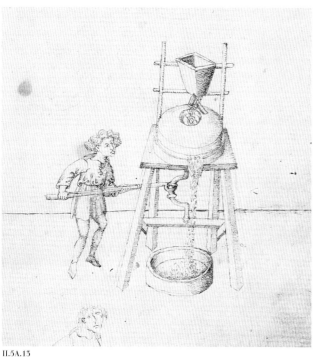

II.5A.13

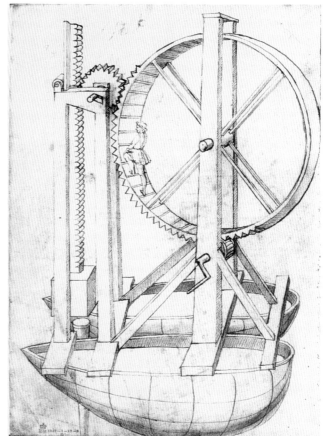

II.5A.14

II.5A.11

FRANCESCO DI GIORGIO

Plow

Ms. 197.b.21 (BML), fol. 23r (detail)

II.5A.12

TACCOLA

Man hoisting a bucket from a well

Ms. Palatino 766 (BNCF), fol. 24r

II.5A.13

TACCOLA

Man operating a mill by means
of a crank-and-rod mechanism

Ms. Palatino 766 (BNCF), fol. 38r

II.5A.14

FRANCESCO DI GIORGIO

Pile-driver

Ms. 197.b. 21 (BML), fol. 48v

Man-powered treadmill operates a
floating pile-driver for laying under-
water foundations.

II.5A.15

PAOLO SANTINI (after TACCOLA)

Double-grindstone mill powered
by two horses

Ms. Lat. 7239 (BNP), fol. 50r

II.5A.16

ANONYMOUS (after TACCOLA)

Ox driving a bucket pump

Ms. Palatino 767 (BNCF), p. 32

II.5A.17

FRANCESCO DI GIORGIO

Treadmill-operated grinding mill

Ms. II.I.141 (BNCF), fol. 97v

As the horse reaches for its feeding
trough, its hind legs move a treadmill
that drives a grindstone.

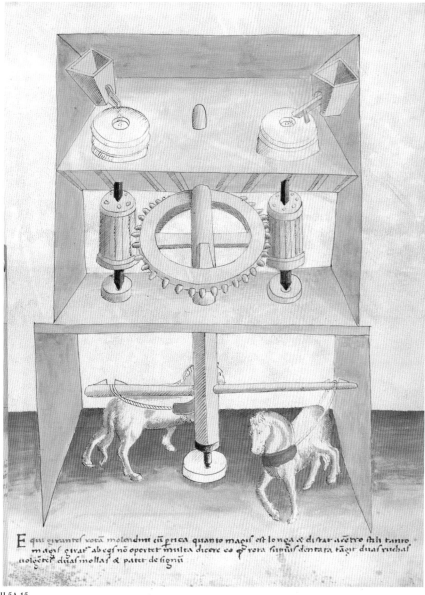

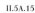

II.5A.15

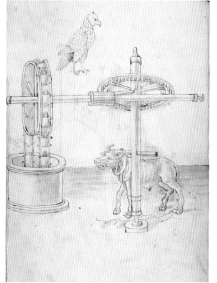

II.5A.16

II.5A.17

II.5A.18
TACCOLA
Mill with weight-driven wheel
Cod. Lat. Monacensis 197 II (BSBM), fol. 57r

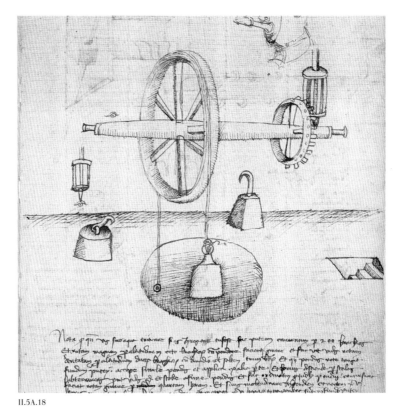

II.5A.18

II.5A.19
TACCOLA
**Mill with wheel driven
by a mercury fall**
Cod. Lat. Monacensis 197 II (BSBM), fol. 74r

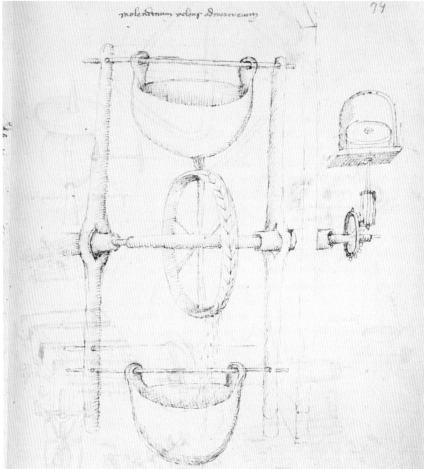

II.5A.19

II.5A.20
FRANCESCO DI GIORGIO
Mill with weight-driven wheel
Ms. Ashburnham 361 (BMLF), fol. 36v (detail)

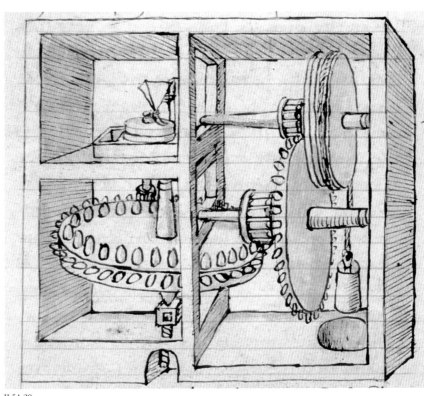

II.5A.21
FRANCESCO DI GIORGIO
**Walking-beam pump
with counterweight**
Ms. II.I.141 (BNCF), fol. 94v

II.5A.22
FRANCESCO DI GIORGIO
**Water-raising device
with weight-driven wheel**
Ms. Saluzziano 148 (BRT), fol. 66r (detail)

II.5A.20

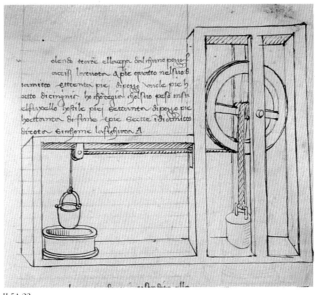

II.5A.22

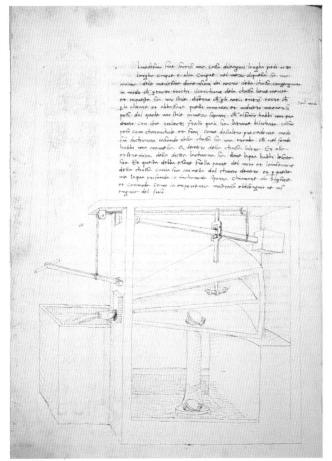

II.5A.21

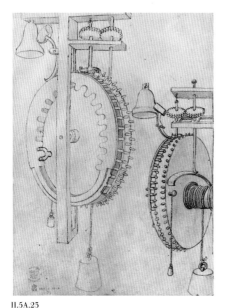

II.5A.23

II.5A.23
FRANCESCO DI GIORGIO
Weight-operated clock bell
Ms. 197.b.21 (BML), fol. 71v

II.5A.24a
ANONYMOUS SIENESE ENGINEER
(after TACCOLA?)
Clock with helical spring
Ms. Additional 34113 (BLL), fol. 156r

II.5A.24b
Clock with helical spring
Working model after Anonymous Sienese
Engineer, Ms. Additional 34113 (BLL), fol.
156r
Brass, iron, and steel (spring); 90 x 13 x 33 cm
Built by: A. Gorla, Cividale Mantovano
(Mantua), 1991
University of Siena

The clock is wound up with a handle.
The gears are arranged in a vertical se-
quence. The cord is fastened to the
lower end of the spring. When the
mechanism is loaded, the cord coils
around the cone-shaped spindle,
which has nine turns. The spring is
thus compressed in an upward direc-
tion. It can only unwind by setting in
motion the gear mechanism, regulated
at the top by a bar balance with small
adjustable weights. The clock func-
tions efficiently for about six hours.
The dial completes one revolution in a
day and is divided into twenty-four
hour sections.

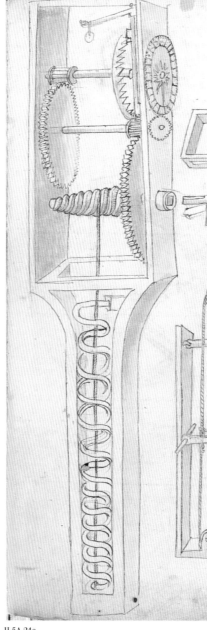

II.5A.24a

II.5A.25

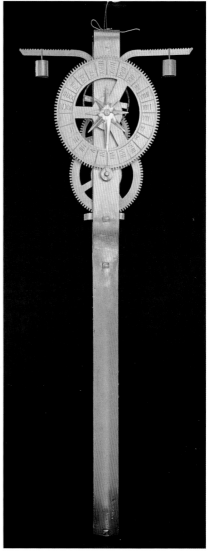

II.5A.24b

II.5A.25
ANONYMOUS
Blowing Moor (steam blower)
Museo Correr, Venice, inv. cl. XI n. 790
Fibreglass copy of original in embossed,
chiseled, and engraved copper; 28 x 17 cm
Made by: L. Becagli and C. Cecconi, Florence,
1995
Istituto e Museo di Storia della Scienza,
Florence

This head-shaped lid fit on a vessel full
of water placed on the fire. When the
water reached boiling-point, it turned
into steam, which was released from
the Moor's mouth with a hiss.

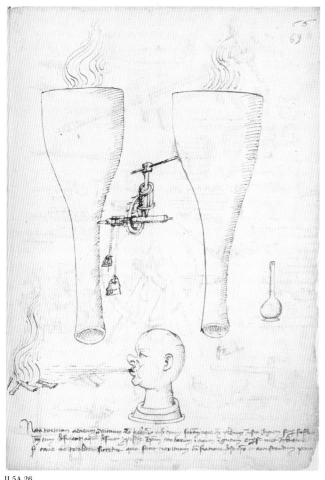

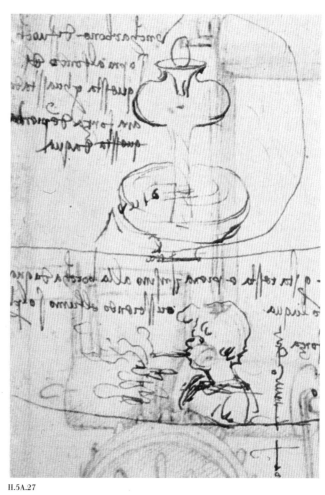

II.5A.26

II.5A.27

II.5A.26
TACCOLA
Steam blower
Cod. Lat. Monacensis 197 II (BSBM), fol. 69r

II.5A.27
LEONARDO DA VINCI
Steam blower
Codex Atlanticus (BAM), fol. 1112v

II.5A.28
GIOVANNI BRANCA
**Steam blower powering
a double pestle**
Le machine, Rome 1629, fig. XXV

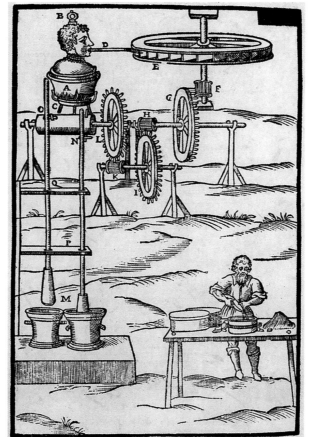

II.5A.28

II.5B *Natural energy*

For the Sienese engineers, the main natural source of energy was water. However, they also repeatedly investigated the possibility of harnessing wind.

Taccola's interest in tide mills – of both the horizontal- and vertical-wheel variety – suggests that such systems were in operation in the Sienese Republic.

Francesco undertook a painstakingly methodical analysis of the hydraulic engines on mills. He made accurate drawings of them, each accompanied by valuable notes that reveal his technical expertise. In some cases, Francesco states he has performed operating tests on the systems illustrated.

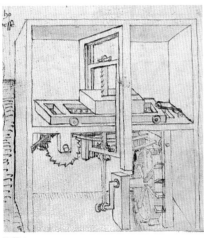

II.5B.1a

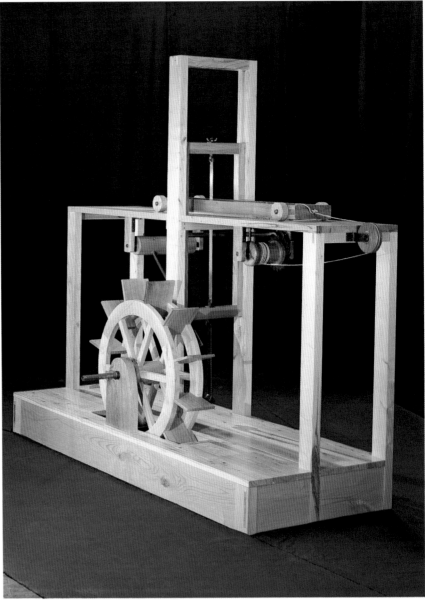

II.5B.1b

II.5B.1a
FRANCESCO DI GIORGIO
Hydraulic saw-mill
Ms. Ashburnham 361 (BMLF), fol. 43v (detail)

II.5B.1b
Hydraulic saw
Working model after Francesco di Giorgio,
Ms. Ashburnham 361 (BMLF), fol. 43v
Chestnut, elm, durmast, iron, and steel
280 x 300 x 120 cm
Built by: SARI and FA-MA, Florence, 1991
IBM Semea, Milan

The waterwheel-powered saw was a fairly widespread industrial machine. It mainly served to cut large tree-trunks into planks. The most notable feature of the version shown here is the mechanism for moving the trunk-

II.5B.2

bearing carriage up to the blade. Indeed, Francesco's own notes next to the drawing give an elaborate explanation of the mechanism, stressing the need for an abundant water supply to power the waterwheel that drives the machine.

II.5B.2
PAOLO SANTINI (after TACCOLA)
Hydraulic blowing plant with two camshaft-operated bellows
Ms. Lat. 7239 (BNP), fol. 47v

II.5B.3
TACCOLA
Box sprinklerpowered
by a waterwheel and camshaft
Cod. Lat. Monacensis 197 II (BSBM), fol. 40r

II.5B.3

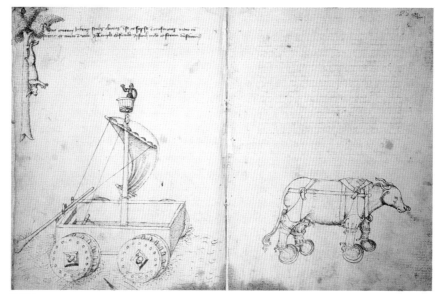

II.5B.4

II.5B.4
TACCOLA
**Amphibious sail cart drawn
by a water buffalo**
Ms. Palatino 766 (BNCF), fols. 27v-28r

II.5B.5
TACCOLA
Tide mill
Ms. Palatino 766 (BNCF), fols. 8v-9r

II.5B.6
ANONYMOUS (after TACCOLA)
Vertical-waterwheel floating mill
Ms. Palatino 767 (BNCF), p. 101

II.5B.7
TACCOLA
Vertical-waterwheel floating mill
Ms. Palatino 766 (BNCF), fol. 39r

The sleeping miller is Taccola's way of
saying that automation frees man from
toil.

II.5B.5

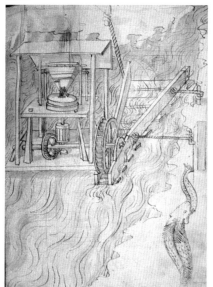

II.5B.6

II.5B.7

II.5B.8

FRANCESCO DI GIORGIO

Horizontal-waterwheel floating mill

Ms. Ashburnham 361 (BMLF), fol. 35v (detail)

II.5B.9

FRANCESCO DI GIORGIO

Mill with vertical vane waterwheel

Ms. Ashburnham 361 (BMLF), fol. 34v (detail)

II.5B.10

TACCOLA

"Still-water" mill

Ms. Palatino 766 (BNCF), fols. 18v-19r

The mill is fed by two pairs of pumps
alternately driven by a camshaft.

II.5B.11a

FRANCESCO DI GIORGIO

Horizontal-waterwheel mill

Ms. Saluzziano 148 (BRT), fol. 34v (detail)

II.5B.11b

Horizontal-waterwheel mill

Model after Francesco di Giorgio,
Ms. Saluzziano 148 (BRT), fol. 34v
Oak; 120 x 120 x 120 cm
Built by: V. Ghione, Vigone (Turin), 1987
Archivio Storico AMMA, Turin

The mill is powered by a horizontal
waterwheel with spoon-shaped vanes.
The water-supply chute narrows to-
ward the spout to impart higher flow
velocity.

A transmission consisting of three
pairs of toothed wheels enables the
waterwheel rotation velocity to be ad-
justed to that of the grindstone. An in-
termediate wheel – a frequent feature
in Francesco di Giorgio's designs – car-
ries two sets of teeth, one axial, the
other radial.

II.5B.12

FRANCESCO DI GIORGIO

Constant-velocity watermill

Ms. Ashburnham 361 (BMLF), fol. 35r (detail)

A constant amount of water is raised
by the bucket pump to an overhead
container. Thus the water falls with
constant flow onto the waterwheel
through the spout, ensuring a constant
velocity of the grindstone via a gearing
system.

II.5B.13

FRANCESCO DI GIORGIO

Recirculation mill

Ms. Ashburnham 361 (BMLF), fol. 36r (detail)

The hopper-shaped spout that feeds
the vertical wheel is filled by means of
a walking-beam pump activated by the
same vertical wheel.

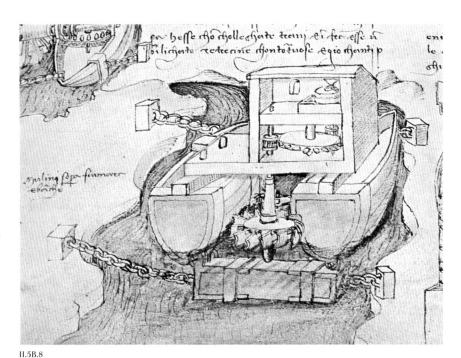

II.5B.8

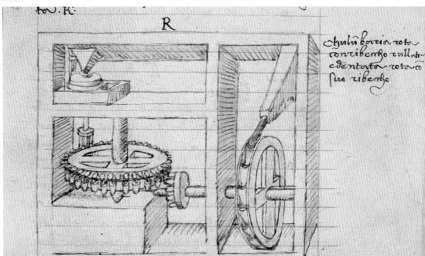

II.5B.9

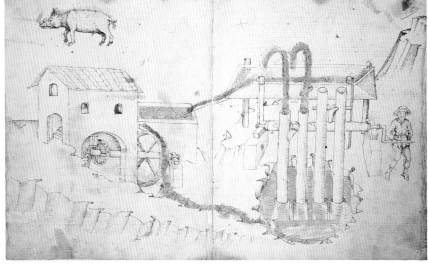

II.5B.10

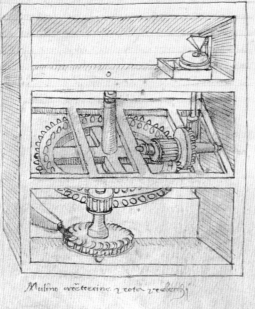

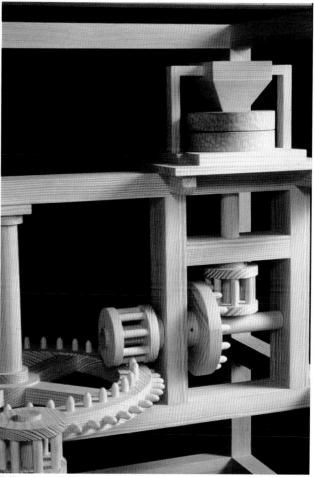

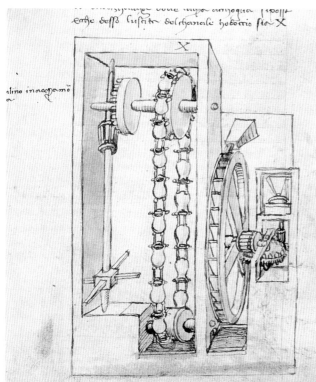

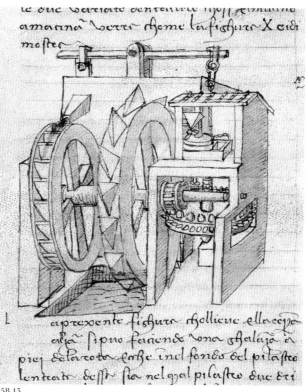

II.5B.14
FRANCESCO DI GIORGIO
Combined wind- and watermill
Ms. Ashburnham 361 (BMLF), fol. 37r (detail)

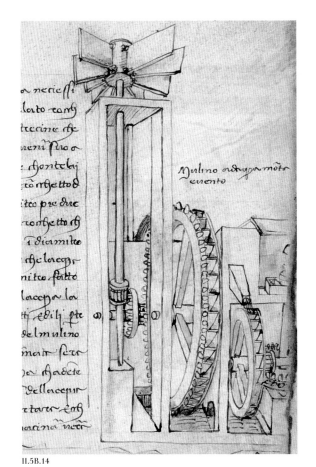

II.5B.15
FRANCESCO DI GIORGIO
Combined wind- and watermill
Ms. Ashburnham 361 (BMLF), fol. 35v (detail)

II.5B.16
FRANCESCO DI GIORGIO
Directional windmill
Ms. Ashburnham 361 (BMLF), fol. 37r (detail)

II.5B.14

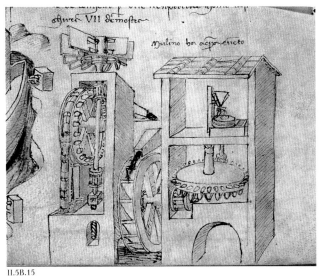

II.5B.15

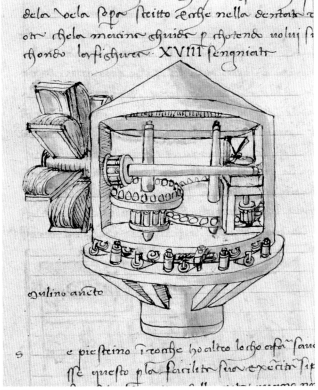

II.5B.16

III.

Leonardo: machines and mechanisms

*Leonardo da Vinci (1453-1519) has long been
celebrated not only as a supremely gifted artist
but as the inventor of extraordinary machines
and mechanical devices dramatically anticipating
modern and contemporary achievements.
However, a close examination of the history of technology
from the late fourteenth century to the end of the fifteenth
century – particularly in Italy – challenges this view.
The Leonardo phenomenon appears
not as an isolated episode, but rather as the logical
and triumphant outcome of a continuous
development of engineering skills
and technical innovation.
Before Leonardo, other outstandingly talented
figures played a role in that process.
Leonardo unquestionably drew much inspiration
from the artist-engineers of his time
and of earlier generations.
Nevertheless, he made original contributions
in many fields, where his prodigiously inventive
mind anticipated future developments.*

III.1 Leonardo's manuscripts

Leonardo filled dozens of notebooks, large and small, with notes and drawings that record a half-century of reflections, projects, and experiments in the realms of art, technology, and science. Less than one-third of Leonardo's written archive has survived. However, the extant manuscripts offer powerful evidence of his far-reaching activity and bold investigations. They form the largest and most outstanding documentary corpus for studying the history of art and, above all, of science and techniques in the Renaissance.

Leonardo's manuscripts are rarely tidy. Seldom do they offer a homogeneous, coherent discussion of a single topic over a long sequence of pages. More often, each page stands as an autonomous universe, unrelated to the neighboring sheets, and gives the impression of an apparently chaotic stratification of notes and drawings.

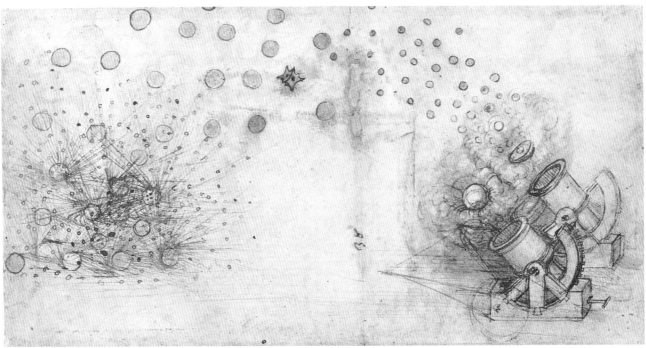

III.1.a

III.1.a

LEONARDO DA VINCI
Codex Atlanticus (BAM)
Facsimile: Giunti (Florence 1973-80)
ca. 1478-1518; 65×44 cm

This is the largest collection of Leonardo's manuscript sheets, formed at the end of the sixteenth century by the sculptor Pompeo Leoni, who dismembered many original notebooks. In the present arrangement, after the restoration work carried out in the 1960s, the codex consists of 1119 sheets. It contains studies related to the entire range of Leonardo's interest in science and technology, together with architectural projects, town planning, biographical records and personal notes.

fols. 30v-31r: Two-wheel hoist (left); mortars firing explosive projectiles (right).

III.1.b

LEONARDO DA VINCI
Royal Collection (RLW)
Facsimile: Giunti (Florence 1980-85)
ca. 1478-1518; 48×35 cm

This collection was gathered at the end of the sixteenth century by the sculptor Pompeo Leoni, who mostly included Leonardo's figurative studies. One can distinguish several dominant themes. The clearest is that of anatomical drawings. There is also a conspicuous group of landscape drawings, a series of studies of horses (including studies for equestrian monuments), numerous drawings of figures and caricatures, as well as a group of geographical maps.

K/P 142r: Notes and sketches on the human skeleton.
K/P 144v: Studies on muscles and the articulation of the shoulder.

III.1.c

LEONARDO DA VINCI
Codex Arundel (BLL)
Facsimile
ca. 1478-1518; 21×15 cm

This is not an original notebook, but a collection of sheets from various dismembered notebooks of Leonardo, making a total of 283 folios. Studies in physics (especially mechanics) and mathematics (optics and Euclidean geometry) predominate in this collection. It also includes architectural and territorial studies, such as those conducted in France for the projected Royal Residence of François I in Romorantin.

fols. 174v-175r: Notes and diagrams on the nature of heaviness and lightness (left); drums and a wind instrument (right).

III.1.d

LEONARDO DA VINCI

Ms. B (IFP)

Facsimile: Giunti (Florence 1990)
ca. 1487-90; 23 x 16 cm

This manuscript originally contained 100 sheets, but was mutilated by Guglielmo Libri in the mid-nineteenth century, and now contains only 90. The missing folios, sold to Lord Ashburnham by Libri, were returned to the Institut de France in 1891. This is the oldest surviving original manuscript of Leonardo. It contains studies of military technology, centrally planned churches, and projects for the "ideal city" and for the flying-machine.

fols. 49v-50r: Sledge for use on mud and device for dredging ditches (top and center left); flexible siege ladder (right).

III.1.e

LEONARDO DA VINCI

Codex Trivulzianus (BTM)

Facsimile: Giunti (Florence 1980)
ca. 1487-90; 20.5 x 14 cm

This manuscript originally contained 62 sheets, but today only 55 remain. It documents Leonardo's attempts to improve his modest literary education, through long lists of learned words copied from authoritative lexical and grammatical sources. The manuscript also contains studies of military and religious architecture.

fols. 21v-22r: Architectural studies; studies for hinges (top left).

III.1.g

LEONARDO DA VINCI

Ms. C (IFP)

Facsimile: Giunti (Florence 1990)
ca. 1490-91; 31.5 x 22 cm

This manuscript, composed of 32 leaves, originally included another treatise – unfortunately lost – "On shadow and light," i.e. on the variations in the appearances of objects according to whether they are illuminated or in the penumbra. Leonardo studied the optical foundations of these phenomena, in order to be able to reproduce them with precision as a painter.

fols. 10v-11r: Studies on the projection of light through a small aperture (left) and on the formation of derived shadows (right).

III.1.c

III.1.i

LEONARDO DA VINCI

Madrid Ms. I (BNM)

Facsimile: Giunti (Florence 1974)
ca. 1490-99; 21 x 15 cm

The recovery of this manuscript in 1966 caused a sensation. Made up of 192 leaves, it is divided into two parts. The first contains drawings and notes on a series of elementary mechanisms. The second (the first in chronological order of compilation) contains research on theoretical mechanics. This is the most accurately paginated of Leonardo's manuscripts that has survived.

fols. 44v-45r: Stretching device (left); spring mechanism for a clock (right).

III.1.f

LEONARDO DA VINCI

Forster Ms. I (VAML)

Facsimile: Giunti (Florence 1992)
ca. 1487-90 and 1505; 14.5 x 10 cm

This manuscript is composed of two different booklets, totaling 101 sheets. The first manuscript (1487-90) contains studies of stereometry, i.e. the transformation of bodies into different shapes of equal volume. These studies display Leonardo's intensive training in Euclidean geometry under the guidance of Luca Pacioli. Hydraulic studies predominate in the second manuscript (1505).

fols. 13v-14r: Studies of the transformation of solids.

III.1.h

LEONARDO DA VINCI

Ms. A (IFP)

Facsimile: Giunti (Florence 1990)
ca. 1490-92; 22 x 15 cm

This manuscript originally contained 114 leaves, but it was mutilated by Guglielmo Libri and now only contains 63. Some of the missing leaves (sold to Lord Ashburnham by Libri) were returned to the Institut de France in 1891. The manuscript contains studies by Leonardo on proportions and on movement, especially that of water. In many notes, he stressed the painter's need for a high degree of scientific training.

fols. 59v-60r: Studies of hydrodynamics; sketches of waterfalls and whirlpools.

III.1.j

LEONARDO DA VINCI

Ms. H (IFP)

Facsimile: Giunti (Florence 1986)
ca. 1493-94; 10.5 x 8 cm

This "pocket-book" consists of three different notebooks totaling 142 leaves. Principally, these contain studies of water, in particular of the erosive effects of vortices and currents. There is also a series of calculations for the excavation of the navigable Martesana Canal between Lecco and Milan, as well as notes of Latin grammar, geometry, and hydraulics.

fols. 29v-30r: Chariot and clock mechanisms (left); study on transmission of movement by means of a toothed-wheel and a rack (right).

III.1.k

LEONARDO DA VINCI

Forster Ms. III (VAML)

Facsimile: Giunti (Florence 1992)

ca. 1493-96; 9 x 6 cm

This manuscript, made up of 94 leaves, has the appearance of a notebook for pencil sketches and occasional notes. There is a remarkable variety of themes: fables and parables, technical recipes, studies for the Sforza monument, town-plans, etc. Leonardo uses a red pencil very frequently in this codex.

fols. 35v-36r: Study of mechanics (left) and of perspective (right).

III.1.l

LEONARDO DA VINCI

Forster Ms. II (VAML)

Facsimile: Giunti (Florence 1992)

ca. 1495-97; 9.5 x 7 cm

This manuscript is composed of two booklets totaling 159 leaves. The first (1497) presents studies of mechanics, ornamental knots and plaits, and of architecture.

The second (1495) records Leonardo's research in physics and mechanics (force, gravity, weight, and movement).

fols. 90v-91r: Perpetual motion wheel (left) and studies on the resistance of arches (right).

III.1.m

LEONARDO DA VINCI

Ms. M (IFP)

Facsimile: Giunti (Florence 1986)

ca. 1495-1500; 10 x 7 cm

This manuscript, which has survived intact, comprises 96 leaves. It documents the period when Leonardo was devoting his attention to the great classical works, especially in geometry and mechanics (Euclid and Archimedes), and attempting to incorporate their achievements in his work. Ms. M also provides evidence of his efforts to further his knowledge of Aristotle's *Physics*. Lastly, the manuscript contains botanical studies and numerous allegorical drawings.

fols. 78v-79r: Studies on the growth of plants.

III.1.n

LEONARDO DA VINCI

Ms. I (IFP)

Facsimile: Giunti (Florence 1986)

ca. 1497-99; 10 x 7.5 cm

This manuscript is composed of two distinct notebooks totaling 148 leaves.

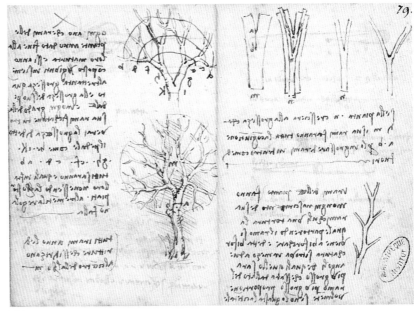

III.1.m

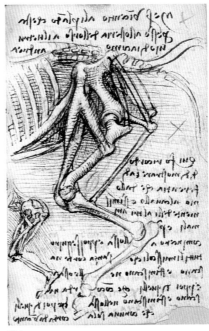

III.1.q

The dominant themes are a series of theorems of Euclidean geometry, studies of the motion of solids and fluids, notes on Latin grammar and projects for court spectacles, as well as a long series of prophecies and allegories.

fols. 61v-62r: Notes on motion (left); vertical section of a building (right).

III.1.o

LEONARDO DA VINCI

Ms. L (IFP)

Facsimile: Giunti (Florence 1987)

ca. 1497-1504; 10 x 7 cm

This manuscript originally comprised 96 leaves, two of which have been lost. The contents include notes and calculations relating to military technology and architecture dating from 1502, when Leonardo was in the service of Cesare Borgia, the Duke of Valentinois (*Il Valentino*). Other significant elements are studies of the flight of birds and preparatory studies for a flying machine.

fols. 65v-66r: Project for a bridge to cross the Bosphorus near Constantinople (left); scaffolding and modular components (right).

III.1.p

LEONARDO DA VINCI

Madrid Ms. II (BNM)

Facsimile: Giunti (Florence 1974)

ca. 1503-05; 21 x 15 cm

Rediscovered in 1966, this 157-leaf manuscript contains studies related to Leonardo's activity in Florence, after the end of his first stay in Milan. It includes plans for military architecture carried out for the Seigneur of Piombino, maps of the Tuscan region, notes on painting, and studies of optics. The final booklet, arbitrarily attached to the manuscript, contains Leonardo's studies carried out between 1491 and 1493 for the casting of the equestrian monument to Francesco Sforza.

fols. 22v-23r: Map of the Arno valley.

III.1.q
LEONARDO DA VINCI
Ms. K (IFP)
Facsimile: Giunti (Florence 1989)
ca. 1503-07
9.6 x 6.5 cm

This manuscript is composed of three different notebooks totaling 128 leaves. The first two notebooks relate to Leonardo's intense studies of Euclidean geometry under Luca Pacioli.
The third notebook presents a miscellaneous series of anatomical studies and water channels, as well as architectural studies probably commissioned from Leonardo by Charles D'Amboise, governor of Milan.

fols. 19v and 29v: Ferry (left); anatomical studies of a horse (right).

III.1.r
LEONARDO DA VINCI
Codex on the Flight of Birds (BRT)
Facsimile: Giunti (Florence 1976)
ca. 1506
21 x 15 cm

This codex was originally composed of 18 leaves, but only 17 remain today. The analysis of the flight of birds involves here the application of rigorous mechanical methods.
The function of the wing is compared to the wedge, that of the tail to the rudder, while the laws of equilibrium account for the way in which the bird-machine balances in the air. Leonardo also studied air-resistance, currents, and winds.

fols. 6v-7r: Studies of the joints of a mechanical wing.

III.1.s
LEONARDO DA VINCI
Codex Leicester
B. Gates Collection, Seattle, WA
Facsimile: Giunti (Florence 1987)
ca. 1506-10
29 x 22 cm

This 36-folio manuscript has changed hands twice in the last fifteen years. In 1980, it was purchased at auction by Armand Hammer from the estate of Lord Leicester; in 1994, it was acquired by Bill Gates at the Hammer estate auction. The analysis of movement of the water is a central theme, together with studies of geology (fossils, the circulation of water, and natural disasters), and astronomy.

fols. 1v-2r: Sketches and studies of cosmology and of the reflected light (*lume riflesso*) of the Moon.

III.1.t
LEONARDO DA VINCI
Ms. F (IFP)
Facsimile: Giunti (Florence 1988)
ca. 1508
14.5 x 10.5 cm

This manuscript, which has remained intact, is made up of 96 leaves. It is largely devoted to studies of water. Leonardo sketches vortices and waves. He also studies the reflection of the Sun and Moon on the surface of the sea, as part of a series of investigation into optics and light. Other topics studied are geology and geometry.

fols. 47v-48r: Waterfalls (left); flow of water against obstacles (right).

III.1.u
LEONARDO DA VINCI
Ms. D (IFP)
Facsimile: Giunti (Florence 1989)
ca. 1508
22.5 x 16 cm

This manuscript is made up of only 10 leaves. It contains a series of sketches and notes concerning the eye, perspective, and the theory of vision. Leonardo proposes the construction of a glass model of the eye. He also illustrates the construction of a camera obscura, and carries out a series of penetrating optical experiments.

fol. 10v: Notes and sketches on the eye and on visual perception.

III.1.v
LEONARDO DA VINCI
Ms. G (IFP)
Facsimile: Giunti (Florence 1989)
ca. 1510-11 and 1515
14 x 10 cm

This manuscript originally contained 96 leaves, three of which are now missing. It documents Leonardo's activities towards the end of his final Milanese period, and in Rome in 1515. The first part contains notes and drawings of vegetable morphology. The second part is dense in studies of mechanics and geometry.

fols. 83v-84r: Device for polishing mirrors (left); screw-press (right).

III.1.w
LEONARDO DA VINCI
Ms. E (IFP)
Facsimile: Giunti (Florence 1989)
ca. 1513-14
14.5 x 10 cm

The manuscript was composed of 96 leaves but now it contains only 80,

owing to Guglielmo Libri's theft of the final group of sheets, which have never been recovered. The gathering documents Leonardo's activities after he moved from Milan to Rome in 1513. The two central themes are mechanics and the flight of birds. There are also drawings and notes concerning water.

fols. 42v-43r: Effect of strong wind on birds (left); maneuvers of birds in wind (right).

III.2 Leonardo da Vinci: the anatomy of machines

The most innovative aspect of Leonardo's technical contribution is his analysis of the components (the "organs") of machines, undertaken during the 1490s. He was the first to regard machines not as an indivisible whole, but as an assemblage of distinct parts. He was thus able to perceive that the infinite variety of machines derived from the many possible combinations of a finite number of mechanisms, which he defines as "elements of machines." Leonardo planned to devote an entire treatise to these elements, in which he would have broken down machines into their basic "organs" and used quantitative methods to study their characteristics and performances. He "explanted" the organs from the machines and depicted them in isolation from the other parts to which they were functionally connected.

During the same decade, Leonardo applied the same method to the study of the human body, whose organs he regarded as highly sophisticated mechanical devices. His vision of the anatomy of machines and man was enshrined in a series of masterly drawings that mark the birth of modern scientific illustration.

WE SHALL DISCUSS here the nature of the screw and of its lever, and how it [the screw] shall be used for lifting rather than for thrusting; and how it has more power when it is simple and not double, and thin rather than quick, when moved by a lever of the same length and force. We shall briefly discuss the many ways there are to use screws, the various types of endless [i.e. worm] screws, ... how the endless screw shall be combined with toothed wheels ... We shall examine the nature of their nuts ... We shall also speak of inverted screws and screws that by a single motion thrust and pull a weight, and screws which, by turning them only once, will rotate the nuts more than once. ... Their method of construction will also be discussed, how to put them to work ...

All such instruments will generally be presented without their armatures or other structures that might hinder the view of those who will study them. ... We shall also deal with the differences existing between a lever operating with constant force, that is, the wheel, and the lever of unequal power, that is, the straight beam, and why the former is better than the latter and the latter more compact and convenient than the former. We shall also discuss the ratchet wheel and its pawl, the flywheel and the impetus of the motion, the axles and their wear; ropes and pulleys, capstans and rollers, will also be described.

Introduction to the "Book of the elements of machines"
(*Trattato degli elementi macchinali*), Madrid Ms. I, fol. 82r

* All quotations from the Madrid manuscripts are taken from Ladislao Reti's translation in Leonardo da Vinci 1974.

III.2A *The screw*

Many pages of Leonardo's manuscripts, notably Madrid Ms. I, contain detailed analyses of the screw. Leonardo was fascinated with the device, and made extensive use of it. He sought to classify the different types of screw, to determine their performances accurately by geometrical methods, and to illustrate their potential applications in machines and mechanical operations. He also designed several screw-threading machines.

III.2A.1a

LEONARDO DA VINCI
Inverted screw
Madrid Ms. I (BNM), fol. 58r

"The inverted screw is a screw in which the threads begin in the middle of its length, and departing from the middle, terminate at the opposite ends of the screw. ... If you turn the inverted screw by both contrary and varied motions, their nuts will also have contrary and varied motion between them."

III.2A.1b

Inverted screw
Working model after Leonardo da Vinci,
Madrid Ms. I (BNM), fol. 58r
Durmast and Plexiglas; 28 × 118 × 63 cm
Built by: Muséo Techni, Montreal, 1987
Istituto e Museo di Storia della Scienza,
Florence

The graduated marks on the board show the symmetrical convergence or divergence of the nuts when the screw is turned.

III.2A.2

LEONARDO DA VINCI
System comprising a sequence
of inverted screws
Madrid Ms. I (BNM), fol. 57v (detail)

Leonardo explains that "at an entire turn of the crank ... the last screw will have moved by a distance equal to 7 teeth." The lower drawing shows in detail how the screw components fit together.

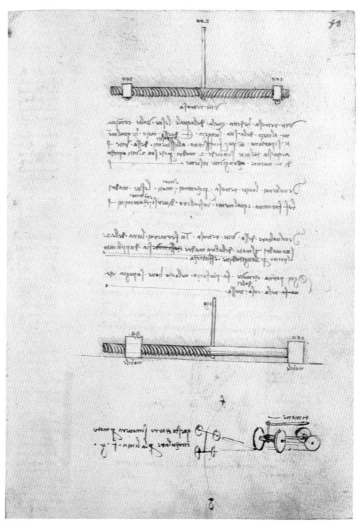

III.2A.1a

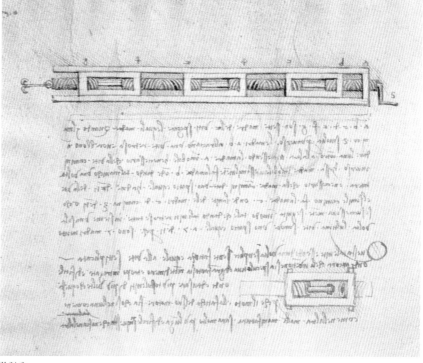

III.2A.2

III.2A.3a
LEONARDO DA VINCI
Differential screw
Madrid Ms. I (BNM), fol. 33v (detail)

The screw bears two threads of different pitches: "*a* and *m* are two nuts, of which the lower is movable while the other is not. And the nuts are exerted by varying forces from the different threads of the screw which pass through them."

III.2A.3b
Differential screw
Working model after Leonardo da Vinci, Madrid Ms. I (BNM), fol. 33v
Ash, oak, and metal; 70 x 50 x 12 cm
Built by: Muséo Techni, Montreal, 1987
Istituto e Museo di Storia della Scienza, Florence

The invention of this type of screw was traditionally attributed to Hunter (1781). It is used to apply extreme pressure in machines such as hand and hydraulic presses.

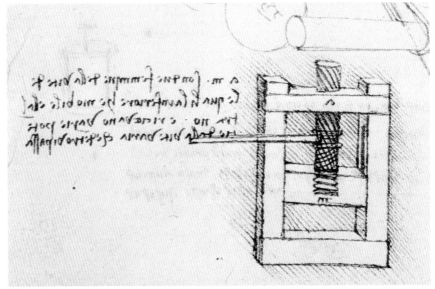

III.2A.3a

III.2A.4
LEONARDO DA VINCI
Circular worm screw
Madrid Ms. I (BNM), fol. 70r (detail)

"If the endless [worm] screw is made to turn with the aid of pinion *m, n*, and nut *f s* is firmly held in place in a way that allows its turning around, the turns of the nut will doubtless have great potency."

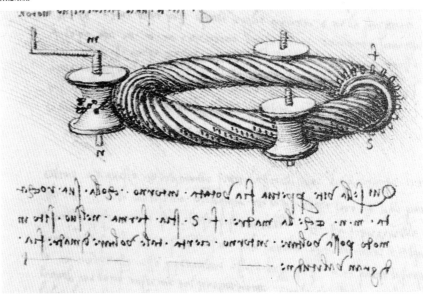

III.2A.4

III.2A.5
LEONARDO DA VINCI
Concave worm screw
Madrid Ms. I (BNM), fol. 19r (detail)

The design shows an early concept of a concave worm screw: "This screw acts upon the wheel with equal and continuous force because it is always touched by four teeth, at varying distances from the center of the wheel it moves [via a crank that rotates a pinion]."

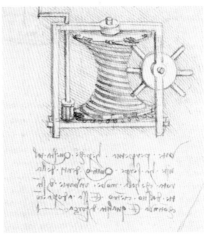

III.2A.5

III.2A.6a
LEONARDO DA VINCI
Worm screw meshing
with a toothed wheel (helical gear)
Madrid Ms. I (BNM), fol. 17v

"This lifting device has an endless screw which engages many teeth on the wheel. For this reason the device is very reliable. Endless screws that engage only one of the teeth on the working wheel [*lower drawing*] could cause great damage and destruction if the tooth breaks. [In such cases] it will be necessary to add a pawl in order to avoid the reversal of the wheel's motion should that tooth break."

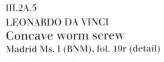

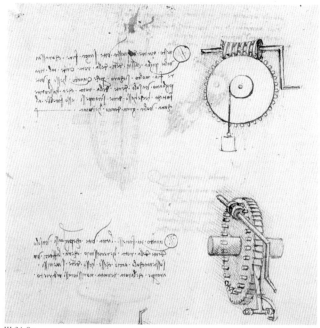

III.2A.6a

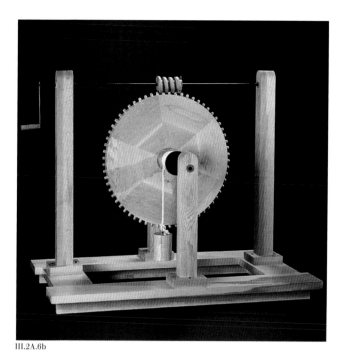

III.2A.6b

III.2A.6b
Helical gear
Working model after Leonardo da Vinci,
Madrid Ms. I, fol. 17v
Durmast and metal; 125 x 157 x 99 cm
Built by: Muséo Techni, Montreal, 1987
Istituto e Museo di Storia della Scienza,
Florence

For safety reasons, Leonardo recommends the use of helical-thread screws, since they prevent the wheel's inverse rotation.

III.2A.7
LEONARDO DA VINCI
Worm screw meshing
with a circular rack
Ms. B (IFP), fol. 72r

A worm screw meshes with a circular-rack segment, causing the linked shaft to move back and forth. This mechanism is analogous to the steering wheel of the modern automobile. Leonardo suggested its use to bend tough metal bars such as those of window gratings.

III.2A.8
LEONARDO DA VINCI
Equivalence between a screw
and an inclined plane
Madrid Ms. I (BNM), fol. 86v (detail)

"It amounts to the same thing to move a weight along the screw, from m to n, as to move it from m to p, along the line p m [inclined plane]."

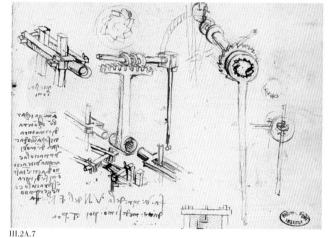

III.2A.7

III.2A.8

III.2A.9a-b
LEONARDO DA VINCI
Power of the screw
Madrid Ms. I (BNM), fol. 121r and v (details)

"Measure the power of the screw by
taking the proportion of the lever to its
counterlever. The lever shall be mea-
sured from the center of the moving
hand or force which turns the screw, to
the center of the screw. The counter-
lever goes from the mentioned center
to the middle of the opposite thread."

III.2A.10
LEONARDO DA VINCI
Static measurement of the power
of the screw
Madrid Ms. I (BNM), fol. 4v (detail)

"Method for measuring and testing the
power of the screw." Leonardo uses
weights to measure the force required
to turn the screw, as well as the resis-
tance of the nut.

III.2A.11a-b
LEONARDO DA VINCI
Automatic screw-threading
machines

a. Ms. B (IFP), fol. 70v

The central iron rod is the one to be
threaded. The two side screws are op-
erated by a mechanism comprising a
crank, a toothed wheel, and two pin-
ions. The screws move the carriage
bearing the die and at the same time
rotate the central rod. Under the
machine, Leonardo shows four gears
for changing the thread pitch.

b. Madrid Ms. I (BNM), fol. 91v

A later, simplified version of the screw-
threading machine. Leonardo provides

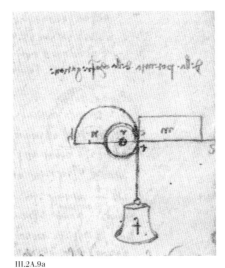

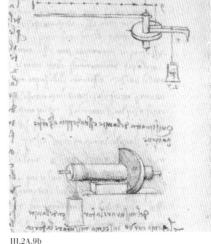

III.2A.9a III.2A.9b

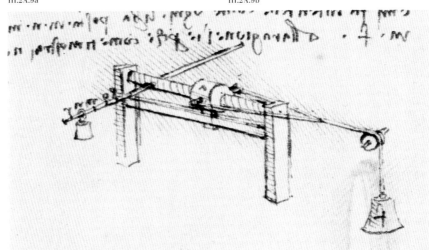

III.2A.10

detailed drawings of two different dies.
The first has a right-angled top and
serves to thread the male screw, while
the second has an acute angle top and
serves to thread the female screw.

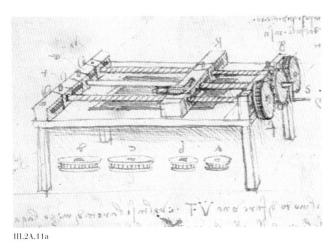

III.2A.11a

III.2A.11b

III.2B *Toothed wheels, pin-gear wheels, and pinions*

The toothed wheel, pin-gear wheel, and pinion played a key role in Renaissance technical applications. Mills, machine tools, hoists, and many other devices were nearly always fitted with gears of this type. Leonardo tried to give a strictly methodical description of the nature and performance of these devices. He focused on the teeth profiles and accurately classified the different types of motion produced by various combinations of toothed wheels, pin-gear wheels, and pinions.

III.2B.1a-f
LEONARDO DA VINCI
Analysis of gear teeth

a. The power of teeth
Madrid Ms. I (BNM), fol. 5r (detail)

Leonardo explains that the "power of the motion made with the help of toothed wheels" varies according to whether the teeth of one wheel mesh with the bases, the middle, or the tips of the teeth of the opposite wheel. Maximum power is obtained in the tip-to-tip combination.

b. Contacts between teeth and notches
Madrid Ms. I (BNM), fol. 116r (detail)

"The top of the tooth must never touch the bottom of its tooth space until the tooth arrives at the point of the central line."

c. Square teeth
Madrid Ms. I (BNM), fol. 118v (detail)

Leonardo states that these are among the most commonly employed and describes their characteristics: "The distance from the middle of the bottom of one tooth space to the other shall equal the length of a tooth."

d. Asymmetrical teeth (peg teeth)
Madrid Ms. I (BNM), fol. 5r (detail)

Leonardo emphasizes their resistance: "These are a very durable type of teeth, more so than any other."

III.2B.1a

III.2B.1b

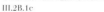

III.2B.1c

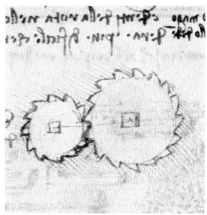

III.2B.1d

e¹. Helical teeth
Codex Atlanticus (BAM), fol. 1103r (detail)

Wheel and pinion with helical gears.

e². Wheel and pinion with helical gears
Working model after Leonardo da Vinci,
Codex Atlanticus (BAM), fol. 1103r
Durmast and metal; 55 x 70 x 80 cm
Built by: Nuova SARI, Florence, 1995
Istituto e Museo di Storia della Scienza,
Florence

Leonardo points out that helical teeth last longer than ordinary ones because of their larger contact surface.

f. Cylindrical antifriction teeth
Codex Atlanticus (BAM), fol. 91r

The teeth of the wheel that drives the two grindstones are composed of a cylinder rotating freely on a pin attached to the wheel.
This device lessens the effects of friction between gears. Leonardo copied the design from Brunelleschi, who used it in the three-speed hoist for the construction of the dome of Florence Cathedral. In his drawing of the mechanism (see I.2B.1a¹), Leonardo made a detailed structural analysis of these innovative teeth.

III.2B.2a-e
LEONARDO DA VINCI
Effects of the combination of two or more toothed wheels

a. Two external wheels
Madrid Ms. I (BNM), fol. 15v (detail)

"If you turn one of these wheels, the other, meshing with it, will turn in the opposite direction."

b. Three external wheels
Madrid Ms. I (BNM), fol. 15v (detail)

Leonardo explains that, to have a wheel that turns in the same direction as the driving wheel, a third wheel must be placed between the two.

c. One wheel inside another
Madrid Ms. I (BNM), fol. 15v (detail)

"If one of the wheels turns the inside of the other wheel with its outside, both wheels will then turn in the same direction regardless of which wheel causes the motion."

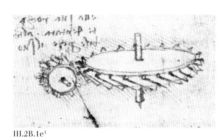

III.2B.1e¹

d. Four wheels (three internal)
Madrid Ms. I (BNM), fol. 15v (detail)

Leonardo observes that the external wheel and the two internal ones will always turn in the same direction, while the central wheel will turn contrariwise.

e. Five wheels (four external)
Madrid Ms. I (BNM), fol. 26v (detail)

"Every wheel placed on one-half of the moving wheel [*the large central wheel*] will turn in a direction opposite to those wheels moved by the other half."

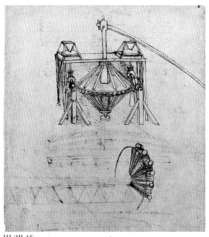

III.2B.1f

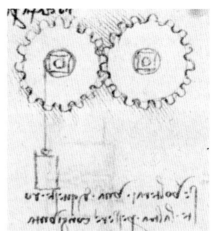

III.2B.2a

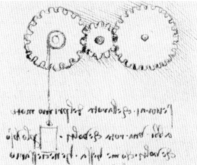

III.2B.2b

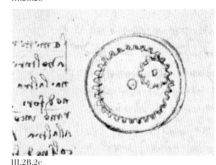

III.2B.2c

III.2B.2d

III.2B.2e

III.2B.3a-f
LEONARDO DA VINCI
Using the toothed wheel to transmit motion

a¹⁻⁵. Continuous rotary motion on different planes

1. Transmitting motion on the same plane
Madrid Ms. I (BNM), fol. 13r (detail)

The axles of the toothed wheel and pinion are parallel.

2. Transmitting motion to a perpendicular plane
Madrid Ms. I (BNM), fol. 15v (detail)

The axles of the pin-gear wheel and pinion are perpendicular to each other.

3. Transmitting motion to an inclined plane
Madrid Ms. I (BNM), fol. 15v (detail)

The axles of the toothed wheel and pinion are set at an angle to each other.

b. Continuous rotary motion with different ratios
Codex Atlanticus (BAM), fol. 77v (detail)

Three coaxial toothed wheels of different diameters mesh with a cone-shaped pinion, thus transmitting motion at three different ratios.

c¹⁻². Continuous rotary motion producing alternate rotations

1a. Semi-toothed pinions and pin-gear wheel
Madrid Ms. I (BNM), fol. 17r (detail)

The driving pinions are toothed on half their surface only: "As crank *a* is constantly turned in the same direction in this instrument, the main wheel turns once in one direction and once in the other, as demonstrated by the teeth of the pinion."

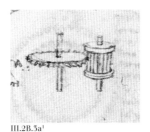

III.2B.3a¹

III.2B.3a²

III.2B.3a⁵

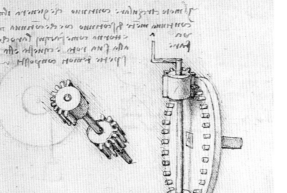

III.2B.3c¹ᵃ

III.2B.3b

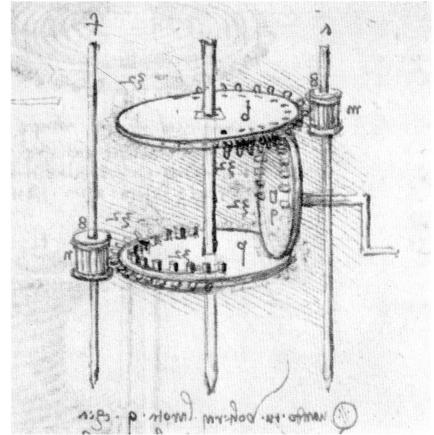

III.2B.3c²

1b. Alternate motion
Working model after Leonardo da Vinci,
Madrid Ms. I (BNM), fol. 17r
Durmast and metal; 109×82×82 cm
Built by: Muséo Techni, Montreal, 1987
Istituto e Museo di Storia della Scienza,
Florence

By turning the crank continuously in
the same direction, the horizontal
wheel moves alternately clockwise and
counterclockwise.

2. Pinions and semi-toothed wheels
Madrid Ms. I (BNM), fol. 19v (detail)

The same effect is produced with a
more complex device. The crank acti-
vates a vertical wheel bearing teeth on
only half its surface. The wheel mesh-
es with two similar wheels placed at
right angles to it. As a result, the two
pinions *m* and *n* turn in alternating
directions.

d¹⁻⁵. Continuous rotary motion producing reciprocal linear motion

1. Pin-gear wheel and camshaft
Madrid Ms. I (BNM), fol. 27r (detail)

The crank moves a worm screw, dri-
ving the toothed wheel. The pins on the
wheel activate a camshaft, causing a
rod to move back and forth.

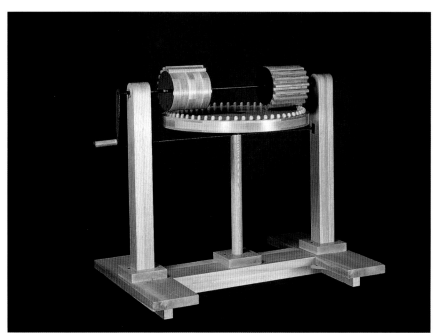

III.2B.3c¹ᵇ

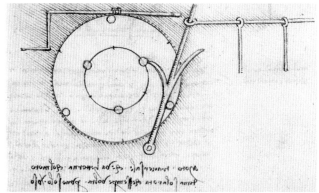

III.2B.3d¹

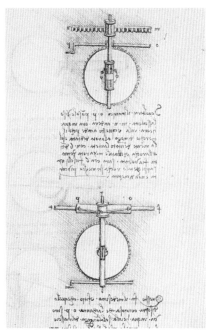

III.2B.3d²ᵃ

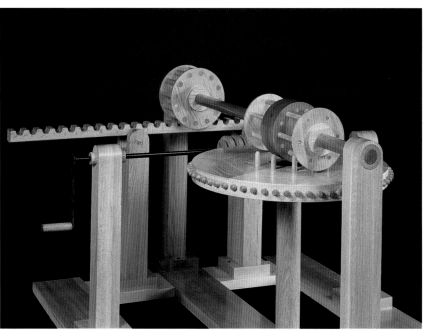

III.2B.3d²ᵇ

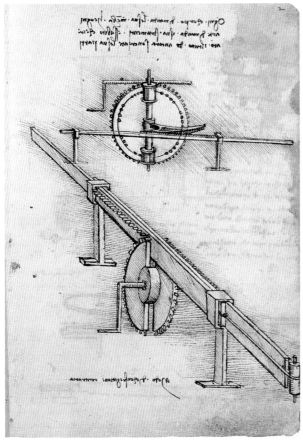

III.2B.3d⁵

III.2B.3e¹

2a. Toothed wheel, pinion, and rack
Madrid Ms. I (BNM), fol. 28r

"If you turn crank *op* in the same direction, rack *mn* will move back and forth." The lower drawing shows the same system, in which the rack has been replaced by a rod moved by a pinion, to which it is connected by ropes.

2b. Continuous rotary motion producing reciprocal linear motion
Working model after Leonardo da Vinci,
Madrid Ms. I (BNM), fol. 28r
Durmast and metal; 98 x 201 x 171 cm
Built by: Muséo Techni, Montreal, 1987
Istituto e Museo di Storia della Scienza,
Florence

When the crank is turned in one direction, the rack moves back and forth.

3. Semi-toothed wheels, rack, and pin bars
Madrid Ms. I (BNM), fol. 2r

In the system shown in the top drawing, each complete revolution of the toothed and pin-gear wheel causes the horizontal rack to move back and forth. The rack is driven by the toothed segment connected to the shaft by two pinions that mesh alternately with a discontinuous series of pins. In the bot-

III.2B.3f

tom drawing, the driving wheel alternately moves the two pin bars, which, being connected by a rope, impart reciprocal motion to each other.

e^{1-2}. Continuous rotary motion producing linear motion

1. Crank, pinion, toothed wheel, and rack
Codex Atlanticus (BAM), fol. 998r (not in Leonardo's hand)

A toothed wheel, operated by means of a crank and toothed wheel, meshes with a rack, turning the rotary motion into a linear motion.

2. Crank, pinion, toothed wheel, and rack
Working model after Leonardo da Vinci, Codex Atlanticus (BAM), fol. 998r
Durmast and metal; 180 x 70 x 60 cm
Built by: Nuova SARI, Florence, 1995
Istituto e Museo di Storia della Scienza, Florence

This device resembles the modern car jack used for changing tires.

f. Reciprocal transverse motion produces continuous rotary motion
Madrid Ms. I (BNM), fol. 123v (detail)

Leonardo shows the device from two different angles: "Motion, by which a handle turned or moved back and forth, makes a wheel turn always in the same direction."

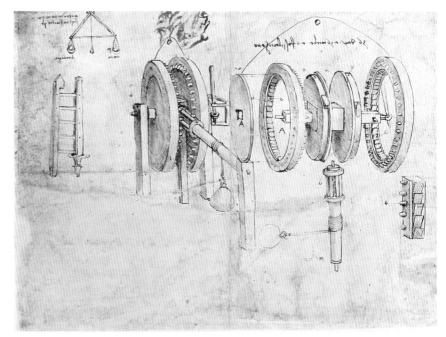

III.2B.4a

III.2B.4a
LEONARDO DA VINCI
Two-wheel hoist
Codex Atlanticus (BAM), fol. 30v

Leonardo's splendid exploded view of the machine reveals its basic operating components.

III.2B.4b
Two-wheel hoist
Working model after Leonardo da Vinci, Codex Atlanticus (BAM), fol. 30v
Chestnut, oak, Plexiglas, and metal accessories; 180 x 220 x 102 cm
Built by: SARI and FA-MA, Florence, 1987
Istituto e Museo di Storia della Scienza, Florence

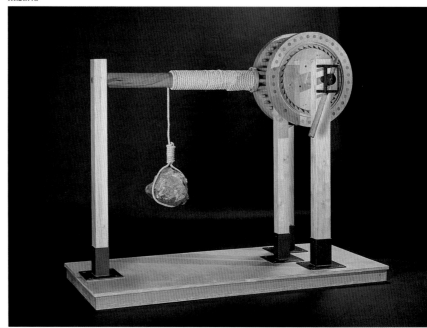

III.2B.4b

In this working model, the two wheels are encased in Plexiglas panels through which one can observe the machine's complex operating mechanism. The driving lever moves back and forth, activating the horizontal square-section beam. A pinion fastened to one end of the beam meshes with the two wheels. Each wheel carries a pawl on its outer rim. The pawls mesh with the teeth of the wheels' inner rims only when the right wheel rotates counterclockwise or the left wheel clockwise. This arrangement ensures each wheel in turn will keep driving the pinion in the same direction, thus lifting the weight attached to the shaft. The model vividly illustrates Leonardo's vision of machines as an assembly of many elementary mechanisms.

III.2C *The ratchet wheel*

Leonardo often employs a ratchet wheel – which he also calls a "servant" (*servitore*) – as a safety device for toothed wheels, especially when these are used to lift heavy loads.

III.2C.1
LEONARDO DA VINCI
Ratchet wheel with slanted pawl
Madrid Ms. I (BNM), fol. 97r (detail)

The wheel teeth have a right-angled profile. The pawl, placed at a slant, leaves the wheel free to rotate counterclockwise but keeps it from rotating clockwise.

III.2C.2
LEONARDO DA VINCI
Ratchet wheel with vertical pawl
Madrid Ms. I (BNM), fol. 116v (detail)

This version exhibits some major changes with respect to the previous device: the wheel carries asymmetrical peg-teeth; the pawl is placed in a vertical position and pressed against the teeth by a spring; moreover, the pawl meshes with three teeth rather than one, enhancing the mechanism's safety.

III.2C.3
LEONARDO DA VINCI
Ratchet wheel with horizontal pawl
Madrid Ms. I (BNM), fol. 117r (detail)

Leonardo regards this as the best type: "Such servants are generally placed along a horizontal line [*with respect to the wheel teeth*], in order to have their weight always operating towards the site they are leaning upon."

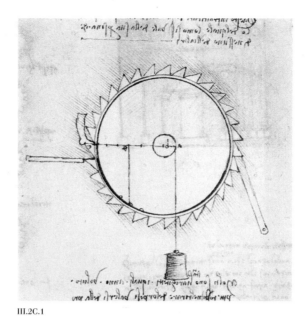

III.2C.1

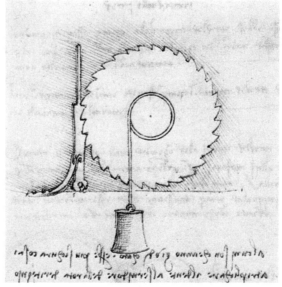

III.2C.2

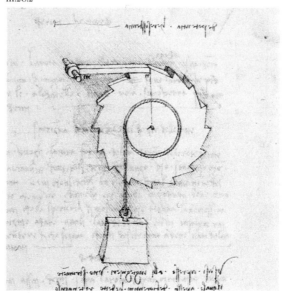

III.2C.3

III.2D *Pulleys and pulley blocks*

Leonardo shows his mature grasp of the laws governing pulleys. He clearly understood the advantages of these devices in transmitting motion and, especially, in facilitating the lifting of heavy loads.

III.2D.1
LEONARDO DA VINCI
Mechanical principles of pulley-block operation
Ms. G (IFP), fol. 82r

The notes and drawings on this page strictly define the variable but always proportional ratios in pulley blocks between the load, the force required to lift it, the rope's angle and displacement, and the time required for lifting.

III.2D.2
LEONARDO DA VINCI
Block of 33 pulleys
Madrid Ms. I (BNM), fol. 36v (detail)

The block comprises 33 pulleys, of which 17 are fixed and 16 mobile. Leonardo claims that a one-pound load applied to the block will balance a 33-pound counterweight. He does not, however, allow for the considerable friction effect.

III.2D.3
LEONARDO DA VINCI
Pulley system braking the descent of a clock weight
Madrid Ms. I (BNM), fol. 27r (detail)

A pulley system regulates the weight's descent. The contrivance was intended to reduce the long downward-travel space typically required to ensure extended operation of the weight-driven clock mechanism.

III.2D.4a
LEONARDO DA VINCI
Stretching device
Madrid Ms. I (BNM), fol. 44v

Splendid perspective view and cross-section of a device to pull weights from the circumference to the center.

III.2D.4b
Pulling device
Working model after Leonardo da Vinci, Madrid Ms. I (BNM), fol. 44v
Durmast, iron, and rope; 60 x 21 x 57 cm
Built by: Nuova SARI, Florence, 1995
Istituto e Museo di Storia della Scienza, Florence

The external pulleys are fixed. The internal ones are driven by the crank to-

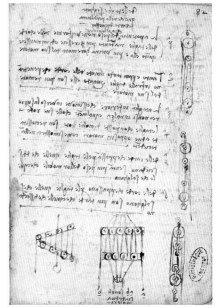

III.2D.1

ward the wheel's outer rim, moving the rods to which they are connected. As the rods straighten, they exert a traction force toward the center. Leonardo may have thought of using the machine for a textile-processing operation.

III.2D.2

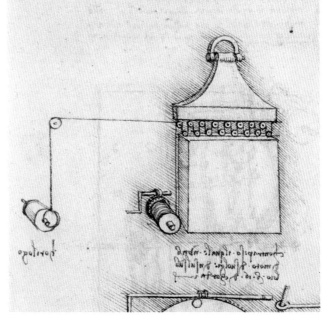

III.2D.3

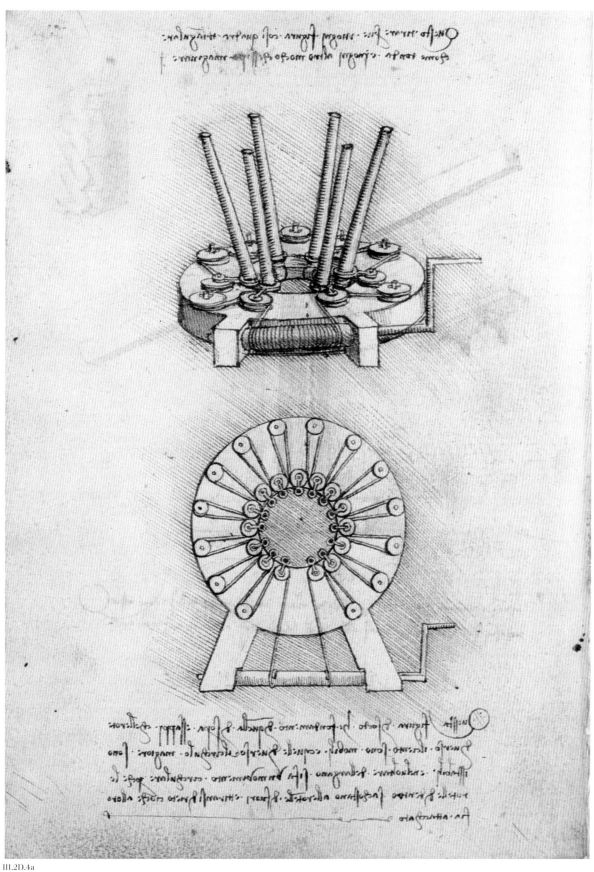

III.2E *Axles, supports, and bearings*

Leonardo minutely described and analyzed many systems to support moving axles and shafts. The systems were chiefly intended to diminish the effect of friction. Leonardo sought to classify the various types of friction (tangent, rotary, etc.), to quantify their impact, and to design complex systems for reducing or eliminating them.

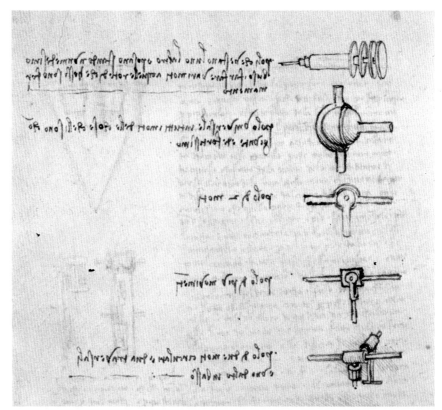

III.2E.1a-e

III.2E.1a-e
LEONARDO DA VINCI
Various types of axle supports
Madrid Ms. I (BNM), fol. 100v (detail)

a. Nested axle supports, each rotating independently

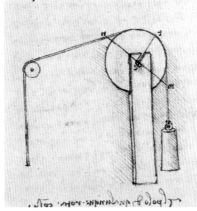

III.2E.2a

b. Universal support, enabling the axle to move in any direction

c. Support for axle with two different motions

d. Support for axle with multiple motions

e. Support for axle with two transverse and two rotary motions

III.2E.2b

III.2E.2a-c
LEONARDO DA VINCI
Wear on axles and supports

a. Lines of wear
Madrid Ms. I (BNM), fol. 132v (detail)

Leonardo states that "every wheel will wear down its support along an oblique line."

III.2E.2c

b. Axle wear
Madrid Ms. I (BNM), fol. 119r (detail)

The drawing shows "how axles wear down at their middle along a curved line."

c. Support wear
Madrid Ms. I (BNM), fol. 118r (detail)

The drawing shows the "hole worn out by the axle which turns in it."

III.2E.3a-b
LEONARDO DA VINCI
Systems to reduce friction
on rotating axles

a. Lubrication
Madrid Ms. I (BNM), fol. 118r (detail)

Automatic lubrication device for vertical rotating iron axles: oil is released by the small cup (right). Leonardo did have some doubts about the efficiency of this solution: "the wear of the axles produces iron filings, which, in admixture with oil and dust, rapidly fill these holes."

b. Adjustable bearings
Madrid Ms. I (BNM), fol. 100v (detail)

The two devices – one using a wedge (top), the other a screw (bottom) – are designed to keep a constant grip on the axle as the support wears down. Leonardo also recommends making the support frame out of "mirror metal, that is, 3 parts of copper and 7 of tin, melted together," a highly friction-resistant alloy.

III.2E.4a-d
LEONARDO DA VINCI
Disk and roller bearings
for horizontal axles
Madrid Ms. I (BNM), fol. 12v

a. Bearings with multiple vertical disks to reduce friction on a horizontal rotating axle. Leonardo doubted the efficiency of this solution.

b. Here, the horizontal axle rests on a single roller disk. This system offers no resistance to side-thrust.

c. The axle rests on three disks or rollers (one under the axle, the other two on the sides). Leonardo describes this as the best solution for a fully revolving axle.

d. Three disk sections support the axle. For Leonardo, this is the best solution for axles that does not perform complete rotations, such as bell shafts.

III.2E.3a

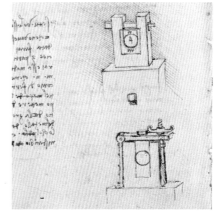

III.2E.3b

III.2E.4a

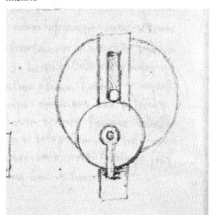

III.2E.4b

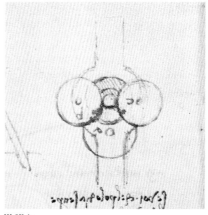

III.2E.4c

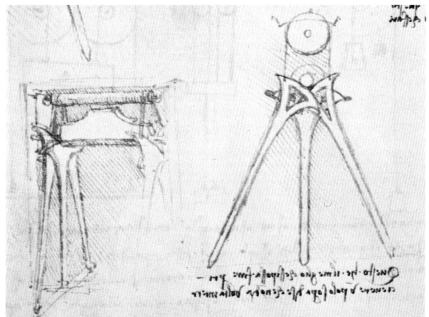

III.2E.4d

III.2E.5a-b
LEONARDO DA VINCI
Roller and ball bearings
for cone-tipped vertical axles

a. Bearing with mobile rollers shaped in the form of truncated cones

Madrid Ms. I (BNM), fol. 101v (detail)

Two bearings with a truncated-cone profile support a cone-tipped axle. In the top drawing, the axle makes three complete revolutions to one complete revolution of the bearings. In the lower solution, the ratio is one axle revolution to one bearing revolution. Leonardo prefers the first solution because it wears down the bearings more slowly.

b¹. Ball bearing

Madrid Ms. I (BNM), fol. 101v (detail)

The cone-tipped vertical axle turns between three equal spheres embedded in the support, but the spheres are free to rotate on themselves. Leonardo provides cross-sectional, lateral, and overhead views of the device.

b². Ball bearing for cone-tipped vertical axle

Working model after Leonardo da Vinci,
Madrid Ms. I (BNM), fol. 101v
Durmast and metal; 77×47×47 cm
Built by: Muséo Techni, Montreal, 1987
Istituto e Museo di Storia della Scienza,
Florence

A cone-tipped axle rotates between three spheres in a nearly hemispheric support. Leonardo notes that "3 balls under the spindle are better than 4, because 3 balls are of necessity always touched and equally moved by the spindle. Using 4 there would be the danger that one of them is left untouched, awaiting the opportunity to produce friction."

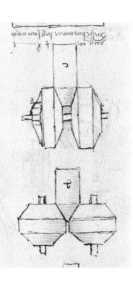

III.2E.5a

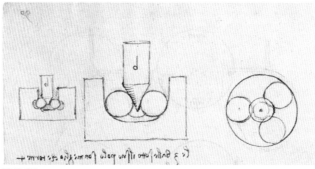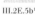

III.2E.5b¹

III.2E.5b²

III.2E.6a

LEONARDO DA VINCI
Pressure-resistant ball bearing
Madrid Ms. I (BNM), fol. 20v (detail)

Leonardo shows a cross-section and a side-view of the device.

III.2E.6b

Pressure-resistant ball bearing
Working model after Leonardo da Vinci,
Madrid Ms. I (BNM), fol. 20v
Oak, Plexiglas, and metal; 31 x Ø 58 cm
Built by: Muséo Techni, Montreal, 1987
Istituto e Museo di Storia della Scienza,
Florence

Eight concave-sided spindles rotating on their own axes prevent lateral movements by the balls, which, however, can rotate freely. The sphere-and-spindle system reduces friction, allowing the top platform to turn easily even when carrying a heavy load.

III.2E.7a

LEONARDO DA VINCI
Screw jack with anti-friction bearing
Madrid Ms. I (BNM), fol. 26r

The drawings illustrate a solution to reduce friction between the fixed plat-

III.2E.6a

form and the rotating toothed disk. Leonardo provides overhead and cross-section sketches of the spheres and cylinder rollers.

III.2E.7b
Screw jack with anti-friction bearing
Working model after Leonardo da Vinci,
Madrid Ms. I (BNM), fol. 26r
Chestnut, oak, and Plexiglas; metal screw and accessories; 145 x 110 x 110 cm
Built by: SARI, FA-MA, and M. Mariani,
Florence, 1987
Istituto e Museo di Storia della Scienza,
Florence

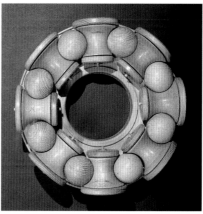

III.2E.6b

The screw jack's anti-friction mechanism is visible through the Plexiglas panel.
The crank-driven worm screw meshes with the crown wheel, raising and lowering the vertical screw slowly but effortlessly even when a heavy load is attached. To reduce friction, Leonardo has placed spheres between the crown wheel and the supporting platform.

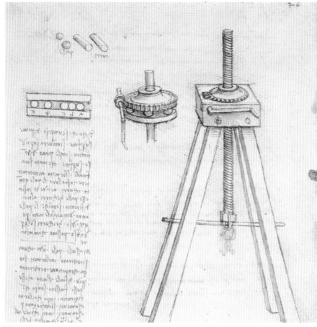
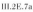

III.2E.7a

III.2E.7b

III.2F *Joints and hinges*

Leonardo's manuscripts contain detailed working drawings of joints and hinges of various types for multiple uses.

III.2F.1
LEONARDO DA VINCI
Wedge joints
Madrid Ms. I (BNM), fol. 62r (detail)

"This is a method for inserting one piece of wood into another, and you shall never be able to pull it from its cavity. It could be used for the legs of a bench."

III.2F.2
LEONARDO DA VINCI
Rotating joints
Madrid Ms. I (BNM), fol. 62r (detail)

Leonardo proposes the two joints at the top as appropriate solutions for moving the two arms of a compass (both drawings) and moving cart axles (top right drawing only). The bottom drawing shows a joint that is "unable to turn on itself only because its male and corresponding female are square."

III.2F.3
LEONARDO DA VINCI
Semi-articulated joints
Madrid Ms. I (BNM), fol. 172r (detail)

This type of joint cannot bend beyond the horizontal. Leonardo emphasizes its use in angle hinges for portable tables and dismountable wood-panel pavilions.

III.2F.4
LEONARDO DA VINCI
Door hinges
Madrid Ms. I (BNM), fol. 96v

III.2F.5
LEONARDO DA VINCI
Hinges for dismountable pavilions
Codex Atlanticus (BAM), fol. 95r

Dismountable field pavilions made of wood panels, with assembly instructions. Leonard provides detailed drawings of the iron hinges.

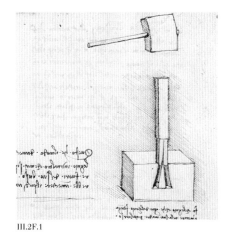
III.2F.1

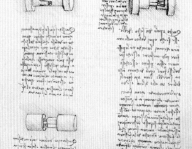
III.2F.2

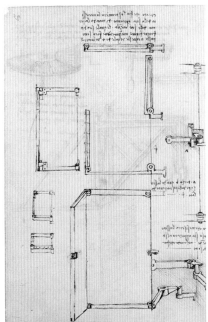
III.2F.4

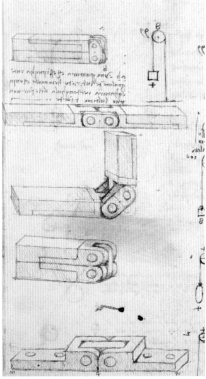
III.2F.3

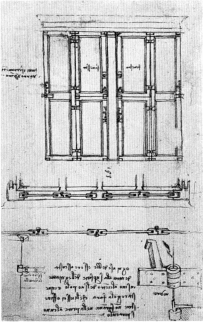
III.2F.5

III.2G *Modular tubes*

Leonardo designed modular wood tubing, mainly for use as water pipes.

III.2G.1
LEONARDO DA VINCI
Modular wood tubing
Madrid Ms. I (BNM), fol. 25v

In addition to the tubes, Leonardo shows the machine for drilling tree trunks and fabricating the tubes (left). The device is powered by a horizontal waterwheel. He also gives a side-view and cross-section of the hinges that fasten the modules securely to one another.

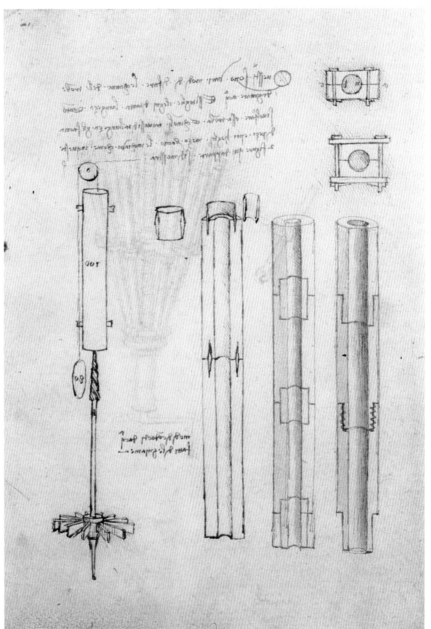

III.2G.1

III.2H *Automatic hooks*

Leonardo developed various types of automatic hooks, mainly to facilitate the raising and lowering of loads.

III.2H.1a
LEONARDO DA VINCI
**Two automatic hooks
with counterweights**
Madrid Ms. I (BNM), fol. 9v (detail)

"Method of letting down a load which immediately releases itself as it touches the ground." Leonardo points out that the hook on the right is superior because it does not come into contact with the lifted load. Thanks to the counterweight, the hook can therefore bounce back when the load touches the ground, freeing the hoist from the load.

III.2H.1b
Hoist with counterweighted automatic hook
Working model after Leonardo da Vinci, Madrid Ms. I (BNM), fol. 9v
Ash, durmast, rope, and metal
140 x 170 x 180 cm (hoist); 89 x 40 x 12 cm (hook)
Built by: Muséo Techni, Montreal, 1987
Istituto e Museo di Storia della Scienza, Florence

As soon as the load touches the ground, the counterweight causes the hook to releases its grip.

III.2H.2
LEONARDO DA VINCI
Safety tong with automatic release
Madrid Ms. I (BNM), fol. 22r (detail)

"The greater the weight held by this lifting tong, the better and stronger it will be supported."

III.2H.3
LEONARDO DA VINCI
Automatic hook for pile-driver
Codex Atlanticus (BAM), fol. 1018v (detail)

This ingenious device allows the pile-driver mallet to be automatically hooked up again after hitting the pile.

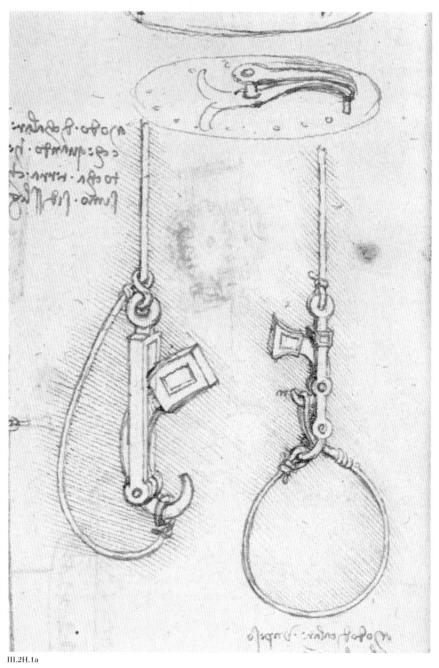

III.2H.1a

III.2H.2

III.2H.3

III.21 *Crankshafts*

The crankshaft (or draw-rod) mechanism turns rotary motion into reciprocal linear motion and vice versa. The system was largely used to operate a wide range of machines, particularly lathes and pumps. Although Leonardo demonstrated his familiarity with the mechanism, he did not make extensive use of it, preferring to obtain the same effect by other means.

III.21.1a
LEONARDO DA VINCI
Crankshaft driven by worm screw and toothed wheel
Madrid Ms. I (BNM), fol. 28v (detail)

In Leonardo's own words, "this movement is most praiseworthy, both for the ease of motion and the compactness of design."

III.21.1b
Crankshaft
Working model after Leonardo da Vinci,
Madrid Ms. I (BNM), fol. 28v
Durmast and metal; 106 × 229 × 96 cm
Built by: Muséo Techni, Montreal, 1987
Istituto e Museo di Storia della Scienza, Florence

III.21.1a

When the crank is turned continuously in the same direction, the horizontal shaft moves left to right and vice versa.

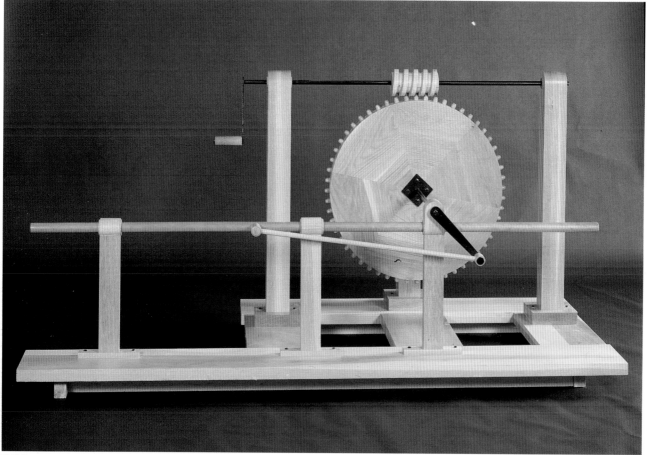

III.21.1b

III.21.2

LEONARDO DA VINCI
Two different crankshaft systems
Madrid Ms. I (BNM), fol. 86r (detail)

Leonardo points out that the longer the
shafts, the easier the systems are to
operate.

III.21.3a

LEONARDO DA VINCI
**Crankshaft to wind thread
on a bobbin**
Madrid Ms. I (BNM), fol. 29v

Leonardo shows the assembled mech-
anism and an exploded view to display
the components. Here, the crankshaft
system imparts a continuous back-
and-forth motion to the axle of the bob-
bin *m*, thus winding the thread evenly
around it.

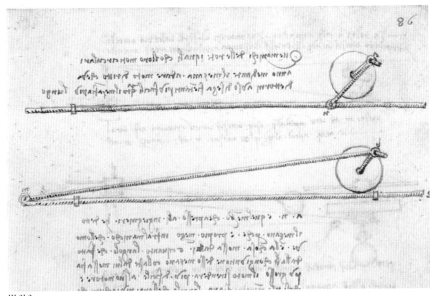

III.21.2

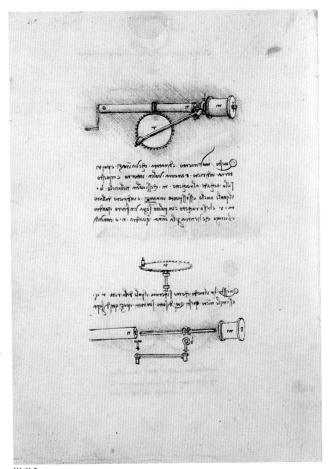

III.21.3a

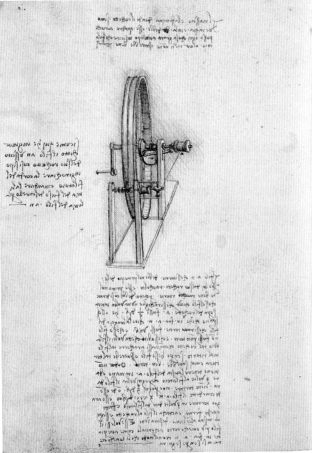

III.21.3b

III.21.3b

LEONARDO DA VINCI
Automatic winder
Madrid Ms. I (BNM), fol. 65v

This complex machine features the
variable-travel bobbin activated by a
crankshaft.

III.2J *Flywheels*

Leonardo made perceptive, pioneering studies of the role of flywheels in facilitating and regulating the motion of rotating shafts.

He refers to the flywheel as an "augmentative wheel" (*ruota di aumento*) to emphasize the device's ability to increase inertia.

III.2J.1

LEONARDO DA VINCI

Flywheels for continuous rotary motion

Madrid Ms. I (BNM), fol. 114r

Leonardo analyzes five different types of flywheel: with four balls; with bars and chains; with a single ball; with a solid wheel; with a spoke wheel.

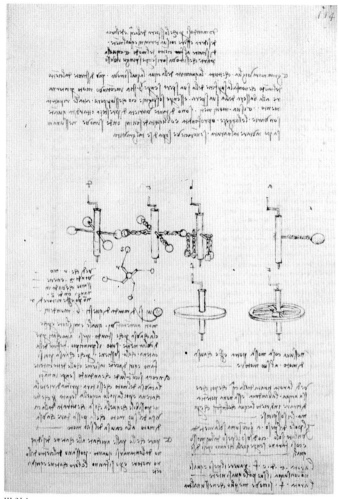

III.2J.1

III.2J.2

LEONARDO DA VINCI

Flywheels for rotary motion generated by crankshaft systems

Madrid Ms. I (BNM), fol. 86r (detail)

In this example, Leonardo exploits the flywheel's inertia capacity to facilitate rotary motion generated by a crankshaft.

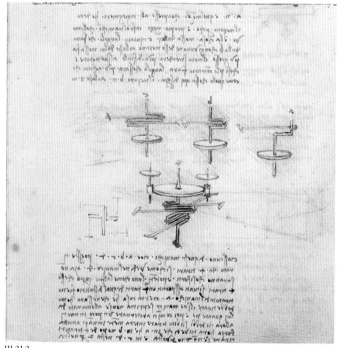

III.2J.2

III.2K *Springs*

Leonardo showed a keen interest in the many potential applications of springs. He particularly emphasized their uses in clockwork.

III.2K.1
LEONARDO DA VINCI
Analysis of various types of springs
Madrid Ms. I (BNM), fol. 85r (detail)

This series of magnificent drawings illustrates several types of springs and winding methods. Leonardo is aware that the thrust imparted by springs varies continuously: "The spring will have different degrees of either power or weakness in each degree of its motion."

III.2K.2a-c
LEONARDO DA VINCI
Techniques for regulating the force generated by springs

a. Spring and cone-shaped spindle
Madrid Ms. I (BNM), fol. 85r (detail)

If the spring's thickness is uniform, its force will diminish gradually. To avoid the negative consequences of this phenomenon, Leonardo imagined a solution that would proportionally diminish resistance. The drawing shows a cone-shaped spindle connected by a thread to the spring. The spindle maintains a constant force as the spring unwinds.

b. Spring, cone-shaped pinion, and helical gear
Madrid Ms. I (BNM), fol. 16r (detail)

Leonardo depicts a clock drive consisting of a helical gear that offers decreasing resistance to the cone-shaped pinion powered by the spring shaft. The spring is housed in the cylindrical base.

c. Spring, cone-shaped pinion, and helical gear
Madrid Ms. I (BNM), fol. 45r (detail)

This superb drawing shows a helical gear different in design from the previous one. The gear serves to regulate the force of the spring housed in the base of the clock drive.

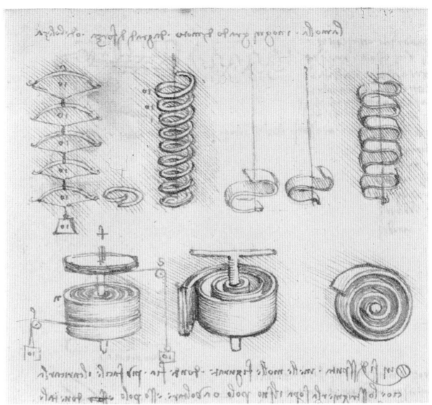

III.2K.1

III.2K.2a

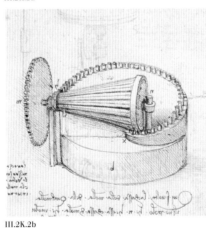

III.2K.2b

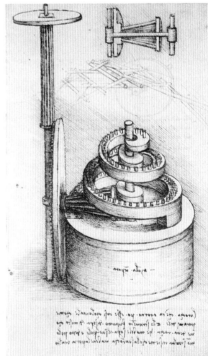

III.2K.2c

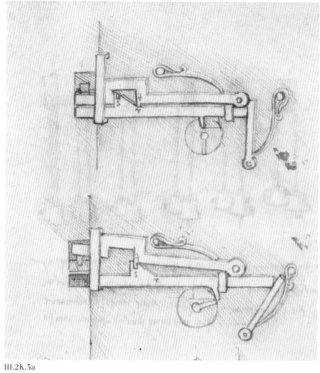

III.2K.3a

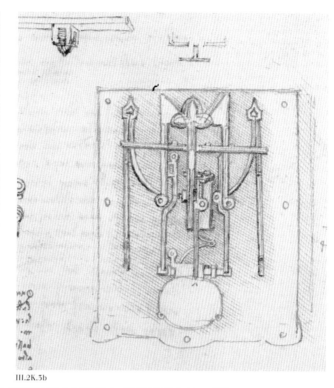

III.2K.3b

III.2K.3a-c

LEONARDO DA VINCI
Springs and locks

Leonardo is well aware that springs
are an essential component of locks.

**a. Spring lock with key in locked
position (top) and open position
(bottom)**
Madrid Ms. I (BNM), fol. 99v (detail)

b. Spring-and-lever lock with key
Madrid Ms. I (BNM), fol. 50r (detail)

**c. Spring-and-lever mechanisms
for automatic fuse-lighting devices
on firearms**
Madrid Ms. I (BNM), fol. 18v (detail)

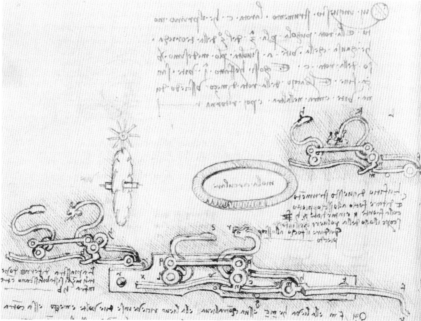

III.2K.3c

III.2K.4
LEONARDO DA VINCI
Spring used as a brake
Madrid Ms. I (BNM), fol. 10r (detail)

Leonardo suggested using a circular
spring as a brake for carriage axles:
"Spring that tightens equally and slack-
ens equally. And it shall be tempered in
the most perfect circle possible."

III.2K.5
LEONARDO DA VINCI
Spring-making machine
Madrid Ms. I (BNM), fol. 14v (detail)

"This is the instrument for making
springs like those used in clockwork."
Leonardo specifies that the springs are
made of steel.

III.2K.6a
LEONARDO DA VINCI
Leaf-spring clock drive
Codex Atlanticus (BAM), fol. 863r (detail)

III.2K.6b
Leaf-spring clock
Working model after Leonardo da Vinci,
Codex Atlanticus (BAM), fol. 863r
Iron and rope; 80 x 70 x 35 cm
Built by: A. Gorla, Cividale Mantovano
(Mantua), 1995
Istituto e Museo di Storia della Scienza,
Florence

Two leaf springs power two cone-
shaped spindles placed on the same
shaft. The spindles activate a rod es-
capement via a series of toothed wheels.
The drawing of this clock mechanism is
included in a sheet of studies on the fly-
ing machine.

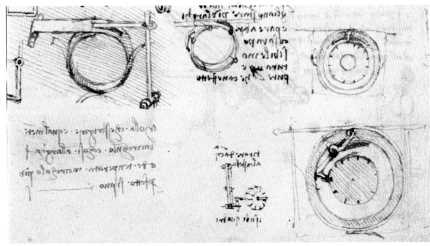

III.2K.4

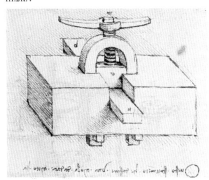

III.2K.5

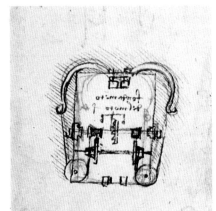

III.2K.6a

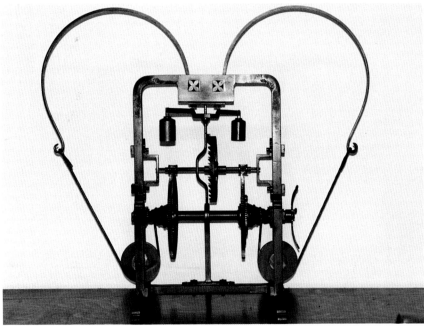

III.2K.6b

III.2K.7a
LEONARDO DA VINCI
Spring motor
Madrid Ms. I (BNM), fol. 14r

To accompany his drawing of this complex mechanism, Leonardo provides detailed sketches of the system that imparts motion to the rack (left) and the top part of the spindle driven by the winding cone-shaped gear (bottom).

III.2K.7b

Spring motor
Working model after Leonardo da Vinci, Madrid Ms. I (BNM), fol. 14r
Chestnut and oak; metal spring and accessories; 125×174×71 cm
Built by: SARI, FA-MA, and M. Mariani, Florence, 1987
Istituto e Museo di Storia della Scienza, Florence

A highly complex device designed to regulate the force of the spring concealed inside the cylindrical drum. The crown wheel on the cylinder drives a winding cone-shaped gear. Continuous meshing is provided by the worm screw at the base of the shaft carrying the cone-shaped gear. The screw meshes with a toothed wheel that drives a rack segment, shifting a horizontal slide to which the cylindrical drum is attached. The top part of the shaft bearing the cone-shaped gear consists of a screw. As the screw turns, it drives down the cone-shaped gear, which pushes the drum toward the right.

This machine, probably intended to regulate the movement of large clocks, offers a varied combination of basic mechanisms including a toothed wheel, a worm screw, a spring, a cone-shaped gear, and a rack.

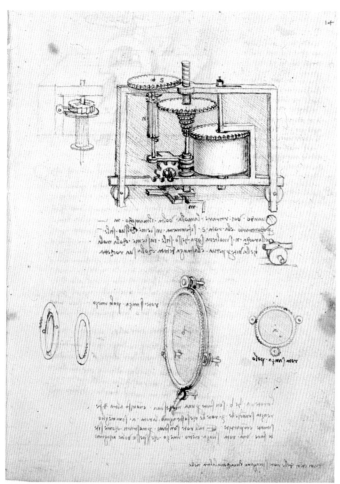

III.2K.7a

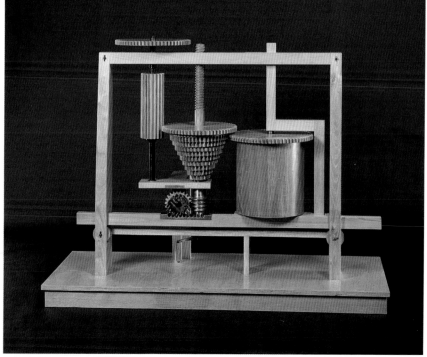

III.2K.7b

III.2L *Cams*

Leonardo made frequent use of cams, especially to generate reciprocal motion or a regular percussive motion from a rotary motion.

III.2L.1a
LEONARDO DA VINCI
Hammer driven by eccentric cam
Madrid Ms. I (BNM), fol. 6v (detail)

III.2L.1b
Hammer driven by eccentric cam
Working model after Leonardo da Vinci,
Madrid Ms. I (BNM), fol. 6v
Durmast and metal; 121 x 83 x 120 cm
Built by: Muséo Techni, Montreal, 1987
Istituto e Museo di Storia della Scienza, Florence

The cam system causes the hammer to strike one blow at every turn of the crank.

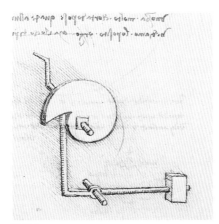

III.2L.1a

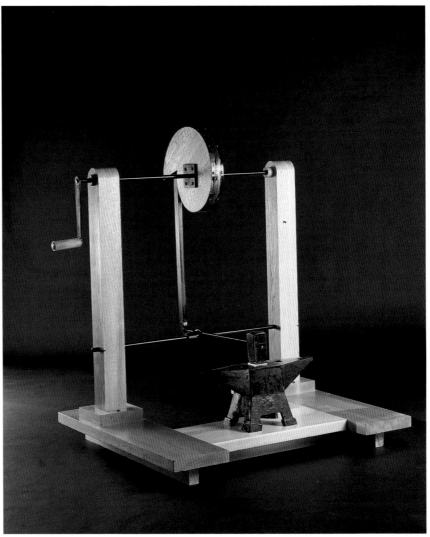

III.2L.1b

III.2L.2
LEONARDO DA VINCI
Eccentric cam to regulate the force of a spring
Ms. M (IFP), fol. 81r (detail)

This application, certainly intended for clocks, seems to be a precursor of what is known as the stack-freed mechanism.

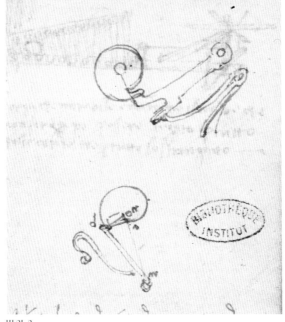

III.2L.2

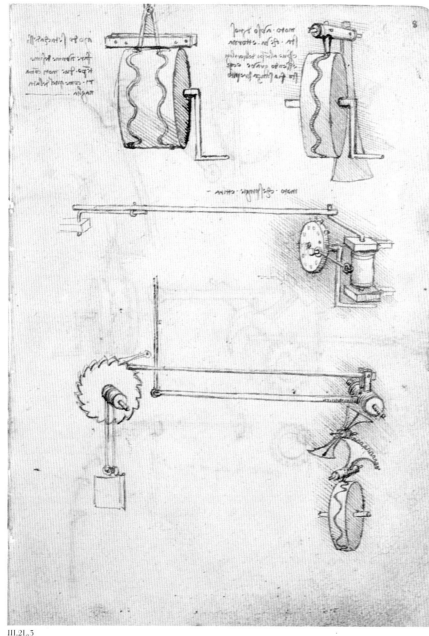

III.2L.3

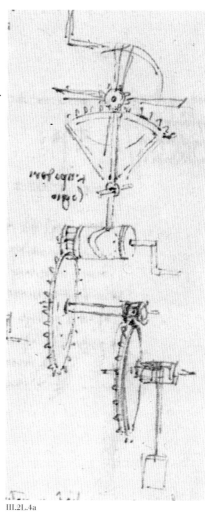

III.2L.4a

III.2L.3
LEONARDO DA VINCI
Silent pendulum escapement with sinusoidal cam
Madrid Ms. I (BNM), fol. 8r

A visionary design of Leonardo: this escapement was not used to regulate clocks until several centuries later.

III.2L.4a
LEONARDO DA VINCI
Escapement with propeller and sinusoidal cam
Madrid Ms. I (BNM), fol. 157v (detail)

The caption "clock time" (*tempo d'orilogi*) indicates this is a study for a weight-driven clock.

III.2L.4b
Escapement with propeller and sinusoidal cam
Working model after Leonardo da Vinci, Madrid Ms. I (BNM), fol. 157v
Iron and rope; 195×48×38 cm
Built by: A. Gorla, Cividale Mantovano (Mantua), 1995
Istituto e Museo di Storia della Scienza, Florence

Mechanism for regulating the movement of a weight-driven clock. Via a trasmission system composed of wheels and pinions, the weight causes the rotation of the drum bearing a sinusoidal track. The drum's revolutions impart a back-and-forth motion to the curved rack (top). The latter, in turn, drives the propeller alternately clockwise and counterclockwise.

III.2M *Chains*

Leonardo designed several types of chains. He especially recommended their use in preference to ropes for lifting heavy loads. He did not, however, seem interested in exploring the use of chains to transmit motion.

III.2M.1
LEONARDO DA VINCI
Various types of chains
Madrid Ms. I (BNM), fol. 10r (detail)

The drawing shows a series of chains composed of variously shaped links.

III.2M.2
LEONARDO DA VINCI
Dismountable chain
Madrid Ms. I (BNM), fol. 10r (detail)

This chain can be assembled and taken apart without breaking its links, of which one is shown on the right.

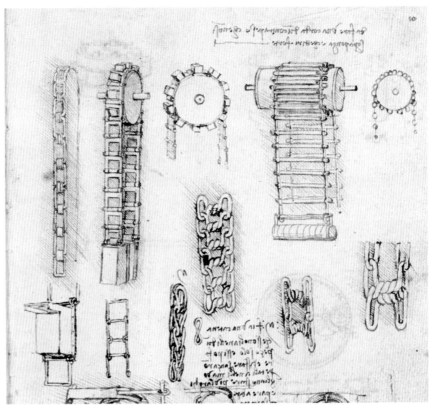

III.2M.1

III.2M.2

III.2M.3
LEONARDO DA VINCI
'Bicycle' chain
Codex Atlanticus (BAM), fol. 158r (detail)

At the center of the disk on top, one can see a few links of a chain resembling those of modern bicycles. Here, however, the chain is used to load the large spring that powers the flint-lock on a firearm.

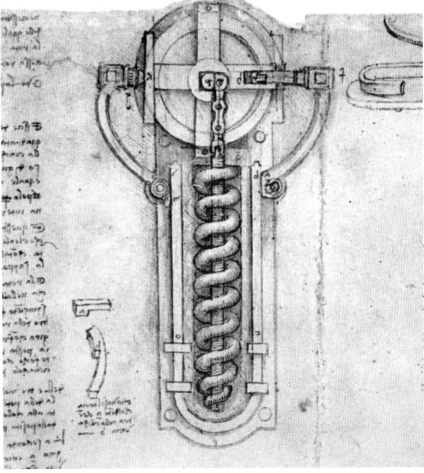

III.2M.3

III.2N *Ropes and belts*

Although Leonardo apparently preferred the worm screw-toothed wheel-pinion system to transmit continuous rotary motion, he sometimes used ropes and belts for the same purpose.

III.2N.1
LEONARDO DA VINCI
Transmitting motion by means of ropes
Madrid Ms. I (BNM), fol. 23r

Systems to turn rotary motion into reciprocal linear motion, or vice versa, by means of ropes or toothed-wheel segments and pinions. Leonardo observes that "every motion made by ropes is gentler and less noisy than if it were made by the aid of toothed wheels and pinions."

III.2N.2
LEONARDO DA VINCI
Transmitting motion by means of rods and ropes
Madrid Ms. I (BNM), fol. 31r

Comparison between two equivalent means of producing reciprocal linear motion from rotary motion: rod (top) and ropes (bottom).

III.2N.3a
LEONARDO DA VINCI
Transmitting motion by means of belts
Madrid Ms. I (BNM), fol. 30v (detail)

Using a belt to turn rotary motion into reciprocal linear motion.

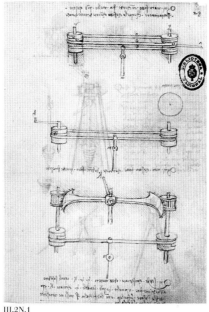

III.2N.1

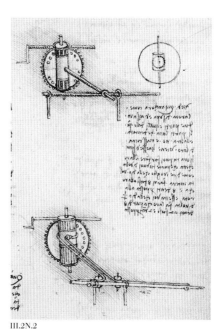

III.2N.2

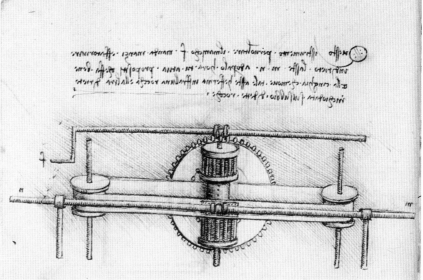

III.2N.3a

III.2N.3b
Reciprocal linear motion produced by means of a belt
Working model after Leonardo da Vinci,
Madrid Ms. I (BNM), fol. 30v
Durmast, iron, and canvas; 61 x 127 x 45 cm
Built by: Nuova SARI, Florence, 1995
Istituto e Museo di Storia della Scienza,
Florence

The crank drives the solid vertical toothed wheel. The semicircular set of pegs on the side of the wheel meshes alternately with one of the two pinions fixed to the horizontal shaft *m n*. The shaft also moves a belt, causing the horizontal rod attached to the belt to move from left to right and vice versa.

III.20 *Shock absorbers*

The study of the flying machine, which Leonardo pursued for many years, also led him to investigate contrivances for reducing the adverse effects of a sudden impact on the ground – a not unlikely event.

III.20.1
LEONARDO DA VINCI
Telescopic shock absorber
Madrid Ms. I (BNM), fol. 62v

"This instrument may be used to allow a man to fall from great heights." The hapless flier was supposed to hang on to the grips *a* and *b*. On impact, the upper wooden shafts would plunge like wedges into the lower ones. This would dampen the shock, which would further be cushioned by the wool bale at the foot of the device.

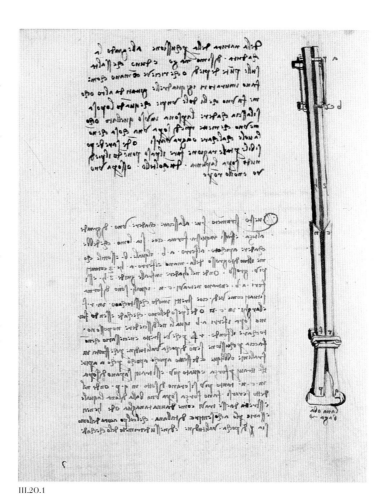

III.20.1

III.20.2
LEONARDO DA VINCI
Shock absorbers on the flying machine
Ms. B (IFP), fol. 89r

"When the foot of the ladder hits the ground, it will be unable to deal a damaging blow to the instrument because it is a wedge that sinks in, encountering no obstacle to its tip. A perfect device." On the right, a detail of the wedge shock absorber.

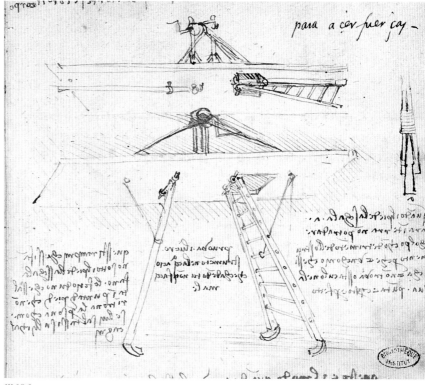

III.20.2

III.2P *The flying machine*

III.2P.1a
LEONARDO DA VINCI
Flying machine
Ms. B (IFP), fol. 74v

III.2P.1b
Flying machine
Working model after Leonardo da Vinci,
Ms. B (IFP), fol. 74v
Beech, iron, brass, coirrope, leather,
and tallow; 167 × 490 × 1100 cm
Built by: A. Ingham & Associates and J. Wink,
Tetra Associated, London, 1995
Istituto e Museo di Storia della Scienza,
Florence

In his studies on mechanical flight, Leonardo sought to find optimal combinations of a multitude of elementary mechanical devices, including pulleys, cranks, toothed wheels, joints, transmission systems, high-strength axles, and shock absorbers.

In this model, the wings are driven by the back pedals, which the flier operates with alternating leg motions. The effect of this thrust is amplified by the hand-operated crank, which powers a hoisting device.

As this life-size model illustrates, Leonardo's projected flying machines had little chance of success, despite their impeccable mechanical design. Their lack of viability was due to the disproportion between the force available to lift the machines (i.e. human power) and their massive weight.

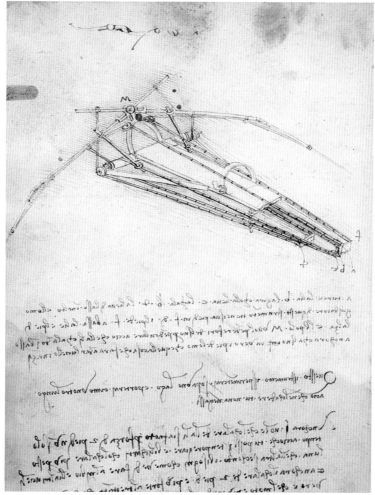

III.2P.1a

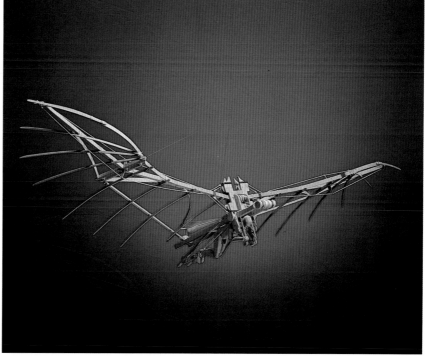

III.2P.1b

III.3 The human body as a wonderful machine

Leonardo engaged in the dissection of human bodies with particular intensity in the years around 1505. This pursuit is documented in many surviving drawings, rightly admired for their expressive power.

Leonardo sought to demonstrate the close analogy between the machine and the human body. He saw both as the wonderful achievements of Nature, whose iron laws govern not only mechanical instruments but also the motions of animals. "Nature," Leonardo notes, "cannot impart motion to animals without mechanical instruments."

Not surprisingly, therefore, his anatomical investigations concentrate on the basic organs of the human body of which his drawings repeatedly underscore the direct analogy with mechanical devices – to the point of suggesting the possibility of building fully operational artificial limbs and models.

The reduction of the motions of the living organism to the elementary laws of mechanics is reflected in Leonardo's plan to use his book of the "elements of machines" as an introduction to his treatise on anatomy:

"Put the book of the elements of machines before the demonstration of the motion and strength of man and other animals, and thanks to [those elements] you will be able to prove all your propositions."

III.3.a[1-2]

LEONARDO DA VINCI
Static measurement of muscular force
Ms. H (IFP), fols. 43v-44r

In the left-hand drawing, Leonardo uses pulleys and weights to measure the force of the muscles in the head, bust, arms, and legs of a crouching figure. The study is probably linked to Leonardo's project of a human-driven flying machine. The right-hand drawing illustrates the measurement of muscular force in the upper limb.

In the first of the two sketches, each rope attached to the elbow and hand carries a hundred-pound weight. In the second, the hand carries a 120-pound weight.

III.3.b

LEONARDO DA VINCI
Arm joints
Royal Collection (RLW), 19000v; K/P 135v

These drawings of the pronation and supination of the arm illustrate Leonardo's efforts to depict the mechanism of the upper limb. He views the arm as a machine consisting of levers rotating on fulcrums.

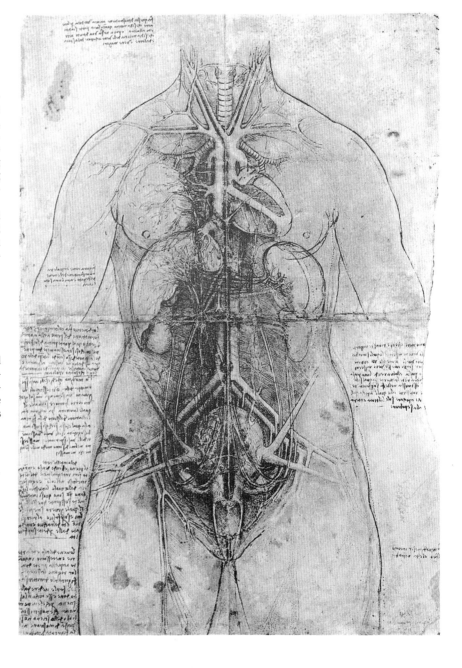

III.3.c

LEONARDO DA VINCI
Studies of arm joints
Royal Collection (RLW), 19005v; K/P 137v

The drawing illustrates the findings of Leonardo's anatomical analysis of shoulder and neck movements. Leonardo concentrates on the muscles that control the movements. The upper right drawing shows the muscles governing shoulder movements. It exemplifies Leonardo's favorite technique of depicting muscles by means of strings or ropes to indicate the direction of their mechanical action. This technique derives directly from Leonardo's recurrent analogy between the components of the living body and mechanical devices.

III.3.a¹

III.3.a²

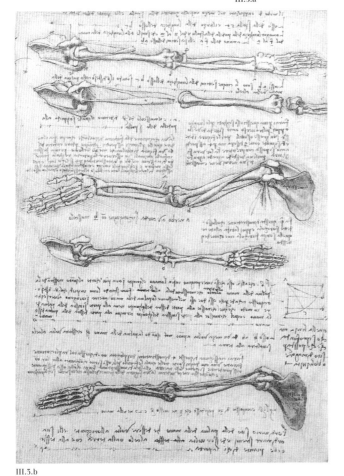

III.3.b

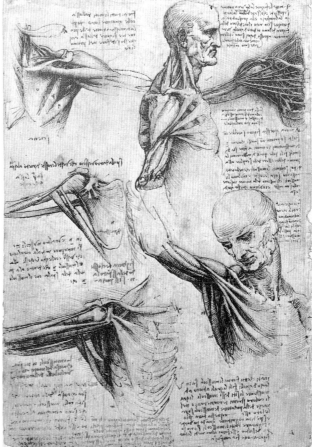

III.3.c

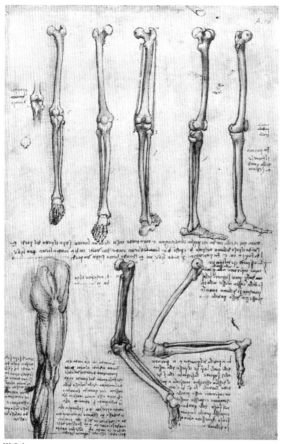

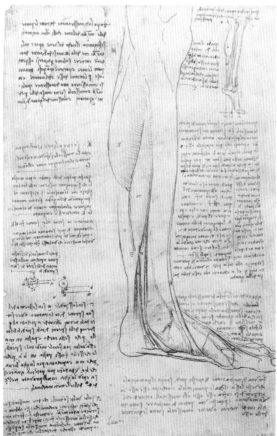

III.3.d

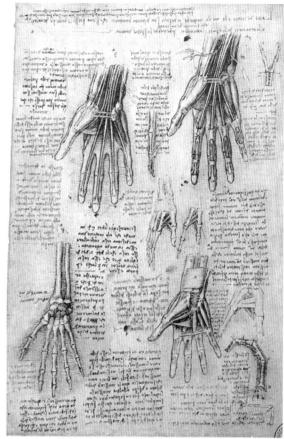

III.3.e

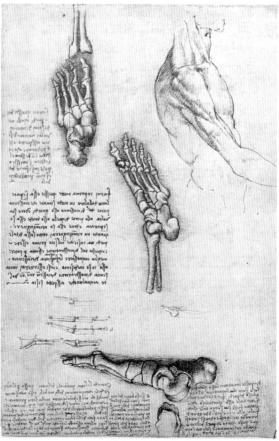

III.3.f

III.3.g

III.3.d

LEONARDO DA VINCI
Studies of leg joints
Royal Collection (RLW), 19008r; K/P 140r

In the studies of the knee and ankle joints on this sheet, Leonardo consistently resorts to the analogy with the lever. In an annotation, he describes the Achilles tendon as a lever that raise the heel using the fore part of the foot as a fulcrum (top right figure), and measures the tendon's exact strength by applying the laws of levers. The lower left figure shows the leg complete with the muscles whose mechanical actions control the movements of the limb.

III.3.e

LEONARDO DA VINCI
Studies of the hand
Royal Collection (RLW), 19009r; K/P 143r

These drawings illustrate a series of dissections of successive layers of the hand, down to the bones, with details highlighting the major and most complex joints. Applying his customary method, Leonardo depicts the muscles as strings or cords ("make strings instead of muscles") to indicate their lines of mechanical action. This enables him to demonstrate movements such as the opening, closing, and rotation of the hand, convergence, connection, and separation of the fingers, flexion and extension of the phalanxes, and so on.
Leonardo also clearly depicts the muscles that govern the independent movements of the thumb and little finger. The complex mechanics of the hand's many movements fascinated him.

III.3.f

LEONARDO DA VINCI
Studies of heel and foot joints
Royal Collection (RLW), 19010v; K/P 147v

The analyses and drawings of this sheet exemplify the mechanistic interpretation that Leonardo sought to give to foot movements. The top right sketch compares the lifting of the heel to the raising of weights placed at either end of a scale with equal arms. The two small sketches on the left margin demonstrate the varying efficiency of the muscles of the cervical vertebrae according to the laws of levers – "as proven," says Leonardo, "in the book of the elements of machines".

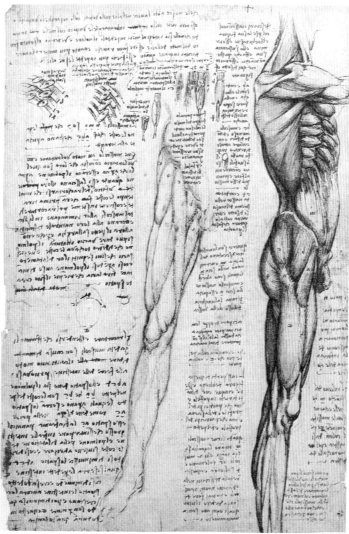

III.3.h

III.3.g

LEONARDO DA VINCI
Studies of the foot and shoulder
Royal Collection (RLW), 19000r; K/P 135r

Leonardo's interest in the mechanics of joints is reflected in the drawings on the lower half of the sheet. The upside-down foot in the lower center is intended to show the friction-reducing function of the sesamoid bone at the base of the big toe.
The small sketches above and to the left of the overturned foot, together with the annotations along the bottom of the page, show how the sesamoid bones ensure the stability and flexibility of the phalanxes of the toes.

III.3.h

LEONARDO DA VINCI
Studies of trunk and thigh muscles
Royal Collection (RLW), 19014v; K/P 148v

These superb drawings are intended to demonstrate the mechanical work performed by muscles in order to rotate the upper and lower parts of the body above the hip joints. Leonardo refers to the hip as an axle (*polo*) to underline the analogy with mechanical devices. In a note, he invites the reader to admire the extraordinary skill of the "composer of such a machine."
The small drawings (top left and center) show Leonardo's attempt to classify the basic parts of the various types of muscle together with their nerves and blood vessels, as well as the muscles that are connected to the ribs and regulate breathing.

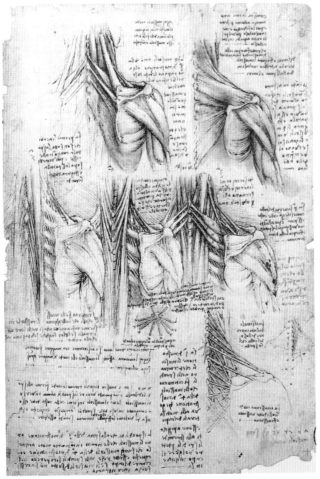

III.3.i

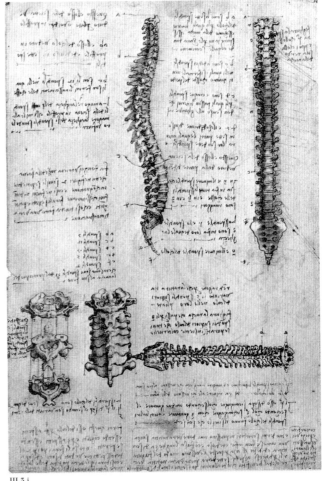

III.3.j

III.3.i

LEONARDO DA VINCI
Studies of back and spinal-column
muscles
Royal Collection (RLW), 19015r; K/P 149r

In this sheet, Leonardo has made a
particularly determined effort to depict
the action of the muscles that ensure
the stability and flexion of the spinal
column. The figures at the center
demonstrate how each vertebra is
controlled by ten muscles grouped in-
to five pairs, each consisting of two
muscles working in opposite directions.
To clarify the complex mechanics of
these integrated muscular actions,
Leonard has added a small diagram
underneath, in which the ten muscles
connected to a vertebra are replaced
by five pairs of ropes or strings. He
uses the same technique in the two
drawings on the lower right, which
show the role of muscles in flexing and
stabilizing the spinal column.

III.3.k¹ III.3.k²

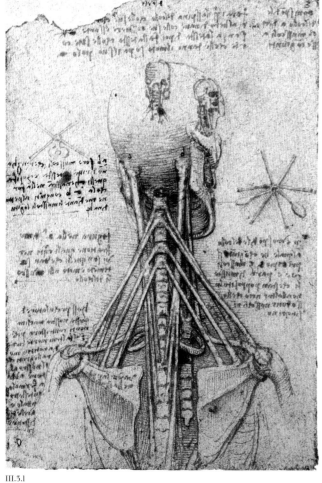

III.3.l

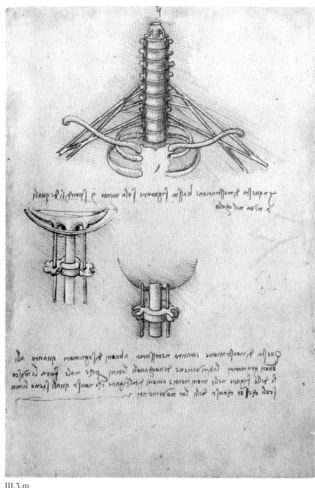

III.3.m

III.3.j

LEONARDO DA VINCI
Studies of the spinal column
Royal Collection (RLW), 19007v; K/P 139v

This extraordinary sheet proves Leonardo's thorough grasp of the mechanics of spinal-column movements. He breaks up the column into individual vertebrae, which he analyzes separately to show their variable dimensions. On the lower left, Leonardo's exploded view provides an exceptionally clear demonstration of the mechanical principles governing the assembly of individual vertebrae into the column.

III.3.k[1]

LEONARDO DA VINCI
Studies of the mechanism of breathing
Royal Collection (RLW), 19015v; K/P 149v (detail)

Leonardo uses mechanical principles to demonstrate the role of muscles and the rib cage in breathing. He stresses the reciprocal, integrated action of the ribs and spinal column. The muscles and ribs that support the column are likened to the shrouds that hold a ship's mast in place.

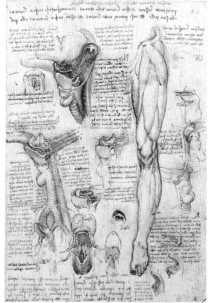

III.3.n

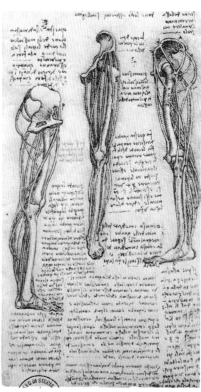

III.3.o

III.3.k[2]

LEONARDO DA VINCI
Studies of the mechanism
of breathing
Royal Collection (RLW), 19061v; K/P 154v
(detail)

Leonardo made a detailed study of the
mechanics of voluntary respiratory
movements (yawning and sighing).
Here, he focuses on the action of the
muscles that raise the ribs. Resorting to
his favorite mechanical analogy, he re-
duces muscular action to the work of a
weight lifting a rod via a pulley.

III.3.l

LEONARDO DA VINCI
Studies of cervical vertebrae
Royal Collection (RLW), 19075v; K/P 179v

This drawing repeats, even more vivid-
ly, the mechanical analogy between
the muscles supporting the neck and
the shrouds that keep a ship's mast up-
right. "First you will make the neck
spine with its ropes, like a ship's mast
with its shrouds. [...] You will then
make the head with its ropes, that im-
part motion to it above its axle."
These notes and drawings are a very
striking example of how Leonardo
does not hesitate to rework his ob-
servational data for the sake of under-
scoring the body-machine analogy.

III.3.m

LEONARDO DA VINCI
Studies of cervical vertebrae
and base of the skull
Royal Collection (RLW), 19021v; K/P 62v

Leonardo's anatomical drawings elo-
quently demonstrate his tendency to
analyze human organs as a series of
perfectly honed mechanisms. This is
especially the case with his drawings of
the base of the skull, which look almost
like reproductions of metal tools.

III.3.n

LEONARDO DA VINCI
Studies of the throat and leg
Royal Collection (RLW), 19002r; K/P 134r

Following his customary method,
Leonardo has broken down the com-
ponent organs of the throat to discover
the secrets of its functions (breathing,
swallowing, phonation), "and then you
gradually put them together, so that
one can put together the whole with a
clear understanding." The most no-
table studies concern the trachea, lar-
ynx, pharynx, and epiglottis. The draw-

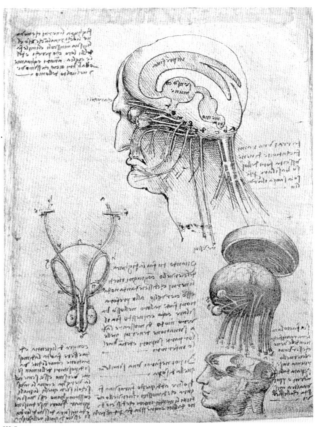

III.3.p

ings of the trachea (bottom left, details
in the center) and larynx (top left)
show that Leonardo analyzes these or-
gans as mechanical instruments. He
attributes the production of sounds
(phonation) to the turbulence of expired
air as it passes through the vocal cords.
He compares this phenomenon to the
eddies produced by water rushing from
a narrow channel into a wider one.

III.3.o

LEONARDO DA VINCI
Studies for the construction
of a model leg
Royal Collection (RLW), 12619r; K/P 152r

This sheet offers an extreme example
of Leonardo's favorite technique of
portraying muscles as ropes or strings
to show their lines of force. Here, he
actually suggests moving up from a
plain drawing to a model of the limb in
which the muscles are represented by
copper wires. The model would help to
produce anatomical drawings of greater
demonstrative efficiency than those
obtained from the direct observation of
the dissected limb. The drawings show
three views of the model, but the anno-
tations refer to a fourth drawing (the
rear view of the leg), missing here.

III.3.p

LEONARDO DA VINCI
Studies of the skull and brain
Weimar Sheet verso, Schloss-Museum,
Weimar

The verso of this loose sheet, original-
ly part of the corpus of Leonardo's
anatomical drawings, contains a spec-
tacular exploded view of the skull that
displays the organs arranged in an or-
derly fashion inside it. The entire set of
drawings is presented as a visual in-
struction manual for assembling the
parts of a complex mechanical device.

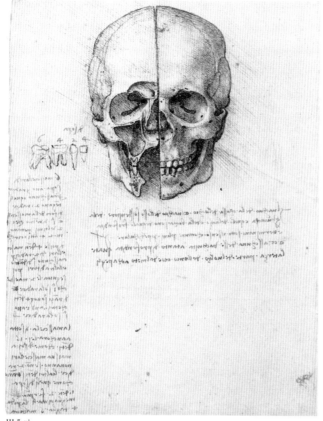

III.3.q¹

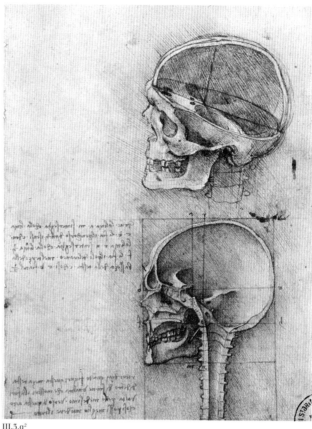

III.3.q²

III.3.q¹⁻²

LEONARDO DA VINCI
Studies of the skull
Royal Collection (RLW), 19058v; K/P 42v, and 19057v; K/P 43v

These superb drawings by the young Leonardo illustrate his effort to analyze the structure of the skull and its component elements within the framework of his passionate quest for geometrical proportionality.

In the drawing on the left, Leonardo shows the arrangement of the teeth, each of which is depicted individually. Elsewhere, he compares the jaw's motion in chewing to that of the lever: "That tooth has less power in its bite which is more distant from the center of its movement."

The top drawing on the right shows a sagittal cross-section of the base of the skull, depicted as a cross-section of a sphere. In the lower right drawing, the cross-section of the skull is inscribed in a square, and that of the entire head in a rectangle.

III.3.r

LEONARDO DA VINCI
The heart as a furnace
Codex Arundel (BLL), fol. 24r (detail)

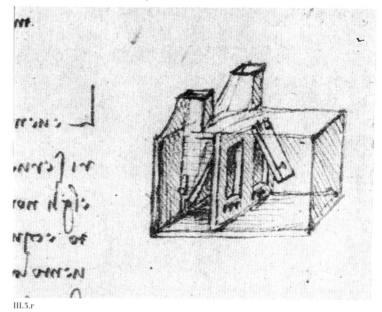

III.3.r

The comparison between the heart's generation of heat and the operation of a furnace is surely one of the boldest of the mechanical analogies that recur in Leonardo's anatomical studies. In his heart-furnace drawings, the air inlet and outlet valves stand respectively for the orifices supplying fresh air to the heart from the lung and the orifices through which the air heated by the heart is released. The trachea and lung act as a chimney stack for removing the fumes contained in the air burned by the heart.

III.4 Leonardo's lost robot

Leonardo's inspiration came from ancient Greek texts. Ctesibus (3rd century b.C.) produced the first organ and water clocks with moving figures. Hero of Alexandria (1st century a.C.) detailed several automata that were used in theater and for religious purposes. The Antikythera Mechanism (ca. 87 b.C.), an astronomical mechanical calculator, shows how sophisticated Greek mechanical technology had become. The Greek tradition was revived by Vitruvius (1st century b.C.), who described several automata and developed the canon of proportions, which is the basis of classical anatomical aesthetics.

Arab authors also designed complex mechanical arrangements. Al-Jazari (1150?-1220?), for instance, illustrated several designs which also anticipated the principle of the modern flush toilet.

In approximately 1495, before he began work on the *Last Supper*, Leonardo designed and possibly built the first humanoid robot in Western civilization. The robot, an outgrowth of his earliest anatomy and kinesiology studies recorded in the Codex Huygens, was designed according to the Vitruvian canon. This armored robot knight was designed to sit up, wave its arms, and move its head via a flexible neck while opening and closing its anatomically correct jaw. It may have made sounds to the accompaniment of automated drums. On the outside, the robot is dressed in a typical German-Italian suit of armor of the late fifteenth century. On the inside, it was made of wood with parts of leather and metal and operated by a system of cables. This robot would influence his later anatomical studies in which he modeled the human limbs with cords to simulate the tendons and muscles.

The robot consisted of two independent systems: three-degree-of-freedom legs, ankles, knees, and hips; and four-degree-of-freedom arms with actuated shoulders, elbows, wrists, and hands. The visor, neck, jaw and possibly the spine may also have been actuated. The orientation of the arms indicates it was designed for whole-arm grasping, which means that all the joints moved in unison. A mechanical, analog-programmable controller within the chest provided power and control for the arms. To drive the arms, the controller had a cylindrical, grooved cam that triggered high-torque worm gears attached to a central pulley. A central shaft, perhaps splined, provided power while still permitting the robot to stand and sit. The legs were powered by an external crank arrangement driving the cable, which was connected to key locations in the ankle, knee, and hip.

Mark E. Rosheim

III.4.a
LEONARDO DA VINCI
Studies of shoulder and trunk joint
of the robot knight
Codex Atlanticus (BAM), fol. 216v-b
[*see p. 83, fig. 80*]

III.4.b
LEONARDO DA VINCI
Drive-train of robot's legs
Madrid Ms. I (BNM), fols. 90v-91r

III.4.c
LEONARDO DA VINCI
Studies of elements of the robot
Codex Atlanticus (BAM), fol. 1077r

III.4.d
Drive-train of robot's arms
Drawing by: M.E. Rosheim, Minneapolis, 1997

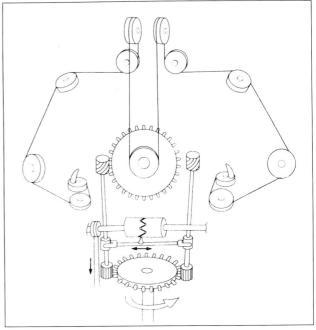

III.4.d

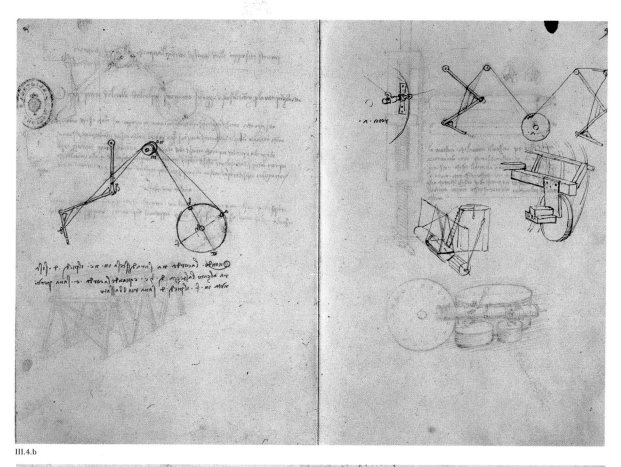

III.4.b

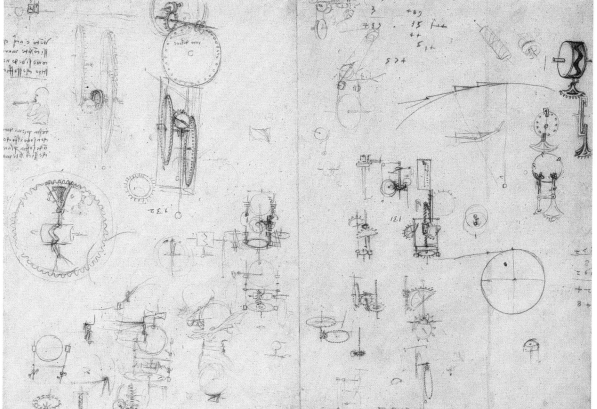

III.4.c

III.5 Body-Earth analogy

For Leonardo, even the Earth is a vast organism whose motions are governed by the universal mechanical laws of Nature. He subjected the Earth's "members" to the same refined anatomy that he practiced on machines and the living body. Leonardo thus discovered in the planet, as in man, a ceaseless internal circulation of waters ascending via distillation processes from the ocean depths to mountain-tops, from which they flow back down to the sea.

Water, whose motion fascinated Leonardo, is the basic dynamic element of his geological universe: it excavates the Earth's crust, lays mountains bare through erosion, and provokes volcanic phenomena and earthquakes.

Leonardo continually refers to the body-Earth analogy, endowing the planet with a vegetative life: "Its flesh is the soil; its bones are the rocks that support the Earth; its blood is underground water streams."

Leonardo explains the Earth's structure in terms of strictly mechanical principles and laws, whether he is investigating its center of gravity, tides, the origin of mountains and geological strata, wind erosion, or the destruction caused by floods and earthquakes.

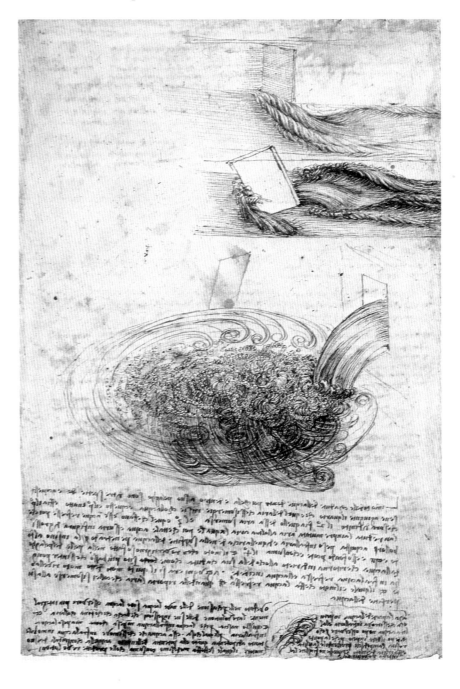

III.5.a
LEONARDO DA VINCI
Exploding mountain
Royal Collection (RLW), 12380r; P 59r

This drawing, with eight others, forms what is known as the "deluge series," laden with allegorical and symbolic references that have not yet been fully elucidated. The picture vividly illustrates Leonardo's passionate interest in the turbulent motions of natural elements – not only water, but also air, wind, and fire. This pursuit loomed large in his hydrodynamic investigations, especially toward the end of his life. Even here, Leonardo sought to describe not so much the effects of Nature's destructive force as its obedience to the precise and necessary mechanical movements that govern the macrocosm and the microcosm.

III.5.a

III.5.b
LEONARDO DA VINCI
Horizontal outrop of rock
Royal Collection (RLW), 12394r; P 53r

In its emphasis on the rectilinear arrangement of rock strata, this study powerfully expresses Leonardo's concept of rocks as the "Earth's bones." The drawing highlights the erosion caused by wind and rain, and evokes the notion of the Earth's vast organism-machine as the arena of forces regulated by universal mechanical principles.

III.5.b

III.6 The machine-building

For Leonardo, even buildings – like any other mechanism or structure – are subjected to the rigid, unchanging laws of Nature. He repeatedly underlines the analogy between buildings and the mechanical structure of the body – a comparison that emerges with particular force in his anatomical drawings of the top of the skull and the heart ventricles. The analogy rests on the notion of structures as organisms composed entirely of indispensable, fully integrated parts.

This vision led him to draw a parallel between the physician and the architect: "Just as doctors ... should understand what man is, what life is, what health is ... and in what manner a balance and concordance of elements will preserve health, while their discordance will destroy it ... The same is necessary for an invalid building, that is, a doctor-architect who has a good knowledge of what a building is, and from which rules good building derives ..."

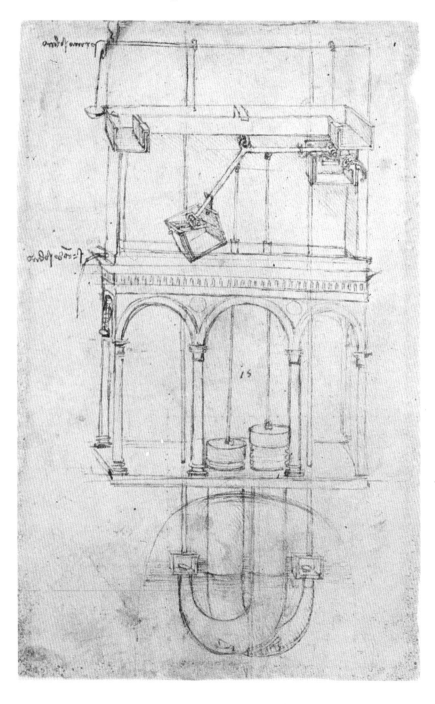

III.6.a
LEONARDO DA VINCI
Centrally planned church
Ms. 2184 (IFP), fol. 5v

Elevated view and plan of centrally-planned octagonal church. The top-left sketch shows one of the eight small domes surrounding the central dome.

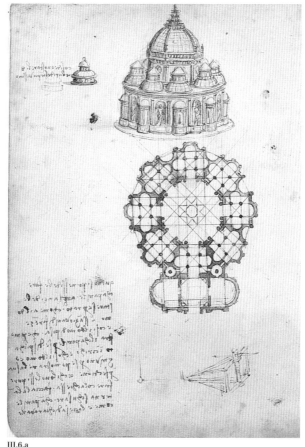

III.6.a

III.6.b
Centrally planned church
Model after Leonardo da Vinci, Ms. 2184 (IFP), fol. 5v
Linden and elm; 268 × Ø 272 cm
Concept and design: K. De Jonge
and J. Guillaume
Built by: SARI, Florence, 1987
Istituto e Museo di Storia della Scienza, Florence

The model illustrates the complex modular geometry so characteristic of Leonardo's architectural projects. Modularity features most prominently in his many studies on the geometric generation of elegant solid forms, his search for special lighting effects, and his concept of a structure – be it a machine, the Earth, the human body, or a building – as a perfectly articulated organism.
This approach is vividly demonstrated by the three-dimensional transposition of the drawing into the model. The church is almost certainly the result of a theoretical analysis unrelated to an actual construction project.

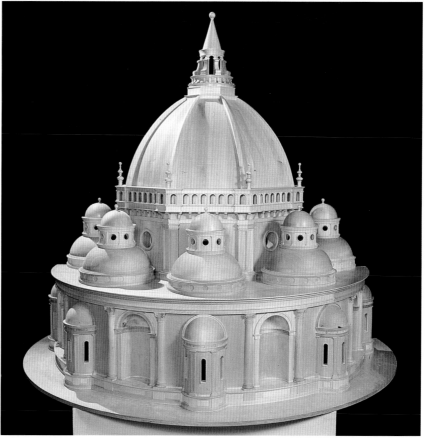

III.6.b

Bibliography

Adams N., 1984. "Architecture for fish: the Sienese dam on the Bruna river. Structures and design, 1468-ca.1530", *Technology and culture*, XXV, 4, pp. 768-97.

Adams N., 1985. "The life and times of Pietro dell'Abaco, a Renaissance estimator from Siena (active 1457-1486)", *Zeitschrift für Kunstgeschichte*, XLVIII, 1, pp. 384-95.

Alberti L.B., 1966. *L'architettura*, edited by G. Orlandi, introduction and notes by P. Portoghesi, Milan.

Angelini A., 1993. "Senesi a Urbino", in *Francesco di Giorgio*, 1993¹, pp. 332-45.

Angelucci A., 1869-1870. *Documenti inediti per la storia delle armi da fuoco italiane...*, 2 vols., Turin (facsimile ed. Graz 1972).

Ascheri M., 1985. *Siena nel Rinascimento. Istituzioni e sistema politico*, Siena.

Ascheri M., 1989. "Siena nel Quattrocento: una riconsiderazione", in K. Christiansen, L.B. Kanter, C. Brandonstrehlke, *La pittura senese nel Rinascimento*, Cinisello Balsamo, pp. xix-lvi.

Averlino, Antonio De Pietro see Filarete, Antonio

Bacci P., 1932. "I: Il pittore, scultore e architetto Iacopo Cozzarelli e la sua permanenza in Urbino con Francesco di Giorgio Martini dal 1478 al 1488"; "II: I due angioletti di bronzo (1489-1490) per l'altare del Duomo di Siena", *Bullettino senese di storia patria*, n.s., III, pp. 97-112.

Baratta M., 1903. *Leonardo da Vinci e i problemi della terra*, Turin.

Bargagli Petrucci F., 1902. "Francesco di Giorgio Martini operaio dei bottini di Siena", *Bullettino senese di storia patria*, IX, pp. 227-36.

Bargagli Petrucci F., 1906. *Le fonti di Siena e i loro acquedotti. Note storiche dalle origini fino al MDLV*, 2 vols. (I: text; II: documents), Siena.

Bartoli L., 1994. *Il disegno della cupola del Brunelleschi*, Florence.

Bâtisseurs, 1989. *Les bâtisseurs des cathedrales gothiques*, edited by R. Recht (catalogue of the exhibition, Strasbourg 1989), Strasbourg.

Battisti E., 1975. *Filippo Brunelleschi*, Rome.

Battisti E., Saccaro Battisti G., 1984. *Le macchine cifrate di Giovanni Fontana. Con la riproduzione del Cod. Icon. 242 della Bayerische Staatsbibliothek di Monaco di Baviera e la decrittazione di esso e del Cod. Lat. Nouv. Acq. 635 della Bibliothèque Nationale di Parigi*, Milan.

Beccafumi, 1990. *Domenico Beccafumi e il suo tempo* (catalogue of the exhibition, Siena 1990), Milan.

Beck J.H., 1968. "The historical Taccola and the Emperor Sigismund in Siena", *Art Bulletin*, L, pp. 309-20.

Beck J.H., 1969. "Introduzione", in Mariano Taccola Iacopo, 1969, pp. 9-38.

Beck T., 1900. *Beiträge zur Geschichte des Machinenbaues* (1st ed. 1899), Berlin

Bedini S.A., 1974. "Leonardo e l'orologeria", in L. Reti (ed.), 1974, pp. 240-63.

Beltrami L., 1912. *Vita di Aristotile da Bologna*, Bologna.

Beltrami L., 1919. *Documenti e memorie riguardanti la vita e le opere di Leonardo da Vinci in ordine cronologico*, Milan.

Bernini Pezzini G., 1985. *Il Fregio dell'arte della guerra nel Palazzo ducale di Urbino. Catalogo dei rilievi*, Rome.

Bersano L., 1957. "L'arte di Giacomo Cozzarelli", *Bullettino senese di storia patria*, III s., XVI, pp. 109-42.

Bertelot L., Campana A., 1939. "Gli scritti di Iacopo Zeno e il suo elogio di Ciriaco d'Ancona", *La bibliofilia*, XLI, pp. 356-76.

Berthelot M., 1891. "Pour l'histoire des arts mécaniques et de l'artillerie vers la fin du Moyen Âge", *Annales de chimie et de physique*, VI s., XXIV, pp. 433-521.

Berthelot M., 1895. "Histoire des corps explosifs", *Journal des savants*, pp. 684-702.

Berthelot M., 1900. "Histoire des machines de guerre et des arts mécaniques au Moyen Âge. Le livre d'un ingénieur militaire à la fin du XIVᵉ siècle", *Annales de chimie et de physique*, VII s., XIX, pp. 289-420.

Berthelot M., 1902. "Les manuscripts de Léonard de Vinci et les machines de guerre", *Journal des savants*, pp. 116-20.

Betts R.J., 1977. "On the chronology of Francesco di Giorgio's treatises: New evidence from an unpublished manuscript", *Journal of the Society of architectural historians*, XXXVI, 1, pp. 3-14.

Biringucci V., 1540. *De la pirotechnia*, Venice.

Biringucci V., 1914. *De la pirotechnia (1540)*, edited by A. Mieli, Bari.

Biringucci V., 1942. *The Pirotechnia of Vannoccio Biringuccio*, translated from the Italian with an introduction and notes by C.S. Smith and M. Teach Gnudi, New York.

Biringucci V., 1977. *De la pirotechnia*, edited by A. Carugo, Milan.

Bisogni F., 1977. "Sull'iconografia della Fonte Gaia", in *Iacopo della Quercia tra gotico e Rinascimento* (proceedings of the conference, Siena 1975), Florence.

Bloch M., 1969. *Lavoro e tecnica nel Medioevo*, Bari.

Boccia L.G., 1991. "L'armamento difensivo nei trattati di Mariano di Iacopo detto il Taccola", in P. Galluzzi (ed.), 1991, pp. 47-56.

Bonini N.P., 1897. "Una rappresentazione figurata dell'assedio di Colle nel 1479 in una tavoletta del R. Archivio di Siena", *Miscellanea storica della Valdelsa*, V, pp. 149-53.

Borsi S., 1985. *Giuliano da Sangallo. I disegni di architettura e dall'antico*, Rome.

Bottini, 1993. *I bottini medievali di Siena*, texts by D. Balestracci, D. Lamberini, M. Civai; preface by P. Galluzzi, Siena.

Bramly S., 1988. *Léonard de Vinci*, Paris.

Branca G., 1629. *Le machine...*, Rome.

Branca G., 1977. *Le machine (1629)*, edited by L. Firpo, Turin.

Brandi C., 1976. "Introduzione", in *Iacopo della Quercia nell'arte del suo tempo* (catalogue of the exhibition, Siena 1976), Florence, pp. 10-14.

Brenzoni R., 1960. *Fra Giovanni Giocondo veronese. Verona 1435-Roma 1515 ...*, Florence.

Brizio A.M., 1954. "Delle acque", in *Leonardo. Studi e ricerche*, Milan, pp. 257-89.

Brizio A.M., 1974. "Bramante e Leonardo alla corte di Ludovico il Moro", in *Studi bramanteschi* (proceedings of the international conference, Milan-Rome-Urbino 1970), Rome, pp. 1-26.

Brugnoli M.V., 1974. "Il monumento Sforza", in L. Reti (ed.), 1974, pp. 86-109.

Brusa G., 1990. "Early mechanical horology in Italy", *Antiquarian horology*, XVIII, 5, pp. 485-513.

Brusa G., 1994. "L'orologio dei pianeti di Lorenzo della Volpaia", *Nuncius*, IX, 2, pp. 645-69.

Burns A., 1974. "Ancient Greek water supply and city planning: A study of Syracuse and Acragas", *Technology and culture*, XV, 3, pp. 389-412.

Calvi G., 1925. *I manoscritti di Leonardo da Vinci dal punto di vista cronologico, storico e biografico*, Bologna (2nd ed. edited by A. Marinoni, Busto Arsizio 1982).

Calvi I., 1953. *L'ingegneria militare di Leonardo*, Milan.

Campana A., 1928. "Una ignota opera di Matteo de' Pasti e la sua missione in Turchia", *Ariminium*, I, pp. 106-8.

Canestrini G., 1939. *Leonardo costruttore di macchine e di veicoli*, Milan-Rome.

Carli E., 1980. *Gli scultori senesi*, Milan.

Carpiceci A.C., 1986. "Il cantiere di Leonardo prima del Cinquecento", in *Studi vinciani in memoria di Nando De Toni*, Brescia, pp. 145-74.

Carugo A., 1981. "Le macchine vitruviane nel Rinascimento", in Vitruvius Pollio M., 1981, pp. xlix-lviii.

Cellini B., 1968. *Opere*, edited by B. Meier, Milan.

Chastel A., 1964. "Le iniziative dei condottieri: l'arte umanistica a Rimini e a Urbino", in A. Chastel, *Arte e umanesimo a Firenze*, Turin, pp. 361 ff.

Chastel A., 1982. *Art et humanisme à Florence au temps de Laurent le Magnifique. Etudes sur la Renaissance et l'Humanisme platonicien*, 3rd ed., Paris.

Chastel A., 1987. *Le cardinal Louis d'Aragon. Un voyageur princier de la Renaissance*, Paris.

Chastel A., 1989. "L'artista", in E. Garin (ed.), *L'uomo del Rinascimento*, Rome-Bari, pp. 229-70.

Chastel A., 1995. *Leonardo da Vinci: studi e ricerche 1952-1990*, Turin.

Chironi G., 1991. "Repertorio dei documenti riguardanti Mariano di Iacopo detto il Taccola e Francesco di Giorgio Martini", in P. Galluzzi (ed.), 1991, pp. 471-82.

Cianchi R., 1964. "Figure nuove del mondo vinciano: Paolo e Vannoccio Biringuccio da Siena", *Raccolta vinciana*, XX, pp. 277-97.

Ciapponi L.A., 1960. "Il *De architectura* di Vitruvio nel primo Umanesimo (dal ms. Bodl. Auct. F.5.7)", *Italia medioevale e umanistica*, III, pp. 59-99.

Ciapponi L.A., 1961. "Appunti per una biografia di Giovanni Giocondo da Verona", *Italia medioevale e umanistica*, IV, pp. 131-58.

Ciapponi L.A., 1984. "Fra Giocondo da Verona and his edition of Vitruvius", *Journal of the Warburg and Courtauld Institutes*, XLVII, pp. 72-90.

Cinelli D., 1976. "Fonte Gaia", in *Iacopo della Quercia nell'arte del suo tempo* (catalogue of the exhibition, Siena 1976), Florence, pp. 106-109.

Clagett M., 1976. "The life and the works of Giovanni Fontana", *Annali dell'Istituto e Museo di Storia della Scienza*, I, 1, pp. 5-28.

Corso C., 1953. "Il Panormita in Siena e l'ermafrodito", *Bullettino senese di storia patria*, III s., XII, pp. 138-88.

Daumas M., 1953. "Les instruments d'observation au XVᵉ et XVIᵉ siècles", in *Léonard de Vinci et l'expérience scientifique au XVIᵉ siècle* (proceedings of the Colloques internationaux du Centre national de la recherche scientifique, Paris 1952), Paris, pp. 121-39.

DBI, 1960-. *Dizionario biografico degli italiani*, Rome.

Deanna W., 1909. "Vases à surprise et vases a puiser le vin", *Bulletin de l'Institute nationale genevois*, XXXVIII, pp. 207-33.

Dechert M.S.A., 1990. "The military architecture of Francesco di Giorgio in Southern Italy", *Journal of the Society of architectural historians*, XLIX, 2, pp. 161-80.

De Feo Corso L., 1940. "Il Filelfo in Siena", *Bullettino senese di storia patria*, n.s., XI, 3, pp. 181-209, 292-316.

Degenhart B., 1939. "Unbekannte Zeichnungen Francescos di Giorgio", *Zeitschrift für Kunstgeschichte*, VIII, pp. 117-50.

Degenhart B., Schmitt A., 1968. *Corpus der italienischen Zeichnungen 1300-1450*, I (*Süd- und Mittelitalien*), 4 vols., Berlin.

Degenhart B., Schmitt A., 1982. *Corpus der italienischen Zeichnungen 1300-1450*, II (*Venedig. Addenda zu Süd- und Mittelitalien*); IV (*Katalog 717-719. Mariano Taccola*), Berlin.

Dezzi Bardeschi M. (ed.), 1968. *Francesco di Giorgio e l'inge-*

gneria militare del suo tempo. Guida alla mostra (catalogue of the exhibition, Lucca 1968), Lucca.

Dezzi Bardeschi M., 1975. "L'architettura militare del '400 nelle Marche con particolare riguardo all'opera di Francesco di Giorgio", *Studi maceratesi*, IX, pp. 137-149 (proceedings of the IX Congresso di studi storici maceratesi, Porto Recanati 1975).

Dibner B., 1952. *Moving the obelisk*, Norwalk, NJ.

Di Pasquale S., 1982. "Riflessioni e note sui progetti di Baldassarre Peruzzi per la formazione di un lago artificiale nel territorio di Siena", in *Rilievi di fabbriche attribuite a Baldassarre Peruzzi*, Siena, pp. 71-88.

Di Pasquale S., 1984. *L'uso dei modelli nella costruzione di S. Maria del Fiore*. Workshop on architecture, Florence.

D'Onofrio C., 1965. *Gli obelischi di Roma*, Rome.

Drachmann A.G., 1948. "Ktesibios, Philon and Heron. A study in ancient pneumatics", *Acta historica scientiarum naturalium et medicinalium*.

Drachmann A.G., 1963. *The mechanical technology of Greek and Roman Antiquity. A study of the literary sources*, Copenhagen.

DSB, 1970-80. *Dictionary of scientific biography*, edited by C.C. Gillispie, 16 vols., New York.

Duhem P., 1906-13. *Etudes sur Léonard de Vinci*, 3 vols., Paris.

Edgerton S.Y. jr., 1975. *The Renaissance rediscovery of linear perspective*, New York.

Escobar S., 1984. "Il tecnico idraulico tra sapere e saper fare", in *Leonardo e le vie d'acqua*, pp. 11-25.

Fara A., 1995. "Ammannati, le colonne di Firenze, l'obelisco vaticano", *Bollettino ingegneri*, XLII, 5, pp. 3-13.

Febvre L., 1942. *Le problème de l'incroyance au XVIᵉ siècle. La religion de Rabelais*, Paris.

Feldhaus F.M., 1904. *Lexicon der Erfindungen*, Heidelberg.

Feldhaus F.M., 1913. *Leonardo der Technicher und Erfinder*, Jena.

Feldhaus F.M., 1914. *Die Technik der Vorzeit, der geschichtlichen Zeit und der Naturvölker. Ein Handbuch für Archäologen und Historiker, Museen und Sammler, Kunsthändler und Antiquare*, Leipzig-Berlin.

Feldhaus F.M., 1924. *Ruhmesblätter der Technik*, Leipzig.

Feldhaus F.M., 1930. *Die Technik der Antike und des Mittelalters*, Potsdam (facsim. ed. Hildesheim-New York 1971).

Feldhaus F.M., 1954. *Die Maschine im Leben der Völker*, Basel.

Filarete Antonio, 1965. *Treatise on architecture*, edited by J.R. Spencer, New Haven-London.

Filarete Antonio, 1972. *Trattato di architettura*, text edited by A.M. Finoli and L. Grassi, introduction and notes by L. Grassi, 2 vols., Milan.

Filippini F., 1925. "Le opere architettoniche di Aristotile Fioravanti in Bologna e in Russia", *Cronache d'arte*, II, 3, pp. 101-20.

Fioravanti G., 1980-81. *Università e città. Cultura umanistica e cultura scolastica a Siena nel '400*, Florence.

Fiore F.P., 1978. *Città e macchine del '400 nei disegni di Francesco di Giorgio Martini*, Florence.

Fiore F.P., 1981. "Le architetture vitruviane nelle illustrazioni del Cesariano", in Vitruvius Pollio, 1981, pp. xxxv-xlviii.

Fiore F.P., 1985. "La traduzione da Vitruvio di Francesco di Giorgio. Note ad una parziale trascrizione", *Architettura. Storia e documenti*, I, 1, pp. 7-30.

Firpo L., 1987. "Léonard urbaniste", in P. Galluzzi (ed.), 1987, pp. 287-301.

Foley V., 1988. "Leonardo and the invention of the Wheellock", *Scientific American*, 278, 1, pp. 74-78.

Fontana D., 1978. *Della trasportatione dell'obelisco vaticano (1590)*, edited by A. Carugo, introduction by P. Portoghesi, Milan.

Fontana P., 1936. "I codici di Francesco di Giorgio Martini e di Mariano di Jacopo detto il Taccola", in *XIVᵉ Congrès international d'histoire de l'art. Résumés des communications présentées en section* (proceedings of the conference, Bruxelles 1936), I, Bern, pp. 102-103.

Fontana V., 1988. *Fra' Giovanni Giocondo architetto 1433c.-1515*, Venice.

Francesco di Giorgio, 1841. *Trattato di architettura civile e militare di Francesco di Giorgio Martini architetto senese del secolo XV ora per la prima volta pubblicato per cura del cavaliere Cesare Saluzzo con dissertazioni e note per servire alla storia militare italiana*, edited by C. Promis, 3 vols. (I, II: text; III: atlas), Turin.

Francesco di Giorgio, 1967. *Trattati di architettura ingegneria e arte militare*, edited by C. Maltese, transcription by L. Maltese Degrassi, 2 vols., Milan.

Francesco di Giorgio, 1970. *La praticha di gieometria dal Codice Ashburnham 361 della Biblioteca Medicea Laurenziana di Firenze*, edited by G. Arrighi, Florence.

Francesco di Giorgio, 1979. *Il Codice Ashburnham 361 della Biblioteca Medicea Laurenziana di Firenze. Trattato di architettura di Francesco di Giorgio Martini*, preface by L. Firpo, introduction, transcription and notes by P.C. Marani, 2 vols. (I: text; II: facsimile), Florence.

Francesco di Giorgio, 1985. *Il Vitruvio magliabechiano di Francesco di Giorgio Martini*, edited by G. Scaglia, Florence.

Francesco di Giorgio, 1989. *Das Skizzenbuch des Francesco di Giorgio Martini. Vat. Urb. Lat. 1757*, introduction by L. Michelini Tocci, 2 vols. (I: introduction; II: facsimile), Zurich.

Francesco di Giorgio, 1993¹. Francesco di Giorgio e il Rinascimento a Siena 1450-1500, edited by L. Bellosi, Milan.

Francesco di Giorgio, 1993². Francesco di Giorgio architetto, edited by F.P. Fiore and M. Tafuri, Milan.

Franci R., Toti Rigatelli L., 1985. "La trattatistica matematica del Rinascimento senese", in *Documenti per una storia della scienza senese. Memorie*, 2, pp. 2-73.

Frontino S.G., 1487. *Stratagemata*, Rome.

Galluzzi P. (ed.), 1974. *Leonardo da Vinci letto e commentato ...* (Letture vinciane I-XII, 1960-72), Florence.

Galluzzi P. (ed.), 1980. "La rinascita della scienza", in *Firenze e la Toscana dei Medici nell'Europa del Cinquecento. La corte il mare i mercanti. La rinascita della scienza. Editoria e società. Astrologia magia e alchimia* (catalogue of the exhibition, Florence 1980), Florence, pp. 123-243.

Galluzzi P. (ed.), 1987. *Leonardo da Vinci engineer and archi-tect/Léonard de Vinci ingénieur et architecte* (catalogue of the exhibition, Montreal 1987), Montreal.

Galluzzi P., 1987[1]. "La carrière d'un technologue", in P. Gal-luzzi (ed.), 1987, pp. 41-109.

Galluzzi P., 1987[2]. "Leonardo da Vinci: from the *elementi mac-chinali* to the man-machine", *History and technology*, IV, 1-4, pp. 235-65.

Galluzzi P., 1989. *Leonardo e i proporzionanti* (Lettura vincia-na XXVIII, 1988), Florence.

Galluzzi P. (ed.), 1991. *Prima di Leonardo. Cultura delle mac-chine a Siena nel Rinascimento* (catalogue of the exhibition, Siena 1991), Milan.

Galluzzi P., 1991. "Le macchine senesi. Ricerca antiquaria, spi-rito di innovazione e cultura del territorio". Introduction to P. Galluzzi (ed.), 1991, pp. 15-44.

Galluzzi P., 1996. "Ritratti di macchine del Quattrocento", in *Inaugurazione dell'Anno Accademico 1995-96*, Florence, pp. 37-66.

Garin E., 1961. "Il problema delle fonti nel pensiero di Leo-nardo", in *La cultura filosofica del Rinascimento*, Florence.

Garin E., 1967. *Ritratti di umanisti*, Florence.

Garin E., 1971, "La città in Leonardo" (Lettura vinciana XII), in P. Galluzzi (ed.), 1974, pp. 309-25.

Ghiberti L., 1912. *Denkwurdigkeiten (I commentari)*, edited by J. von Schlosser, Berlin.

Ghiberti L., 1947. *I commentari*, edited by O. Morisani, Naples.

Giacomelli E., 1936. *Gli scritti di Leonardo da Vinci sul volo*, Rome.

Giangaspro P. (ed.), 1982. *L'architettura delle macchine. Il Ri-nascimento*, texts by D. Giacosa and A.D. Pica, Milan.

Giardina A. (ed.), 1989. *Le cose della guerra*, Milan.

Gille B., 1953. "Léonard de Vinci et la technique de son tem-ps", in *Léonard de Vinci et l'expérience scientifique au XVIᵉ siè-cle* (proceedings of the Colloques internationaux du Centre national de la recherche scientifique, Paris 1952), Paris, pp. 141-49.

Gille B., 1972. *Leonardo e gli ingegneri del Rinascimento* (1st ed. *Les ingénieurs de la Renaissance*, Paris 1964), Milan.

Gille B., 1980[1]. *Leonardo e gli ingegneri del Rinascimento*, 2nd ed., Milan.

Gille B., 1980[2]. *Les mécaniciens grecs. La naissance de la tech-nologie*, Paris.

Gille B., 1985. *Storia delle tecniche*, edited by C. Tarsitani (1st ed. *Histoire des techniques*, Paris 1978) Rome.

Gimpel J., 1975. *La révolution industrielle du Moyen Âge*, Paris.

Giovannoni G., 1959. *Antonio da Sangallo il Giovane*, 2 vols., Rome.

Gombrich E.H., 1969. "The form of movement in water and air", in *Leonardo's Legacy*, Berkeley and Los Angeles, pp. 171-204. Repr. in *The heritage of Apelles*, London, 1976.

Grant E., 1971. "Henricus Aristippus, William of Moerbeke and two alleged medieval translations of Hero's *Pneumatica*", *Speculum*, XLVI, pp. 656-69.

Gualandi M., 1870. *Aristotele Fioravanti meccanico ed ingegne-re del secolo XV* ..., Bologna.

Guasti C., 1857. *La cupola di S. Maria del Fiore illustrata con i documenti dell'archivio dell'opera secolare*, Florence.

Gurrieri F. (ed.), 1994. *La cattedrale di Santa Maria del Fiore*, Florence.

Hale J.R., 1965. "Gunpowder and the Renaissance. An essay in the history of ideas", in C.H. Cartes (ed.), *From the Renais-sance to Counter-Reformation*, New York.

Hale J.R., 1987. *Guerra e società nell'Europa del Rinascimento, 1450-1620* (1st ed. *War and society in Renaissance Europe, 1450-1620*, London 1985), Rome-Bari.

Hall A.R., 1956. "The military inventions of Guido da Vigeva-no", *Archives internationales d'histoire des sciences*, IX, vol. III (proceedings of the conference, Florence-Milan 1956), pp. 966-69.

Hall B.S., 1973. "Crossbows and crosswords", *Isis*, LXIV, pp. 527-33.

Hall A.R., 1976. "Guido's Texaurus, 1335", *Humana civilitas*, I (*On pre-modern technology and science. A volume of studies in honor of Lynn White, Jr.*, edited by B.S. Hall and D.C. West), pp. 11-52.

Hall B.S. (ed.), 1979. *The technological illustrations of the so-called* Anonymous of the Hussite Wars. *Codex Latinus Mona-censis, 197, I*, Wiesbaden.

Hart I.B., 1925. *The mechanical investigations of Leonardo da Vinci*, London. Repr. in *The world of Leonardo da Vinci*, Lon-don, 1961, pp. 185-339.

Hart I.B., 1985. "Leonardo's theory of bird flight and his last or-nithopters", in *The Prehistory of flight*, Berkeley, pp. 94-115.

Hassenstein W., 1941-1943. *Das Feuerwerkbuch von 1420*, Mu-nich.

Heron of Alexandria, 1988. *Les mécaniques ou l'élévateur des corps lourds. Texte arabe de Qusta Ibn Luqa établi et traduit par B. Carra de Vaux*, introduction by D.R. Hill, commentary by A.G. Drachmann, (1st ed. Paris 1894), Paris.

Heydenreich L.H., 1968. "Bemerkungen zu den zwei wieder-gefundenen Manuskripten Leonardo da Vinci im Madrid", *Kunstchronik*, IV, pp. 85-100.

Heydenreich L.H., 1974. "L'architettura militare", in Reti L. (ed.), 1974, pp. 136-65.

Hill D.R., 1973. "Trebuchets", *Viator*, IV, pp. 99-116.

Hill D.R., 1984. *A history of engineering in classical and medie-val times*, La Salle, IL.

Horvath E., 1925. *Siena e il primo Rinascimento ungherese*, Ro-me-Budapest (also in *Corvina*, 1925, V, 10).

Hülsen C. (ed.), 1910. *Il libro di Giuliano da Sangallo. Codice Vaticano Barberiniano Latino 4424*, Leipzig (2nd ed. Rome 1984), 2 vols. (I: text; II: plates).

Hülsen C., 1914. "Der *Liber instrumentorum* des Giovanni Fon-tana", in *Festgabe Hugo Blümner uberreicht zum 7.8.1914 von Freunden und Schulern*, Zurich, pp. 507-15.

Ippolito L., Peroni C., 1997. *La cupola di Santa Maria del Fio-re*, Rome.

Jähns M., 1889. *Geschichte der Kriegwissenschaften*, I, Munich-Leipzig.

Keele K., 1983. *Leonardo da Vinci's elements of the science of man*, London-New York.

Keller A.G., 1971. "The oblique treadmill of the Renaissance: theory and reality", in *Transactions of the II International Symposium on molinology* (proceedings of the Symposium, Denmark 1969), Breda.

Keller A.G., 1978. "Renaissance theaters of machines", *Technology and culture*, XIX, 3, pp. 495-508.

Kemp M., 1982. *Leonardo da Vinci. Le mirabili operazioni della natura e dell'uomo.* (1st ed. *Leonardo da Vinci. The marvellous works of nature and man*, London-Melbourne-Toronto 1981), Milan.

Kemp M. (ed.), 1989. *Leonardo on painting*, London-New Haven.

Kemp M., 1990. *The science of art. Optical themes in Western art from Brunelleschi to Seurat*, London-New Haven (Italian ed. *La scienza dell'arte*, Florence 1994).

Kemp M., 1991. "La diminutione di ciascun piano. La rappresentazione delle forme nello spazio di Francesco di Giorgio", in P. Galluzzi (ed.), 1991, pp. 105-12.

Kiely E., 1947. *Surveying instruments. Their history and classroom use*, New York.

Knobloch E., 1981. "Mariano di Jacopo detto Taccolas, ein Werk der italienischen Frührenaissance", *Technikgeschichte*, 48, pp. 1-27.

Koyré A., 1966. "Léonard de Vinci 500 ans après", in *Etudes d'histoire de la pensée scientifique*, Paris, pp. 85-100.

Krautheimer-Hess T., 1964. "More Ghibertiana", *Art Bulletin*, XLVI, pp. 307-21.

Krinsky C.H., 1969. "Introduction", in Vitruvius Pollio, 1969, pp. 5-28.

Kyeser C., 1967. *Bellifortis*. Transcription and translation by G. Quarg, 2 vols. (I: text; II: facsimile), Düsseldorf.

Laboratorio su Leonardo, 1983. Catalogue of the exhibition (Milan 1983), Milan.

Lamberini D., 1991. "La fortuna delle macchine senesi nel Cinquecento", in P. Galluzzi (ed.), 1991, pp. 135-46.

Lasciapassare, 1993. *Il lasciapassare di Cesare Borgia e Vaprio d'Adda e il viaggio di Leonardo in Romagna.* Preface by C. Pedretti, introduction by Francesca Vaglienti, texts by Sandra Facini and Lorella Grassi; with a contribution by Angelo Cerizza, Florence.

Laurenza D., 1999. "Leonardo. La scienza trasfigurata in arte", *Le scienze. I grandi della scienza*, II, 9 (June).

Leonardo da Vinci, 1883. *The literary works of Leonardo da Vinci...*, edited by J.P. Richter, 2 vols., London.

Leonardo da Vinci, 1909. *Il codice di Leonardo da Vinci nella biblioteca di Lord Leicester ... Pubblicato ... da Gerolamo Calvi*, Milan.

Leonardo da Vinci, 1923-30. *I manoscritti e i disegni di Leonardo da Vinci. Il Codice Arundel 263*, 4 vols., Rome.

Leonardo da Vinci, 1973-80. *Il Codice Atlantico.* Transcription and commentary by A. Marinoni, 24 vols. (12 of facsimiles and 12 of transcriptions), Florence.

Leonardo da Vinci, 1974. *I codici di Madrid*, edited by L. Reti, 5 vols., Florence.

Leonardo da Vinci, 1976. *Codice sul volo degli uccelli.* Iconographic and critical transcription by A. Marinoni, Florence.

Leonardo da Vinci, 1977. *The literary works of Leonardo da Vinci.* Iconographic and critical transcription by J.P. Richter. Commentary di C. Pedretti, 2 vols., Oxford.

Leonardo da Vinci, 1978-80. *Corpus of the anatomical studies in the collection of Her Majesty the Queen at Windsor Castle*, edited by K.D. Keele and C. Pedretti, 3 vols., London-New York (Italian ed. Florence 1980-85).

Leonardo da Vinci, 1980. *Il Codice Trivulziano nella Biblioteca Trivulziana di Milano.* Iconographic and critical transcription by A. M. Brizio, Florence.

Leonardo da Vinci, 1985. *I disegni di Leonardo e della sua cerchia nel Gabinetto disegni e stampe della Galleria degli Uffizi a Firenze.* Arranged and presented by C. Pedretti, catalogue edited by G. Dalli Regoli, Florence.

Leonardo da Vinci, 1986[1]. *Il manoscritto H.* Iconographic and critical transcription by A. Marinoni, Florence.

Leonardo da Vinci, 1986[2]. *Il manoscritto I.* Iconographic and critical transcription by A. Marinoni, Florence.

Leonardo da Vinci, 1986[3]. *Il manoscritto M.* Iconographic and critical transcription by A. Marinoni, Florence.

Leonardo da Vinci, 1987[1]. *The Codex Hammer of Leonardo da Vinci*, edited by C. Pedretti, Florence, 2 vols. (I: text; II: facsimile).

Leonardo da Vinci, 1987[2]. *Il manoscritto L.* Iconographic and critical transcription by A. Marinoni, Florence.

Leonardo da Vinci, 1987[3]. *Il manoscritto C.* Iconographic and critical transcription by A. Marinoni, Florence.

Leonardo da Vinci, 1988. *Il manoscritto F.* Iconographic and critical transcription by A. Marinoni, Florence.

Leonardo da Vinci, 1989[1]. *Il manoscritto D.* Iconographic and critical transcription by A. Marinoni, Florence.

Leonardo da Vinci, 1989[2]. *Il manoscritto E.* Iconographic and critical transcription by A. Marinoni, Florence.

Leonardo da Vinci, 1989[3]. *Il manoscritto G.* Iconographic and critical transcription by A. Marinoni, Florence.

Leonardo da Vinci, 1989[4]. *Il manoscritto K.* Iconographic and critical transcription by A. Marinoni, Florence.

Leonardo da Vinci, 1989[5]. Catalogue of the exhibition (London 1989), London.

Leonardo da Vinci, 1990[1]. *Il manoscritto A.* Iconographic and critical transcription by A. Marinoni, Florence.

Leonardo da Vinci, 1990[2]. *Il manoscritto B.* Iconographic and critical transcription by A. Marinoni, Florence

Leonardo da Vinci, 1992. *I Codici Forster I-III.* Iconographic and critical transcription by A. Marinoni, 3 vols., Florence.

Leonardo da Vinci, 1995[1]. *Della Natura, peso e moto delle Acque. Il Codice Leicester*, Milan.

Leonardo da Vinci, 1995[2]. *Libro di Pittura. Edizione in facsimile del Codice Urbinate Lat. 1270 nella Biblioteca Apostolica Vaticana*, edited by C. Pedretti. Critical transcription by C. Vecce, Florence.

Leonardo e le vie d'acqua, 1984. Catalogue of the exhibition (Milan 1984), Florence.

Leonardos, 1993. *Leonardos broar* (catalogue of the exhibition, Malmö 1993), Florence.

Macagno E., 1986. "Analogies in Leonardo's studies of flow phenomena", in *Studi vinciani in memoria di N. De Toni*, Brescia, pp. 19-49.

Maccagni C., 1967. "Notizie sugli artigiani della famiglia della Volpaia. Appunti su cose pisane dal codice marciano di Benvenuto di Lorenzo", *Rassegna periodica di informazioni del Comune di Pisa*, III, 8, pp. 1-13.

Maccagni C., 1970. "Riconsiderando il problema delle fonti di Leonardo" (Lettura vinciana X), in P. Galluzzi (ed), 1974, pp. 275-302.

Macchine di Valturio, 1988. *Le macchine di Valturio nei documenti dell'archivio storico AMMA*, preface by S. Ricossa, contributions by G. Amoretti, P.L. Bassignana, F. Gambaruto, V. Marchis and A. Vitale-Brovarone, Turin.

MacGregor J., 1858. "On the paddle-wheel and screw propeller from the earliest times", *Journal of the Society of arts*, VI, p. 282, pp. 335-42.

Machiavelli N., 1971-1985. *Legazioni. Commissarie. Scritti di governo*, edited by F. Chiappelli, 4 vols., Rome-Bari.

Maltese C., 1949. "Opere e soggiorni urbinati di Francesco di Giorgio", in *Studi artistici urbinati*, I, pp. 57-83.

Maltese C., 1965. "L'attività di Francesco di Giorgio Martini architetto militare nelle Marche attraverso il suo *Trattato*", in *Atti del XI Congresso di storia dell'architettura* (Marches 1959), Rome, pp. 281-328.

Maltese C., 1967. "Introduzione", in Francesco di Giorgio, 1967, pp. IX-LXV.

Mancini F., 1979. *Urbanistica rinascimentale a Imola da Girolamo Riaro a Leonardo da Vinci (1479-1502)*, Imola.

Mancini G., 1882. *Vita di Leon Battista Alberti*, Florence.

Mancini G., 1885. "Di un codice artistico e scientifico del Quattrocento con alcuni ricordi autografi di Leonardo da Vinci", *Archivio storico italiano*, XV, pp. 354-63.

Manetti A. di Tuccio, 1970. *The life of Brunelleschi by Antonio di Tuccio Manetti*, edited by H. Saalman, Philadelphia-London.

Manetti A. di Tuccio, 1976. *Vita di Filippo di Ser Brunelleschi (1490 c.)*, edited by G. Tanturli and D. De Robertis, Florence.

Marani P.C., 1979. "Introduzione", in Francesco di Giorgio, 1979, I, pp. XI-XXV.

Marani P.C., 1982. "Leonardo, Francesco di Giorgio e il tiburio del Duomo di Milano", *Arte lombarda*, n.s., LXII, pp. 81-92.

Marani P.C., 1984. *L'architettura fortificata negli studi di Leonardo da Vinci. Con il catalogo completo dei disegni*, Florence.

Marani P.C., 1985[1]. Circulo dentato ortogonalmente *(Ms. Madrid 8937, f. 117r)*. Leonardo, gli ingegneri e alcune macchine lombarde (Lettura vinciana XXV, 1985), Florence.

Marani P.C., 1985[2]. "La mappa di Imola di Leonardo", in *Leonardo: il Codice Hammer e la mappa di Imola*, Florence, pp. 140-41.

Marani P.C., 1987. "Leonardo e Francesco di Giorgio. Architettura militare e territorio", *Raccolta vinciana*, XXII, pp. 71-93.

Marchis V., 1988. "Macchine tra realtà e fantasia. L'orizzonte tecnico di Roberto Valturio", in *Macchine di Valturio*, pp. 116-41.

Mariano Taccola Iacopo, 1969. *Liber tertius de ingeneis ac edifitiis non usitatis*, edited by J.H. Beck, Milan.

Mariano Taccola Iacopo, 1971. *De machinis. The engineering treatise of 1449*, edited by G. Scaglia, 2 vols. (I: text; II: atlas), Wiesbaden.

Mariano Taccola Iacopo, 1984[1]. *De ingeneis. Liber primus leonis, liber secundus draconis, ...and addenda ... (the notebook)*, edited by G. Scaglia, F.D. Prager and U. Montag, 2 vols. (I: text; II: facsimile), Wiesbaden.

Mariano Taccola Iacopo, 1984[2]. *De rebus militaribus (De machinis, 1449). Mit dem vollständigen Faksimile der Parigier Handschrift*, edited by E. Knobloch, Baden-Baden.

Marinoni A., 1942. *Gli appunti grammaticali e lessicali di Leonardo da Vinci*, 2 vols., Milan.

Marinoni A., 1954. "I manoscritti di Leonardo da Vinci e le loro edizioni", in *Leonardo. Saggi e ricerche*, Milan, pp. 231-74.

Marinoni A., 1982. *La matematica di Leonardo da Vinci. Una nuova immagine dello scienziato*, Milan.

Marinoni A., 1987. "Les machines impossibles de Léonard", in P. Galluzzi (ed.), 1987, pp. 111-30.

Marinoni A., 1988. "Leonardo in Romagna", *Torricelliana*, 39, pp. 53-62.

Marsden E.W., 1969-71. *A history of Greek and Roman artillery*, 2nd ed., Oxford.

Michelini Tocci L., 1962. "Disegni e appunti autografi di Francesco di Giorgio in un codice del Taccola", in *Scritti di storia dell'arte in onore di Mario Salmi*, II, Rome, pp. 203-12.

Michelini Tocci L., 1986. "Federico da Montefeltro e Ottaviano Ubaldini della Corda", in *Federico da Montefeltro. Lo stato. Le arti. La cultura*, Rome, pp. 297-344.

Milanesi G. (ed.), 1854-1856. *Documenti per la storia dell'arte senese...*, 3 vols., Siena.

Minchinton W.E., 1979. "Early tide mills: some problems", *Technology and culture*, XX, 4, pp. 777-86.

Miniati M. (ed.), 1991. *Il Museo di Storia della Scienza. Catalogo*, Florence.

Minucci G., Kosuta L., 1989. *Lo Studio di Siena nei secoli XIV-XVI. Documenti e notizie biografiche*, Milan.

Mitchell C., 1962. "Ex libris Kiriaci Anconitani", *Italia medioevale e umanistica*, V, pp. 283-99.

Morachiello P., 1972. *Programmi umanistici e scienza militare nello Stato di Federico da Montefeltro*, Urbino.

Morpurgo E., 1950. *Dizionario degli orologiai italiani*, Rome.

Morpurgo E., 1954[1]. "Gli orologi di Casa Medici", *La Clessidra*, X, 7.

Morpurgo E., 1954[2]. "Ruote o molle?", *La Clessidra*, X, 9, pp. 31 ff.

Müller M., 1908. *Johann Albrecht v. Widmanstetter, 1506-1557*, Bamberg.

Mussini M., 1991. *Il Trattato di Francesco di Giorgio Martini e Leonardo: il Manoscritto Estense (Ashburnham 361) restituito*, Parma.

Mussini M., 1993. "La trattatistica di Francesco di Giorgio", in *Francesco di Giorgio*, 1993², pp. 358-79.

Oechslin W., 1976. "La fama di Aristotele Fioravanti ingegnere e architetto", *Arte lombarda*, n.s., XLIV-XLV, pp. 102-20.

Olsson K.G., 1994. "The vision of a bridge", *Achademia Leonardi Vinci*, VI, pp. 216-21.

Omodei F., 1835. "Dell'origine della polvere da guerra e del primo uso delle artiglierie a fuoco ...", *Memorie della Reale Accademia delle scienze di Torino. Memorie della Classe di scienze morali, storiche e filologiche*, XXXVIII, pp. 145-224.

Ostuni G. (ed.), 1993. *Le macchine del re. Il "Texaurus Regis Francie" di Guido da Vigevano*, Vigevano.

Pagliara P.N., 1977. "Una fonte di illustrazioni del Vitruvio di Fra' Giocondo", *Ricerche di storia dell'arte*, VI, pp. 113-20.

Pagliara P.N., 1986. "Vitruvio da testo a canone", in *Storia dell'arte italiana. Memoria dell'antico nell'arte italiana*, III (*Dalle tradizioni all'archeologia*, edited by S. Settis), Turin, pp. 5-85.

Panofsky E., 1955. "The history of the theory of human proportions as a reflection of the history of styles", in E. Panofsky, *Meaning in the visual arts*, Garden City, NY, pp. 55-107.

Papini R., 1946. *Francesco di Giorgio architetto*, 3 vols., Florence.

Parronchi A., 1971. "Sulla composizione dei trattati attribuiti a Francesco di Giorgio Martini", *Atti e memorie dell'Accademia toscana di scienze e lettere "La Colombaria"*, XXXVI, pp. 163-230.

Parronchi A., 1976. "Distrazioni e sviste di Leonardo copista (o dei suoi commentatori)", *Rinascimento*, XVI, pp. 231-240.

Parsons W.B., 1939. *Engineers and engineering in the Renaissance*, Baltimore.

Partington J.R., 1960. *A history of Greek fire and gunpowder*, Cambridge.

Payne Gallwey R., 1903. *The crossbow, with a treatise on the balista and catapult of the Ancients*, London.

Payne Gallwey R., 1907. *The projectile-throwing engines of the Ancients*, London (repr. Totowa, N.J. 1973).

Pedretti C., 1953. *Documenti e memorie riguardanti Leonardo da Vinci a Bologna e in Emilia*, Bologna.

Pedretti C., 1954. "La macchina idraulica costruita da Leonardo per conto di Bernardo Rucellai e i primi contatori ad acqua", *Raccolta vinciana*, XVII, pp. 177-215.

Pedretti C., 1957. "Il codice di Benvenuto di Lorenzo della Golpaja", in C. Pedretti, *Studi vinciani*, Geneva, pp. 23-33.

Pedretti C., 1960. "Saggio di una cronologia dei fogli del Codice Arundel", *Bibliothèque d'Humanisme et Renaissance*, XXII, pp. 172-77.

Pedretti C., 1962. *A chronology of Leonardo da Vinci's architectural studies after 1500*, Geneva.

Pedretti C., 1964. *Leonardo da Vinci on painting. A last book (Libro A)*, Berkeley-Los Angeles, CA.

Pedretti C., 1972. *Leonardo da Vinci. The Royal Palace at Romorantin*, Cambridge, MA.

Pedretti C., 1976. *Il primo Leonardo a Firenze. L'Arno, la cupola, il battistero*, Florence.

Pedretti C., 1977. *The literary works of Leonardo da Vinci. A commentary to J.P. Richter's edition*, 2 vols., Oxford.

Pedretti C., 1978. *Leonardo architetto*, Milan.

Pedretti C., 1978-1979. *The Codex Atlanticus of Leonardo da Vinci. A catalogue of its newly restored sheets*, 2 vols., New York.

Pedretti C., 1982. "Introduzione", in A. Vezzosi (ed.), *Leonardo dopo Milano* (catalogue of the exhibition, Vinci 1982), Florence, pp. 11-23.

Pedretti C., 1983. "Le *magne opere romane*", in A. Vezzosi (ed.), 1983, pp. 191-98.

Pedretti C., 1987. "Introduction", in P. Galluzzi (ed.), 1987, pp. 1-21.

Pedretti C., 1991. "La campana di Siena", in P. Galluzzi (ed.), 1991, pp. 121-33.

Pedretti C., 1994. "Leonardo in Sweden", *Achademia Leonardi Vinci*, VI, pp. 200-11.

Perina C., 1968. "Biringucci Oreste detto Vannocci", in *DBI*, X, pp. 624-5.

Peruzzi B., 1982. *Trattato di architettura militare*, edited by A. Parronchi, Florence.

Philon of Byzantium, 1899. *Pneumatica*, in *Opera quae supersunt*, edited by W. Schmidt, I, Leipzig, pp. 1-333.

Philon of Byzantium, 1974. *Pneumatica. The first treatise on experimental physics: Western version and Eastern version ...*, edited by F.D. Prager, Wiesbaden.

Philon of Byzantium, 1989. *Le livre des appareils pneumatiques et des machines hydrauliques*, Paris

Pidcock M., 1994. "The hang glider", *Achademia Leonardi Vinci*, VI, pp. 222-25.

Pieri P., 1952. *Il Rinascimento e la crisi militare italiana*, 2nd ed., Turin.

Popham A.E., Pouncey P., 1950. *Italian drawings in the Department of Prints and Drawings in the British Museum. The fourteenth and fifteenth centuries*, 2 vols., London.

Portoghesi P., 1981. *L'infanzia delle macchine*, Rome-Bari.

Prager F.D., 1946. "*Brunelleschi's patent*", *Journal of the Patent Office Society*, XXVIII, pp. 109-35.

Prager F.D., 1950. "Brunelleschi's inventions and the renewal of Roman masonry work", *Osiris*, IX, pp. 457-554.

Prager F.D., 1968¹. "Brunelleschi's clock?", *Physis*, X, 3, pp. 203-16.

Prager F.D., 1968². "A manuscript of Taccola, quoting Brunelleschi on problems of inventors and builders", *Proceedings of the American Philosophical Society*, CXII, 3, pp. 131-49.

Prager F.D., 1971. "Fontana on fountains", *Physis*, XIII, 4, pp. 341-60.

Prager F.D., 1975. "The Greek evacuators", *Physis*, XVII, 3-4, pp. 234-48.

Prager F.D., 1978. "Vitruvius and the elevated aqueducts", *History of technology*, III (edited by A.R. Hall and N. Smith), pp. 105-21.

Prager F.D., Scaglia G., 1970. *Brunelleschi: Studies of his technology and inventions*, Cambridge, MA-London.

Prager F.D., Scaglia G., 1972. *Mariano Taccola and his book* De ingeneis, Cambridge, MA-London.

Price Derek J. de Solla, 1955-56. "Clockwork before the clock", *Horological Journal*, XCVII (1955), pp. 810-14; XCVIII (1956), pp. 31-35.

Price Derek J. de Solla, 1964. "Automata and the origins of mechanism and mechanistic philosophy", *Technology and culture*, V, 1, pp. 9-23.

Promis C., 1841[1]. "Catalogo analitico de' codici scritti e figurati di Francesco di Giorgio Martini", in Francesco di Giorgio, 1841, I, pp. 87-122 (also in C. Promis, *Vita di Francesco di Giorgio Martini architetto senese del secolo XV aggiuntovi il catalogo de' codici*, Turin 1841, pp. 87-122).

Promis C., 1841[2]. "Della vita e delle opere degl'italiani scrittori di artiglieria, architettura e meccanica militare da Egidio Colonna a Francesco Marchi 1285-1560. Memoria storica I", in Francesco di Giorgio, 1841, II, pp. 1-119.

Promis C., 1841[3]. "Vita di Francesco di Giorgio Martini", in Francesco di Giorgio, 1841, I, pp. 1-86 (also in C. Promis, *Vita di Francesco di Giorgio Martini architetto senese del secolo XV aggiuntovi il catalogo de' codici*, Turin 1841, pp. 1-86).

Promis C., 1874. *Biografie di ingegneri militari italiani dal secolo XIV alla metà del XVIII*, Turin.

Prunai G., 1950. "Lo Studio senese dalla *migratio* bolognese alla fondazione della Domus Sapientiae (1321-1408), *Bullettino senese di storia patria*, VII, pp. 3-54.

Ragghianti L., 1977. *Filippo Brunelleschi, un uomo un universo*, Florence.

Ramelli A., 1588. *Le diverse et artificiose machine...*, Paris.

Ramelli A., 1976. *The various and ingenious machines of Agostino Ramelli*, edited by M. Teach Gnudi, Baltimore-London.

Reti L., 1956-1957. "Leonardo da Vinci nella storia della macchina a vapore", *Rivista di ingegneria*, VI (1956), pp. 27-38; VII (1957), pp. 773-89.

Reti L., 1963. "Francesco di Giorgio Martini's Treatise on engineering and its plagiarists", *Technology and culture*, IV, 3, pp. 287-98.

Reti L., 1964[1]. "Helicopters and whirligigs", *Raccolta vinciana*, XX, pp. 331-8.

Reti L., 1964[2]. *Tracce dei progetti perduti di Filippo Brunelleschi nel Codice Atlantico* (Lettura vinciana IV). Repr. in P. Galluzzi (ed.), 1974, pp. 83-130.

Reti L., 1965. "A postscript to the Filarete discussion. On horizontal waterwheels and smelter blowers in the writings of Leonardo da Vinci and Juanelo Turriano", *Technology and culture*, VI, 3, pp. 428-41.

Reti L., 1968. "The two unpublished manuscripts of Leonardo Da Vinci in the Biblioteca Nacional of Madrid", *The Burlington Magazine*, 778, pp. 10-22; 779, pp. 81-89.

Reti L. (ed.), 1974. *Leonardo*, Milan.

Reti L., 1974. "Elementi di macchine", in L. Reti (ed.), 1974, pp. 264-87.

Ricci M., 1983. *Il fiore di S. Maria del Fiore. Ipotesi sulla regola di costruzione della Cupola*, Florence.

Rinascimento, 1994. *Rinascimento. Da Brunelleschi a Michelangelo. La rappresentazione dell'architettura*, edited by H. Millon and V. Magnago Lampugnani (catalogue of the exhibition, Venice 1994), Milan.

Romagnoli E., 1976. *Biografia cronologica de' bellartisti senesi*, Florence, 13 voll. (repr. of ms. *ante* 1835 in the Biblioteca Comunale of Siena), Florence.

Rose P.L., 1968. "The Taccola manuscripts", *Physis*, X, 4, pp. 337-46.

Rose P.L., 1975. *The Italian Renaissance of mathematics. Studies on humanists and mathematicians from Petrarch to Galileo*, Geneva.

Rosheim M.E., 1994. *Robot evolution. The development of anthrobotics*, New York-Chichester-Brisbane-Toronto-Singapore.

Rosheim M.E., 1996. "Leonardo's Lost Robot", *Achademia Leonardi Vinci*, IX, pp. 99-108.

Rossi P.A., 1977. *Le cupole di Brunelleschi*, Florence.

Saalman H., 1959. "Early Renaissance architectural theory and practice in Antonio Filarete's *Trattato di architettura*", *Art Bulletin*, XLI, 1, pp. 89-106.

Saalman H., 1980. *Filippo Brunelleschi. The Cupola of Santa Maria del Fiore*, London.

Sabbadini R., 1931. *Carteggio di Giovanni Aurispa*, Rome.

Sackur W., 1925. *Vitruv und die Poliorketiker*, Berlin.

Salmi M., 1947. *Disegni di Francesco di Giorgio nella collezione Chigi Saracini*, Siena.

Sanpaolesi P., 1941. *La cupola di Santa Maria del Fiore. Il progetto. La costruzione*, Rome.

Sarton G., 1949. *Agrippa, Fontana e Pigafetta. The erection of the Vatican obelisk in 1586*, Paris.

Scaglia G., 1960-1961. "Drawings of Brunelleschi's mechanical inventions for the construction of the Cupola", *Marsyas*, X, pp. 45-68.

Scaglia G., 1966. "Drawings of machines for architecture from the early Quattrocento in Italy", *Journal of the Society of architectural historians*, XXV, 2, pp. 90-114.

Scaglia G., 1968. "An allegorical portrait of Emperor Sigismond by Mariano Taccola of Siena", *Journal of the Warburg and Courtauld Institutes*, XXXI, pp. 428-34.

Scaglia G., 1971. Saggio introduttivo a Mariano Taccola Iacopo, 1971, I, pp. 7-55.

Scaglia G., 1976[1]. "A miscellany of bronze works and texts in the Zibaldone of Buonaccorso Ghiberti", *Proceedings of the American Philosophical Society*, CXX, 6, pp. 485-513.

Scaglia G., 1976[2]. "The *Opera De Architectura* of Francesco di Giorgio Martini for Alfonso Duke of Calabria, *Napoli nobilissima*, XV, 5-6, pp. 133-61.

Scaglia G., 1979. "A translation of Vitruvius and copies of late antique drawings in Buonaccorso Ghiberti's *Zibaldone*", *Transactions of the American Philosophical Society*, LXIX, 1.

Scaglia G., 1980. "Autour de Francesco di Giorgio Martini, ingénieur et dessinateur", *Revue de l'art*, XLVIII, pp. 7-25.

Scaglia G., 1981. *Alle origini degli studi tecnologici di Leonardo* (Lettura vinciana XX, 1980), Florence.

Scaglia G., 1982[1]. "Francesco di Giorgio's chapters on fortresses and on war machines", *FORT. Fortress Study Group*, 10, pp. 39-69.

Scaglia G., 1982². "Leonardo e Francesco di Giorgio a Milano nel 1490", in E. Bellone, P. Rossi (eds.), *Leonardo e l'età della ragione*, Milan, pp. 225-53.

Scaglia G., 1985. Introduction to Francesco di Giorgio, 1985, pp. 13-71.

Scaglia G., 1988¹. "The development of Francesco di Giorgio's treatises in Siena", in J. Guillaume (ed.), *Les traités d'architecture de la Renaissance* (proceedings of the conference, Tours 1981), Paris.

Scaglia G., 1988². "Drawings of forts and engines by Lorenzo Donati, Giovanbattista Alberti, Sallustio Peruzzi, The Machine Complex Artist, and Oreste Biringuccio", *Architectura*, II, pp. 169-97.

Scaglia G., 1991¹. *Francesco di Giorgio checklist and history of manuscripts and drawings in autographs and copies from ca. 1470 to 1687 and renewed copies (1764-1839)*, London.

Scaglia G., 1991². "Drawings of machines", in *Corpus of the drawings by Antonio da Sangallo il Giovane*, I, New York.

Scaglia G., 1991³, "Francesco di Giorgio autore", in P. Galluzzi (ed.), 1991, pp. 57-80.

Scaglia G., Prager F.D., Montag U., 1984¹. "Appendix II. Drawings in Add. 34113, The British Library, and in Codex Santini, Urbino. Machines and structures developed from the notebook of Taccola. The Machine Complex", in Mariano Taccola Iacopo, 1984¹, I, pp. 160-71.

Scaglia G., Prager F.D., Montag U., 1984². "Introduction", in Mariano Taccola Iacopo, 1984¹, I, pp. 11-33.

Segnini C.A. (ed.), 1986. *Disegni di macchine. Il Codice S.IV.5 della Biblioteca Comunale degl'Intronati di Siena*, introduction by C. Maccagni, supervision by A. Cerizza, Milan.

Settle T., 1978. "Brunelleschi's horizontal arches and related devices", *Annali dell'Istituto e Museo di Storia della Scienza*, III, 1, pp. 65-79.

Shapiro S., 1964. "The origin of the suction pump", *Technology and culture*, V, 4, pp. 566-74.

Shelby L.R., 1975. "Mariano Taccola and his books on engines and machines", *Technology and culture*, XVI, 3, pp. 466-75.

Simoni A., 1954. "A new document and some views about early spring-driven clocks", *Horological Journal*, XCVI, pp. 590 ff.

Simoni A., 1965. *Orologi dal '500 all'800*, Milan.

Sixl P., 1898-1899. "Entwickelung und Gebrauch der Handfeuerwaffen", *Zeitschrift für Historische Waffenkunde*, I, 5 (1898), pp. 112-7; 6 (1898), pp. 137-41; 7 (1898), pp. 182-4; 8 (1898), pp. 199-202; 9 (1899), pp. 220-8; 10 (1899), pp. 248-56; 11 (1899), pp. 276-82; 12 (1899), pp. 300-6 (facsim.ed. Graz 1972).

Smith C.S., 1971. "Biringuccio Vannoccio", in *DSB*, II, pp. 142-3.

Smith C.S. e Hawthorne J.G. (eds.), 1974. "*Mappae Clavicula*. A little key to the world of medieval techniques (Sélestat, Ms. 17)", *Transactions of the American Philosophical Society*, n.s., LXIV, 4.

Smith N.A.F., 1976. "Attitudes to Roman engineering and the question of the inverted siphon", *History of technology*, I (edited by A.R. Hall and N. Smith), pp. 45-71.

Solmi E., 1908. "Le fonti dei manoscritti di Leonardo da Vinci", *Giornale storico della letteratura italiana* (repr. in E. Solmi, *Scritti vinciani*, Florence 1976).

Soranzo G., 1909. "Una missione di Sigismondo Pandolfo Malatesta a Maometto II nel 1461", *La Romagna*, s. III, VI, 1, pp. 43-54; 2, pp. 93-6.

Soranzo G., 1910. "Ancora sulla missione di Sigismondo Pandolfo Malatesta a Maometto II e Matteo de' Pasti", *La Romagna*, s. III, VII, 1-2, pp. 62-4.

Steinitz K.T., 1969. "Leonardo architetto teatrale e organizzatore di feste" (Lettura vinciana IX), in P. Galluzzi (ed.), 1974, pp. 249-71.

Straub H., 1952. "Die Maschinenreliefs des Francesco di Giorgio in Urbino", *Schweizerische Bauzeitung*, XLIV, pp. 632 foll.

Strobino G., 1953. *Leonardo da Vinci e la meccanica tessile*, Milan.

Teach Gnudi M., 1974. "Agostino Ramelli and Ambroise Bachot", *Technology and culture*, XV, 4, pp. 614-25.

Theophilus, 1961. *De diversis artibus. The various arts*, edited by C.R. Dodwell, London.

Theophilus, 1963. *On divers arts. The treatise of Theophilus*, edited by J.G. Hawthorne and C.S. Smith, Chicago.

Thevenot M. (ed.), 1693. *Veterum mathematicorum... opera...*, Paris.

Thorndike L., 1955. "Marianus Jacobus Taccola", *Archives internationales d'histoire des sciences*, n.s., VIII, 30, pp. 7-26.

Toca M., 1970. "Un progetto peruzziano per una diga di sbarramento nella Maremma", *Annali della Scuola normale superiore di Pisa. Lettere, storia e filosofia*, s. II, XXXIX, 1-2, pp. 107-17.

Tucci U., 1968. "Biringucci Vannoccio", in *DBI*, X, pp. 625-31.

Tugnoli Pattaro S., 1976. "Le opere bolognesi di Aristotele Fioravanti architetto e ingegnere del secolo quindicesimo", *Arte lombarda*, n.s., XLIV-XLV, pp. 35-70.

Tursini L., 1954. "Navi e scafandri negli studi di Leonardo", in G. Castelfranco (ed.), *Leonardo. Saggi e ricerche*, Rome, pp. 67-84.

Uccelli A., 1940. *Leonardo da Vinci. I libri di meccanica*, Milan.

Ucelli Di Nemi G., 1940. *Le navi di Nemi*, Rome.

Uzielli G., 1904. "Le deviazioni dei fiumi negli assedi di Lucca, Pisa ecc. e in altre imprese guerresche, ossia Difesa di Filippo Brunelleschi, Niccolò Machiavelli e Leonardo da Vinci contro i loro accusatori", in *La navigazione interna*, Florence (also in *Atti del Convegno Internazionale di scienze storiche*, Rome 1906).

Vasari G., 1878-1881. "Le vite de' più eccellenti pittori scultori et architettori ...", in G. Vasari, *Le opere*, edited by G. Milanesi, I-VII, Florence (facsim. ed. Florence 1981).

Vegezio Renato F., 1885. *Epitoma rei militaris*, edited by K. Lang, Stuttgart (facsim. ed. Stuttgart 1967).

Venturi G.B., 1797. *Essai sur les ouvrages physico-mathématiques de Léonard de Vinci...*, Paris.

Venturi G.B., 1815. *Dell'origine e dei primi progressi delle odierne artiglierie...*, Reggio Emilia.

Venturi G. B., 1817. "Dei fuochi militari presso gli antichi", *Biblioteca italiana*, 17, pp. 243-59; 18, pp. 377-89.

Vezzosi A. (ed.), 1983. *Leonardo e il leonardismo a Napoli e a Roma* (catalogue of the exhibition, Naples-Rome 1983-84), Florence.

Villard de Honnecourt, 1858. *Album de Villard de Honnecourt, architecte du XIII^e siècle*, edited by J.B.A. Lassus and A. Darcel, Paris.

Villard de Honnecourt, 1972. *Kritische Gesamtausgabe des Bauhüttenbuches Ms. fr 19093 der Parigier Nationalbibliothek*, H.R. Hahnloser, 2nd ed., Graz.

Vitruvius Pollio, M., 1511. *M. Vitruvium per Jocundum solito castigatior factus cum figuris et tabula...*, Venice.

Vitruvius Pollio, M., 1969. *De architectura. Nachdruck der kommentierten ersten italienischen Ausgabe von Cesare Cesariano (Como, 1521)*. Edited by C.H. Krinsky, Munich.

Vitruvius Pollio, M., 1981. *De architectura. Translato commentato et affigurato da Caesare Caesariano, 1521*, edited by A. Bruschi, A. Carugo and F.P. Fiore, Milan.

Vogel L., 1973. *The column of Antoninus Pius*, Cambridge, MA.

Wackernagel M., 1994. *Il mondo degli artisti nel Rinascimento fiorentino* (1st ed. Leipzig 1938), Florence.

Weller A.S., 1943. *Francesco di Giorgio, 1439-1501*, Chicago, IL.

White L. jr., 1962. *Medieval technology and social change*, Oxford.

White L. jr., 1967. *Tecnologia e società nel Medioevo* (1st ed. Oxford 1962), Milan.

White L. jr., 1968. "The invention of the *paracadute*", *Technology and culture*, IX, pp. 462-67.

White L. jr., 1969. "Kyeser's *Bellifortis*. The first technological treatise of the fifteenth century", *Technology and culture*, X, pp. 436-41.

White L. jr., 1975. "Medical astrologers and late medieval technology", *Viator*, VI, pp. 295-308.

Wilbur C.M., 1936. "The history of the crossbow", *Annual report of the Smithsonian Institution*, pp. 427-38.

Winternitz E., 1974. "Leonardo e la musica", in L. Reti (ed.), 1974, pp. 110-35.

Winternitz E., 1982. *Leonardo da Vinci as a musician*, New Haven-London.

Wurm H., 1984. *Baldassarre Peruzzi. Architekturzeichnungen*, Tübingen.

Zammattio C., 1974. "Acque e pietre: loro meccanica", in L. Reti (ed.), 1974, pp. 190-215.

Zdekauer L., 1894. *Lo Studio di Siena nel Rinascimento*, Milan (facsim. ed. Bologna 1977).

Zdekauer L. (ed.), 1902. *Il taccuino senese di Giuliano da Sangallo*, Siena.

Zonca V., 1985. *Teatro di machine et edifici*, edited by C. Poni, Milan.

Zoubov V.P., 1960. "Vitruve et ses commentateurs du XVI^e siècle", in *La science au seizième siècle* (proceedings of the International conference, Royaumont 1957), Paris, pp. 67-90.

List of abbreviations

Photographic credits

Printed in Italy
Giunti Industrie Grafiche
2001